WALTER PATER

The Renaissance

STUDIES
IN ART
AND POETRY

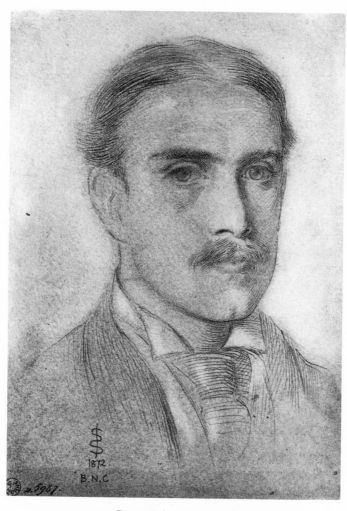

WALTER PATER. Portrait by Simeon Solomon, 1872.
By courtesy of Gabinetto fotografico, Florence.

WALTER PATER

The Renaissance

STUDIES IN ART AND POETRY

THE 1893 TEXT

Edited, with Textual
and Explanatory Notes,
by DONALD L. HILL

University of California Press
Berkeley · Los Angeles · London

University of California Press
Berkeley and Los Angeles, California

University of California Press, Ltd.
London, England

Copyright © 1980 by
The Regents of the University of California

ISBN 0-520-03325-6
Library of Congress Catalog Card Number: 76-24582
Printed in the United States of America

1 2 3 4 5 6 7 8

Contents

v

CONTENTS

List of Illustrations

vii

LIST OF ILLUSTRATIONS

Editor's Preface

WALTER PATER'S first and best-known book, *The Renaissance*, exists in several different editions; but no single one of these can satisfy the scholar, and no scholarly edition of the book has ever been published. The first edition of 1873 consisted of ten essays, five of which had already appeared in periodicals. An eleventh essay, "The School of Giorgione," was added in the third edition after it too had been published in a magazine. For each of the four editions of *The Renaissance* published during his lifetime (1873, 1877, 1888, 1893), Pater made revisions in every one of the republished essays; indeed there is hardly a page of the book which has not been revised. Most of the revisions are minute, but some amount to extensive recastings and some involve significant additions or omissions. After Pater's death a fifth edition of *The Renaissance* appeared as the first volume of Macmillan's eight-volume edition of Pater's *Works* (London, 1900–1901). For reasons not yet known or explained, the text of this edition usually follows not that of 1893, Pater's own last revised version, but that of 1888. Often, however, the text of 1900–1901 does include readings from the 1893 edition, and sometimes it offers its own unique language.

The standard edition of Pater's works in use today is Macmillan's ten-volume Library Edition, published in London in 1910 and several times reprinted until the mid-1920's. The text of *The Renaissance* in the 1910 edition is based closely, but not exactly, on that of 1893. The original volumes of this edition, those in libraries now often battered, defaced, and rebound, have been replaceable since 1967 by reprints available through Basil Blackwell of Oxford and the Johnson Reprint Corporation of New York. Though an attractive set of books, this edition has no annotations apart from the few supplied for earlier editions by Pater himself. More recent

editions merely reproduce one or another of the published texts, often without noting which one has been selected.

For this edition I have chosen to reproduce the text of 1893, that of the fourth edition, as the latest text that Pater saw through the press, the one which thus embodies his own maturest judgment in matters of form, style, and meaning. Though it is quite a good text, some errors nonetheless escaped Pater's eye, and I have made a few corrections. My Textual Notes provide a record of the wording of each of the other published versions of each essay through 1910 wherever it differs from that of the 1893 edition. To the text of *The Renaissance* I have appended two of Pater's book reviews, one published in 1872 while he was planning his first edition and writing the new chapters for it, the other in 1875, a more substantial piece of work in which he was moved to speak with more candor and emphasis than usual. These reviews will repay the student's attention, partly for what they contribute to his understanding of Pater's interests and convictions during the early 1870's, partly for the language of certain sentences which have their counterparts in *The Renaissance*.

The only earlier attempt to supply the book with full annotation is that of Bruce E. Vardon in his unpublished Ph.D. dissertation "Variant Readings in Walter Pater's *Studies in the History of The Renaissance*" (University of Chicago, 1950). As his title implies, Vardon takes the first edition as his basic text. Though his explanatory notes are far from complete, he was an especially resourceful editor, and I acknowledge my debt to him with admiration. Valuable notes on some of the art works mentioned in the text have been provided by Lord Kenneth Clark in his illustrated Meridian Books edition of *The Renaissance* (New York, 1961; repr. 1967), now out of print.

My Critical and Explanatory Notes are preceded by an outline history of the composition, publication, and immediate reception of the book as a whole, and each of Pater's chapters is supplied with headnotes of a similar kind. To keep the headnotes within manageable compass, I have had to confine my account of the reception of the book to the year of

publication; the complex history of its reputation and influence through the last quarter of the century and down to the present time was more than I could undertake to follow. Wherever it seemed appropriate, I have included the comments of modern scholars on the merits or the character of particular essays. Though my Critical and Explanatory Notes are ample, I have tried to avoid unnecessary criticism or interpretation.

This book is meant to be useful in the first place as a collection of materials already more or less well known to scholars but not until now brought together into a single volume. As such it will be at least a convenience, but if my hope is fulfilled it will be more than that. While my notes draw more fully than I can acknowledge on the work of other scholars, they nevertheless include much that is new. And perhaps I hardly need to say that I have tried to make this edition a necessary tool for reference and a starting point for any further study of *The Renaissance*.

Many of my colleagues have responded generously to my appeals for assistance in the work of annotation. While I cannot name everyone here whose counsel has been of value, I wish to express my special gratitude to my old friend Professor Robert H. Super, who has examined the manuscript with care and made a great many helpful suggestions. I am grateful also to a friend of briefer acquaintance, Miss Helen B. Hall, Curator before her retirement of the University of Michigan Museum of Art, without whose extraordinary interest, kindness, and expertise the mystery of "Titian's Lace-girl" and several other problems of the kind would almost certainly have gone unsolved in this edition. Others whose learned suggestions have found their way into my pages include Professors George Bornstein, Don Monson, Paul M. Spurlin, and Ralph G. Williams, to each of whom I express my thanks.

During the spring of 1974 I was enabled through a generous grant from the Horace H. Rackham School of Graduate Studies to spend six weeks in Oxford. There I examined the records of books borrowed from the Brasenose College li-

brary, the library of the Taylor Institution, and the Bodleian Library and read the books that Pater himself had consulted while writing *The Renaissance*. I owe thanks to members of the staff of each of these libraries for freely and courteously making their records available to me and for favors of many other kinds. With Mr. Bernard Richards, Fellow of Brasenose College, I had several helpful conversations about Pater, found my way through his kindness to others who could aid in my inquiries, and under his guidance visited Pater's old rooms at Brasenose. Mr. John Sparrow, Warden of All Souls College, graciously allowed me to spend a couple of mornings looking through his personal collection of Pater's books and papers. For advice and services in the identification of certain drawings I am indebted to several members of the Department of Western Art at the Ashmolean Museum and especially to Mr. Hugh Macandrew, Assistant Keeper. And I spent a spring day enjoying the hospitality of Mr. and Mrs. Samuel Wright at their home near Colchester, drawing on Mr. Wright's close acquaintance with Pater's writings and profiting from his suggestions. My thanks are due also to a number of people with whom I have been in touch only by correspondence. These include Lord Clark; Mr. J. A. Gere, Keeper of Prints and Drawings at the British Museum; Miss Frances F. Jones, Curator of Collections, The Art Museum, Princeton University; Mr. John Sunderland, Witt Librarian, Courtauld Institute of Art, University of London; the selfless archivists of Christie, Manson, and Woods of London; and Professor Lawrence Evans of Northwestern University, with whose permission I examined the Pater manuscripts at the Houghton Library, Harvard University.

D.L.H.

Ann Arbor, Michigan

Textual Corrections and Emendations

For this edition corrections in the text of 1893 have been made at nine points: page 28: line 8, 42:24, 66:23, 94:19, 112:8, 140:6, 145:26, 152:8–9, and 180:32. These corrections are explained in the Textual Notes. An emendation has been made at xxi:9 for reasons given in the Critical and Explanatory Notes. An emendation has not been made in the incomplete passage at 86:27–28, though one might seem required, and again an explanation is offered in the Critical and Explanatory Notes. A few minor corrections in punctuation, in the use of italics, and in accents in foreign words have been made without comment.

THE RENAISSANCE

STUDIES IN ART AND POETRY

BY

WALTER PATER

FELLOW OF BRASENOSE COLLEGE

SEVENTH THOUSAND

MACMILLAN AND CO.

LONDON AND NEW YORK

1893

The Renaissance

STUDIES IN ART AND POETRY

THE 1893 TEXT

DEDICATION
TO
C. L. S.
February, 1873

Yet shall ye be as the wings of a dove

Preface

Many attempts have been made by writers on art and poetry to define beauty in the abstract, to express it in the most general terms, to find some universal formula for it. The value of these attempts has most often been in the suggestive and penetrating things said by the way. Such discussions help us very little to enjoy what has been well done in art or poetry, to discriminate between what is more and what is less excellent in them, or to use words like beauty, excellence, art, poetry, with a more precise meaning than they would otherwise have. Beauty, like all other qualities presented to human experience, is relative; and the definition of it becomes unmeaning and useless in proportion to its abstractness. To define beauty, not in the most abstract but in the most concrete terms possible, to find, not its universal formula, but the formula which expresses most adequately this or that special manifestation of it, is the aim of the true student of æsthetics.

"To see the object as in itself it really is," has been justly said to be the aim of all true criticism whatever; and in æsthetic criticism the first step towards seeing one's object as it really is, is to know one's own impression as it really is, to discriminate it, to realise it distinctly. The objects with which æsthetic criticism deals —music, poetry, artistic and accomplished forms of human life—are indeed receptacles of so many powers or forces: they possess, like the products of nature, so many virtues or qualities. What is this song or picture,

this engaging personality presented in life or in a book, to *me*? What effect does it really produce on me? Does it give me pleasure? and if so, what sort or degree of pleasure? How is my nature modified by its presence, and under its influence? The answers to these questions are the original facts with which the æsthetic critic has to do; and, as in the study of light, of morals, of number, one must realise such primary data for one's self, or not at all. And he who experiences these impressions strongly, and drives directly at the discrimination and analysis of them, has no need to trouble himself with the abstract question what beauty is in itself, or what its exact relation to truth or experience—metaphysical questions, as unprofitable as metaphysical questions elsewhere. He may pass them all by as being, answerable or not, of no interest to him.

The æsthetic critic, then, regards all the objects with which he has to do, all works of art, and the fairer forms of nature and human life, as powers or forces producing pleasurable sensations, each of a more or less peculiar or unique kind. This influence he feels, and wishes to explain, by analysing and reducing it to its elements. To him, the picture, the landscape, the engaging personality in life or in a book, *La Gioconda*, the hills of Carrara, Pico of Mirandola, are valuable for their virtues, as we say, in speaking of a herb, a wine, a gem; for the property each has of affecting one with a special, a unique, impression of pleasure. Our education becomes complete in proportion as our susceptibility to these impressions increases in depth and variety. And the function of the æsthetic critic is to distinguish, to analyse, and separate from its adjuncts, the virtue by

which a picture, a landscape, a fair personality in life or
in a book, produces this special impression of beauty or
pleasure, to indicate what the source of that impression
is, and under what conditions it is experienced. His end
is reached when he has disengaged that virtue, and 5
noted it, as a chemist notes some natural element, for
himself and others; and the rule for those who would
reach this end is stated with great exactness in the words
of a recent critique of Sainte-Beuve:—*De se borner à con-
naître de près les belles choses, et à s'en nourrir en exquis* 10
amateurs, en humanistes accomplis.

What is important, then, is not that the critic should
possess a correct abstract definition of beauty for the
intellect, but a certain kind of temperament, the power
of being deeply moved by the presence of beautiful 15
objects. He will remember always that beauty exists in
many forms. To him all periods, types, schools of taste,
are in themselves equal. In all ages there have been some
excellent workmen, and some excellent work done. The
question he asks is always:—In whom did the stir, the 20
genius, the sentiment of the period find itself? where
was the receptacle of its refinement, its elevation, its
taste? "The ages are all equal," says William Blake, "but
genius is always above its age."

Often it will require great nicety to disengage this 25
virtue from the commoner elements with which it may
be found in combination. Few artists, not Goethe or
Byron even, work quite cleanly, casting off all *débris*,
and leaving us only what the heat of their imagination
has wholly fused and transformed. Take, for instance, 30
the writings of Wordsworth. The heat of his genius,
entering into the substance of his work, has crystallised

a part, but only a part, of it; and in that great mass of verse there is much which might well be forgotten. But scattered up and down it, sometimes fusing and trans-forming entire compositions, like the Stanzas on *Resolu-*
5 *tion and Independence*, or the *Ode on the Recollections of Childhood*, sometimes, as if at random, depositing a fine crystal here or there, in a matter it does not wholly search through and transmute, we trace the action of his unique, incommunicable faculty, that strange, mystical
10 sense of a life in natural things, and of man's life as a part of nature, drawing strength and colour and character from local influences, from the hills and streams, and from natural sights and sounds. Well! that is the *virtue*, the active principle in Wordsworth's poetry; and then
15 the function of the critic of Wordsworth is to follow up that active principle, to disengage it, to mark the degree in which it penetrates his verse.

The subjects of the following studies are taken from the history of the *Renaissance*, and touch what I think the
20 chief points in that complex, many-sided movement. I have explained in the first of them what I understand by the word, giving it a much wider scope than was intended by those who originally used it to denote that revival of classical antiquity in the fifteenth century
25 which was only one of many results of a general excitement and enlightening of the human mind, but of which the great aim and achievements of what, as Christian art, is often falsely opposed to the Renais-sance, were another result. This outbreak of the human
30 spirit may be traced far into the middle age itself, with its motives already clearly pronounced, the care for physical beauty, the worship of the body, the breaking

down of those limits which the religious system of the middle age imposed on the heart and the imagination. I have taken as an example of this movement, this earlier Renaissance within the middle age itself, and as an expression of its qualities, two little compositions in early French; not because they constitute the best possible expression of them, but because they help the unity of my series, inasmuch as the Renaissance ends also in France, in French poetry, in a phase of which the writings of Joachim du Bellay are in many ways the most perfect illustration. The Renaissance, in truth, put forth in France an aftermath, a wonderful later growth, the products of which have to the full that subtle and delicate sweetness which belongs to a refined and comely decadence, as its earliest phases have the freshness which belongs to all periods of growth in art, the charm of *ascèsis*, of the austere and serious girding of the loins in youth.

But it is in Italy, in the fifteenth century, that the interest of the Renaissance mainly lies,—in that solemn fifteenth century which can hardly be studied too much, not merely for its positive results in the things of the intellect and the imagination, its concrete works of art, its special and prominent personalities, with their profound æsthetic charm, but for its general spirit and character, for the ethical qualities of which it is a consummate type.

The various forms of intellectual activity which together make up the culture of an age, move for the most part from different starting-points, and by unconnected roads. As products of the same generation they partake indeed of a common character, and unconsciously illus-

trate each other; but of the producers themselves, each group is solitary, gaining what advantage or disadvantage there may be in intellectual isolation. Art and poetry, philosophy and the religious life, and that other life of refined pleasure and action in the conspicuous places of the world, are each of them confined to its own circle of ideas, and those who prosecute either of them are generally little curious of the thoughts of others. There come, however, from time to time, eras of more favourable conditions, in which the thoughts of men draw nearer together than is their wont, and the many interests of the intellectual world combine in one complete type of general culture. The fifteenth century in Italy is one of these happier eras, and what is sometimes said of the age of Pericles is true of that of Lorenzo:—it is an age productive in personalities, many-sided, centralised, complete. Here, artists and philosophers and those whom the action of the world has elevated and made keen, do not live in isolation, but breathe a common air, and catch light and heat from each other's thoughts. There is a spirit of general elevation and enlightenment in which all alike communicate. The unity of this spirit gives unity to all the various products of the Renaissance; and it is to this intimate alliance with mind, this participation in the best thoughts which that age produced, that the art of Italy in the fifteenth century owes much of its grave dignity and influence.

I have added an essay on Winckelmann, as not incongruous with the studies which precede it, because Winckelmann, coming in the eighteenth century, really belongs in spirit to an earlier age. By his enthusiasm for the things of the intellect and the imagination for their

own sake, by his Hellenism, his life-long struggle to attain to the Greek spirit, he is in sympathy with the humanists of a previous century. He is the last fruit of the Renaissance, and explains in a striking way its motive and tendencies. 5

 1873.

Two Early French Stories

THE HISTORY of the Renaissance ends in France, and carries us away from Italy to the beautiful cities of the country of the Loire. But it was in France also, in a very important sense, that the Renaissance had begun. French writers, who are fond of connecting the creations of Italian genius with a French origin, who tell us how Saint Francis of Assisi took not his name only, but all those notions of chivalry and romantic love which so deeply penetrated his thoughts, from a French source, how Boccaccio borrowed the outlines of his stories from the old French *fabliaux*, and how Dante himself expressly connects the origin of the art of miniature-painting with the city of Paris, have often dwelt on this notion of a Renaissance in the end of the twelfth and the beginning of the thirteenth century, a Renaissance within the limits of the middle age itself—a brilliant, but in part abortive effort to do for human life and the human mind what was afterwards done in the fifteenth. The word *Renaissance*, indeed, is now generally used to denote not merely the revival of classical antiquity which took place in the fifteenth century, and to which the word was first applied, but a whole complex movement, of which that revival of classical antiquity was but one element or symptom. For us the Renaissance is the name of a many-sided but yet united movement, in which the love of the things of the intellect and the imagination for their own sake, the desire for a more liberal and comely way of conceiving life, make them-

selves felt, urging those who experience this desire to search out first one and then another means of intellectual or imaginative enjoyment, and directing them not only to the discovery of old and forgotten sources of this enjoyment, but to the divination of fresh sources thereof—new experiences, new subjects of poetry, new forms of art. Of such feeling there was a great outbreak in the end of the twelfth and the beginning of the following century. Here and there, under rare and happy conditions, in pointed architecture, in the doctrines of romantic love, in the poetry of Provence, the rude strength of the middle age turns to sweetness; and the taste for sweetness generated there becomes the seed of the classical revival in it, prompting it constantly to seek after the springs of perfect sweetness in the Hellenic world. And coming after a long period in which this instinct had been crushed, that true "dark age," in which so many sources of intellectual and imaginative enjoyment had actually disappeared, this outbreak is rightly called a Renaissance, a revival.

Theories which bring into connexion with each other modes of thought and feeling, periods of taste, forms of art and poetry, which the narrowness of men's minds constantly tends to oppose to each other, have a great stimulus for the intellect, and are almost always worth understanding. It is so with this theory of a Renaissance within the middle age, which seeks to establish a continuity between the most characteristic work of that period, the sculpture of Chartres, the windows of Le Mans, and the work of the later Renaissance, the work of Jean Cousin and Germain Pilon, thus healing that rupture between the middle age and the Renaissance which has so often been exaggerated. But it is not so

much the ecclesiastical art of the middle age, its sculpture and painting—work certainly done in a great measure for pleasure's sake, in which even a secular, a rebellious spirit often betrays itself—but rather its profane poetry, the poetry of Provence, and the magnificent after-growth of that poetry in Italy and France, which those French writers have in view when they speak of this medieval Renaissance. In that poetry, earthly passion, with its intimacy, its freedom, its variety—the liberty of the heart—makes itself felt; and the name of Abelard, the great scholar and the great lover, connects the expression of this liberty of heart with the free play of human intelligence around all subjects presented to it, with the liberty of the intellect, as that age understood it.

Every one knows the legend of Abelard, a legend hardly less passionate, certainly not less characteristic of the middle age, than the legend of Tannhäuser; how the famous and comely clerk, in whom Wisdom herself, self-possessed, pleasant, and discreet, seemed to sit enthroned, came to live in the house of a canon of the church of *Notre-Dame*, where dwelt a girl, Heloïse, believed to be the old priest's orphan niece; how the old priest had testified his love for her by giving her an education then unrivalled, so that rumour asserted that, through the knowledge of languages, enabling her to penetrate into the mysteries of the older world, she had become a sorceress, like the Celtic druidesses; and how as Abelard and Heloïse sat together at home there, to refine a little further on the nature of abstract ideas, "Love made himself of the party with them." You conceive the temptations of the scholar, who, in such dreamy tranquillity, amid the bright and busy spectacle of the

3

"Island," lived in a world of something like shadows; and that for one who knew so well how to assign its exact value to every abstract thought, those restraints which lie on the consciences of other men had been re-
5 laxed. It appears that he composed many verses in the vulgar tongue: already the young men sang them on the quay below the house. Those songs, says M. de Ré-musat, were probably in the taste of the *Trouvères*, "of whom he was one of the first in date, or, so to speak,
10 the predecessor." It is the same spirit which has mould-ed the famous "letters," written in the quaint Latin of the middle age.

 At the foot of that early Gothic tower, which the next generation raised to grace the precincts of Abelard's
15 school, on the "Mountain of Saint Geneviève," the his-torian Michelet sees in thought "a terrible assembly; not the hearers of Abelard alone, fifty bishops, twenty car-dinals, two popes, the whole body of scholastic philos-ophy; not only the learned Heloïse, the teaching of lan-
20 guages, and the Renaissance; but Arnold of Brescia— that is to say, the revolution." And so from the rooms of this shadowy house by the Seine side we see that spir-it going abroad, with its qualities already well defined, its intimacy, its languid sweetness, its rebellion, its sub-
25 tle skill in dividing the elements of human passion, its care for physical beauty, its worship of the body, which penetrated the early literature of Italy, and finds an echo even in Dante.

 That Abelard is not mentioned in the *Divine Comedy*
30 may appear a singular omission to the reader of Dante, who seems to have inwoven into the texture of his work whatever had impressed him as either effective in colour or spiritually significant among the recorded incidents

of actual life. Nowhere in his great poem do we find the name, nor so much as an allusion to the story of one who had left so deep a mark on the philosophy of which Dante was an eager student, of whom in the *Latin Quarter*, and from the lips of scholar or teacher in the University of Paris, during his sojourn among them, he can hardly have failed to hear. We can only suppose that he had indeed considered the story and the man, and abstained from passing judgment as to his place in the scheme of "eternal justice."

In the famous legend of Tannhäuser, the erring knight makes his way to Rome, to seek absolution at the centre of Christian religion. "So soon," thought and said the Pope, "as the staff in his hand should bud and blossom, so soon might the soul of Tannhäuser be saved, and no sooner;" and it came to pass not long after that the dry wood of a staff which the Pope had carried in his hand was covered with leaves and flowers. So, in the cloister of Godstow, a petrified tree was shown of which the nuns told that the fair Rosamond, who had died among them, had declared that, the tree being then alive and green, it would be changed into stone at the hour of her salvation. When Abelard died, like Tannhäuser, he was on his way to Rome. What might have happened had he reached his journey's end is uncertain; and it is in this uncertain twilight that his relation to the general beliefs of his age has always remained. In this, as in other things, he prefigures the character of the Renaissance, that movement in which, in various ways, the human mind wins for itself a new kingdom of feeling and sensation and thought, not opposed to but only beyond and independent of the spiritual system then actually realised. The opposition into which Abelard is

thrown, which gives its colour to his career, which breaks his soul to pieces, is a no less subtle opposition than that between the merely professional, official, hireling ministers of that system, with their ignorant wor-
5 ship of system for its own sake, and the true child of light, the humanist, with reason and heart and senses quick, while theirs were almost dead. He reaches out towards, he attains, modes of ideal living, beyond the prescribed limits of that system, though in essential
10 germ, it may be, contained within it. As always happens, the adherents of the poorer and narrower culture had no sympathy with, because no understanding of, a culture richer and more ample than their own. After the discovery of wheat they would still live upon acorns—
15 *après l'invention du blé ils voulaient encore vivre du gland*; and would hear of no service to the higher needs of humanity with instruments not of their forging.

But the human spirit, bold through those needs, was too strong for them. Abelard and Heloïse write their
20 letters—letters with a wonderful outpouring of soul— in medieval Latin; and Abelard, though he composes songs in the vulgar tongue, writes also in Latin those treatises in which he tries to find a ground of reality below the abstractions of philosophy, as one bent on try-
25 ing all things by their congruity with human experience, who had felt the hand of Heloïse, and looked into her eyes, and tested the resources of humanity in her great and energetic nature. Yet it is only a little later, early in the thirteenth century, that French prose romance be-
30 gins; and in one of the pretty volumes of the *Biblio-thèque Elzevirienne* some of the most striking fragments of it may be found, edited with much intelligence. In one of these thirteenth-century stories, *Li Amitiez de*

one-sided presentment of mere form, that solid material frame which only motion can relieve, a thing of heavy shadows, and an individuality of expression pushed to caricature. Against this tendency to the hard presentment of mere form trying vainly to compete with the reality of nature itself, all noble sculpture constantly struggles; each great system of sculpture resisting it in its own way, etherealising, spiritualising, relieving, its stiffness, its heaviness, and death. The use of colour in sculpture is but an unskilful contrivance to effect, by borrowing from another art, what the nobler sculpture effects by strictly appropriate means. To get not colour, but the equivalent of colour; to secure the expression and the play of life; to expand the too firmly fixed individuality of pure, unrelieved, uncoloured form:—this is the problem which the three great styles in sculpture have solved in three different ways.

Allgemeinheit—breadth, generality, universality—is the word chosen by Winckelmann, and after him by Goethe and many German critics, to express that law of the most excellent Greek sculptors, of Pheidias and his pupils, which prompted them constantly to seek the type in the individual, to abstract and express only what is structural and permanent, to purge from the individual all that belongs only to him, all the accidents, the feelings and actions of the special moment, all that (because in its own nature it endures but for a moment) is apt to look like a frozen thing if one arrests it.

In this way their works came to be like some subtle extract or essence, or almost like pure thoughts or ideas: and hence the breadth of humanity in them, that detachment from the conditions of a particular place or people,

which has carried their influence far beyond the age which produced them, and insured them universal acceptance.

That was the Greek way of relieving the hardness and unspirituality of pure form. But it involved to a certain degree the sacrifice of what we call *expression*; and a system of abstraction which aimed always at the broad and general type, at the purging away from the individual of what belonged only to him, and of the mere accidents of a particular time and place, imposed upon the range of effects open to the Greek sculptor limits somewhat narrowly defined. When Michelangelo came, therefore, with a genius spiritualised by the reverie of the middle age, penetrated by its spirit of inwardness and introspection, living not a mere outward life like the Greek, but a life full of intimate experiences, sorrows, consolations, a system which sacrificed so much of what was inward and unseen could not satisfy him. To him, lover and student of Greek sculpture as he was, work which did not bring what was inward to the surface, which was not concerned with individual expression, with individual character and feeling, the special history of the special soul, was not worth doing at all.

And so, in a way quite personal and peculiar to himself, which often is, and always seems, the effect of accident, he secured for his work individuality and intensity of expression, while he avoided a too heavy realism, that tendency to harden into caricature which the representation of feeling in sculpture is apt to display. What time and accident, its centuries of darkness under the furrows of the "little Melian farm," have done with singular felicity of touch for the Venus of Melos, fraying its surface and softening its lines, so that some

spirit in the thing seems always on the point of breaking out, as though in it classical sculpture had advanced already one step into the mystical Christian age, its expression being in the whole range of ancient work most like that of Michelangelo's own:—this effect Michelangelo gains by leaving nearly all his sculpture in a puzzling sort of incompleteness, which suggests rather than realises actual form. Something of the wasting of that snow-image which he moulded at the command of Piero de' Medici, when the snow lay one night in the court of the *Pitti* palace, almost always lurks about it, as if he had determined to make the quality of a task, exacted from him half in derision, the pride of all his work. Many have wondered at that incompleteness, suspecting, however, that Michelangelo himself loved and was loath to change it, and feeling at the same time that they too would lose something if the half-realised form ever quite emerged from the stone, so rough-hewn here, so delicately finished there; and they have wished to fathom the charm of this incompleteness. Well! that incompleteness is Michelangelo's equivalent for colour in sculpture; it is his way of etherealising pure form, of relieving its stiff realism, and communicating to it breath, pulsation, the effect of life. It was a characteristic too which fell in with his peculiar temper and mode of living, his disappointments and hesitations. And it was in reality perfect finish. In this way he combines the utmost amount of passion and intensity with the sense of a yielding and flexible life: he gets not vitality merely, but a wonderful force, of expression.

Midway between these two systems—the system of the Greek sculptors and the system of Michelangelo—comes the system of Luca della Robbia and the other

Tuscan sculptors of the fifteenth century, partaking both of the *Allgemeinheit* of the Greeks, their way of extracting certain select elements only of pure form and sacrificing all the rest, and the studied incompleteness of
5 Michelangelo, relieving that sense of intensity, passion, energy, which might otherwise have stiffened into caricature. Like Michelangelo, these sculptors fill their works with intense and individualised expression. Their noblest works are the careful sepulchral portraits of par-
10 ticular persons—the monument of Conte Ugo in the *Badía* of Florence, of the youthful Medea Colleoni, with the wonderful, long throat, in the chapel on the cool north side of the Church of *Santa Maria Maggiore* at Bergamo—monuments such as abound in the churches
15 of Rome, inexhaustible in suggestions of repose, of a subdued sabbatic joy, a kind of sacred grace and refinement. And these elements of tranquillity, of repose, they unite to an intense and individual expression by a system of conventionalism as skilful and subtle as that of
20 the Greeks, repressing all such curves as indicate solid form, and throwing the whole into low relief.

The life of Luca, a life of labour and frugality, with no adventure and no excitement except what belongs to the trial of new artistic processes, the struggle with new ar-
25 tistic difficulties, the solution of purely artistic problems, fills the first seventy years of the fifteenth century. After producing many works in marble for the *Duomo* and the *Campanile* of Florence, which place him among the foremost masters of the sculpture of his age, he
30 became desirous to realise the spirit and manner of that sculpture, in a humbler material, to unite its science, its exquisite and expressive system of low relief, to the homely art of pottery, to introduce those high qualities

54

into common things, to adorn and cultivate daily household life. In this he is profoundly characteristic of the Florence of that century, of that in it which lay below its superficial vanity and caprice, a certain old-world modesty and seriousness and simplicity. People had not yet begun to think that what was good art for churches was not so good, or less fitted, for their own houses. Luca's new work was in plain white earthenware at first, a mere rough imitation of the costly, laboriously wrought marble, finished in a few hours. But on this humble path he found his way to a fresh success, to another artistic grace. The fame of the oriental pottery, with its strange, bright colours—colours of art, colours not to be attained in the natural stone—mingled with the tradition of the old Roman pottery of the neighbourhood. The little red, coral-like jars of Arezzo, dug up in that district from time to time, are much prized. These colours haunted Luca's fancy. "He still continued seeking something more," his biographer says of him; "and instead of making his figures of baked earth simply white, he added the further invention of giving them colour, to the astonishment and delight of all who beheld them"— *Cosa singolare, e multo utile per la state!*—a curious thing, and very useful for summer-time, full of coolness and repose for hand and eye. Luca loved the forms of various fruits, and wrought them into all sorts of marvellous frames and garlands, giving them their natural colours, only subdued a little, a little paler than nature.

I said that the art of Luca della Robbia possessed in an unusual measure that special characteristic which belongs to all the workmen of his school, a characteristic which, even in the absence of much positive information about their actual history, seems to bring those

workmen themselves very near to us. They bear the im-
press of a personal quality, a profound expressiveness,
what the French call *intimité*, by which is meant some
subtler sense of originality—the seal on a man's work of
5 what is most inward and peculiar in his moods, and
manner of apprehension: it is what we call *expression*,
carried to its highest intensity of degree. That character-
istic is rare in poetry, rarer still in art, rarest of all in the
abstract art of sculpture; yet essentially, perhaps, it is the
10 quality which alone makes work in the imaginative
order really worth having at all. It is because the works
of the artists of the fifteenth century possess this quality
in an unmistakable way that one is anxious to know all
that can be known about them, and explain to one's self
15 the secret of their charm.

 1872.

The Poetry of Michelangelo

CRITICS OF MICHELANGELO have sometimes spoken as if the only characteristic of his genius were a wonderful strength, verging, as in the things of the imagination great strength always does, on what is singular or strange. A certain strangeness, something of the blossoming of the aloe, is indeed an element in all true works of art: that they shall excite or surprise us is indispensable. But that they shall give pleasure and exert a charm over us is indispensable too; and this strangeness must be sweet also—a lovely strangeness. And to the true admirers of Michelangelo this is the true type of the Michelangelesque—sweetness and strength, pleasure with surprise, an energy of conception which seems at every moment about to break through all the conditions of comely form, recovering, touch by touch, a loveliness found usually only in the simplest natural things—*ex forti dulcedo*.

In this way he sums up for them the whole character of medieval art itself in that which distinguishes it most clearly from classical work, the presence of a convulsive energy in it, becoming in lower hands merely monstrous or forbidding, and felt, even in its most graceful products, as a subdued quaintness or grotesque. Yet those who feel this grace or sweetness in Michelangelo might at the first moment be puzzled if they were asked wherein precisely such quality resided. Men of inventive temperament—Victor Hugo, for instance, in whom, as in Michelangelo, people have for the most

part been attracted or repelled by the strength, while few have understood his sweetness—have sometimes relieved conceptions of merely moral or spiritual greatness, but with little æsthetic charm of their own, by lovely accidents or accessories, like the butterfly which alights on the blood-stained barricade in *Les Misérables*, or those sea-birds for whom the monstrous Gilliatt comes to be as some wild natural thing, so that they are no longer afraid of him, in *Les Travailleurs de la Mer*. But the austere genius of Michelangelo will not depend for its sweetness on any mere accessories like these. The world of natural things has almost no existence for him; "When one speaks of him," says Grimm, "woods, clouds, seas, and mountains disappear, and only what is formed by the spirit of man remains behind;" and he quotes a few slight words from a letter of his to Vasari as the single expression in all he has left of a feeling for nature. He has traced no flowers, like those with which Leonardo stars over his gloomiest rocks; nothing like the fretwork of wings and flames in which Blake frames his most startling conceptions. No forest-scenery like Titian's fills his backgrounds, but only blank ranges of rock, and dim vegetable forms as blank as they, as in a world before the creation of the first five days.

Of the whole story of the creation he has painted only the creation of the first man and woman, and, for him at least, feebly, the creation of light. It belongs to the quality of his genius thus to concern itself almost exclusively with the making of man. For him it is not, as in the story itself, the last and crowning act of a series of developments, but the first and unique act, the creation of life itself in its supreme form, off-hand and im-

mediately, in the cold and lifeless stone. With him the beginning of life has all the characteristics of resurrection; it is like the recovery of suspended health or animation, with its gratitude, its effusion, and eloquence. Fair as the young men of the Elgin marbles, the Adam of the Sistine Chapel is unlike them in a total absence of that balance and completeness which express so well the sentiment of a self-contained, independent life. In that languid figure there is something rude and satyr-like, something akin to the rugged hillside on which it lies. His whole form is gathered into an expression of mere expectancy and reception; he has hardly strength enough to lift his finger to touch the finger of the creator; yet a touch of the finger-tips will suffice.

This creation of life—life coming always as relief or recovery, and always in strong contrast with the rough-hewn mass in which it is kindled—is in various ways the motive of all his work, whether its immediate subject be pagan or Christian, legend or allegory; and this, although at least one-half of his work was designed for the adornment of tombs—the tomb of Julius, the tombs of the Medici. Not the Judgment but the Resurrection is the real subject of his last work in the Sistine Chapel; and his favourite pagan subject is the legend of Leda, the delight of the world breaking from the egg of a bird. As I have already pointed out, he secures that ideality of expression which in Greek sculpture depends on a delicate system of abstraction, and in early Italian sculpture on lowness of relief, by an incompleteness, which is surely not always undesigned, and which, as I think, no one regrets, and trusts to the spectator to complete the half-emergent form. And as his persons have something of the unwrought stone about them, so, as if to realise

the expression by which the old Florentine records de-
scribe a sculptor—*master of live stone*—with him the
very rocks seem to have life. They have but to cast away
the dust and scurf that they may rise and stand on their
5 feet. He loved the very quarries of Carrara, those
strange grey peaks which even at mid-day convey into
any scene from which they are visible something of the
solemnity and stillness of evening, sometimes wander-
ing among them month after month, till at last their
10 pale ashen colours seem to have passed into his painting;
and on the crown of the head of the *David* there still
remains a morsel of uncut stone, as if by one touch to
maintain its connexion with the place from which it was
hewn.

15 And it is in this penetrative suggestion of life that the
secret of that sweetness of his is to be found. He gives us
indeed no lovely natural objects like Leonardo or Titian,
but only the coldest, most elementary shadowing of
rock or tree; no lovely draperies and comely gestures of
20 life, but only the austere truths of human nature; "sim-
ple persons"—as he replied in his rough way to the
querulous criticism of Julius the Second, that there was
no gold on the figures of the Sistine Chapel—"simple
persons, who wore no gold on their garments;" but he
25 penetrates us with a feeling of that power which we
associate with all the warmth and fulness of the world,
the sense of which brings into one's thoughts a swarm
of birds and flowers and insects. The brooding spirit of
life itself is there; and the summer may burst out in a
30 moment.

He was born in an interval of a rapid midnight jour-
ney in March, at a place in the neighborhood of Arezzo,

the thin, clear air of which was then thought to be favourable to the birth of children of great parts. He came of a race of grave and dignified men, who, claiming kinship with the family of Canossa, and some colour of imperial blood in their veins, had, generation after generation, received honourable employment under the government of Florence. His mother, a girl of nineteen years, put him out to nurse at a country-house among the hills of Settignano, where every other inhabitant is a worker in the marble-quarries, and the child early became familiar with that strange first stage in the sculptor's art. To this succeeded the influence of the sweetest and most placid master Florence had yet seen, Domenico Ghirlandajo. At fifteen he was at work among the curiosities of the garden of the Medici, copying and restoring antiques, winning the condescending notice of the great Lorenzo. He knew too how to excite strong hatreds; and it was at this time that in a quarrel with a fellow-student he received a blow on the face which deprived him for ever of the comeliness of outward form.

It was through an accident that he came to study those works of the early Italian sculptors which suggested much of his own grandest work, and impressed it with so deep a sweetness. He believed in dreams and omens. One of his friends dreamed twice that Lorenzo, then lately dead, appeared to him in grey and dusty apparel. To Michelangelo this dream seemed to portend the troubles which afterwards really came, and with the suddenness which was characteristic of all his movements, he left Florence. Having occasion to pass through Bologna, he neglected to procure the little seal of red wax which the stranger entering Bologna must

carry on the thumb of his right hand. He had no money
to pay the fine, and would have been thrown into prison
had not one of the magistrates interposed. He remained
in this man's house a whole year, rewarding his hospi-
5 tality by readings from the Italian poets whom he loved.
Bologna, with its endless colonnades and fantastic lean-
ing towers, can never have been one of the lovelier cities
of Italy. But about the portals of its vast unfinished
churches and its dark shrines, half hidden by votive
10 flowers and candles, lie some of the sweetest works of
the early Tuscan sculptors, Giovanni da Pisa and Jacopo
della Quercia, things as winsome as flowers; and the
year which Michelangelo spent in copying these works
was not a lost year. It was now, on returning to Flor-
15 ence, that he put forth that unique presentment of Bac-
chus, which expresses, not the mirthfulness of the god
of wine, but his sleepy seriousness, his enthusiasm, his
capacity for profound dreaming. No one ever expressed
more truly than Michelangelo the notion of inspired
20 sleep, of faces charged with dreams. A vast fragment of
marble had long lain below the *Loggia* of Orcagna, and
many a sculptor had had his thoughts of a design which
should just fill this famous block of stone, cutting the
diamond, as it were, without loss. Under Michelan-
25 gelo's hand it became the *David* which stood till lately
on the steps of the *Palazzo Vecchio*, when it was replaced
below the *Loggia*. Michelangelo was now thirty years
old, and his reputation was established. Three great
works fill the remainder of his life—three works often
30 interrupted, carried on through a thousand hesitations,
a thousand disappointments, quarrels with his patrons,
quarrels with his family, quarrels perhaps most of all

with himself—the Sistine Chapel, the Mausoleum of Julius the Second, and the Sacristy of *San Lorenzo*.

In the story of Michelangelo's life the strength, often turning to bitterness, is not far to seek. A discordant note sounds throughout it which almost spoils the music. He "treats the Pope as the King of France himself would not dare to treat him:" he goes along the streets of Rome "like an executioner," Raphael says of him. Once he seems to have shut himself up with the intention of starving himself to death. As we come, in reading his life, on its harsh, untempered incidents, the thought again and again arises that he is one of those who incur the judgment of Dante, as having "wilfully lived in sadness." Even his tenderness and pity are embittered by their strength. What passionate weeping in that mysterious figure which, in the *Creation of Adam*, crouches below the image of the Almighty, as he comes with the forms of things to be, woman and her progeny, in the fold of his garment! What a sense of wrong in those two captive youths, who feel the chains like scalding water on their proud and delicate flesh! The idealist who became a reformer with Savonarola, and a republican superintending the fortification of Florence—the nest where he was born, *il nido ove naqqu'io*, as he calls it once, in a sudden throb of affection—in its last struggle for liberty, yet believed always that he had imperial blood in his veins and was of the kindred of the great Matilda, had within the depths of his nature some secret spring of indignation or sorrow. We know little of his youth, but all tends to make one believe in the vehemence of its passions. Beneath the Platonic calm of the sonnets there is latent a deep delight in carnal form

and colour. There, and still more in the madrigals, he often falls into the language of less tranquil affections; while some of them have the colour of penitence, as from a wanderer returning home. He who spoke so decisively of the supremacy in the imaginative world of the unveiled human form had not been always, we may think, a mere Platonic lover. Vague and wayward his loves may have been; but they partook of the strength of his nature, and sometimes, it may be, would by no means become music, so that the comely order of his days was quite put out: *par che amaro ogni mio dolce io senta.*

But his genius is in harmony with itself; and just as in the products of his art we find resources of sweetness within their exceeding strength, so in his own story also, bitter as the ordinary sense of it may be, there are select pages shut in among the rest—pages one might easily turn over too lightly, but which yet sweeten the whole volume. The interest of Michelangelo's poems is that they make us spectators of this struggle; the struggle of a strong nature to adorn and attune itself; the struggle of a desolating passion, which yearns to be resigned and sweet and pensive, as Dante's was. It is a consequence of the occasional and informal character of his poetry, that it brings us nearer to himself, his own mind and temper, than any work done only to support a literary reputation could possibly do. His letters tell us little that is worth knowing about him—a few poor quarrels about money and commissions. But it is quite otherwise with these songs and sonnets, written down at odd moments, sometimes on the margins of his sketches, themselves often unfinished sketches, arresting some salient feeling or unpremeditated idea as it passed. And

it happens that a true study of these has become within the last few years for the first time possible. A few of the sonnets circulated widely in manuscript, and became almost within Michelangelo's own lifetime a subject of academical discourses. But they were first collected in a volume in 1623 by the great-nephew of Michelangelo, Michelangelo Buonarroti the younger. He omitted much, re-wrote the sonnets in part, and sometimes compressed two or more compositions into one, always losing something of the force and incisiveness of the original. So the book remained, neglected even by Italians themselves in the last century, through the influence of that French taste which despised all compositions of the kind, as it despised and neglected Dante. "His reputation will ever be on the increase, because he is so little read," says Voltaire of Dante.—But in 1858 the last of the Buonarroti bequeathed to the municipality of Florence the curiosities of his family. Among them was a precious volume containing the autograph of the sonnets. A learned Italian, Signor Cesare Guasti, undertook to collate this autograph with other manuscripts at the Vatican and elsewhere, and in 1863 published a true version of Michelangelo's poems, with dissertations and a paraphrase[1].

People have often spoken of these poems as if they were a mere cry of distress, a lover's complaint over the obduracy of Vittoria Colonna. But those who speak thus forget that though it is quite possible that Michelangelo had seen Vittoria, that somewhat shadowy figure, as early as 1537, yet their closer intimacy did not begin till about the year 1542, when Michelangelo was

[1] The sonnets have been translated into English, with much skill, and poetic taste, by Mr. J. A. Symonds.

nearly seventy years old. Vittoria herself, an ardent neo-catholic, vowed to perpetual widowhood since the news had reached her, seventeen years before, that her husband, the youthful and princely Marquess of Pescara, 5 lay dead of the wounds he had received in the battle of Pavia, was then no longer an object of great passion. In a dialogue written by the painter, Francesco d'Ollanda, we catch a glimpse of them together in an empty church at Rome, one Sunday afternoon, discussing indeed the 10 characteristics of various schools of art, but still more the writings of Saint Paul, already following the ways and tasting the sunless pleasures of weary people, whose care for external things is slackening. In a letter still extant he regrets that when he visited her after death he 15 had kissed her hands only. He made, or set to work to make, a crucifix for her use, and two drawings, perhaps in preparation for it, are now in Oxford. From allusions in the sonnets, we may divine that when they first approached each other he had debated much with himself 20 whether this last passion would be the most unsoftening, the most desolating of all—*un dolce amaro, un sì e no mi muovi.* Is it carnal affection, or, *del suo prestino stato* (of Plato's ante-natal state) *il raggio ardente?* The older, conventional criticism, dealing with the text of 1623, had 25 lightly assumed that all or nearly all the sonnets were actually addressed to Vittoria herself; but Signor Guasti finds only four, or at most five, which can be so attributed on genuine authority. Still, there are reasons which make him assign the majority of them to the period be-30 tween 1542 and 1547, and we may regard the volume as a record of this resting-place in Michelangelo's story. We know how Goethe escaped from the stress of sentiments too strong for him by making a book about

them; and for Michelangelo, to write down his passionate thoughts at all, to express them in a sonnet, was already in some measure to command, and have his way with them—

> *La vita del mia amor non è il cor mio,* 5
> *Ch'amor, di quel ch'io t'amo, è senza core.*

It was just because Vittoria raised no great passion that the space in his life where she reigns has such peculiar suavity; and the spirit of the sonnets is lost if we once take them out of that dreamy atmosphere in which men 10
have things as they will, because the hold of all outward things upon them is faint and uncertain. Their prevailing tone is a calm and meditative sweetness. The cry of distress is indeed there, but as a mere residue, a trace of bracing chalybeate salt, just discernible in the 15
song which rises like a clear, sweet spring from a charmed space in his life.

This charmed and temperate space in Michelangelo's life, without which its excessive strength would have been so imperfect, which saves him from the judgment 20
of Dante on those who "wilfully lived in sadness," is then a well-defined period there, reaching from the year 1542 to the year 1547, the year of Vittoria's death. In it the lifelong effort to tranquillise his vehement emotions by withdrawing them into the region of ideal sentiment, 25
becomes successful; and the significance of Vittoria is, that she realises for him a type of affection which even in disappointment may charm and sweeten his spirit.

In this effort to tranquillise and sweeten life by idealising its vehement sentiments, there were two great tra- 30
ditional types, either of which an Italian of the sixteenth century might have followed. There was Dante, whose

little book of the *Vita Nuova* had early become a pattern of imaginative love, maintained somewhat feebly by the later followers of Petrarch; and, since Plato had become something more than a name in Italy by the publication of the Latin translation of his works by Marsilio Ficino, there was the Platonic tradition also. Dante's belief in the resurrection of the body, through which, even in heaven, Beatrice loses for him no tinge of flesh-colour, or fold of raiment even; and the Platonic dream of the passage of the soul through one form of life after another, with its passionate haste to escape from the burden of bodily form altogether; are, for all effects of art or poetry, principles diametrically opposite. Now it is the Platonic tradition rather than Dante's that has moulded Michelangelo's verse. In many ways no sentiment could have been less like Dante's love for Beatrice than Michelangelo's for Vittoria Colonna. Dante's comes in early youth: Beatrice is a child, with the wistful, ambiguous vision of a child, with a character still unaccentuated by the influence of outward circumstances, almost expressionless. Vittoria, on the other hand, is a woman already weary, in advanced age, of grave intellectual qualities. Dante's story is a piece of figured work, inlaid with lovely incidents. In Michelangelo's poems, frost and fire are almost the only images—the refining fire of the goldsmith; once or twice the phoenix; ice melting at the fire; fire struck from the rock which it afterwards consumes. Except one doubtful allusion to a journey, there are almost no incidents. But there is much of the bright, sharp, unerring skill, with which in boyhood he gave the look of age to the head of a faun by chipping a tooth from its jaw with a single stroke of the hammer. For Dante, the

amiable and devout materialism of the middle age sanc-
tifies all that is presented by hand and eye; while Mi-
chelangelo is always pressing forward from the outward
beauty—*il bel del fuor che agli occhi piace*, to apprehend
the unseen beauty; *trascenda nella forma universale*—that
abstract form of beauty, about which the Platonists rea-
son. And this gives the impression in him of something
flitting and unfixed, of the houseless and complaining
spirit, almost clairvoyant through the frail and yielding
flesh. He accounts for love at first sight by a previous
state of existence—*la dove io t'amai prima*.

And yet there are many points in which he is really
like Dante, and comes very near to the original image,
beyond those later and feebler followers in the wake of
Petrarch. He learns from Dante rather than from Plato,
that for lovers, the surfeiting of desire—*ove gran desir
gran copia affrena*, is a state less happy than poverty with
abundance of hope—*una miseria di speranza piena*. He re-
calls him in the repetition of the words *gentile* and *cor-
tesia*, in the personification of *Amor*, in the tendency to
dwell minutely on the physical effects of the presence of
a beloved object on the pulses and the heart. Above all,
he resembles Dante in the warmth and intensity of his
political utterances, for the lady of one of his noblest
sonnets was from the first understood to be the city of
Florence; and he avers that all must be asleep in heaven,
if she, who was created "of angelic form" for a thou-
sand lovers, is appropriated by one alone, some Piero,
or Alessandro de' Medici. Once and again he introduces
Love and Death, who dispute concerning him. For, like
Dante and all the nobler souls of Italy, he is much occu-
pied with thoughts of the grave, and his true mistress is
death,—death at first as the worst of all sorrows and

disgraces, with a clod of the field for its brain; afterwards, death in its high distinction, its detachment from vulgar needs, the angry stains of life and action escaping fast.

5 Some of those whom the gods love die young. This man, because the gods loved him, lingered on to be of immense, patriarchal age, till the sweetness it had taken so long to secrete in him was found at last. Out of the strong came forth sweetness, *ex forti dulcedo*. The world 10 had changed around him. The "new catholicism" had taken the place of the Renaissance. The spirit of the Roman Church had changed: in the vast world's cathedral which his skill had helped to raise for it, it looked stronger than ever. Some of the first members of the 15 *Oratory* were among his intimate associates. They were of a spirit as unlike as possible from that of Lorenzo, or Savonarola even. The opposition of the Reformation to art has been often enlarged upon; far greater was that of the Catholic revival. But in thus fixing itself in a frozen 20 orthodoxy, the Roman Church had passed beyond him, and he was a stranger to it. In earlier days, when its beliefs had been in a fluid state, he too might have been drawn into the controversy. He might have been for spiritualising the papal sovereignty, like Savonarola; or 25 for adjusting the dreams of Plato and Homer with the words of Christ, like Pico of Mirandola. But things had moved onward, and such adjustments were no longer possible. For himself, he had long since fallen back on that divine ideal, which above the wear and tear 30 of creeds has been forming itself for ages as the possession of nobler souls. And now he began to feel the soothing influence which since that time the Roman Church has often exerted over spirits too independent to

be its subjects, yet brought within the neighbourhood of its action; consoled and tranquillised, as a traveller might be, resting for one evening in a strange city, by its stately aspect and the sentiment of its many fortunes, just because with those fortunes he has nothing to do. So he lingers on; a *revenant*, as the French say, a ghost out of another age, in a world too coarse to touch his faint sensibilities very closely; dreaming, in a worn-out society, theatrical in its life, theatrical in its art, theatrical even in its devotion, on the morning of the world's history, on the primitive form of man, on the images under which that primitive world had conceived of spiritual forces.

I have dwelt on the thought of Michelangelo as thus lingering beyond his time in a world not his own, because, if one is to distinguish the peculiar savour of his work, he must be approached, not through his followers, but through his predecessors; not through the marbles of *Saint Peter's*, but through the work of the sculptors of the fifteenth century over the tombs and altars of Tuscany. He is the last of the Florentines, of those on whom the peculiar sentiment of the Florence of Dante and Giotto descended: he is the consummate representative of the form that sentiment took in the fifteenth century with men like Luca Signorelli and Mino da Fiesole. Up to him the tradition of sentiment is unbroken, the progress towards surer and more mature methods of expressing that sentiment continuous. But his professed disciples did not share this temper; they are in love with his strength only, and seem not to feel his grave and temperate sweetness. Theatricality is their chief characteristic; and that is a quality as little attributable to Mi-

chelangelo as to Mino or Luca Signorelli. With him, as
with them, all is serious, passionate, impulsive.

This discipleship of Michelangelo, this dependence of
his on the tradition of the Florentine schools, is no-
where seen more clearly than in his treatment of the
Creation. The *Creation of Man* had haunted the mind of
the middle age like a dream; and weaving it into a hun-
dred carved ornaments of capital or doorway, the Italian
sculptors had early impressed upon it that pregnancy of
expression which seems to give it many veiled mean-
ings. As with other artistic conceptions of the middle
age, its treatment became almost conventional, handed
on from artist to artist, with slight changes, till it came
to have almost an independent and abstract existence of
its own. It was characteristic of the medieval mind thus
to give an independent traditional existence to a special
pictorial conception, or to a legend, like that of *Tristram*
or *Tannhäuser*, or even to the very thoughts and sub-
stance of a book, like the *Imitation*, so that no single
workman could claim it as his own, and the book, the
image, the legend, had itself a legend, and its fortunes,
and a personal history; and it is a sign of the medieval-
ism of Michelangelo, that he thus receives from tradi-
tion his central conception, and does but add the last
touches, in transferring it to the frescoes of the Sistine
Chapel.

But there was another tradition of those earlier, more
serious Florentines, of which Michelangelo is the inher-
itor, to which he gives the final expression, and which
centres in the sacristy of *San Lorenzo*, as the tradition of
the *Creation* centres in the Sistine Chapel. It has been
said that all the great Florentines were preoccupied with
death. *Outre-tombe! Outre-tombe!*—is the burden of their

thoughts, from Dante to Savonarola. Even the gay and licentious Boccaccio gives a keener edge to his stories by putting them in the mouths of a party of people who had taken refuge in a country-house from the danger of death by plague. It was to this inherited sentiment, this practical decision that to be preoccupied with the thought of death was in itself dignifying, and a note of high quality, that the seriousness of the great Florentines of the fifteenth century was partly due; and it was reinforced in them by the actual sorrows of their times. How often, and in what various ways, had they seen life stricken down, in their streets and houses. *La bella Simonetta* dies in early youth, and is borne to the grave with uncovered face. The young Cardinal Jacopo di Portogallo dies on a visit to Florence—*insignis formâ fui et mirabili modestiâ*—his epitaph dares to say. Antonio Rossellino carves his tomb in the church of San Miniato, with care for the shapely hands and feet, and sacred attire; Luca della Robbia puts his skyiest works there; and the tomb of the youthful and princely prelate became the strangest and most beautiful thing in that strange and beautiful place. After the execution of the Pazzi conspirators, Botticelli is employed to paint their portraits. This preoccupation with serious thoughts and sad images might easily have resulted, as it did, for instance, in the gloomy villages of the Rhine, or in the overcrowded parts of medieval Paris, as it still does in many a village of the Alps, in something merely morbid or grotesque, in the *Danse Macabre* of many French and German painters, or the grim inventions of Dürer. From such a result the Florentine masters of the fifteenth century were saved by the nobility of their Italian culture, and still more by their tender pity for the thing it-

self. They must often have leaned over the lifeless body, when all was at length quiet and smoothed out. After death, it is said, the traces of slighter and more superficial dispositions disappear; the lines become more
5 simple and dignified; only the abstract lines remain, in a great indifference. They came thus to see death in its distinction. Then following it perhaps one stage further, dwelling for a moment on the point where all this transitory dignity must break up, and discerning with no
10 clearness a new body, they paused just in time, and abstained, with a sentiment of profound pity.

Of all this sentiment Michelangelo is the achievement; and, first of all, of pity. *Pietà*, pity, the pity of the Virgin Mother over the dead body of Christ, expanded
15 into the pity of all mothers over all dead sons, the entombment, with its cruel "hard stones":—this is the subject of his predilection. He has left it in many forms, sketches, half-finished designs, finished and unfinished groups of sculpture; but always as a hopeless, rayless,
20 almost heathen sorrow—no divine sorrow, but mere pity and awe at the stiff limbs and colourless lips. There is a drawing of his at Oxford, in which the dead body has sunk to the earth between the mother's feet, with the arms extended over her knees. The tombs in the
25 sacristy of *San Lorenzo* are memorials, not of any of the nobler and greater Medici, but of Giuliano, and Lorenzo the younger, noticeable chiefly for their somewhat early death. It is mere human nature therefore which has prompted the sentiment here. The titles assigned tradi-
30 tionally to the four symbolical figures, *Night* and *Day*, *The Twilight* and *The Dawn*, are far too definite for them; for these figures come much nearer to the mind and spirit of their author, and are a more direct expres-

sion of his thoughts, than any merely symbolical conceptions could possibly have been. They concentrate and express, less by way of definite conceptions than by the touches, the promptings of a piece of music, all those vague fancies, misgivings, presentiments, which shift and mix and are defined and fade again, whenever the thoughts try to fix themselves with sincerity on the conditions and surroundings of the disembodied spirit. I suppose no one would come to the sacristy of San Lorenzo for consolation; for seriousness, for solemnity, for dignity of impression, perhaps, but not for consolation. It is a place neither of consoling nor of terrible thoughts, but of vague and wistful speculation. Here, again, Michelangelo is the disciple not so much of Dante as of the Platonists. Dante's belief in immortality is formal, precise, and firm, almost as much so as that of a child, who thinks the dead will hear if you cry loud enough. But in Michelangelo you have maturity, the mind of the grown man, dealing cautiously and dispassionately with serious things; and what hope he has is based on the consciousness of ignorance—ignorance of man, ignorance of the nature of the mind, its origin and capacities. Michelangelo is so ignorant of the spiritual world, of the new body and its laws, that he does not surely know whether the consecrated Host may not be the body of Christ. And of all that range of sentiment he is the poet, a poet still alive, and in possession of our inmost thoughts—dumb inquiry over the relapse after death into the formlessness which preceded life, the change, the revolt from that change, then the correcting, hallowing, consoling rush of pity; at last, far off, thin and vague, yet not more vague than the most definite thoughts men have had through three centuries on

a matter that has been so near their hearts, the new body —a passing light, a mere intangible, external effect, over those too rigid, or too formless faces; a dream that lingers a moment, retreating in the dawn, incomplete, aimless, helpless; a thing with faint hearing, faint memory, faint power of touch; a breath, a flame in the doorway, a feather in the wind.

The qualities of the great masters in art or literature, the combination of those qualities, the laws by which they moderate, support, relieve each other, are not peculiar to them; but most often typical standards, or revealing instances of the laws by which certain æsthetic effects are produced. The old masters indeed are simpler; their characteristics are written larger, and are easier to read, than the analogues of them in all the mixed, confused productions of the modern mind. But when once we have succeeded in defining for ourselves those characteristics, and the law of their combination, we have acquired a standard or measure which helps us to put in its right place many a vagrant genius, many an unclassified talent, many precious though imperfect products of art. It is so with the components of the true character of Michelangelo. That strange interfusion of sweetness and strength is not to be found in those who claimed to be his followers; but it is found in many of those who worked before him, and in many others down to our own time, in William Blake, for instance, and Victor Hugo, who, though not of his school, and unaware, are his true sons, and help us to understand him, as he in turn interprets and justifies them. Perhaps this is the chief use in studying old masters.

1871.

Leonardo da Vinci

Homo minister et interpres naturæ

IN VASARI'S LIFE of Leonardo da Vinci as we now read
it there are some variations from the first edition.
There, the painter who has fixed the outward type of
Christ for succeeding centuries was a bold speculator,
holding lightly by other men's beliefs, setting philoso- 5
phy above Christianity. Words of his, trenchant enough
to justify this impression, are not recorded, and would
have been out of keeping with a genius of which one
characteristic is the tendency to lose itself in a refined
and graceful mystery. The suspicion was but the time- 10
honoured mode in which the world stamps its apprecia-
tion of one who has thoughts for himself alone, his high
indifference, his intolerance of the common forms of
things; and in the second edition the image was changed
into something fainter and more conventional. But it is 15
still by a certain mystery in his work, and something
enigmatical beyond the usual measure of great men, that
he fascinates, or perhaps half repels. His life is one of
sudden revolts, with intervals in which he works not at
all, or apart from the main scope of his work. By a 20
strange fortune the pictures on which his more popular
fame rested disappeared early from the world, like the
Battle of the Standard; or are mixed obscurely with the
product of meaner hands, like the *Last Supper*. His type
of beauty is so exotic that it fascinates a larger number 25
than it delights, and seems more than that of any other
artist to reflect ideas and views and some scheme of the

world within; so that he seemed to his contemporaries to be the possessor of some unsanctified and secret wisdom; as to Michelet and others to have anticipated modern ideas. He trifles with his genius, and crowds all his chief work into a few tormented years of later life; yet he is so possessed by his genius that he passes unmoved through the most tragic events, overwhelming his country and friends, like one who comes across them by chance on some secret errand.

His *legend*, as the French say, with the anecdotes which every one remembers, is one of the most brilliant chapters of Vasari. Later writers merely copied it, until, in 1804, Carlo Amoretti applied to it a criticism which left hardly a date fixed, and not one of those anecdotes untouched. The various questions thus raised have since that time become, one after another, subjects of special study, and mere antiquarianism has in this direction little more to do. For others remain the editing of the thirteen books of his manuscripts, and the separation by technical criticism of what in his reputed works is really his, from what is only half his, or the work of his pupils. But a lover of strange souls may still analyse for himself the impression made on him by those works, and try to reach through it a definition of the chief elements of Leonardo's genius. The *legend*, as corrected and enlarged by its critics, may now and then intervene to support the results of this analysis.

His life has three divisions—thirty years at Florence, nearly twenty years at Milan, then nineteen years of wandering, till he sinks to rest under the protection of Francis the First at the *Château de Clou*. The dishonour of illegitimacy hangs over his birth. Piero Antonio, his father, was of a noble Florentine house, of Vinci in the

Val d'Arno, and Leonardo, brought up delicately among the true children of that house, was the love-child of his youth, with the keen, puissant nature such children often have. We see him in his boyhood fascinating all men by his beauty, improvising music and songs, buy- 5 ing the caged birds and setting them free, as he walked the streets of Florence, fond of odd bright dresses and spirited horses.

From his earliest years he designed many objects, and constructed models in relief, of which Vasari mentions 10 some of women smiling. His father, pondering over this promise in the child, took him to the workshop of Andrea del Verrocchio, then the most famous artist in Florence. Beautiful objects lay about there—reliquaries, pyxes, silver images for the pope's chapel at Rome, 15 strange fancy-work of the middle age, keeping odd company with fragments of antiquity, then but lately discovered. Another student Leonardo may have seen there—a lad into whose soul the level light and aerial illusions of Italian sunsets had passed, in after days 20 famous as Perugino. Verrocchio was an artist of the earlier Florentine type, carver, painter, and worker in metals, in one; designer, not of pictures only, but of all things for sacred or household use, drinking-vessels, ambries, instruments of music, making them all fair to 25 look upon, filling the common ways of life with the reflexion of some far-off brightness; and years of patience had refined his hand till his work was now sought after from distant places.

It happened that Verrocchio was employed by the 30 brethren of Vallombrosa to paint the Baptism of Christ, and Leonardo was allowed to finish an angel in the left-hand corner. It was one of those moments in which the

progress of a great thing—here, that of the art of Italy—
presses hard on the happiness of an individual, through
whose discouragement and decrease, humanity, in more
fortunate persons, comes a step nearer to its final suc-
5 cess.

For beneath the cheerful exterior of the mere well-
paid craftsman, chasing brooches for the copes of *Santa
Maria Novella*, or twisting metal screens for the tombs
of the Medici, lay the ambitious desire to expand the
10 destiny of Italian art by a larger knowledge and insight
into things, a purpose in art not unlike Leonardo's still
unconscious purpose; and often, in the modelling of
drapery, or of a lifted arm, or of hair cast back from the
face, there came to him something of the freer manner
15 and richer humanity of a later age. But in this *Baptism*
the pupil had surpassed the master; and Verrocchio
turned away as one stunned, and as if his sweet earlier
work must thereafter be distasteful to him, from the
bright animated angel of Leonardo's hand.

20 The angel may still be seen in Florence, a space of
sunlight in the cold, laboured old picture; but the legend
is true only in sentiment, for painting had always been
the art by which Verrocchio set least store. And as in a
sense he anticipates Leonardo, so, to the last Leonardo
25 recalls the studio of Verrocchio, in the love of beautiful
toys, such as the vessel of water for a mirror, and lovely
needlework about the implicated hands in the *Modesty
and Vanity*, and of reliefs, like those cameos which in the
Virgin of the Balances hang all round the girdle of Saint
30 Michael, and of bright variegated stones, such as the
agates in the *Saint Anne*, and in a hieratic preciseness
and grace, as of a sanctuary swept and garnished. Amid
all the cunning and intricacy of his Lombard manner

this never left him. Much of it there must have been in that lost picture of *Paradise*, which he prepared as a cartoon for tapestry, to be woven in the looms of Flanders. It was the perfection of the older Florentine style of miniature-painting, with patient putting of each leaf upon the trees and each flower in the grass, where the first man and woman were standing.

And because it was the perfection of that style, it awoke in Leonardo some seed of discontent which lay in the secret places of his nature. For the way to perfection is through a series of disgusts; and this picture—all that he had done so far in his life at Florence—was after all in the old slight manner. His art, if it was to be something in the world, must be weighted with more of the meaning of nature and purpose of humanity. Nature was "the true mistress of higher intelligences." He plunged, then, into the study of nature. And in doing this he followed the manner of the older students; he brooded over the hidden virtues of plants and crystals, the lines traced by the stars as they moved in the sky, over the correspondences which exist between the different orders of living things, through which, to eyes opened, they interpret each other, and for years he seemed to those about him as one listening to a voice, silent for other men.

He learned here the art of going deep, of tracking the sources of expression to their subtlest retreats, the power of an intimate presence in the things he handled. He did not at once or entirely desert his art; only he was no longer the cheerful, objective painter, through whose soul, as through clear glass, the bright figures of Florentine life, only made a little mellower and more pensive by the transit, passed on to the white wall. He

wasted many days in curious tricks of design, seeming
to lose himself in the spinning of intricate devices of line
and colour. He was smitten with a love of the impossi-
ble—the perforation of mountains, changing the course
of rivers, raising great buildings, such as the church of
San Giovanni, in the air; all those feats for the perfor-
mance of which natural magic professed to have the
key. Later writers, indeed, see in these efforts an antici-
pation of modern mechanics; in him they were rather
dreams, thrown off by the overwrought and labouring
brain. Two ideas were especially confirmed in him, as
reflexes of things that had touched his brain in child-
hood beyond the depth of other impressions—the smil-
ing of women and the motion of great waters.

And in such studies some interfusion of the extremes
of beauty and terror shaped itself, as an image that
might be seen and touched, in the mind of this gracious
youth, so fixed that for the rest of his life it never left
him. As if catching glimpses of it in the strange eyes or
hair of chance people, he would follow such about the
streets of Florence till the sun went down, of whom
many sketches of his remain. Some of these are full of
a curious beauty, that remote beauty which may be ap-
prehended only by those who have sought it carefully;
who, starting with acknowledged types of beauty, have
refined as far upon these, as these refine upon the world
of common forms. But mingled inextricably with this
there is an element of mockery also; so that, whether in
sorrow or scorn, he caricatures Dante even. Legions of
grotesques sweep under his hand; for has not nature
too her grotesques—the rent rock, the distorting lights
of evening on lonely roads, the unveiled structure of
man in the embryo, or the skeleton?

All these swarming fancies unite in the *Medusa* of the *Uffizii*. Vasari's story of an earlier Medusa, painted on a wooden shield, is perhaps an invention; and yet, properly told, has more of the air of truth about it than anything else in the whole legend. For its real subject is not the serious work of a man, but the experiment of a child. The lizards and glowworms and other strange small creatures which haunt an Italian vineyard bring before one the whole picture of a child's life in a Tuscan dwelling—half castle, half farm—and are as true to nature as the pretended astonishment of the father for whom the boy has prepared a surprise. It was not in play that he painted that other Medusa, the one great picture which he left behind him in Florence. The subject has been treated in various ways; Leonardo alone cuts to its centre; he alone realises it as the head of a corpse, exercising its powers through all the circumstances of death. What may be called the fascination of corruption penetrates in every touch its exquisitely finished beauty. About the dainty lines of the cheek the bat flits unheeded. The delicate snakes seem literally strangling each other in terrified struggle to escape from the Medusa brain. The hue which violent death always brings with it is in the features; features singularly massive and grand, as we catch them inverted, in a dexterous foreshortening, crown foremost, like a great calm stone against which the wave of serpents breaks.

The science of that age was all divination, clairvoyance, unsubjected to our exact modern formulas, seeking in an instant of vision to concentrate a thousand experiences. Later writers, thinking only of the well-ordered treatise on painting which a Frenchman, Raffaelle du Fresne, a hundred years afterwards, compiled

from Leonardo's bewildered manuscripts, written strangely, as his manner was, from right to left, have imagined a rigid order in his inquiries. But this rigid order would have been little in accordance with the rest-
5 lessness of his character; and if we think of him as the mere reasoner who subjects design to anatomy, and composition to mathematical rules, we shall hardly have that impression which those around Leonardo received from him. Poring over his crucibles, making experi-
10 ments with colour, trying, by a strange variation of the alchemist's dream, to discover the secret, not of an elixir to make man's natural life immortal, but of giving im- mortality to the subtlest and most delicate effects of painting, he seemed to them rather the sorcerer or the
15 magician, possessed of curious secrets and a hidden knowledge, living in a world of which he alone pos- sessed the key. What his philosophy seems to have been most like is that of Paracelsus or Cardan; and much of the spirit of the older alchemy still hangs about it, with
20 its confidence in short cuts and odd byways to knowl- edge. To him philosophy was to be something giving strange swiftness and double sight, divining the sources of springs beneath the earth or of expression beneath the human countenance, clairvoyant of occult gifts in
25 common or uncommon things, in the reed at the brook- side, or the star which draws near to us but once in a century. How, in this way, the clear purpose was over- clouded, the fine chaser's hand perplexed, we but dimly see; the mystery which at no point quite lifts from Le-
30 onardo's life is deepest here. But it is certain that at one period of his life he had almost ceased to be an artist.

The year 1483—the year of the birth of Raphael and the thirty-first of Leonardo's life—is fixed as the date of

his visit to Milan by the letter in which he recommends himself to Ludovico Sforza, and offers to tell him, for a price, strange secrets in the art of war. It was that Sforza who murdered his young nephew by slow poison, yet was so susceptible of religious impressions that he blended mere earthly passion with a sort of religious sentimentalism, and who took for his device the mulberry-tree—symbol, in its long delay and sudden yielding of flowers and fruit together, of a wisdom which economises all forces for an opportunity of sudden and sure effect. The fame of Leonardo had gone before him, and he was to model a colossal statue of Francesco, the first Duke of Milan. As for Leonardo himself, he came not as an artist at all, or careful of the fame of one; but as a player on the harp, a strange harp of silver of his own construction, shaped in some curious likeness to a horse's skull. The capricious spirit of Ludovico was susceptible also to the power of music, and Leonardo's nature had a kind of spell in it. Fascination is always the word descriptive of him. No portrait of his youth remains; but all tends to make us believe that up to this time some charm of voice and aspect, strong enough to balance the disadvantage of his birth, had played about him. His physical strength was great; it was said that he could bend a horse-shoe like a coil of lead.

The *Duomo*, work of artists from beyond the Alps, so fantastic to the eye of a Florentine used to the mellow, unbroken surfaces of Giotto and Arnolfo, was then in all its freshness; and below, in the streets of Milan, moved a people as fantastic, changeful, and dreamlike. To Leonardo least of all men could there be anything poisonous in the exotic flowers of sentiment which grew there. It was a life of brilliant sins and exquisite amuse-

ments: Leonardo became a celebrated designer of pageants; and it suited the quality of his genius, composed, in almost equal parts, of curiosity and the desire of beauty, to take things as they came.

5 Curiosity and the desire of beauty—these are the two elementary forces in Leonardo's genius; curiosity often in conflict with the desire of beauty, but generating, in union with it, a type of subtle and curious grace.

The movement of the fifteenth century was two-fold; 10 partly the Renaissance, partly also the coming of what is called the "modern spirit," with its realism, its appeal to experience. It comprehended a return to antiquity, and a return to nature. Raphael represents the return to antiquity, and Leonardo the return to nature. In this 15 return to nature, he was seeking to satisfy a boundless curiosity by her perpetual surprises, a microscopic sense of finish by her *finesse*, or delicacy of operation, that *subtilitas naturae* which Bacon notices. So we find him often in intimate relations with men of science,—with Fra 20 Luca Paccioli the mathematician, and the anatomist Marc Antonio della Torre. His observations and experiments fill thirteen volumes of manuscript; and those who can judge describe him as anticipating long before, by rapid intuition, the later ideas of science. He ex- 25 plained the obscure light of the unilluminated part of the moon, knew that the sea had once covered the mountains which contain shells, and of the gathering of the equatorial waters above the polar.

He who thus penetrated into the most secret parts of 30 nature preferred always the more to the less remote, what, seeming exceptional, was an instance of law more refined, the construction about things of a peculiar atmosphere and mixed lights. He paints flowers with such

curious felicity that different writers have attributed to him a fondness for particular flowers, as Clement the cyclamen, and Rio the jasmin; while, at Venice, there is a stray leaf from his portfolio dotted all over with studies of violets and the wild rose. In him first appears the taste for what is *bizarre* or *recherché* in landscape; hollow places full of the green shadow of bituminous rocks, ridged reefs of trap-rock which cut the water into quaint sheets of light,—their exact antitype is in our own western seas; all the solemn effects of moving water. You may follow it springing from its distant source among the rocks on the heath of the *Madonna of the Balances*, passing, as a little fall, into the treacherous calm of the *Madonna of the Lake*, as a goodly river next, below the cliffs of the *Madonna of the Rocks*, washing the white walls of its distant villages, stealing out in a network of divided streams in *La Gioconda* to the seashore of the *Saint Anne*—that delicate place, where the wind passes like the point of some fine etcher over the surface, and the untorn shells are lying thick upon the sand, and the tops of the rocks, to which the waves never rise, are green with grass, grown fine as hair. It is the landscape, not of dreams or of fancy, but of places far withdrawn, and hours selected from a thousand with a miracle of *finesse*. Through Leonardo's strange veil of sight things reach him so; in no ordinary night or day, but as in faint light of eclipse, or in some brief interval of falling rain at daybreak, or through deep water.

And not into nature only; but he plunged also into human personality, and became above all a painter of portraits; faces of a modelling more skilful than has been seen before or since, embodied with a reality which almost amounts to illusion, on the dark air. To take a

character as it was, and delicately sound its stops, suited one so curious in observation, curious in invention. He painted thus the portraits of Ludovico's mistresses, Lucretia Crivelli and Cecilia Galerani the poetess, of Ludovico himself, and the Duchess Beatrice. The portrait of Cecilia Galerani is lost, but that of Lucretia Crivelli has been identified with *La Belle Feronière* of the Louvre, and Ludovico's pale, anxious face still remains in the Ambrosian library. Opposite is the portrait of Beatrice d'Este, in whom Leonardo seems to have caught some presentiment of early death, painting her precise and grave, full of the refinement of the dead, in sad earth-coloured raiment, set with pale stones.

Sometimes this curiosity came in conflict with the desire of beauty; it tended to make him go too far below that outside of things in which art really begins and ends. This struggle between the reason and its ideas, and the senses, the desire of beauty, is the key to Leonardo's life at Milan—his restlessness, his endless retouchings, his odd experiments with colour. How much must he leave unfinished, how much recommence! His problem was the transmutation of ideas into images. What he had attained so far had been the mastery of that earlier Florentine style, with its naïve and limited sensuousness. Now he was to entertain in this narrow medium those divinations of a humanity too wide for it, that larger vision of the opening world, which is only not too much for the great, irregular art of Shakespeare; and everywhere the effort is visible in the work of his hands. This agitation, this perpetual delay, give him an air of weariness and *ennui*. To others he seems to be aiming at an impossible effect, to do something that art, that painting, can never do. Often the

expression of physical beauty at this or that point seems strained and marred in the effort, as in those heavy German foreheads—too heavy and German for perfect beauty.

For there was a touch of Germany in that genius which, as Goethe said, had "thought itself weary"— *müde sich gedacht*. What an anticipation of modern Germany, for instance, in that debate on the question whether sculpture or painting is the nobler art[1]! But there is this difference between him and the German, that, with all that curious science, the German would have thought nothing more was needed. The name of Goethe himself reminds one how great for the artist may be the danger of over-much science; how Goethe, who, in the *Elective Affinities* and the first part of *Faust*, does transmute ideas into images, who wrought many such transmutations, did not invariably find the spell-word, and in the second part of *Faust* presents us with a mass of science which has almost no artistic character at all. But Leonardo will never work till the happy moment comes—that moment of *bien-être*, which to imaginative men is the moment of invention. On this he waits with a perfect patience; other moments are but a preparation, or after-taste of it. Few men distinguish between them as jealously as he. Hence, so many flaws even in the choicest work. But for Leonardo the distinction is absolute, and, in the moment of *bien-être*, the alchemy complete: the idea is stricken into colour and imagery: a cloudy mysticism is refined to a subdued and graceful mystery, and painting pleases the eye while it satisfies the soul.

[1] How princely, how characteristic of Leonardo, the answer, *Quanto più un' arte porta seco fatica di corpo tanto più è vile!*

This curious beauty is seen above all in his drawings, and in these chiefly in the abstract grace of the bounding lines. Let us take some of these drawings, and pause over them awhile; and, first, one of those at Florence—
5 the heads of a woman and a little child, set side by side, but each in its own separate frame. First of all, there is much pathos in the reappearance, in the fuller curves of the face of the child, of the sharper, more chastened lines of the worn and older face, which leaves no doubt
10 that the heads are those of a little child and its mother. A feeling for maternity is indeed always characteristic of Leonardo; and this feeling is further indicated here by the half-humorous pathos of the diminutive, rounded shoulders of the child. You may note a like pathetic
15 power in drawings of a young man, seated in a stooping posture, his face in his hands, as in sorrow; of a slave sitting in an uneasy inclined attitude, in some brief interval of rest; of a small Madonna and Child, peeping sideways in half-reassured terror, as a mighty griffin
20 with batlike wings, one of Leonardo's finest *inventions*, descends suddenly from the air to snatch up a great wild beast wandering near them. But note in these, as that which especially belongs to art, the contour of the young man's hair, the poise of the slave's arm above his
25 head, and the curves of the head of the child, following the little skull within, thin and fine as some seashell worn by the wind.

Take again another head, still more full of sentiment, but of a different kind, a little drawing in red chalk
30 which every one will remember who has examined at all carefully the drawings by old masters at the Louvre. It is a face of doubtful sex, set in the shadow of its own hair, the cheek-line in high light against it, with some-

thing voluptuous and full in the eyelids and the lips.
Another drawing might pass for the same face in child-
hood, with parched and feverish lips, but much sweet-
ness in the loose, short-waisted childish dress, with
necklace and *bulla*, and in the daintily bound hair. We 5
might take the thread of suggestion which these two
drawings offer, when thus set side by side, and, follow-
ing it through the drawings at Florence, Venice, and
Milan, construct a sort of series, illustrating better than
anything else Leonardo's type of womanly beauty. 10
Daughters of Herodias, with their fantastic head-dresses
knotted and folded so strangely to leave the dainty oval
of the face disengaged, they are not of the Christian
family, or of Raphael's. They are the clairvoyants,
through whom, as through delicate instruments, one 15
becomes aware of the subtler forces of nature, and the
modes of their action, all that is magnetic in it, all those
finer conditions wherein material things rise to that
subtlety of operation which constitutes them spiritual,
where only the finer nerve and the keener touch can 20
follow. It is as if in certain significant examples we ac-
tually saw those forces at their work on human flesh.
Nervous, electric, faint always with some inexplicable
faintness, these people seem to be subject to exceptional
conditions, to feel powers at work in the common air 25
unfelt by others, to become, as it were, the receptacle of
them, and pass them on to us in a chain of secret in-
fluences.

But among the more youthful heads there is one at
Florence which Love chooses for its own—the head of a 30
young man, which may well be the likeness of Andrea
Salaino, beloved of Leonardo for his curled and waving
hair—*belli capelli ricci e inanellati*—and afterwards his

favourite pupil and servant. Of all the interests in living
men and women which may have filled his life at Milan,
this attachment alone is recorded. And in return Salaino
identified himself so entirely with Leonardo, that the
picture of *St. Anne*, in the Louvre, has been attributed
to him. It illustrates Leonardo's usual choice of pupils,
men of some natural charm of person or intercourse
like Salaino, or men of birth and princely habits of life
like Francesco Melzi—men with just enough genius to
be capable of initiation into his secret, for the sake of
which they were ready to efface their own individuality.
Among them, retiring often to the villa of the Melzi at
Canonica al Vaprio, he worked at his fugitive manu-
scripts and sketches, working for the present hour, and
for a few only, perhaps chiefly for himself. Other artists
have been as careless of present or future applause, in
self-forgetfulness, or because they set moral or political
ends above the ends of art; but in him this solitary cul-
ture of beauty seems to have hung upon a kind of self-
love, and a carelessness in the work of art of all but art
itself. Out of the secret places of a unique temperament
he brought strange blossoms and fruits hitherto un-
known; and for him, the novel impression conveyed,
the exquisite effect woven, counted as an end in itself—a
perfect end.

And these pupils of his acquired his manner so thor-
oughly, that though the number of Leonardo's authen-
tic works is very small indeed, there is a multitude of
other men's pictures through which we undoubtedly see
him, and come very near to his genius. Sometimes, as
in the little picture of the *Madonna of the Balances*, in
which, from the bosom of His mother, Christ weighs
the pebbles of the brook against the sins of men, we

have a hand, rough enough by contrast, working upon some fine hint or sketch of his. Sometimes, as in the subjects of the *Daughter of Herodias* and the *Head of John the Baptist*, the lost originals have been re-echoed and varied upon again and again by Luini and others. At 5 other times the original remains, but has been a mere theme or motive, a type of which the accessories might be modified or changed; and these variations have but brought out the more the purpose, or expression of the original. It is so with the so-called *Saint John the Baptist* 10 of the Louvre—one of the few naked figures Leonardo painted—whose delicate brown flesh and woman's hair no one would go out into the wilderness to seek, and whose treacherous smile would have us understand something far beyond the outward gesture or circum- 15 stance. But the long, reedlike cross in the hand, which suggests Saint John the Baptist, becomes faint in a copy at the Ambrosian Library, and disappears altogether in another version, in the *Palazzo Rosso* at Genoa. Return- ing from the latter to the original, we are no longer sur- 20 prised by Saint John's strange likeness to the *Bacchus* which hangs near it, and which set Théophile Gautier thinking of Heine's notion of decayed gods, who, to maintain themselves, after the fall of paganism, took employment in the new religion. We recognise one of 25 those symbolical inventions in which the ostensible sub- ject is used, not as matter for definite pictorial realisa- tion, but as the starting-point of a train of sentiment, subtle and vague as a piece of music. No one ever ruled over the mere *subject* in hand more entirely than Leo- 30 nardo, or bent it more dexterously to purely artistic ends. And so it comes to pass that though he handles sacred subjects continually, he is the most profane of

painters; the given person or subject, Saint John in the Desert, or the Virgin on the knees of Saint Anne, is often merely the pretext for a kind of work which car- ries one altogether beyond the range of its conventional 5 associations.

About the *Last Supper*, its decay and restorations, a whole literature has risen up, Goethe's pensive sketch of its sad fortunes being perhaps the best. The death in child-birth of the Duchess Beatrice was followed in Lu- 10 dovico by one of those paroxysms of religious feeling which in him were constitutional. The low, gloomy Dominican church of *Saint Mary of the Graces* had been the favourite oratory of Beatrice. She had spent her last days there, full of sinister presentiments; at last it had 15 been almost necessary to remove her from it by force; and now it was here that mass was said a hundred times a day for her repose. On the damp wall of the refectory, oozing with mineral salts, Leonardo painted the *Last Supper*. A hundred anecdotes were told about it, his re- 20 touchings and delays. They show him refusing to work except at the moment of invention, scornful of anyone who supposed that art could be a work of mere industry and rule, often coming the whole length of Milan to give a single touch. He painted it, not in fresco, where 25 all must be *impromptu*, but in oils, the new method which he had been one of the first to welcome, because it allowed of so many after-thoughts, so refined a work- ing-out of perfection. It turned out that on a plastered wall no process could have been less durable. Within 30 fifty years it had fallen into decay. And now we have to turn back to Leonardo's own studies, above all to one drawing of the central head at the *Brera*, which, in a union of tenderness and severity in the face-lines, re-

minds one of the monumental work of Mino da Fiesole, to trace it as it was.

Here was another effort to lift a given subject out of the range of its traditional associations. Strange, after all the mystic developments of the middle age, was the effort to see the Eucharist, not as the pale Host of the altar, but as one taking leave of his friends. Five years afterwards the young Raphael, at Florence, painted it with sweet and solemn effect in the refectory of Saint Onofrio; but still with all the mystical unreality of the school of Perugino. Vasari pretends that the central head was never finished. But finished or unfinished, or owing part of its effect to a mellowing decay, the head of Jesus does but consummate the sentiment of the whole company—ghosts through which you see the wall, faint as the shadows of the leaves upon the wall on autumn afternoons. This figure is but the faintest, the most spectral of them all.

The *Last Supper* was finished in 1497; in 1498 the French entered Milan, and whether or not the Gascon bowmen used it as a mark for their arrows, the model of Francesco Sforza certainly did not survive. What, in that age, such work was capable of being—of what nobility, amid what racy truthfulness to fact—we may judge from the bronze statue of Bartolomeo Colleoni on horseback, modelled by Leonardo's master, Verrocchio, (he died of grief, it was said, because, the mould accidentally failing, he was unable to complete it,) still standing in the *piazza* of Saint John and Saint Paul at Venice. Some traces of the thing may remain in certain of Leonardo's drawings, and perhaps also, by a singular circumstance, in a far-off town of France. For Ludovico became a prisoner, and ended his days at Loches in

Touraine. After many years of captivity in the dungeons below, where all seems sick with barbarous feudal memories, he was allowed at last, it is said, to breathe fresher air for awhile in one of the rooms of the great
5 tower still shown, its walls covered with strange painted arabesques, ascribed by tradition to his hand, amused a little, in this way, through the tedious years. In those vast helmets and human faces and pieces of armour, among which, in great letters, the motto *Infelix Sum* is
10 woven in and out, it is perhaps not too fanciful to see the fruit of a wistful after-dreaming over Leonardo's sundry experiments on the armed figure of the great duke, which had occupied the two so much during the days of their good fortune at Milan.

15 The remaining years of Leonardo's life are more or less years of wandering. From his brilliant life at court he had saved nothing, and he returned to Florence a poor man. Perhaps necessity kept his spirit excited: the next four years are one prolonged rapture or ecstasy of
20 invention. He painted now the pictures of the Louvre, his most authentic works, which came there straight from the cabinet of Francis the First, at Fontainebleau. One picture of his, the *Saint Anne*—not the *Saint Anne* of the Louvre, but a simple cartoon, now in London—
25 revived for a moment a sort of appreciation more common in an earlier time, when good pictures had still seemed miraculous. For two days a crowd of people of all qualities passed in naïve excitement through the chamber where it hung, and gave Leonardo a taste of
30 the "triumph" of Cimabue. But his work was less with the saints than with the living women of Florence. For he lived still in the polished society that he loved, and in the houses of Florence, left perhaps a little subject to

light thoughts by the death of Savonarola—the latest gossip (1869) is of an undraped Monna Lisa, found in some out-of-the-way corner of the late *Orleans* collection—he saw Ginevra di Benci, and Lisa, the young third wife of Francesco del Giocondo. As we have seen him using incidents of sacred story, not for their own sake, or as mere subjects for pictorial realisation, but as a cryptic language for fancies all his own, so now he found a vent for his thought in taking one of these languid women, and raising her, as Leda or Pomona, as Modesty or Vanity, to the seventh heaven of symbolical expression.

La Gioconda is, in the truest sense, Leonardo's masterpiece, the revealing instance of his mode of thought and work. In suggestiveness, only the *Melancholia* of Dürer is comparable to it; and no crude symbolism disturbs the effect of its subdued and graceful mystery. We all know the face and hands of the figure, set in its marble chair, in that circle of fantastic rocks, as in some faint light under sea. Perhaps of all ancient pictures time has chilled it least[1]. As often happens with works in which invention seems to reach its limit, there is an element in it given to, not invented by, the master. In that inestimable folio of drawings, once in the possession of Vasari, were certain designs by Verrocchio, faces of such impressive beauty that Leonardo in his boyhood copied them many times. It is hard not to connect with these designs of the elder, by-past master, as with its germinal principle, the unfathomable smile, always with a touch of something sinister in it, which plays over all Leonardo's work. Besides, the picture is a portrait. From child-

[1] Yet for Vasari there was some further magic of crimson in the lips and cheeks, lost for us.

hood we see this image defining itself on the fabric of his dreams; and but for express historical testimony, we might fancy that this was but his ideal lady, embodied and beheld at last. What was the relationship of a living Florentine to this creature of his thought? By what strange affinities had the dream and the person grown up thus apart, and yet so closely together? Present from the first incorporeally in Leonardo's brain, dimly traced in the designs of Verrocchio, she is found present at last in *Il Giocondo's* house. That there is much of mere portraiture in the picture is attested by the legend that by artificial means, the presence of mimes and flute-players, that subtle expression was protracted on the face. Again, was it in four years and by renewed labour never really completed, or in four months and as by stroke of magic, that the image was projected?

The presence that rose thus so strangely beside the waters, is expressive of what in the ways of a thousand years men had come to desire. Hers is the head upon which all "the ends of the world are come," and the eyelids are a little weary. It is a beauty wrought out from within upon the flesh, the deposit, little cell by cell, of strange thoughts and fantastic reveries and exquisite passions. Set it for a moment beside one of those white Greek goddesses or beautiful women of antiquity, and how would they be troubled by this beauty, into which the soul with all its maladies has passed! All the thoughts and experience of the world have etched and moulded there, in that which they have of power to refine and make expressive the outward form, the animalism of Greece, the lust of Rome, the mysticism of the middle age with its spiritual ambition and imaginative loves, the return of the Pagan world, the sins of the

Borgias. She is older than the rocks among which she
sits; like the vampire, she has been dead many times,
and learned the secrets of the grave; and has been a diver
in deep seas, and keeps their fallen day about her; and
trafficked for strange webs with Eastern merchants:
and, as Leda, was the mother of Helen of Troy, and, as
Saint Anne, the mother of Mary; and all this has been to
her but as the sound of lyres and flutes, and lives only in
the delicacy with which it has moulded the changing
lineaments, and tinged the eyelids and the hands. The
fancy of a perpetual life, sweeping together ten thou-
sand experiences, is an old one; and modern philosophy
has conceived the idea of humanity as wrought upon
by, and summing up in itself, all modes of thought and
life. Certainly Lady Lisa might stand as the embodiment
of the old fancy, the symbol of the modern idea.

During these years at Florence Leonardo's history is
the history of his art; for himself, he is lost in the bright
cloud of it. The outward history begins again in 1502,
with a wild journey through central Italy, which he
makes as the chief engineer of Cæsar Borgia. The biog-
rapher, putting together the stray jottings of his manu-
scripts, may follow him through every day of it, up the
strange tower of Siena, elastic like a bent bow, down to
the seashore at Piombino, each place appearing as fitful-
ly as in a fever dream.

One other great work was left for him to do, a work
all trace of which soon vanished, *The Battle of the Stan-
dard*, in which he had Michelangelo for his rival. The
citizens of Florence, desiring to decorate the walls of the
great council-chamber, had offered the work for com-
petition, and any subject might be chosen from the Flor-
entine wars of the fifteenth century. Michelangelo chose

for his cartoon an incident of the war with Pisa, in which the Florentine soldiers, bathing in the Arno, are surprised by the sound of trumpets, and run to arms. His design has reached us only in an old engraving, which helps us less perhaps than our remembrance of the background of his *Holy Family* in the *Uffizii* to imagine in what superhuman form, such as might have beguiled the heart of an earlier world, those figures ascended out of the water. Leonardo chose an incident from the battle of Anghiari, in which two parties of soldiers fight for a standard. Like Michelangelo's, his cartoon is lost, and has come to us only in sketches, and in a fragment of Rubens. Through the accounts given we may discern some lust of terrible things in it, so that even the horses tore each other with their teeth. And yet one fragment of it, in a drawing of his at Florence, is far different—a waving field of lovely armour, the chased edgings running like lines of sunlight from side to side. Michelangelo was twenty-seven years old; Leonardo more than fifty; and Raphael, then nineteen years of age, visiting Florence for the first time, came and watched them as they worked.

We catch a glimpse of Leonardo again, at Rome in 1514, surrounded by his mirrors and vials and furnaces, making strange toys that seemed alive of wax and quicksilver. The hesitation which had haunted him all through life, and made him like one under a spell, was upon him now with double force. No one had ever carried political indifferentism further; it had always been his philosophy to "fly before the storm"; he is for the Sforzas, or against them, as the tide of their fortune turns. Yet now, in the political society of Rome, he came to be suspected of secret French sympathies. It

paralysed him to find himself among enemies; and he turned wholly to France, which had long courted him.

France was about to become an Italy more Italian than Italy itself. Francis the First, like Lewis the Twelfth before him, was attracted by the *finesse* of Leonardo's work; *La Gioconda* was already in his cabinet, and he offered Leonardo the little *Château de Clou*, with its vineyards and meadows, in the pleasant valley of the Masse, just outside the walls of the town of Amboise, where, especially in the hunting season, the court then frequently resided. *A Monsieur Lyonard, peinteur du Roy pour Amboyse:*—so the letter of Francis the First is headed. It opens a prospect, one of the most interesting in the history of art, where, in a peculiarly blent atmosphere, Italian art dies away as a French exotic.

Two questions remain, after much busy antiquarianism, concerning Leonardo's death—the question of the exact form of his religion, and the question whether Francis the First was present at the time. They are of about equally little importance in the estimate of Leonardo's genius. The directions in his will concerning the thirty masses and the great candles for the church of Saint Florentin are things of course, their real purpose being immediate and practical; and on no theory of religion could these hurried offices be of much consequence. We forget them in speculating how one who had been always so desirous of beauty, but desired it always in such precise and definite forms, as hands or flowers or hair, looked forward now into the vague land, and experienced the last curiosity.

1869.

The School of Giorgione

IT IS THE MISTAKE of much popular criticism to regard
poetry, music, and painting—all the various prod-
ucts of art—as but translations into different languages
of one and the same fixed quantity of imaginative
thought, supplemented by certain technical qualities of
colour, in painting; of sound, in music; of rhythmical
words, in poetry. In this way, the sensuous element in
art, and with it almost everything in art that is essential-
ly artistic, is made a matter of indifference; and a clear
apprehension of the opposite principle—that the sensu-
ous material of each art brings with it a special phase or
quality of beauty, untranslatable into the forms of any
other, an order of impressions distinct in kind—is the
beginning of all true æsthetic criticism. For, as art
addresses not pure sense, still less the pure intellect, but
the "imaginative reason" through the senses, there are
differences of kind in æsthetic beauty, corresponding to
the differences in kind of the gifts of sense themselves.
Each art, therefore, having its own peculiar and un-
translatable sensuous charm, has its own special mode
of reaching the imagination, its own special responsi-
bilities to its material. One of the functions of æsthetic
criticism is to define these limitations; to estimate the
degree in which a given work of art fulfils its responsi-
bilities to its special material; to note in a picture that
true pictorial charm, which is neither a mere poetical
thought or sentiment, on the one hand, nor a mere
result of communicable technical skill in colour or

design, on the other; to define in a poem that true poeti-
cal quality, which is neither descriptive nor meditative
merely, but comes of an inventive handling of rhythmi-
cal language, the element of song in the singing; to note
in music the musical charm, that essential music, which 5
presents no words, no matter of sentiment or thought,
separable from the special form in which it is conveyed
to us.

To such a philosophy of the variations of the beauti-
ful, Lessing's analysis of the spheres of sculpture and 10
poetry, in the *Laocoon*, was an important contribution.
But a true appreciation of these things is possible only
in the light of a whole system of such art-casuistries.
Now painting is the art in the criticism of which this
truth most needs enforcing, for it is in popular judg- 15
ments on pictures that the false generalisation of all art
into forms of poetry is most prevalent. To suppose that
all is mere technical acquirement in delineation or touch,
working through and addressing itself to the intelli-
gence, on the one side, or a merely poetical, or what 20
may be called literary interest, addressed also to the pure
intelligence, on the other:—this is the way of most spec-
tators, and of many critics, who have never caught sight
all the time of that true pictorial quality which lies be-
tween, unique pledge, as it is, of the possession of the 25
pictorial gift, that inventive or creative handling of pure
line and colour, which, as almost always in Dutch paint-
ing, as often also in the works of Titian or Veronese, is
quite independent of anything definitely poetical in the
subject it accompanies. It is the *drawing*—the design 30
projected from that peculiar pictorial temperament or
constitution, in which, while it may possibly be ignor-
ant of true anatomical proportions, all things whatever,

all poetry, all ideas however abstract or obscure, float up as visible scene or image: it is the *colouring*—that weaving of light, as of just perceptible gold threads, through the dress, the flesh, the atmosphere, in Titian's *Lace-girl*, that staining of the whole fabric of the thing with a new, delightful physical quality. This *drawing*, then—the arabesque traced in the air by Tintoret's flying figures, by Titian's forest branches; this colouring—the magic conditions of light and hue in the atmosphere of Titian's *Lace-girl*, or Rubens's *Descent from the Cross*:—these essential pictorial qualities must first of all delight the sense, delight it as directly and sensuously as a fragment of Venetian glass; and through this delight alone become the vehicle of whatever poetry or science may lie beyond them in the intention of the composer. In its primary aspect, a great picture has no more definite message for us than an accidental play of sunlight and shadow for a few moments on the wall or floor: is itself, in truth, a space of such fallen light, caught as the colours are in an Eastern carpet, but refined upon, and dealt with more subtly and exquisitely than by nature itself. And this primary and essential condition fulfilled, we may trace the coming of poetry into painting, by fine gradations upwards; from Japanese fan-painting, for instance, where we get, first, only abstract colour; then, just a little interfused sense of the poetry of flowers; then, sometimes, perfect flower-painting; and so, onwards, until in Titian we have, as his poetry in the *Ariadne*, so actually a touch of true childlike humour in the diminutive, quaint figure with its silk gown, which ascends the temple stairs, in his picture of the *Presentation of the Virgin*, at Venice.

But although each art has thus its own specific order of impressions, and an untranslatable charm, while a just apprehension of the ultimate differences of the arts is the beginning of æsthetic criticism; yet it is noticeable that, in its special mode of handling its given material, 5 each art may be observed to pass into the condition of some other art, by what German critics term an *Anders-streben*—a partial alienation from its own limitations, through which the arts are able, not indeed to supply the place of each other, but reciprocally to lend each 10 other new forces.

Thus, some of the most delightful music seems to be always approaching to figure, to pictorial definition. Architecture, again, though it has its own laws—laws esoteric enough, as the true architect knows only too 15 well—yet sometimes aims at fulfilling the conditions of a picture, as in the *Arena* chapel; or of sculpture, as in the flawless unity of Giotto's tower at Florence; and often finds a true poetry, as in those strangely twisted staircases of the *châteaux* of the country of the Loire, as 20 if it were intended that among their odd turnings the actors in a theatrical mode of life might pass each other unseen; there being a poetry also of memory and of the mere effect of time, by which architecture often profits greatly. Thus, again, sculpture aspires out of the hard 25 limitation of pure form towards colour, or its equiva-lent; poetry also, in many ways, finding guidance from the other arts, the analogy between a Greek tragedy and a work of Greek sculpture, between a sonnet and a re-lief, of French poetry generally with the art of engrav- 30 ing, being more than mere figures of speech; and all the arts in common aspiring towards the principle of music;

music being the typical, or ideally consummate art, the object of the great *Anders-streben* of all art, of all that is artistic, or partakes of artistic qualities.

All art constantly aspires towards the condition of music.
5 For while in all other kinds of art it is possible to distinguish the matter from the form, and the understanding can always make this distinction, yet it is the constant effort of art to obliterate it. That the mere matter of a poem, for instance, its subject, namely, its given
10 incidents or situation—that the mere matter of a picture, the actual circumstances of an event, the actual topography of a landscape—should be nothing without the form, the spirit, of the handling, that this form, this mode of handling, should become an end in itself,
15 should penetrate every part of the matter: this is what all art constantly strives after, and achieves in different degrees.

This abstract language becomes clear enough, if we think of actual examples. In an actual landscape we see
20 a long white road, lost suddenly on the hill-verge. That is the matter of one of the etchings of M. Alphonse Legros: only, in this etching, it is informed by an indwelling solemnity of expression, seen upon it or half-seen, within the limits of an exceptional moment, or
25 caught from his own mood perhaps, but which he maintains as the very essence of the thing, throughout his work. Sometimes a momentary hint of stormy light may invest a homely or too familiar scene with a character which might well have been drawn from the deep
30 places of the imagination. Then we might say that this particular effect of light, this sudden inweaving of gold thread through the texture of the haystack, and the poplars, and the grass, gives the scene artistic qualities, that

it is like a picture. And such tricks of circumstance are commonest in landscape which has little salient character of its own; because, in such scenery, all the material details are so easily absorbed by that informing expression of passing light, and elevated, throughout their whole extent, to a new and delightful effect by it. And hence the superiority, for most conditions of the picturesque, of a river-side in France to a Swiss valley, because, on the French river-side, mere topography, the simple material, counts for so little, and, all being very pure, untouched, and tranquil in itself, mere light and shade have such easy work in modulating it to one dominant tone. The Venetian landscape, on the other hand, has in its material conditions much which is hard, or harshly definite; but the masters of the Venetian school have shown themselves little burdened by them. Of its Alpine background they retain certain abstracted elements only, of cool colour and tranquillising line; and they use its actual details, the brown windy turrets, the straw-coloured fields, the forest arabesques, but as the notes of a music which duly accompanies the presence of their men and women, presenting us with the spirit or essence only of a certain sort of landscape—a country of the pure reason or half-imaginative memory.

Poetry, again, works with words addressed in the first instance to the pure intelligence; and it deals, most often, with a definite subject or situation. Sometimes it may find a noble and quite legitimate function in the conveyance of moral or political aspiration, as often in the poetry of Victor Hugo. In such instances it is easy enough for the understanding to distinguish between the matter and the form, however much the matter, the subject, the element which is addressed to the mere in-

telligence, has been penetrated by the informing, artistic spirit. But the ideal types of poetry are those in which this distinction is reduced to its *minimum*; so that lyrical poetry, precisely because in it we are least able to de-
5 tach the matter from the form, without a deduction of something from that matter itself, is, at least artistically, the highest and most complete form of poetry. And the very perfection of such poetry often appears to depend, in part, on a certain suppression or vagueness of mere
10 subject, so that the meaning reaches us through ways not distinctly traceable by the understanding, as in some of the most imaginative compositions of William Blake, and often in Shakespeare's songs, as preeminently in that song of Mariana's page in *Measure for Measure*, in
15 which the kindling force and poetry of the whole play seems to pass for a moment into an actual strain of music.

And this principle holds good of all things that partake in any degree of artistic qualities, of the furniture of
20 our houses, and of dress, for instance, of life itself, of gesture and speech, and the details of daily intercourse; these also, for the wise, being susceptible of a suavity and charm, caught from the way in which they are done, which gives them a worth in themselves. Herein,
25 again, lies what is valuable and justly attractive, in what is called the fashion of a time, which elevates the trivialities of speech, and manner, and dress, into "ends in themselves," and gives them a mysterious grace and attractiveness in the doing of them.
30 Art, then, is thus always striving to be independent of the mere intelligence, to become a matter of pure perception, to get rid of its responsibilities to its subject or material; the ideal examples of poetry and painting

being those in which the constituent elements of the composition are so welded together, that the material or subject no longer strikes the intellect only; nor the form, the eye or the ear only; but form and matter, in their union or identity, present one single effect to the "imag- 5 inative reason," that complex faculty for which every thought and feeling is twin-born with its sensible ana- logue or symbol.

It is the art of music which most completely realises this artistic ideal, this perfect identification of matter and 10 form. In its consummate moments, the end is not dis- tinct from the means, the form from the matter, the subject from the expression; they inhere in and com- pletely saturate each other; and to it, therefore, to the condition of its perfect moments, all the arts may be 15 supposed constantly to tend and aspire. In music, then, rather than in poetry, is to be found the true type or measure of perfected art. Therefore, although each art has its incommunicable element, its untranslatable order of impressions, its unique mode of reaching the "imag- 20 inative reason," yet the arts may be represented as con- tinually struggling after the law or principle of music, to a condition which music alone completely realises; and one of the chief functions of æsthetic criticism, dealing with the products of art, new or old, is to estimate the 25 degree in which each of those products approaches, in this sense, to musical law.

By no school of painters have the necessary limita- tions of the art of painting been so unerringly though instinctively apprehended, and the essence of what is 30 pictorial in a picture so justly conceived, as by the school of Venice; and the train of thought suggested in

what has been now said is, perhaps, a not unfitting introduction to a few pages about Giorgione, who, though much has been taken by recent criticism from what was reputed to be his work, yet, more entirely than any other painter, sums up, in what we know of himself and his art, the spirit of the Venetian school.

The beginnings of Venetian painting link themselves to the last, stiff, half-barbaric splendours of Byzantine decoration, and are but the introduction into the crust of marble and gold on the walls of the *Duomo* of Murano, or of *Saint Mark's*, of a little more of human expression. And throughout the course of its later development, always subordinate to architectural effect, the work of the Venetian school never escaped from the influence of its beginnings. Unassisted, and therefore unperplexed, by naturalism, religious mysticism, philosophical theories, it had no Giotto, no Angelico, no Botticelli. Exempt from the stress of thought and sentiment, which taxed so severely the resources of the generations of Florentine artists, those earlier Venetian painters, down to Carpaccio and the Bellini, seem never for a moment to have been so much as tempted to lose sight of the scope of their art in its strictness, or to forget that painting must be before all things decorative, a thing for the eye, a space of colour on the wall, only more dexterously blent than the marking of its precious stone or the chance interchange of sun and shade upon it:—this, to begin and end with; whatever higher matter of thought, or poetry, or religious reverie might play its part therein, between. At last, with final mastery of all the technical secrets of his art, and with somewhat more than "a spark of the divine fire" to his share, comes Giorgione. He is the inventor of *genre*, of those easily movable

pictures which serve neither for uses of devotion, nor of allegorical or historic teaching—little groups of real men and women, amid congruous furniture or land-scape—morsels of actual life, conversation or music or play, but refined upon or idealised, till they come to 5 seem like glimpses of life from afar. Those spaces of more cunningly blent colour, obediently filling their places, hitherto, in a mere architectural scheme, Giorgione detaches from the wall. He frames them by the hands of some skilful carver, so that people may move 10 them readily and take with them where they go, as one might a poem in manuscript, or a musical instrument, to be used, at will, as a means of self-education, stimulus or solace, coming like an animated presence, into one's cabinet, to enrich the air as with some choice 15 aroma, and, like persons, live with us, for a day or a lifetime. Of all art such as this, art which has played so large a part in men's culture since that time, Giorgione is the initiator. Yet in him too that old Venetian clearness or justice, in the apprehension of the essential 20 limitations of the pictorial art, is still undisturbed. While he interfuses his painted work with a high-strung sort of poetry, caught directly from a singularly rich and high-strung sort of life, yet in his selection of subject, or phase of subject, in the subordination of mere subject 25 to pictorial design, to the main purpose of a picture, he is typical of that aspiration of all the arts towards music, which I have endeavoured to explain,—towards the perfect identification of matter and form.

Born so near to Titian, though a little before him, 30 that these two companion pupils of the aged Giovanni Bellini may almost be called contemporaries, Giorgione stands to Titian in something like the relationship of

Sordello to Dante, in Browning's poem. Titian, when
he leaves Bellini, becomes, in turn, the pupil of Gior-
gione. He lives in constant labour more than sixty years
after Giorgione is in his grave; and with such fruit, that
hardly one of the greater towns of Europe is without
some fragment of his work. But the slightly older man,
with his so limited actual product (what remains to us of
it seeming, when narrowly examined, to reduce itself to
almost one picture, like Sordello's one fragment of love-
ly verse) yet expresses, in elementary motive and prin-
ciple, that spirit—itself the final acquisition of all the
long endeavours of Venetian art—which Titian spreads
over his whole life's activity.

And, as we might expect, something fabulous and
illusive has always mingled itself in the brilliancy of
Giorgione's fame. The exact relationship to him of
many works—drawings, portraits, painted idylls—
often fascinating enough, which in various collections
went by his name, was from the first uncertain. Still,
six or eight famous pictures at Dresden, Florence and
the Louvre, were with no doubt attributed to him, and
in these, if anywhere, something of the splendour of the
old Venetian humanity seemed to have been preserved.
But of those six or eight famous pictures it is now
known that only one is certainly from Giorgione's hand.
The accomplished science of the subject has come at
last, and, as in other instances, has not made the past
more real for us, but assured us only that we possess
less of it than we seemed to possess. Much of the work
on which Giorgione's immediate fame depended, work
done for instantaneous effect, in all probability passed
away almost within his own age, like the frescoes on the
façade of the *fondaco dei Tedeschi* at Venice, some crim-

son traces of which, however, still give a strange additional touch of splendour to the scene of the *Rialto*. And then there is a barrier or borderland, a period about the middle of the sixteenth century, in passing through which the tradition miscarries, and the true outlines of Giorgione's work and person are obscured. It became fashionable for wealthy lovers of art, with no critical standard of authenticity, to collect so-called works of Giorgione, and a multitude of imitations came into circulation. And now, in the "new Vasari[1]," the great traditional reputation, woven with so profuse demand on men's admiration, has been scrutinised thread by thread; and what remains of the most vivid and stimulating of Venetian masters, a live flame, as it seemed, in those old shadowy times, has been reduced almost to a name by his most recent critics.

Yet enough remains to explain why the legend grew up above the name, why the name attached itself, in many instances, to the bravest work of other men. The *Concert* in the *Pitti* Palace, in which a monk, with cowl and tonsure, touches the keys of a harpsichord, while a clerk, placed behind him, grasps the handle of a viol, and a third, with cap and plume, seems to wait upon the true interval for beginning to sing, is undoubtedly Giorgione's. The outline of the lifted finger, the trace of the plume, the very threads of the fine linen, which fasten themselves on the memory, in the moment before they are lost altogether in that calm unearthly glow, the skill which has caught the waves of wandering sound, and fixed them for ever on the lips and hands—these are indeed the master's own; and the criticism which, while dismissing so much hitherto believed to be Giorgione's,

[1] Crowe and Cavalcaselle: *History of Painting in North Italy*.

has established the claims of this one picture, has left it among the most precious things in the world of art.

It is noticeable that the "distinction" of this *Concert*, its sustained evenness of perfection, alike in design, in execution, and in choice of personal type, becomes for the "new Vasari" the standard of Giorgione's genuine work. Finding here sufficient to explain his influence, and the true seal of mastery, its authors assign to Pellegrino da San Daniele the *Holy Family* in the Louvre, in consideration of certain points where it comes short of this standard. Such shortcoming however will hardly diminish the spectator's enjoyment of a singular charm of liquid air, with which the whole picture seems instinct, filling the eyes and lips, the very garments, of its sacred personages, with some wind-searched brightness and energy; of which fine air the blue peak, clearly defined in the distance, is, as it were, the visible pledge. Similarly, another favourite picture in the Louvre, subject of a delightful sonnet by a poet[1] whose own painted work often comes to mind as one ponders over these precious things—the *Fête Champêtre*, is assigned to an imitator of Sebastian del Piombo; and the *Tempest*, in the Academy at Venice, to Paris Bordone, or perhaps to "some advanced craftsman of the sixteenth century." From the gallery at Dresden, the *Knight embracing a Lady*, where the knight's broken gauntlet seems to mark some well-known pause in a story we would willingly hear the rest of, is conceded to "a Brescian hand," and *Jacob meeting Rachel* to a pupil of Palma. And then, whatever their charm, we are called on to give up the *Ordeal*, and the *Finding of Moses* with its jewel-like pools of water, perhaps to Bellini.

[1] Dante Gabriel Rossetti.

Nor has the criticism, which thus so freely diminishes the number of his authentic works, added anything important to the well-known outline of the life and personality of the man: only, it has fixed one or two dates, one or two circumstances, a little more exactly. Giorgione was born before the year 1477, and spent his childhood at Castelfranco, where the last crags of the Venetian Alps break down romantically, with something of park-like grace, to the plain. A natural child of the family of the Barbarelli by a peasant-girl of Vedelago, he finds his way early into the circle of notable persons—people of courtesy. He is initiated into those differences of personal type, manner, and even of dress, which are best understood there—that "distinction" of the *Concert* of the *Pitti* Palace. Not far from his home lives Catherine of Cornara, formerly Queen of Cyprus; and, up in the towers which still remain, Tuzio Costanzo, the famous *condottiere*, a picturesque remnant of medieval manners, amid a civilisation rapidly changing. Giorgione paints their portraits; and when Tuzio's son, Matteo, dies in early youth, adorns in his memory a chapel in the church of Castelfranco, painting on this occasion, perhaps, the altar-piece, foremost among his authentic works, still to be seen there, with the figure of the warrior-saint, Liberale, of which the original little study in oil, with the delicately gleaming, silver-grey armour, is one of the greater treasures of the National Gallery. In that figure, as in some other knightly personages attributed to him, people have supposed the likeness of the painter's own presumably gracious presence. Thither, at last, he is himself brought home from Venice, early dead, but celebrated. It happened, about his thirty-fourth year, that in one of those parties at

which he entertained his friends with music, he met a certain lady of whom he became greatly enamoured, and "they rejoiced greatly," says Vasari, "the one and the other, in their loves." And two quite different leg-
5 ends concerning it agree in this, that it was through this lady he came by his death; Ridolfi relating that, being robbed of her by one of his pupils, he died of grief at the double treason; Vasari, that she being secretly stricken of the plague, and he making his visits to her as usual,
10 Giorgione took the sickness from her mortally, along with her kisses, and so briefly departed.

But, although the number of Giorgione's extant works has been thus limited by recent criticism, all is not done when the real and the traditional elements in
15 what concerns him have been discriminated; for, in what is connected with a great name, much that is not real is often very stimulating. For the æsthetic philosopher, therefore, over and above the real Giorgione and his authentic extant works, there remains the *Gior-*
20 *gionesque* also—an influence, a spirit or type in art, active in men so different as those to whom many of his supposed works are really assignable. A veritable school, in fact, grew together out of all those fascinating works rightly or wrongly attributed to him; out of many
25 copies from, or variations on him, by unknown or uncertain workmen, whose drawings and designs were, for various reasons, prized as his; out of the immediate impression he made upon his contemporaries, and with which he continued in men's minds; out of many tra-
30 ditions of subject and treatment, which really descend from him to our own time, and by retracing which we fill out the original image. Giorgione thus becomes a sort of impersonation of Venice itself, its projected re-

flex or ideal, all that was intense or desirable in it crystal-
lising about the memory of this wonderful young man.

And now, finally, let me illustrate some of the char-
acteristics of this *School of Giorgione*, as we may call it,
which, for most of us, notwithstanding all that negative 5
criticism of the "new Vasari," will still identify itself
with those famous pictures at Florence, at Dresden and
Paris. A certain artistic ideal is there defined for us—the
conception of a peculiar aim and procedure in art, which
we may understand as the *Giorgionesque*, wherever we 10
find it, whether in Venetian work generally, or in work
of our own time. Of this the *Concert*, that undoubted
work of Giorgione in the *Pitti* Palace, is the typical in-
stance, and a pledge authenticating the connexion of the
school, and the spirit of the school, with the master. 15

I have spoken of a certain interpenetration of the mat-
ter or subject of a work of art with the form of it, a
condition realised absolutely only in music, as the con-
dition to which every form of art is perpetually aspiring.
In the art of painting, the attainment of this ideal con- 20
dition, this perfect interpenetration of the subject with
the elements of colour and design, depends, of course,
in great measure, on dexterous choice of that subject, or
phase of subject; and such choice is one of the secrets of
Giorgione's school. It is the school of *genre*, and em- 25
ploys itself mainly with "painted idylls," but, in the
production of this pictorial poetry, exercises a wonder-
ful tact in the selecting of such matter as lends itself most
readily and entirely to pictorial form, to complete ex-
pression by drawing and colour. For although its pro- 30
ductions are painted poems, they belong to a sort of
poetry which tells itself without an articulated story.

The master is pre-eminent for the resolution, the ease and quickness, with which he reproduces instantaneous motion—the lacing-on of armour, with the head bent back so stately—the fainting lady—the embrace, rapid
5 as the kiss, caught with death itself from dying lips—some momentary conjunction of mirrors and polished armour and still water, by which all the sides of a solid image are exhibited at once, solving that casuistical question whether painting can present an object as com-
10 pletely as sculpture. The sudden act, the rapid transition of thought, the passing expression—these he arrests with that vivacity which Vasari has attributed to him, *il fuoco Giorgionesco*, as he terms it. Now it is part of the ideality of the highest sort of dramatic poetry, that it
15 presents us with a kind of profoundly significant and animated instants, a mere gesture, a look, a smile, per-haps—some brief and wholly concrete moment—into which, however, all the motives, all the interests and effects of a long history, have condensed themselves,
20 and which seem to absorb past and future in an intense consciousness of the present. Such ideal instants the school of Giorgione selects, with its admirable tact, from that feverish, tumultuously coloured world of the old citizens of Venice—exquisite pauses in time, in
25 which, arrested thus, we seem to be spectators of all the fulness of existence, and which are like some con-summate extract or quintessence of life.

It is to the law or condition of music, as I said, that all art like this is really aspiring; and, in the school of Gior-
30 gione, the perfect moments of music itself, the making or hearing of music, song or its accompaniment, are themselves prominent as subjects. On that background of the silence of Venice, so impressive to the modern

visitor, the world of Italian music was then forming. In choice of subject, as in all besides, the *Concert* of the *Pitti* Palace is typical of everything that Giorgione, himself an admirable musician, touched with his influence. In sketch or finished picture, in various collections, we may follow it through many intricate variations—men fainting at music; music at the pool-side while people fish, or mingled with the sound of the pitcher in the well, or heard across running water, or among the flocks; the tuning of instruments; people with intent faces, as if listening, like those described by Plato in an ingenious passage of the Republic, to detect the smallest interval of musical sound, the smallest undulation in the air, or feeling for music in thought on a stringless instrument, ear and finger refining themselves infinitely, in the appetite for sweet sound; a momentary touch of an instrument in the twilight, as one passes through some unfamiliar room, in a chance company.

In these then, the favourite incidents of Giorgione's school, music or the musical intervals in our existence, life itself is conceived as a sort of listening—listening to music, to the reading of Bandello's novels, to the sound of water, to time as it flies. Often such moments are really our moments of play, and we are surprised at the unexpected blessedness of what may seem our least important part of time; not merely because play is in many instances that to which people really apply their own best powers, but also because at such times, the stress of our servile, everyday attentiveness being relaxed, the happier powers in things without are permitted free passage, and have their way with us. And so, from music, the school of Giorgione passes often to the play which is like music; to those masques in which men

avowedly do but play at real life, like children "dressing-up," disguised in the strange old Italian dresses, parti-coloured, or fantastic with embroidery and furs, of which the master was so curious a designer, and which,
5 above all the spotless white linen at wrist and throat, he painted so dexterously.

But when people are happy in this thirsty land water will not be far off; and in the school of Giorgione, the presence of water—the well, or marble-rimmed pool,
10 the drawing or pouring of water, as the woman pours it from a pitcher with her jewelled hand in the *Fête Champêtre*, listening, perhaps, to the cool sound as it falls, blent with the music of the pipes—is as characteristic, and almost as suggestive, as that of music itself. And
15 the landscape feels, and is glad of it also—a landscape full of clearness, of the effects of water, of fresh rain newly passed through the air, and collected into the grassy channels. The air, moreover, in the school of Giorgione, seems as vivid as the people who breathe it,
20 and literally empyrean, all impurities being burnt out of it, and no taint, no floating particle of anything but its own proper elements allowed to subsist within it.

Its scenery is such as in England we call "park sce-nery," with some elusive refinement felt about the
25 rustic buildings, the choice grass, the grouped trees, the undulations deftly economised for graceful effect. Only, in Italy all natural things are as it were woven through and through with gold thread, even the cypress revealing it among the folds of its blackness. And it is
30 with gold dust, or gold thread, that these Venetian painters seem to work, spinning its fine filaments, through the solemn human flesh, away into the white

plastered walls of the thatched huts. The harsher details
of the mountains recede to a harmonious distance, the
one peak of rich blue above the horizon remaining but
as the sensible warrant of that due coolness which is all
we need ask here of the Alps, with their dark rains and 5
streams. Yet what real, airy space, as the eye passes from
level to level, through the long-drawn valley in which
Jacob embraces Rachel among the flocks! Nowhere is
there a truer instance of that balance, that modulated
unison of landscape and persons—of the human image 10
and its accessories—already noticed as characteristic of
the Venetian school, so that, in it, neither personage
nor scenery is ever a mere pretext for the other.

Something like this seems to me to be the *vraie vérité*
about Giorgione, if I may adopt a serviceable expres- 15
sion, by which the French recognise those more liberal
and durable impressions which, in respect of any really
considerable person or subject, anything that has at all
intricately occupied men's attention, lie beyond, and
must supplement, the narrower range of the strictly 20
ascertained facts about it. In this, Giorgione is but an
illustration of a valuable general caution we may abide
by in all criticism. As regards Giorgione himself, we
have indeed to take note of all those negations and ex-
ceptions, by which, at first sight, a "new Vasari" seems 25
merely to have confused our apprehension of a delight-
ful object, to have explained away in our inheritance
from past time what seemed of high value there. Yet it
is not with a full understanding even of those exceptions
that one can leave off just at this point. Properly quali- 30
fied, such exceptions are but a salt of genuineness in

our knowledge; and beyond all those strictly ascertained facts, we must take note of that indirect influence by which one like Giorgione, for instance, enlarges his permanent efficacy and really makes himself felt in our cul-
5 ture. In a just impression of that, is the essential truth, the *vraie vérité*, concerning him.

 1877.

Joachim du Bellay

IN THE MIDDLE of the sixteenth century, when the spirit of the Renaissance was everywhere, and people had begun to look back with distaste on the works of the middle age, the old Gothic manner had still one chance more, in borrowing something from the rival which was about to supplant it. In this way there was produced, chiefly in France, a new and peculiar phase of taste with qualities and a charm of its own, blending the somewhat attenuated grace of Italian ornament with the general outlines of northern design. It created the *Château de Gaillon*, as you may still see it in the delicate engravings of Isräel Silvestre—a Gothic donjon veiled faintly by a surface of dainty Italian traceries—Chenonceaux, Blois, Chambord, and the church of Brou. In painting, there came from Italy workmen like *Maître Roux* and the masters of the school of Fontainebleau, to have their later Italian voluptuousness attempered by the naïve and silvery qualities of the native style; and it was characteristic of these painters that they were most successful in painting on glass, an art so essentially medieval. Taking it up where the middle age had left it, they found their whole work among the last subtleties of colour and line; and keeping within the true limits of their material, they got quite a new order of effects from it, and felt their way to refinements on colour never dreamed of by those older workmen, the glass-painters of Chartres or Le Mans. What is called the *Renaissance in*

France is thus not so much the introduction of a wholly new taste ready-made from Italy, but rather the finest and subtlest phase of the middle age itself, its last fleeting splendour and temperate Saint Martin's sum-
5 mer. In poetry, the Gothic spirit in France had produced a thousand songs; so in the Renaissance, French poetry too did but borrow something to blend with a native growth, and the poems of Ronsard, with their ingenu-ity, their delicately figured surfaces, their slightness,
10 their fanciful combinations of rhyme, are the correlative of the traceries of the house of Jacques Cœur at Bourges, or the *Maison de Justice* at Rouen.

There was indeed something in the native French taste naturally akin to that Italian *finesse*. The character-
15 istic of French work had always been a certain nicety, a remarkable daintiness of hand, *une netteté remarquable d'exécution*. In the paintings of François Clouet, for ex-ample, or rather of the Clouets—for there was a whole family of them—painters remarkable for their resistance
20 to Italian influences, there is a silveriness of colour and a clearness of expression which distinguish them very definitely from their Flemish neighbours, Hemling or the Van Eycks. And this nicety is not less characteristic of old French poetry. A light, aerial delicacy, a simple
25 elegance—*une netteté remarquable d'exécution*: these are essential characteristics alike of Villon's poetry, and of the *Hours of Anne of Brittany*. They are characteristic too of a hundred French Gothic carvings and traceries. Alike in the old Gothic cathedrals, and in their counterpart,
30 the old Gothic *chansons de geste*, the rough and ponder-ous mass becomes, as if by passing for a moment into happier conditions, or through a more gracious stratum of air, graceful and refined, like the carved ferneries on

the granite church at Folgoat, or the lines which de-
scribe the fair priestly hands of Archbishop Turpin, in
the song of Roland; although below both alike there is
a fund of mere Gothic strength, or heaviness[1].

Now Villon's songs and Clouet's painting are like
these. It is the higher touch making itself felt here and
there, betraying itself, like nobler blood in a lower
stock, by a fine line or gesture or expression, the turn of
a wrist, the tapering of a finger. In Ronsard's time that
rougher element seemed likely to predominate. No one
can turn over the pages of Rabelais without feeling how
much need there was of softening, of castigation. To
effect this softening is the object of the revolution in
poetry which is connected with Ronsard's name. Cast-
ing about for the means of thus refining upon and sav-
ing the character of French literature, he accepted that
influx of Renaissance taste, which, leaving the build-
ings, the language, the art, the poetry of France, at bot-
tom, what they were, old French Gothic still, gilds their
surfaces with a strange, delightful, foreign aspect pass-
ing over all that northern land, in itself neither deeper
nor more permanent than a chance effect of light. He
reinforces, he doubles the French daintiness by Italian
finesse. Thereupon, nearly all the force and all the seri-
ousness of French work disappear; only the elegance,
the aerial touch, the perfect manner remain. But this
elegance, this manner, this daintiness of execution are
consummate, and have an unmistakable æsthetic value.

So the old French *chanson*, which, like the old north-
ern Gothic ornament, though it sometimes refined itself

[1] The purely artistic aspects of this subject have been interpreted, in a
work of great taste and learning, by Mrs. Mark Pattison.—*The Renaissance
of Art in France*.

into a sort of weird elegance, was often, in its essence, something rude and formless, became in the hands of Ronsard a Pindaric ode. He gave it structure, a sustained system, *strophe* and *antistrophe*, and taught it a change-
5 fulness and variety of metre which keep the curiosity always excited, so that the very aspect of it, as it lies written on the page, carries the eye lightly onwards, and of which this is a good instance:—

> *Avril, la grace, et le ris*
10 > *De Cypris,*
> *Le flair et la douce haleine;*
> *Avril, le parfum des dieux,*
> *Qui, des cieux,*
> *Sentent l'odeur de la plaine;*

15 > *C'est toy, courtois et gentil,*
> *Qui, d'exil*
> *Retire ces passageres,*
> *Ces arondelles qui vont,*
> *Et qui sont*
20 > *Du printemps les messageres.*

That is not by Ronsard, but by Remy Belleau, for Ronsard soon came to have a school. Six other poets threw in their lot with him in his literary revolution,—this Remy Belleau, Antoine de Baïf, Pontus de Tyard,
25 Étienne Jodelle, Jean Daurat, and lastly Joachim du Bellay; and with that strange love of emblems which is characteristic of the time, which covered all the works of Francis the First with the salamander, and all the works of Henry the Second with the double crescent,
30 and all the works of Anne of Brittany with the knotted cord, they called themselves the *Pleiad*; seven in all, al-

though, as happens with the celestial Pleiad, if you scrutinise this constellation of poets more carefully you may find there a great number of minor stars.

The first note of this literary revolution was struck by Joachim du Bellay in a little tract written at the early age of twenty-four, which coming to us through three centuries seems of yesterday, so full is it of those delicate critical distinctions which are sometimes supposed peculiar to modern writers. The piece has for its title *La Deffense et Illustration de la langue Françoyse*; and its problem is how to illustrate or ennoble the French language, to give it lustre. We are accustomed to speak of the varied critical and creative movement of the fifteenth and sixteenth centuries as the *Renaissance*, and because we have a single name for it we may sometimes fancy that there was more unity in the thing itself than there really was. Even the Reformation, that other great movement of the fifteenth and sixteenth centuries, had far less unity, far less of combined action, than is at first sight supposed; and the Renaissance was infinitely less united, less conscious of combined action, than the Reformation. But if anywhere the Renaissance became conscious, as a German philosopher might say, if ever it was understood as a systematic movement by those who took part in it, it is in this little book of Joachim du Bellay's, which it is impossible to read without feeling the excitement, the animation, of change, of discovery. "It is a remarkable fact," says M. Sainte-Beuve, "and an inversion of what is true of other languages, that, in French, prose has always had the precedence over poetry." Du Bellay's prose is perfectly transparent, flexible, and chaste. In many ways it is a more characteristic example of the culture of the *Pleiad* than any of its verse;

and those who love the whole movement of which the
Pleiad is a part, for a weird foreign grace in it, and may
be looking about for a true specimen of it, cannot have
a better than Joachim du Bellay and this little treatise of
his.

Du Bellay's object is to adjust the existing French
culture to the rediscovered classical culture; and in dis-
cussing this problem, and developing the theories of the
Pleiad, he has lighted upon many principles of perma-
nent truth and applicability. There were some who de-
spaired of the French language altogether, who thought
it naturally incapable of the fulness and elegance of
Greek and Latin—*cette élégance et copie qui est en la langue
Greque et Romaine*—that science could be adequately
discussed, and poetry nobly written, only in the dead
languages. "Those who speak thus," says du Bellay,
"make me think of the relics which one may only see
through a little pane of glass, and must not touch with
one's hands. That is what these people do with all
branches of culture, which they keep shut up in Greek
and Latin books, not permitting one to see them
otherwise, or transport them out of dead words into
those which are alive, and wing their way daily through
the mouths of men." "Languages," he says again, "are
not born like plants and trees, some naturally feeble and
sickly, others healthy and strong and apter to bear the
weight of men's conceptions, but all their virtue is
generated in the world of choice and men's freewill
concerning them. Therefore, I cannot blame too strong-
ly the rashness of some of our countrymen, who being
anything rather than Greeks or Latins, depreciate and
reject with more than stoical disdain everything written
in French; nor can I express my surprise at the odd

opinion of some learned men who think that our vulgar tongue is wholly incapable of erudition and good literature."

It was an age of translations. Du Bellay himself translated two books of the *Æneid*, and other poetry, old and new, and there were some who thought that the translation of the classical literature was the true means of *ennobling* the French language:—strangers are ever favourites with us—*nous favorisons toujours les étrangers.* Du Bellay moderates their expectations. "I do not believe that one can learn the right use of them"—he is speaking of figures and ornament in language—"from translations, because it is impossible to reproduce them with the same grace with which the original author used them. For each language has I know not what peculiarity of its own; and if you force yourself to express the naturalness (*le naïf*) of this in another language, observing the law of translation,—not to expatiate beyond the limits of the author himself, your words will be constrained, cold and ungraceful." Then he fixes the test of all good translation:—"To prove this, read me Demosthenes and Homer in Latin, Cicero and Virgil in French, and see whether they produce in you the same affections which you experience in reading those authors in the original."

In this effort to ennoble the French language, to give it grace, number, perfection, and as painters do to their pictures, that last, so desirable, touch—*cette dernière main que nous désirons*—what du Bellay is really pleading for is his mother-tongue, the language, that is, in which one will have the utmost degree of what is moving and passionate. He recognised of what force the music and dignity of languages are, how they enter into the inmost

part of things; and in pleading for the cultivation of the French language, he is pleading for no merely scholastic interest, but for freedom, impulse, reality, not in literature only, but in daily communion of speech. After all, it was impossible to have this impulse in Greek and Latin, dead languages shut up in books as in reliquaries —*péris et mises en reliquaires de livres*. By aid of this starveling stock—*pauvre plante et vergette*—of the French language, he must speak delicately, movingly, if he is ever to speak so at all: that, or none, must be for him the medium of what he calls, in one of his great phrases, *le discours fatal des choses mondaines*—that discourse about affairs which decides men's fates. And it is his patriotism not to despair of it; he sees it already perfect in all elegance and beauty of words—*parfait en toute élégance et vénusté de paroles.*

Du Bellay was born in the disastrous year 1525, the year of the battle of Pavia, and the captivity of Francis the First. His parents died early, and to him, as the younger son, his mother's little estate, *ce petit Liré*, the beloved place of his birth, descended. He was brought up by a brother only a little older than himself; and left to themselves, the two boys passed their lives in daydreams of military glory. Their education was neglected; "The time of my youth," says du Bellay, "was lost, like the flower which no shower waters, and no hand cultivates." He was just twenty years old when the elder brother died, leaving Joachim to be the guardian of his child. It was with regret, with a shrinking sense of incapacity, that he took upon him the burden of this responsibility. Hitherto he had looked forward to the profession of a soldier, hereditary in his family. But at this time a sickness attacked him which brought him cruel

sufferings, and seemed likely to be mortal. It was then
for the first time that he read the Greek and Latin poets.
These studies came too late to make him what he so
much desired to be, a trifler in Greek and Latin verse,
like so many others of his time now forgotten; instead, 5
they made him a lover of his own homely native tongue,
that poor starveling stock of the French language. It was
through this fortunate shortcoming in his education that
he became national and modern; and he learned after-
wards to look back on that wild garden of his youth 10
with only a half-regret. A certain Cardinal du Bellay
was the successful member of the family, a man often
employed in high official business. To him the thoughts
of Joachim turned when it became necessary to choose
a profession, and in 1552 he accompanied the Cardinal 15
to Rome. He remained there nearly five years, burdened
with the weight of affairs, and languishing with home-
sickness. Yet it was under these circumstances that his
genius yielded its best fruits. From Rome, so full of
pleasurable sensation for men of an imaginative temper- 20
ament such as his, with all the curiosities of the Renais-
sance still fresh in it, his thoughts went back painfully,
longingly, to the country of the Loire, with its wide
expanse of waving corn, its homely pointed roofs of
grey slate, and its far-off scent of the sea. He reached 25
home at last, but only to die there, quite suddenly, one
wintry day, at the early age of thirty-five.

Much of du Bellay's poetry illustrates rather the age
and school to which he belonged than his own temper
and genius. As with the writings of Ronsard and the 30
other poets of the *Pleiad*, its interest depends not so
much on the impress of individual genius upon it, as on
the circumstance that it was once poetry *à la mode*, that

it is part of the manner of a time—a time which made much of manner, and carried it to a high degree of perfection. It is one of the decorations of an age which threw a large part of its energy into the work of decoration. We feel a pensive pleasure in gazing on these faded adornments, and observing how a group of actual men and women pleased themselves long ago. Ronsard's poems are a kind of epitome of his age. Of one side of that age, it is true, of the strenuous, the progressive, the serious movement, which was then going on, there is little; but of the catholic side, the losing side, the forlorn hope, hardly a figure is absent. The Queen of Scots, at whose desire Ronsard published his Odes, reading him in her northern prison, felt that he was bringing back to her the true flavour of her early days in the court of Catherine at the Louvre, with its exotic Italian gaieties. Those who disliked that poetry, disliked it because they found that age itself distasteful. The poetry of Malherbe came, with its sustained style and weighty sentiment, but with nothing that set people singing; and the lovers of such poetry saw in the poetry of the *Pleiad* only the latest trumpery of the middle age. But the time arrived when the school of Malherbe also had had its day; and the *Romanticists*, who in their eagerness for excitement, for strange music and imagery, went back to the works of the middle age, accepted the *Pleiad* too with the rest; and in that new middle age which their genius has evoked, the poetry of the *Pleiad* has found its place. At first, with Malherbe, you may think it, like the architecture, the whole mode of life, the very dresses of that time, fantastic, faded, *rococo*. But if you look long enough to understand it, to conceive its sentiment, you will find that those wanton lines have a spirit guiding

their caprices. For there is *style* there; one temper has shaped the whole; and everything that has style, that has been done as no other man or age could have done it, as it could never, for all our trying, be done again, has its true value and interest. Let us dwell upon it for a moment, and try to gather from it that special flower, *ce fleur particulier*, which Ronsard himself tells us every garden has.

It is poetry not for the people, but for a confined circle, for courtiers, great lords and erudite persons, people who desire to be humoured, to gratify a certain refined voluptuousness they have in them. Ronsard loves, or dreams that he loves, a rare and peculiar type of beauty, *la petite pucelle Angevine*, with golden hair and dark eyes. But he has the ambition not only of being a courtier and a lover, but a great scholar also; he is anxious about orthography, about the letter *è Grecque*, the true spelling of Latin names in French writing, and the restoration of the letter *i* to its primitive liberty—*del' i voyelle en sa première liberté*. His poetry is full of quaint, remote learning. He is just a little pedantic, true always to his own express judgment, that to be natural is not enough for one who in poetry desires to produce work worthy of immortality. And therewithal a certain number of Greek words, which charmed Ronsard and his circle by their gaiety and daintiness, and a certain air of foreign elegance about them, crept into the French language; as there were other strange words which the poets of the *Pleiad* forged for themselves, and which had only an ephemeral existence.

With this was united the desire to taste a more exquisite and various music than that of the older French verse, or of the classical poets. The music of the mea-

sured, scanned verse of Latin and Greek poetry is one thing; the music of the rhymed, unscanned verse of Villon and the old French poets, *la poésie chantée*, is another. To combine these two kinds of music in a new school of French poetry, to make verse which should scan and rhyme as well, to search out and harmonise the measure of every syllable, and unite it to the swift, flitting, swallow-like motion of rhyme, to penetrate their poetry with a double music—this was the ambition of the *Pleiad*. They are insatiable of music, they cannot have enough of it; they desire a music of greater compass perhaps than words can possibly yield, to drain out the last drops of sweetness which a certain note or accent contains.

It was Goudimel, the serious and protestant Goudimel, who set Ronsard's songs to music; but except in this eagerness for music the poets of the *Pleiad* seem never quite in earnest. The old Greek and Roman mythology, which the great Italians had found a motive so weighty and severe, becomes with them a mere toy. That "Lord of terrible aspect," *Amor*, has become Love the boy, or the babe. They are full of fine railleries; they delight in diminutives, *ondelette*, *fontelette*, *doucelette*, *Cassandrette*. Their loves are only half real, a vain effort to prolong the imaginative loves of the middle age beyond their natural lifetime. They write love-poems for hire. Like that party of people who tell the tales in Boccaccio's *Decameron*, they form a circle which in an age of great troubles, losses, anxieties, can amuse itself with art, poetry, intrigue. But they amuse themselves with wonderful elegance. And sometimes their gaiety becomes satiric, for, as they play, real passions insinuate themselves, and at least the reality of death. Their de-

jection at the thought of leaving this fair abode of our common daylight—*le beau sejour du commun jour*—is expressed by them with almost wearisome reiteration. But with this sentiment too they are able to trifle. The imagery of death serves for delicate ornament, and they weave into the airy nothingness of their verses their trite reflexions on the vanity of life. Just so the grotesque details of the charnel-house nest themselves, together with birds and flowers and the fancies of the pagan mythology, in the traceries of the architecture of that time, which wantons in its graceful arabesques with the images of old age and death.

Ronsard became deaf at sixteen; and it was this circumstance which finally determined him to be a man of letters instead of a diplomatist, significantly, one might fancy, of a certain premature agedness, and of the tranquil, temperate sweetness appropriate to that, in the school of poetry which he founded. Its charm is that of a thing not vigorous or original, but full of the grace which comes of long study and reiterated refinements, and many steps repeated, and many angles worn down, with an exquisite faintness, *une fadeur exquise*, a certain tenuity and caducity, as for those who can bear nothing vehement or strong; for princes weary of love, like Francis the First, or of pleasure, like Henry the Third, or of action, like Henry the Fourth. Its merits are those of the old,—grace and finish, perfect in minute detail. For these people are a little jaded, and have a constant desire for a subdued and delicate excitement, to warm their creeping fancy a little. They love a constant change of rhyme in poetry, and in their houses that strange, fantastic interweaving of thin, reed-like lines, which are a kind of rhetoric in architecture.

But the poetry of the *Pleiad* is true not only to the physiognomy of its age, but also to its country, *ce pays du Vendomois*, the names and scenery of which so often recur in it:—the great Loire, with its long spaces of white sand; the little river Loir; the heathy, upland country, with its scattered pools of water and waste roadsides, and retired manors, with their crazy old feudal defences half fallen into decay; *La Beauce*, where the vast rolling fields seem to anticipate the great western sea itself. It is full of the traits of that country. We see du Bellay and Ronsard gardening, or hunting with their dogs, or watch the pastimes of a rainy day; and with all this is connected a domesticity, a homeliness and simple goodness, by which the northern country gains upon the south. They have the love of the aged for warmth, and understand the poetry of winter; for they are not far from the Atlantic, and the west wind which comes up from it, turning the poplars white, spares not this new Italy in France. So the fireside often appears, with the pleasures of the frosty season, about the vast emblazoned chimneys of the time, and with a *bonhomie* as of little children, or old people.

It is in du Bellay's *Olive*, a collection of sonnets in praise of a half-imaginary lady, *Sonnetz a la louange d'Olive*, that these characteristics are most abundant. Here is a perfectly crystallised example:—

> *D'amour, de grace, et de haulte valeur*
> *Les feux divins estoient ceinctz et les cieulx*
> *S'estoient vestuz d'un manteau precieux*
> *A raiz ardens de diverse couleur:*
> *Tout estoit plein de beauté, de bonheur,*
> *La mer tranquille, et le vent gracieulx,*

Quand celle la nasquit en ces bas lieux
Qui a pillé du monde tout l'honneur.
Ell' prist son teint des beaux lyz blanchissans,
Son chef de l'or, ses deux levres des rozes,
Et du soleil ses yeux resplandissans: 5
Le ciel usant de liberalité,
Mist en l'esprit ses semences encloses,
Son nom des Dieux prist l'immortalité.

That he is thus a characteristic specimen of the poetical taste of that age, is indeed du Bellay's chief interest. 10 But if his work is to have the highest sort of interest, if it is to do something more than satisfy curiosity, if it is to have an æsthetic as distinct from an historical value, it is not enough for a poet to have been the true child of his age, to have conformed to its æsthetic conditions, 15 and by so conforming to have charmed and stimulated that age; it is necessary that there should be perceptible in his work something individual, inventive, unique, the impress there of the writer's own temper and personality. This impress M. Sainte-Beuve thought he 20 found in the *Antiquités de Rome*, and the *Regrets*, which he ranks as what has been called *poésie intime*, that intensely modern sort of poetry in which the writer has for his aim the portraiture of his own most intimate moods, and to take the reader into his confidence. That 25 age had other instances of this intimacy of sentiment: Montaigne's *Essays* are full of it, the carvings of the church of Brou are full of it. M. Sainte-Beuve has perhaps exaggerated the influence of this quality in du Bellay's *Regrets*; but the very name of the book has a touch 30 of Rousseau about it, and reminds one of a whole generation of self-pitying poets in modern times. It was in

the atmosphere of Rome, to him so strange and mournful, that these pale flowers grew up. For that journey to Italy, which he deplored as the greatest misfortune of his life, put him in full possession of his talent, and brought out all its originality. And in effect you do find intimacy, *intimité*, here. The trouble of his life is analysed, and the sentiment of it conveyed directly to our minds; not a great sorrow or passion, but only the sense of loss in passing days, the *ennui* of a dreamer who must plunge into the world's affairs, the opposition between actual life and the ideal, a longing for rest, nostalgia, home-sickness—that pre-eminently childish, but so suggestive sorrow, as significant of the final regret of all human creatures for the familiar earth and limited sky.

The feeling for landscape is often described as a modern one; still more so is that for antiquity, the sentiment of ruins. Du Bellay has this sentiment. The duration of the hard, sharp outlines of things is a grief to him, and passing his wearisome days among the ruins of ancient Rome, he is consoled by the thought that all must one day end, by the sentiment of the grandeur of nothingness—*la grandeur du rien*. With a strange touch of far-off mysticism, he thinks that the great whole—*le grand tout*—into which all other things pass and lose themselves, ought itself sometimes to perish and pass away. Nothing less can relieve his weariness. From the stately aspects of Rome his thoughts went back continually to France, to the smoking chimneys of his little village, the longer twilight of the north, the soft climate of Anjou—*la douceur Angevine*; yet not so much to the real France, we may be sure, with its dark streets and roofs of rough-hewn slate, as to that other country, with slenderer towers, and more winding rivers, and trees like

flowers, and with softer sunshine on more gracefully-proportioned fields and ways, which the fancy of the exile, and the pilgrim, and of the schoolboy far from home, and of those kept at home unwillingly, everywhere builds up before or behind them.

He came home at last, through the *Grisons*, by slow journeys; and there, in the cooler air of his own country, under its skies of milkier blue, the sweetest flower of his genius sprang up. There have been poets whose whole fame has rested on one poem, as Gray's on the *Elegy in a Country Churchyard*, or Ronsard's, as many critics have thought, on the eighteen lines of one famous ode. Du Bellay has almost been the poet of one poem; and this one poem of his is an Italian product transplanted into that green country of Anjou; out of the Latin verses of Andrea Navagero, into French. But it is a composition in which the matter is almost nothing, and the form almost everything; and the form of the poem as it stands, written in old French, is all du Bellay's own. It is a song which the winnowers are supposed to sing as they winnow the corn, and they invoke the winds to lie lightly on the grain.

D'UN VANNEUR DE BLE AUX VENTS[1].

> *A vous trouppe legère*
> *Qui d'aile passagère*
> *Par le monde volez,*
> *Et d'un sifflant murmure*
> *L'ombrageuse verdure*
> *Doulcement esbranlez.*

[1] A graceful translation of this and some other poems of the *Pleiad* may be found in *Ballads and Lyrics of Old France*, by Mr. Andrew Lang.

J'offre ces violettes,
Ces lis & ces fleurettes,
Et ces roses icy,
Ces vermeillettes roses
5 *Sont freschement écloses,*
Et ces œillets aussi.

De vostre doulce haleine
Eventez ceste plaine
Eventez ce sejour;
10 *Ce pendant que j'ahanne*
A mon blé que je vanne
A la chaleur du jour.

·That has, in the highest degree, the qualities, the val-
ue, of the whole *Pleiad* school of poetry, of the whole
15 phase of taste from which that school derives—a cer-
tain silvery grace of fancy, nearly all the pleasure of
which is in the surprise at the happy and dexterous way
in which a thing slight in itself is handled. The sweet-
ness of it is by no means to be got at by crushing, as
20 you crush wild herbs to get at their perfume. One seems
to hear the measured motion of the fans, with a child's
pleasure on coming across the incident for the first time,
in one of those great barns of du Bellay's own country,
La Beauce, the granary of France. A sudden light trans-
25 figures some trivial thing, a weather-vane, a windmill,
a winnowing-fan, the dust in the barn door. A moment
—and the thing has vanished, because it was pure effect;
but it leaves a relish behind it, a longing that the acci-
dent may happen again.
30 1872.

Winckelmann

Et ego in Arcadia fui

GOETHE'S FRAGMENTS of art-criticism contain a few pages of strange pregnancy on the character of Winckelmann. He speaks of the teacher who had made his career possible, but whom he had never seen, as of an abstract type of culture, consummate, tranquil, withdrawn already into the region of ideals, yet retaining colour from the incidents of a passionate intellectual life. He classes him with certain works of art, possessing an inexhaustible gift of suggestion, to which criticism may return again and again with renewed freshness. Hegel, in his lectures on the *Philosophy of Art*, estimating the work of his predecessors, has also passed a remarkable judgment on Winckelmann's writings:—"Winckelmann, by contemplation of the ideal works of the ancients, received a sort of inspiration, through which he opened a new sense for the study of art. He is to be regarded as one of those who, in the sphere of art, have known how to initiate a new organ for the human spirit." That it has given a new sense, that it has laid open a new organ, is the highest that can be said of any critical effort. It is interesting then to ask what kind of man it was who thus laid open a new organ. Under what conditions was that effected?

Johann Joachim Winckelmann was born at Stendal, in Brandenburg, in the year 1717. The child of a poor tradesman, he passed through many struggles in early youth, the memory of which ever remained in him as a

fitful cause of dejection. In 1763, in the full emancipa-
tion of his spirit, looking over the beautiful Roman
prospect, he writes—"One gets spoiled here; but God
owed me this; in my youth I suffered too much." Des-
tined to assert and interpret the charm of the Hellenic
spirit, he served first a painful apprenticeship in the tar-
nished intellectual world of Germany in the earlier half
of the eighteenth century. Passing out of that into the
happy light of the antique, he had a sense of exhilaration
almost physical. We find him as a child in the dusky
precincts of a German school, hungrily feeding on a few
colourless books. The master of this school grows
blind; Winckelmann becomes his *famulus*. The old man
would have had him study theology. Winckelmann,
free of the master's library, chooses rather to become
familiar with the Greek classics. Herodotus and Homer
win, with their "vowelled" Greek, his warmest enthu-
siasm; whole nights of fever are devoted to them; dis-
turbing dreams of an Odyssey of his own come to him.
"He felt in himself," says Madame de Staël, "an ardent
attraction towards the south. In German imaginations
even now traces are often to be found of that love of the
sun, that weariness of the north (*cette fatigue du nord*)
which carried the northern peoples away into the coun-
tries of the south. A fine sky brings to birth sentiments
not unlike the love of one's Fatherland."

To most of us, after all our steps towards it, the an-
tique world, in spite of its intense outlines, its own per-
fect self-expression, still remains faint and remote. To
him, closely limited except on the side of the ideal,
building for his dark poverty "a house not made with
hands," it early came to seem more real than the pres-
ent. In the fantastic plans of foreign travel continually

passing through his mind, to Egypt, for instance, and to France, there seems always to be rather a wistful sense of something lost to be regained, than the desire of discovering anything new. Goethe has told us how, in his eagerness actually to handle the antique, he became interested in the insignificant vestiges of it which the neighbourhood of Strasburg afforded. So we hear of Winckelmann's boyish antiquarian wanderings among the ugly Brandenburg sandhills. Such a conformity between himself and Winckelmann, Goethe would have gladly noted.

At twenty-one he enters the University of Halle, to study theology, as his friends desire; instead, he becomes the enthusiastic translator of Herodotus. The condition of Greek learning in German schools and universities had fallen, and there were no professors at Halle who could satisfy his sharp, intellectual craving. Of his professional education he always speaks with scorn, claiming to have been his own teacher from first to last. His appointed teachers did not perceive that a new source of culture was within their hands. *Homo vagus et inconstans!*—one of them pedantically reports of the future pilgrim to Rome, unaware on which side his irony was whetted. When professional education confers nothing but irritation on a Schiller, no one ought to be surprised; for Schiller, and such as he, are primarily spiritual adventurers. But that Winckelmann, the votary of the gravest of intellectual traditions, should get nothing but an attempt at suppression from the professional guardians of learning, is what may well surprise us.

In 1743 he became master of a school at Seehausen. This was the most wearisome period of his life. Notwithstanding a success in dealing with children, which

seems to testify to something simple and primeval in his nature, he found the work of teaching very depressing. Engaged in this work, he writes that he still has within him a longing desire to attain to the knowledge of beau-
5 ty—*sehnlich wünschte zur Kenntniss des Schönen zu gelang-en*. He had to shorten his nights, sleeping only four hours, to gain time for reading. And here Winckelmann made a step forward in culture. He multiplied his intellectual force by detaching from it all flaccid interests. He
10 renounced mathematics and law, in which his reading had been considerable, all but the literature of the arts. Nothing was to enter into his life unpenetrated by its central enthusiasm. At this time he undergoes the charm of Voltaire. Voltaire belongs to that flimsier,
15 more artificial, classical tradition, which Winckelmann was one day to supplant, by the clear ring, the eternal outline, of the genuine antique. But it proves the authority of such a gift as Voltaire's that it allures and wins even those born to supplant it. Voltaire's impression on
20 Winckelmann was never effaced; and it gave him a consideration for French literature which contrasts with his contempt for the literary products of Germany. German literature transformed, siderealised, as we see it in Goethe, reckons Winckelmann among its initiators. But
25 Germany at that time presented nothing in which he could have anticipated *Iphigenie*, and the formation of an effective classical tradition in German literature.

Under this purely literary influence, Winckelmann protests against Christian Wolff and the philosophers.
30 Goethe, in speaking of this protest, alludes to his own obligations to Emmanuel Kant. Kant's influence over the culture of Goethe, which he tells us could not have been resisted by him without loss, consisted in a severe

limitation to the concrete. But he adds, that in born antiquaries, like Winckelmann, a constant handling of the antique, with its eternal outline, maintains that limitation as effectually as a critical philosophy. Plato, however, saved so often for his redeeming literary manner, is excepted from Winckelmann's proscription of the philosophers. The modern student most often meets Plato on that side which seems to pass beyond Plato into a world no longer pagan, and based upon the conception of a spiritual life. But the element of affinity which he presents to Winckelmann is that which is wholly Greek, and alien from the Christian world, represented by that group of brilliant youths in the *Lysis*, still uninfected by any spiritual sickness, finding the end of all endeavor in the aspects of the human form, the continual stir and motion of a comely human life.

This new-found interest in Plato's dialogues could not fail to increase his desire to visit the countries of the classical tradition. "It is my misfortune," he writes, "that I was not born to great place, wherein I might have had cultivation, and the opportunity of following my instinct and forming myself." A visit to Rome probably was already designed, and he silently preparing for it. Count Bünau, the author of a historical work then of note, had collected at Nöthenitz a valuable library, now part of the library of Dresden. In 1748 Winckelmann wrote to Bünau in halting French:—He is emboldened, he says, by Bünau's indulgence for needy men of letters. He desires only to devote himself to study, having never allowed himself to be dazzled by favourable prospects in the Church. He hints at his doubtful position "in a metaphysical age, by which humane literature is trampled under foot. At present," he

goes on, "little value is set on Greek literature, to which I have devoted myself so far as I could penetrate, when good books are so scarce and expensive." Finally, he desires a place in some corner of Bünau's library. "Per-
5 haps, at some future time, I shall become more useful to the public, if, drawn from obscurity in whatever way, I can find means to maintain myself in the capital."

Soon afterwards we find Winckelmann in the library at Nöthenitz. Thence he made many visits to the col-
10 lection of antiquities at Dresden. He became acquainted with many artists, above all with Oeser, Goethe's future friend and master, who, uniting a high culture with the practical knowledge of art, was fitted to minister to Winckelmann's culture. And now a new channel of
15 communion with the Greek life was opened for him. Hitherto he had handled the words only of Greek poetry, stirred indeed and roused by them, yet divining beyond the words some unexpressed pulsation of sensuous life. Suddenly he is in contact with that life, still
20 fervent in the relics of plastic art. Filled as our culture is with the classical spirit, we can hardly imagine how deeply the human mind was moved, when, at the Renaissance, in the midst of a frozen world, the buried fire of ancient art rose up from under the soil. Winckel-
25 mann here reproduces for us the earlier sentiment of the Renaissance. On a sudden the imagination feels itself free. How facile and direct, it seems to say, is this life of the senses and the understanding, when once we have apprehended it! Here, surely, is that more liberal mode
30 of life we have been seeking so long, so near to us all the while. How mistaken and round-about have been our efforts to reach it by mystic passion, and monastic reverie; how they have deflowered the flesh; how little

have they really emancipated us! Hermione melts from her stony posture, and the lost proportions of life right themselves. Here, then, in vivid realisation, we see the native tendency of Winckelmann to escape from abstract theory to intuition, to the exercise of sight and touch. Lessing, in the *Laocoon*, has theorised finely on the relation of poetry to sculpture; and philosophy may give us theoretical reasons why not poetry but sculpture should be the most sincere and exact expression of the Greek ideal. By a happy, unperplexed dexterity, Winckelmann solves the question in the concrete. It is what Goethe calls his *Gewahrwerden der griechischen Kunst*, his *finding* of Greek art.

Through the tumultuous richness of Goethe's culture, the influence of Winckelmann is always discernible, as the strong, regulative under-current of a clear, antique motive. "One learns nothing from him," he says to Eckermann, "but one becomes something." If we ask what the secret of this influence was, Goethe himself will tell us—wholeness, unity with one's self, intellectual integrity. And yet these expressions, because they fit Goethe, with his universal culture, so well, seem hardly to describe the narrow, exclusive interest of Winckelmann. Doubtless Winckelmann's perfection is a narrow perfection: his feverish nursing of the one motive of his life is a contrast to Goethe's various energy. But what affected Goethe, what instructed him and ministered to his culture, was the integrity, the truth to its type, of the given force. The development of this force was the single interest of Winckelmann, unembarrassed by anything else in him. Other interests, practical or intellectual, those slighter talents and motives not supreme, which in most men are the waste part of na-

ture, and drain away their vitality, he plucked out and cast from him. The protracted longing of his youth is not a vague, romantic longing: he knows what he longs for, what he wills. Within its severe limits his enthusi-
5 asm burns like lava. "You know," says Lavater, speaking of Winckelmann's countenance, "that I consider ardour and indifference by no means incompatible in the same character. If ever there was a striking instance of that union, it is in the countenance before us." "A low-
10 ly childhood," says Goethe, "insufficient instruction in youth, broken, distracted studies in early manhood, the burden of school-keeping! He was thirty years old before he enjoyed a single favour of fortune: but so soon as he had attained to an adequate condition of freedom,
15 he appears before us consummate and entire, complete in the ancient sense."

But his hair is turning grey, and he has not yet reached the south. The Saxon court had become Roman Catholic, and the way to favour at Dresden was through
20 Roman ecclesiastics. Probably the thought of a profession of the papal religion was not new to Winckelmann. At one time he had thought of begging his way to Rome, from cloister to cloister, under the pretence of a disposition to change his faith. In 1751, the papal *nuncio*,
25 Archinto, was one of the visitors at Nöthenitz. He suggested Rome as the fitting stage for Winckelmann's accomplishments, and held out the hope of a place in the pope's library. Cardinal Passionei, charmed with Winckelmann's beautiful Greek writing, was ready to play
30 the part of Mæcenas, if the indispensable change were made. Winckelmann accepted the bribe, and visited the *nuncio* at Dresden. Unquiet still at the word "profes-

sion," not without a struggle, he joined the Roman Church, July the 11th, 1754.

Goethe boldly pleads that Winckelmann was a pagan, that the landmarks of Christendom meant nothing to him. It is clear that he intended to deceive no one by his disguise; fears of the inquisition are sometimes visible during his life in Rome; he entered Rome notoriously with the works of Voltaire in his possession; the thought of what Count Bünau might be thinking of him seems to have been his greatest difficulty. On the other hand, he may have had a sense of a certain antique and as it were pagan grandeur in the Roman Catholic religion. Turning from the crabbed Protestantism, which had been the *ennui* of his youth, he might reflect that while Rome had reconciled itself to the Renaissance, the Protestant principle in art had cut off Germany from the supreme tradition of beauty. And yet to that transparent nature, with its simplicity as of the earlier world, the loss of absolute sincerity must have been a real loss. Goethe understands that Winckelmann had made this sacrifice. Yet at the bar of the highest criticism, perhaps, Winckelmann may be absolved. The insincerity of his religious profession was only one incident of a culture in which the moral instinct, like the religious or political, was merged in the artistic. But then the artistic interest was that, by desperate faithfulness to which Winckelmann was saved from a mediocrity, which, breaking through no bounds, moves ever in a bloodless routine, and misses its one chance in the life of the spirit and the intellect. There have been instances of culture developed by every high motive in turn, and yet intense at every point; and the aim of our

culture should be to attain not only as intense but as complete a life as possible. But often the higher life is only possible at all, on condition of the selection of that in which one's motive is native and strong; and this
5 selection involves the renunciation of a crown reserved for others. Which is better?—to lay open a new sense, to initiate a new organ for the human spirit, or to cultivate many types of perfection up to a point which leaves us still beyond the range of their transforming power?
10 Savonarola is one type of success; Winckelmann is another; criticism can reject neither, because each is true to itself. Winckelmann himself explains the motive of his life when he says, "It will be my highest reward, if posterity acknowledges that I have written worthily."

15 For a time he remained at Dresden. There his first book appeared, *Thoughts on the Imitation of Greek Works of Art in Painting and Sculpture*. Full of obscurities as it was, obscurities which baffled but did not offend Goethe when he first turned to art-criticism, its purpose was
20 direct—an appeal from the artificial classicism of the day to the study of the antique. The book was well received, and a pension supplied through the king's confessor. In September 1755 he started for Rome, in the company of a young Jesuit. He was introduced to
25 Raphael Mengs, a painter then of note, and found a home near him, in the artists' quarter, in a place where he could "overlook, far and wide, the eternal city." At first he was perplexed with the sense of being a stranger on what was to him, spiritually, native soil. "Unhappi-
30 ly," he cries in French, often selected by him as the vehicle of strong feeling, "I am one of those whom the Greeks call ὀψιμαθεῖς.—I have come into the world and into Italy too late." More than thirty years after-

wards, Goethe also, after many aspirations and severe preparation of mind, visited Italy. In early manhood, just as he too was *finding* Greek art, the rumour of that true artist's life of Winckelmann in Italy had strongly moved him. At Rome, spending a whole year drawing from the antique, in preparation for *Iphigenie*, he finds the stimulus of Winckelmann's memory ever active. Winckelmann's Roman life was simple, primeval, Greek. His delicate constitution permitted him the use only of bread and wine. Condemned by many as a renegade, he had no desire for places of honour, but only to see his merits acknowledged, and existence assured to him. He was simple without being niggardly; he desired to be neither poor nor rich.

Winckelmann's first years in Rome present all the elements of an intellectual situation of the highest interest. The beating of the soul against its bars, the sombre aspect, the alien traditions, the still barbarous literature of Germany, are afar off. Before him are adequate conditions of culture, the sacred soil itself, the first tokens of the advent of the new German literature, with its broad horizons, its boundless intellectual promise. Dante, passing from the darkness of the *Inferno*, is filled with a sharp and joyful sense of light, which makes him deal with it, in the opening of the *Purgatorio*, in a wonderfully touching and penetrative way. Hellenism, which is the principle pre-eminently of intellectual light, (our modern culture may have more colour, the medieval spirit greater heat and profundity, but Hellenism is pre-eminent for light,) has always been most effectively conceived by those who have crept into it out of an intellectual world in which the sombre elements predominate. So it had been in the ages of the Renaissance. This

repression, removed at last, gave force and glow to Winckelmann's native affinity to the Hellenic spirit. "There had been known before him," says Madame de Staël, "learned men who might be consulted like books; but no one had, if I may say so, made himself a pagan for the purpose of penetrating antiquity." "One is always a poor executant of conceptions not one's own." —*On exécute mal ce qu'on n'a pas conçu soi-même* [1]—words spoken on so high an occasion—are true in their measure of every genuine enthusiasm. Enthusiasm,—that, in the broad Platonic sense of the *Phaedrus*, was the secret of his divinatory power over the Hellenic world. This enthusiasm, dependent as it is to a great degree on bodily temperament, has a power of reinforcing the purer emotions of the intellect with an almost physical excitement. That his affinity with Hellenism was not merely intellectual, that the subtler threads of temperament were inwoven in it, is proved by his romantic, fervent friendships with young men. He has known, he says, many young men more beautiful than Guido's archangel. These friendships, bringing him into contact with the pride of human form, and staining the thoughts with its bloom, perfected his reconciliation to the spirit of Greek sculpture. A letter on taste, addressed from Rome to a young nobleman, Freidrich von Berg, is the record of such a friendship.

"I shall excuse my delay," he begins,

in fulfilling my promise of an essay on the taste for beauty in works of art, in the words of Pindar. He says to Agesidamus, a youth of Locri—ἰδέᾳ τε καλόν, ὥρᾳ τε κεκραμένον— whom he had kept waiting for an intended ode, that a debt paid with usury is the end of reproach. This may win your

[1] Words of Charlotte Corday before the *Convention*.

good-nature on behalf of my present essay, which has turned out far more detailed and circumstantial than I had at first intended.

It is from yourself that the subject is taken. Our intercourse has been short, too short both for you and me; but the first time I saw you, the affinity of our spirits was revealed to me: your culture proved that my hope was not groundless; and I found in a beautiful body a soul created for nobleness, gifted with the sense of beauty. My parting from you was therefore one of the most painful in my life; and that this feeling continues our common friend is witness, for your separation from me leaves me no hope of seeing you again. Let this essay be a memorial of our friendship, which, on my side, is free from every selfish motive, and ever remains subject and dedicate to yourself alone.

The following passage is characteristic—

As it is confessedly the beauty of man which is to be conceived under one general idea, so I have noticed that those who are observant of beauty only in women, and are moved little or not at all by the beauty of men, seldom have an impartial, vital, inborn instinct for beauty in art. To such persons the beauty of Greek art will ever seem wanting, because its supreme beauty is rather male than female. But the beauty of art demands a higher sensibility than the beauty of nature, because the beauty of art, like tears shed at a play, gives no pain, is without life, and must be awakened and repaired by culture. Now, as the spirit of culture is much more ardent in youth than in manhood, the instinct of which I am speaking must be exercised and directed to what is beautiful, before that age is reached, at which one would be afraid to confess that one had no taste for it.

Certainly, of that beauty of living form which regulated Winckelmann's friendships, it could not be said that it gave no pain. One notable friendship, the fortune of which we may trace through his letters, begins with an antique, chivalrous letter in French, and ends noisily

in a burst of angry fire. Far from reaching the quietism, the bland indifference of art, such attachments are nevertheless more susceptible than any others of equal strength of a purely intellectual culture. Of passion, of physical excitement, they contain only just so much as stimulates the eye to the finest delicacies of colour and form. These friendships, often the caprices of a moment, make Winckelmann's letters, with their troubled colouring, an instructive but bizarre addition to the *History of Art*, that shrine of grave and mellow light around the mute Olympian family. The impression which Winckelmann's literary life conveyed to those about him, was that of excitement, intuition, inspiration, rather than the contemplative evolution of general principles. The quick, susceptible enthusiast, betraying his temperament even in appearance, by his olive complexion, his deep-seated, piercing eyes, his rapid movements, apprehended the subtlest principles of the Hellenic manner, not through the understanding, but by instinct or touch. A German biographer of Winckelmann has compared him to Columbus. That is not the aptest of comparisons; but it reminds one of a passage in which Edgar Quinet describes the great discoverer's famous voyage. His science was often at fault; but he had a way of estimating at once the slightest indication of land, in a floating weed or passing bird; he seemed actually to come nearer to nature than other men. And that world in which others had moved with so much embarrassment, seems to call out in Winckelmann new senses fitted to deal with it. He is in touch with it; it penetrates him, and becomes part of his temperament. He remodels his writings with constant renewal of insight; he catches the thread of a whole sequence of laws

in some hollowing of the hand, or dividing of the hair; he seems to realise that fancy of the reminiscence of a forgotten knowledge hidden for a time in the mind itself; as if the mind of one, lover and philosopher at once in some phase of pre-existence—φιλοσοφήσας ποτὲ μέτ' ἔρωτος—fallen into a new cycle, were beginning its intellectual career over again, yet with a certain power of anticipating its results. And so comes the truth of Goethe's judgments on his works; they are a life, a living thing, designed for those who are alive—*ein Lebendiges für die Lebendigen geschrieben, ein Leben selbst.*

In 1758 Cardinal Albani, who had formed in his Roman villa a precious collection of antiquities, became Winckelmann's patron. Pompeii had just opened its treasures; Winckelmann gathered its first-fruits. But his plan of a visit to Greece remained unfulfilled. From his first arrival in Rome he had kept the *History of Ancient Art* ever in view. All his other writings were a preparation for that. It appeared, finally, in 1764; but even after its publication Winckelmann was still employed in perfecting it. It is since his time that many of the most significant examples of Greek art have been submitted to criticism. He had seen little or nothing of what we ascribe to the age of Pheidias; and his conception of Greek art tends, therefore, to put the mere elegance of the imperial society of ancient Rome in place of the severe and chastened grace of the *palaestra.* For the most part he had to penetrate to Greek art through copies, imitations, and later Roman art itself; and it is not surprising that this turbid medium has left in Winckelmann's actual results much that a more privileged criticism can correct.

He had been twelve years in Rome. Admiring Ger-

many had made many calls to him. At last, in 1768, he set out to revisit the country of his birth; and as he left Rome, a strange, inverted home-sickness, a strange reluctance to leave it at all, came over him. He reached Vienna. There he was loaded with honours and presents: other cities were awaiting him. Goethe, then nineteen years old, studying art at Leipsic, was expecting his coming, with that wistful eagerness which marked his youth, when the news of Winckelmann's murder arrived. All his "weariness of the north" had revived with double force. He left Vienna, intending to hasten back to Rome, and at Trieste a delay of a few days occurred. With characteristic openness, Winckelmann had confided his plans to a fellow-traveller, a man named Arcangeli, and had shown him the gold medals received at Vienna. Arcangeli's avarice was roused. One morning he entered Winckelmann's room, under pretence of taking leave. Winckelmann was then writing "memoranda for the future editor of the *History of Art*," still seeking the perfection of his great work. Arcangeli begged to see the medals once more. As Winckelmann stooped down to take them from the chest, a cord was thrown round his neck. Some time afterwards, a child with whose companionship Winckelmann had beguiled his delay, knocked at the door, and receiving no answer, gave the alarm. Winckelmann was found dangerously wounded, and died a few hours later, after receiving the last sacraments. It seemed as if the gods, in reward for his devotion to them, had given him a death which, for its swiftness and its opportunity, he might well have desired. "He has," says Goethe, "the advantage of figuring in the memory of posterity, as one eternally able and strong; for the image in which one leaves the world,

is that in which one moves among the shadows." Yet,
perhaps, it is not fanciful to regret that his proposed
meeting with Goethe never took place. Goethe, then in
all the pregnancy of his wonderful youth, still unruffled
by the "press and storm" of his earlier manhood, was 5
awaiting Winckelmann with a curiosity of the worthiest
kind. As it was, Winckelmann became to him some-
thing like what Virgil was to Dante. And Winckel-
mann, with his fiery friendships, had reached that age
and that period of culture at which emotions hitherto 10
fitful, sometimes concentrate themselves in a vital, un-
changeable relationship. German literary history seems
to have lost the chance of one of those famous friend-
ships, the very tradition of which becomes a stimulus to
culture, and exercises an imperishable influence. 15

In one of the frescoes of the Vatican, Raphael has
commemorated the tradition of the Catholic religion.
Against a space of tranquil sky, broken in upon by the
beatific vision, are ranged the great personages of Chris-
tian history, with the Sacrament in the midst. Another 20
fresco of Raphael in the same apartment presents a very
different company, Dante alone appearing in both. Sur-
rounded by the muses of Greek mythology, under a
thicket of laurel, sits Apollo, with the sources of Cas-
talia at his feet. On either side are grouped those on 25
whom the spirit of Apollo descended, the classical and
Renaissance poets, to whom the waters of Castalia come
down, a river making glad this other "City of God." In
this fresco it is the classical tradition, the orthodoxy of
taste, that Raphael commemorates. Winckelmann's in- 30
tellectual history authenticates the claims of this tradi-
tion in human culture. In the countries where that tra-

dition arose, where it still lurked about its own artistic relics, and changes of language had not broken its continuity, national pride might sometimes light up anew an enthusiasm for it. Aliens might imitate that enthusiasm, and classicism become from time to time an intellectual fashion. But Winckelmann was not further removed by language, than by local aspects and associations, from those vestiges of the classical spirit; and he lived at a time when, in Germany, classical studies were out of favour. Yet, remote in time and place, he feels after the Hellenic world, divines those channels of ancient art, in which its life still circulates, and, like Scyles, the half-barbarous yet Hellenising king, in the beautiful story of Herodotus, is irresistibly attracted by it. This testimony to the authority of the Hellenic tradition, its fitness to satisfy some vital requirement of the intellect, which Winckelmann contributes as a solitary man of genius, is offered also by the general history of the mind. The spiritual forces of the past, which have prompted and informed the culture of a succeeding age, live, indeed, within that culture, but with an absorbed, underground life. The Hellenic element alone has not been so absorbed, or content with this underground life; from time to time it has started to the surface; culture has been drawn back to its sources to be clarified and corrected. Hellenism is not merely an absorbed element in our intellectual life; it is a conscious tradition in it.

Again, individual genius works ever under conditions of time and place: its products are coloured by the varying aspects of nature, and type of human form, and outward manners of life. There is thus an element of change in art; criticism must never for a moment forget that "the artist is the child of his time." But besides these

conditions of time and place, and independent of them, there is also an element of permanence, a standard of taste, which genius confesses. This standard is maintained in a purely intellectual tradition. It acts upon the artist, not as one of the influences of his own age, but through those artistic products of the previous generation which first excited, while they directed into a particular channel, his sense of beauty. The supreme artistic products of succeeding generations thus form a series of elevated points, taking each from each the reflexion of a strange light, the source of which is not in the atmosphere around and above them, but in a stage of society remote from ours. The standard of taste, then, was fixed in Greece, at a definite historical period. A tradition for all succeeding generations, it originates in a spontaneous growth out of the influences of Greek society. What were the conditions under which this ideal, this standard of artistic orthodoxy, was generated? How was Greece enabled to force its thought upon Europe?

Greek art, when we first catch sight of it, is entangled with Greek religion. We are accustomed to think of Greek religion as the religion of art and beauty, the religion of which the Olympian Zeus and the Athene Polias are the idols, the poems of Homer the sacred books. Thus Cardinal Newman speaks of "the classical polytheism which was gay and graceful, as was natural in a civilised age." Yet such a view is only a partial one. In it the eye is fixed on the sharp, bright edge of high Hellenic culture, but loses sight of the sombre world across which it strikes. Greek religion, where we can observe it most distinctly, is at once a magnificent ritualistic system, and a cycle of poetical conceptions. Religions, as they grow by natural laws out of man's life,

are modified by whatever modifies his life. They bright-
en under a bright sky, they become liberal as the social
range widens, they grow intense and shrill in the clefts
of human life, where the spirit is narrow and confined,
and the stars are visible at noonday; and a fine analysis
of these differences is one of the gravest functions of
religious criticism. Still, the broad foundation, in mere
human nature, of all religions as they exist for the great-
est number, is a universal pagan sentiment, a paganism
which existed before the Greek religion, and has lin-
gered far onward into the Christian world, ineradicable,
like some persistent vegetable growth, because its seed
is an element of the very soil out of which it springs.

This pagan sentiment measures the sadness with
which the human mind is filled, whenever its thoughts
wander far from what is here, and now. It is beset by
notions of irresistible natural powers, for the most part
ranged against man, but the secret also of his fortune,
making the earth golden and the grape fiery for him. He
makes gods in his own image, gods smiling and flower-
crowned, or bleeding by some sad fatality, to console
him by their wounds, never closed from generation to
generation. It is with a rush of home-sickness that the
thought of death presents itself. He would remain at
home for ever on the earth if he could. As it loses its
colour and the senses fail, he clings ever closer to it; but
since the mouldering of bones and flesh must go on to
the end, he is careful for charms and talismans, which
may chance to have some friendly power in them, when
the inevitable shipwreck comes. Such sentiment is a part
of the eternal basis of all religions, modified indeed by
changes of time and place, but indestructible, because its
root is so deep in the earth of man's nature. The breath

of religious initiators passes over them; a few "rise up
with wings as eagles," but the broad level of religious
life is not permanently changed. Religious progress, like
all purely spiritual progress, is confined to a few. This
sentiment attaches itself in the earliest times to certain
usages of patriarchal life, the kindling of fire, the wash-
ing of the body, the slaughter of the flock, the gathering
of harvest, holidays and dances. Here are the beginnings
of a ritual, at first as occasional and unfixed as the senti-
ment which it expresses, but destined to become the
permanent element of religious life. The usages of patri-
archal life change; but this germ of ritual remains, pro-
moted now with a consciously religious motive, losing
its domestic character, and therefore becoming more
and more inexplicable with each generation. Such pagan
worship, in spite of local variations, essentially one, is
an element in all religions. It is the anodyne which the
religious principle, like one administering opiates to the
incurable, has added to the law which makes life sombre
for the vast majority of mankind.

More definite religious conceptions come from other
sources, and fix themselves upon this ritual in various
ways, changing it, and giving it new meanings. In
Greece they were derived from mythology, itself not
due to a religious source at all, but developing in the
course of time into a body of religious conceptions,
entirely human in form and character. To the unpro-
gressive ritual element it brought these conceptions, it-
self—ἡ πτεροῦ δύναμις, the power of the wing —an
element of refinement, of ascension, with the promise
of an endless destiny. While the ritual remains un-
changed, the æsthetic element, only accidentally con-
nected with it, expands with the freedom and mobility

of the things of the intellect. Always, the fixed element is the religious observance; the fluid, unfixed element is the myth, the religious conception. This religion is itself pagan, and has in any broad view of it the pagan sad-
5 ness. It does not at once, and for the majority, become the higher Hellenic religion. The country people, of course, cherish the unlovely idols of an earlier time, such as those which Pausanias found still devoutly pre-served in Arcadia. Athenæus tells the story of one who,
10 coming to a temple of Latona, had expected to find some worthy presentment of the mother of Apollo, and laughed on seeing only a shapeless wooden figure. The wilder people have wilder gods, which, however, in Athens, or Corinth, or Lacedæmon, changing ever with
15 the worshippers in whom they live and move and have their being, borrow something of the lordliness and distinction of human nature there. Greek religion too has its mendicants, its purifications, its antinomian mys-ticism, its garments offered to the gods, its statues worn
20 with kissing, its exaggerated superstitions for the vulgar only, its worship of sorrow, its *addolorata*, its mournful mysteries. Scarcely a wild or melancholy note of the medieval church but was anticipated by Greek polythe-ism! What should we have thought of the vertiginous
25 prophetess at the very centre of Greek religion? The su-preme Hellenic culture is a sharp edge of light across this gloom. The fiery, stupefying wine becomes in a happier climate clear and exhilarating. The Dorian wor-ship of Apollo, rational, chastened, debonair, with his
30 unbroken daylight, always opposed to the sad Chthon-ian divinities, is the aspiring element, by force and spring of which Greek religion sublimes itself. Out of Greek religion, under happy conditions, arises Greek

art, to minister to human culture. It was the privilege of Greek religion to be able to transform itself into an artistic ideal.

For the thoughts of the Greeks about themselves, and their relation to the world generally, were ever in the happiest readiness to be transformed into objects for the senses. In this lies the main distinction between Greek art and the mystical art of the Christian middle age, which is always struggling to express thoughts beyond itself. Take, for instance, a characteristic work of the middle age, Angelico's *Coronation of the Virgin*, in the cloister of *Saint Mark's* at Florence. In some strange halo of a moon Jesus and the Virgin Mother are seated, clad in mystical white raiment, half shroud, half priestly linen. Jesus, with rosy nimbus and the long pale hair— *tanquam lana alba et tanquam nix*—of the figure in the Apocalypse, with slender finger-tips is setting a crown of pearl on the head of Mary, who, corpse-like in her refinement, is bending forward to receive it, the light lying like snow upon her forehead. Certainly, it cannot be said of Angelico's fresco that it throws into a sensible form our highest thoughts about man and his relation to the world; but it did not do this adequately even for Angelico. For him, all that is outward or sensible in his work—the hair like wool, the rosy nimbus, the crown of pearl—is only the symbol or type of a really inexpressible world, to which he wishes to direct the thoughts; he would have shrunk from the notion that what the eye apprehended was all. Such forms of art, then, are inadequate to the matter they clothe; they remain ever below its level. Something of this kind is true also of oriental art. As in the middle age from an exaggerated inwardness, so in the East from a vague-

ness, a want of definition, in thought, the matter presented to art is unmanageable, and the forms of sense struggle vainly with it. The many-headed gods of the East, the orientalised, many-breasted Diana of Ephesus, like Angelico's fresco, are at best overcharged symbols, a means of hinting at an idea which art cannot fitly or completely express, which still remains in the world of shadows.

But take a work of Greek art,—the Venus of Melos. That is in no sense a symbol, a suggestion, of anything beyond its own victorious fairness. The mind begins and ends with the finite image, yet loses no part of the spiritual motive. This motive is not lightly and loosely attached to the sensuous form, as its meaning to an allegory, but saturates and is identical with it. The Greek mind had advanced to a particular stage of self-reflexion, but was careful not to pass beyond it. In oriental thought there is a vague conception of life everywhere, but no true appreciation of itself by the mind, no knowledge of the distinction of man's nature: in its consciousness of itself, humanity is still confused with the fantastic, indeterminate life of the animal and vegetable world. In Greek thought, on the other hand, the "lordship of the soul" is recognised; that lordship gives authority and divinity to human eyes and hands and feet; inanimate nature is thrown into the background. But just there Greek thought finds its happy limit; it has not yet become too inward; the mind has not yet learned to boast its independence of the flesh; the spirit has not yet absorbed everything with its emotions, nor reflected its own colour everywhere. It has indeed committed itself to a train of reflexion which must end in defiance of form, of all that is outward, in an exaggerated idealism.

But that end is still distant: it has not yet plunged into the depths of religious mysticism.

This ideal art, in which the thought does not outstrip or lie beyond the proper range of its sensible embodiment, could not have arisen out of a phase of life that was uncomely or poor. That delicate pause in Greek reflexion was joined, by some supreme good luck, to the perfect animal nature of the Greeks. Here are the two conditions of an artistic ideal. The influences which perfected the animal nature of the Greeks are part of the process by which "the ideal" was evolved. Those "Mothers" who, in the second part of *Faust*, mould and remould the typical forms that appear in human history, preside, at the beginning of Greek culture, over such a concourse of happy physical conditions as ever generates by natural laws some rare type of intellectual or spiritual life. That delicate air, "nimbly and sweetly recommending itself " to the senses, the finer aspects of nature, the finer lime and clay of the human form, and modelling of the dainty framework of the human countenance:—these are the good luck of the Greek when he enters upon life. Beauty becomes a distinction, like genius, or noble place.

"By no people," says Winckelmann,

has beauty been so highly esteemed as by the Greeks. The priests of a youthful Jupiter at Ægæ, of the Ismenian Apollo, and the priest who at Tanagra led the procession of Mercury, bearing a lamb upon his shoulders, were always youths to whom the prize of beauty had been awarded. The citizens of Egesta erected a monument to a certain Philip who was not their fellow-citizen, but of Croton, for his distinguished beauty; and the people made offerings at it. In an ancient song, ascribed to Simonides or Epicharmus, of four wishes, the first was health, the second beauty. And as beauty was so

longed for and prized by the Greeks, every beautiful person sought to become known to the whole people by this distinction, and above all to approve himself to the artists, because they awarded the prize; and this was for the artists an occasion for having supreme beauty ever before their eyes. Beauty even gave a right to fame; and we find in Greek histories the most beautiful people distinguished. Some were famous for the beauty of one single part of their form; as Demetrius Phalereus, for his beautiful eyebrows, was called *Charito-blepharos*. It seems even to have been thought that the procreation of beautiful children might be promoted by prizes. This is shown by the existence of contests for beauty, which in ancient times were established by Cypselus, King of Arcadia, by the river Alpheus; and, at the feast of Apollo of Philæ, a prize was offered to the youths for the deftest kiss. This was decided by an umpire; as also at Megara, by the grave of Diocles. At Sparta, and at Lesbos, in the temple of Juno, and among the Parrhasii, there were contests for beauty among women. The general esteem for beauty went so far, that the Spartan women set up in their bedchambers a Nireus, a Narcissus, or a Hyacinth, that they might bear beautiful children.

So, from a few stray antiquarianisms, a few faces cast up sharply from the waves, Winckelmann, as his manner was, divines the temperament of the antique world, and that in which it had delight. It has passed away with that distant age, and we may venture to dwell upon it. What sharpness and reality it has is the sharpness and reality of suddenly arrested life. The Greek system of gymnastics originated as part of a religious ritual. The worshipper was to recommend himself to the gods by becoming fleet and fair, white and red, like them. The beauty of the *palaestra*, and the beauty of the artist's workshop, reacted on one another. The youth tried to rival his gods; and his increased beauty passed back into

them.—"I take the gods to witness, I had rather have a
fair body than a king's crown"—Ὄμνυμι πάντας θεοὺς
μὴ ἑλέσθαι ἂν τὴν βασιλέως ἀρχὴν ἀντὶ τοῦ καλὸς
εἶναι —that is the form in which one age of the world
chose the higher life.—A perfect world, if the gods 5
could have seemed for ever only fleet and fair, white and
red! Let us not regret that this unperplexed youth of
humanity, satisfied with the vision of itself, passed, at
the due moment, into a mournful maturity; for already
the deep joy was in store for the spirit, of finding the 10
ideal of that youth still red with life in the grave.

It followed that the Greek ideal expressed itself pre-
eminently in sculpture. All art has a sensuous element,
colour, form, sound—in poetry a dexterous recalling of
these, together with the profound, joyful sensuousness 15
of motion, and each of them may be a medium for the
ideal: it is partly accident which in any individual case
makes the born artist, poet, or painter rather than sculp-
tor. But as the mind itself has had an historical develop-
ment, one form of art, by the very limitations of its 20
material, may be more adequate than another for the ex-
pression of any one phase of that development. Differ-
ent attitudes of the imagination have a native affinity
with different types of sensuous form, so that they com-
bine together, with completeness and ease. The arts 25
may thus be ranged in a series, which corresponds to a
series of developments in the human mind itself. Archi-
tecture, which begins in a practical need, can only
express by vague hint or symbol, the spirit or mind of
the artist. He closes his sadness over.him, or wanders in 30
the perplexed intricacies of things, or projects his pur-
pose from him clean-cut and sincere, or bares himself to
the sunlight. But these spiritualities, felt rather than

seen, can but lurk about architectural form as volatile effects, to be gathered from it by reflexion. Their expression is, indeed, not really sensuous at all. As human form is not the subject with which it deals,
5 architecture is the mode in which the artistic effort centres, when the thoughts of man concerning himself are still indistinct, when he is still little preoccupied with those harmonies, storms, victories, of the unseen and intellectual world, which, wrought out into the bodily
10 form, give it an interest and significance communicable to it alone. The art of Egypt, with its supreme architectural effects, is, according to Hegel's beautiful comparison, a Memnon waiting for the day, the day of the Greek spirit, the humanistic spirit, with its power of
15 speech.

Again, painting, music, and poetry, with their endless power of complexity, are the special arts of the romantic and modern ages. Into these, with the utmost attenuation of detail, may be translated every delicacy
20 of thought and feeling, incidental to a consciousness brooding with delight over itself. Through their gradations of shade, their exquisite intervals, they project in an external form that which is most inward in passion or sentiment. Between architecture and those romantic
25 arts of painting, music, and poetry, comes sculpture, which, unlike architecture, deals immediately with man, while it contrasts with the romantic arts, because it is not self-analytical. It has to do more exclusively than any other art with the human form, itself one entire
30 medium of spiritual expression, trembling, blushing, melting into dew, with inward excitement. That spirituality which only lurks about architecture as a volatile effect, in sculpture takes up the whole given material,

and penetrates it with an imaginative motive; and at first sight sculpture, with its solidity of form, seems a thing more real and full than the faint, abstract world of poetry or painting. Still the fact is the reverse. Discourse and action show man as he is, more directly than the play of the muscles and the moulding of the flesh; and over these poetry has command. Painting, by the flushing of colour in the face and dilatation of light in the eye—music, by its subtle range of tones—can refine most delicately upon a single moment of passion, unravelling its subtlest threads.

But why should sculpture thus limit itself to pure form? Because, by this limitation, it becomes a perfect medium of expression for one peculiar motive of the imaginative intellect. It therefore renounces all those attributes of its material which do not forward that motive. It has had, indeed, from the beginning an unfixed claim to colour; but this element of colour in it has always been more or less conventional, with no melting or modulation of tones, never permitting more than a very limited realism. It was maintained chiefly as a religious tradition. In proportion as the art of sculpture ceased to be merely decorative, and subordinate to architecture, it threw itself upon pure form. It renounces the power of expression by lower or heightened tones. In it, no member of the human form is more significant than the rest; the eye is wide, and without pupil; the lips and brow are hardly less significant than hands, and breasts, and feet. But the limitation of its resources is part of its pride: it has no backgrounds, no sky or atmosphere, to suggest and interpret a train of feeling; a little of suggested motion, and much of pure light on its gleaming surfaces, with pure form—only these. And it

gains more than it loses by this limitation to its own distinguishing motives; it unveils man in the repose of his unchanging characteristics. That white light, purged from the angry, bloodlike stains of action and passion,
5 reveals, not what is accidental in man, but the tranquil godship in him, as opposed to the restless accidents of life. The art of sculpture records the first naïve, unperplexed recognition of man by himself; and it is a proof of the high artistic capacity of the Greeks, that they ap-
10 prehended and remained true to these exquisite limitations, yet, in spite of them, gave to their creations a mobile, a vital, individuality.

Heiterkeit—blitheness or repose, and *Allgemeinheit*—generality or breadth, are, then, the supreme character-
15 istics of the Hellenic ideal. But that generality or breadth has nothing in common with the lax observation, the unlearned thought, the flaccid execution, which have sometimes claimed superiority in art, on the plea of being "broad" or "general." Hellenic breadth and gen-
20 erality come of a culture minute, severe, constantly renewed, rectifying and concentrating its impressions into certain pregnant types.

The basis of all artistic genius lies in the power of conceiving humanity in a new and striking way, of put-
25 ting a happy world of its own creation in place of the meaner world of our common days, generating around itself an atmosphere with a novel power of refraction, selecting, transforming, recombining the images it transmits, according to the choice of the imaginative
30 intellect. In exercising this power, painting and poetry have a variety of subject almost unlimited. The range of characters or persons open to them is as various as life itself; no character, however trivial, misshapen, or un-

lovely, can resist their magic. That is because those arts can accomplish their function in the choice and development of some special situation, which lifts or glorifies a character, in itself not poetical. To realise this situation, to define, in a chill and empty atmosphere, the focus 5 where rays, in themselves pale and impotent, unite and begin to burn, the artist may have, indeed, to employ the most cunning detail, to complicate and refine upon thought and passion a thousandfold. Let us take a brilliant example from the poems of Robert Browning. His 10 poetry is pre-eminently the poetry of situations. The characters themselves are always of secondary importance; often they are characters in themselves of little interest; they seem to come to him by strange accidents from the ends of the world. His gift is shown by the 15 way in which he accepts such a character, throws it into some situation, or apprehends it in some delicate pause of life, in which for a moment it becomes ideal. In the poem entitled *Le Byron de nos Jours*, in his *Dramatis Personae*, we have a single moment of passion thrown into 20 relief after this exquisite fashion. Those two jaded Parisians are not intrinsically interesting: they begin to interest us only when thrown into a choice situation. But to discriminate that moment, to make it appreciable by us, that we may "find" it, what a cobweb of allu- 25 sions, what double and treble reflexions of the mind upon itself, what an artificial light is constructed and broken over the chosen situation: on how fine a needle's point that little world of passion is balanced! Yet, in spite of this intricacy, the poem has the clear ring of a 30 central motive. We receive from it the impression of one imaginative tone, of a single creative act.

To produce such effects at all requires all the resources

of painting, with its power of indirect expression, of subordinate but significant detail, its atmosphere, its foregrounds and backgrounds. To produce them in a pre-eminent degree requires all the resources of poetry, language in its most purged form, its remote associations and suggestions, its double and treble lights. These appliances sculpture cannot command. In it, therefore, not the special situation, but the type, the general character of the subject to be delineated, is all-important. In poetry and painting, the situation predominates over the character; in sculpture, the character over the situation. Excluded by the proper limitation of its material from the development of exquisite situations, it has to choose from a select number of types intrinsically interesting— interesting, that is, independently of any special situation into which they may be thrown. Sculpture finds the secret of its power in presenting these types, in their broad, central, incisive lines. This it effects not by accumulation of detail, but by abstracting from it. All that is accidental, all that distracts the simple effect upon us of the supreme types of humanity, all traces in them of the commonness of the world, it gradually purges away.

Works of art produced under this law, and only these, are really characterised by Hellenic generality or breadth. In every direction it is a law of restraint. It keeps passion always below that degree of intensity at which it must necessarily be transitory, never winding up the features to one note of anger, or desire, or surprise. In some of the feebler allegorical designs of the middle age, we find isolated qualities portrayed as by so many masks; its religious art has familiarised us with

faces fixed immovably into blank types of placid reverie. Men and women, again, in the hurry of life, often wear the sharp impress of one absorbing motive, from which it is said death sets their features free. All such instances may be ranged under the *grotesque*; and the Hellenic ideal has nothing in common with the grotesque. It allows passion to play lightly over the surface of the individual form, losing thereby nothing of its central impassivity, its depth and repose. To all but the highest culture, the reserved faces of the gods will ever have something of insipidity.

Again, in the best Greek sculpture, the archaic immobility has been stirred, its forms are in motion; but it is a motion ever kept in reserve, and very seldom committed to any definite action. Endless as are the attitudes of Greek sculpture, exquisite as is the invention of the Greeks in this direction, the actions or situations it permits are simple and few. There is no Greek Madonna; the goddesses are always childless. The actions selected are those which would be without significance, except in a divine person—binding on a sandal, or preparing for the bath. When a more complex and significant action is permitted, it is most often represented as just finished, so that eager expectancy is excluded, as in the image of Apollo just after the slaughter of the Python, or of Venus with the apple of Paris already in her hand. The *Laocoon*, with all that patient science through which it has triumphed over an almost unmanageable subject, marks a period in which sculpture has begun to aim at effects legitimate, because delightful, only in painting.

The hair, so rich a source of expression in painting, because, relatively to the eye or the lip, it is mere drap-

ery, is withdrawn from attention; its texture, as well as its colour, is lost, its arrangement but faintly and severely indicated, with no broken or enmeshed light. The eyes are wide and directionless, not fixing anything
5 with their gaze, nor riveting the brain to any special external object, the brows without hair. Again, Greek sculpture deals almost exclusively with youth, where the moulding of the bodily organs is still as if suspended between growth and completion, indicated but not em-
10 phasised; where the transition from curve to curve is so delicate and elusive, that Winckelmann compares it to a quiet sea, which, although we understand it to be in motion, we nevertheless regard as an image of repose; where, therefore, the exact degree of development is so
15 hard to apprehend. If a single product only of Hellenic art were to be saved in the wreck of all beside, one might choose perhaps from the "beautiful multitude" of the Panathenaic frieze, that line of youths on horseback, with their level glances, their proud, patient lips,
20 their chastened reins, their whole bodies in exquisite service. This colourless, unclassified purity of life, with its blending and interpenetration of intellectual, spiritual, and physical elements, still folded together, pregnant with the possibilities of a whole world closed within it,
25 is the highest expression of the indifference which lies beyond all that is relative or partial. Everywhere there is the effect of an awaking, of a child's sleep just disturbed. All these effects are united in a single instance—the *adorante* of the museum of Berlin, a youth who has
30 gained the wrestler's prize, with hands lifted and open, in praise for the victory. Fresh, unperplexed, it is the image of man as he springs first from the sleep of nature, his white light taking no colour from any one-sided

experience. He is characterless, so faɪ as *character* involves subjection to the accidental influences of life.

"This sense," says Hegel,

for the consummate modelling of divine and human forms was pre-eminently at home in Greece. In its poets and 5
orators, its historians and philosophers, Greece cannot be conceived from a central point, unless one brings, as a key to the understanding of it, an insight into the ideal forms of sculpture, and regards the images of statesmen and philosophers, as well as epic and dramatic heroes, from the artistic 10
point of view. For those who act, as well as those who create and think, have, in those beautiful days of Greece, this plastic character. They are great and free, and have grown up on the soil of their own individuality, creating themselves out of themselves, and moulding themselves to what they were, and 15
willed to be. The age of Pericles was rich in such characters; Pericles himself, Pheidias, Plato, above all Sophocles, Thucydides also, Xenophon and Socrates, each in his own order, the perfection of one remaining undiminished by that of the others. They are ideal artists of themselves, cast each in one 20
flawless mould, works of art, which stand before us as an immortal presentment of the gods. Of this modelling also are those bodily works of art, the victors in the Olympic games; yes! and even Phryne, who, as the most beautiful of women, ascended naked out of the water, in the presence of assembled 25
Greece.

This key to the understanding of the Greek spirit, Winckelmann possessed in his own nature, itself like a relic of classical antiquity, laid open by accident to our alien, modern atmosphere. To the criticism of that con- 30
summate Greek modelling he brought not only his culture but his temperament. We have seen how definite was the leading motive of that culture; how, like some central root-fibre, it maintained the well-rounded unity of his life through a thousand distractions. Interests not 35

his, nor meant for him, never disturbed him. In morals, as in criticism, he followed the clue of instinct, of an unerring instinct. Penetrating into the antique world by his passion, his temperament, he enunciated no formal principles, always hard and one-sided. Minute and anxious as his culture was, he never became one-sidedly self-analytical. Occupied ever with himself, perfecting himself and developing his genius, he was not content, as so often happens with such natures, that the atmosphere between him and other minds should be thick and clouded; he was ever jealously refining his meaning into a form, express, clear, objective. This temperament he nurtured and invigorated by friendships which kept him always in direct contact with the spirit of youth. The beauty of the Greek statues was a sexless beauty: the statues of the gods had the least traces of sex. Here there is a moral sexlessness, a kind of ineffectual wholeness of nature, yet with a true beauty and significance of its own.

One result of this temperament is a serenity—*Heiterkeit*—which characterises Winckelmann's handling of the sensuous side of Greek art. This serenity is, perhaps, in great measure, a negative quality: it is the absence of any sense of want, or corruption, or shame. With the sensuous element in Greek art he deals in the pagan manner; and what is implied in that? It has been sometimes said that art is a means of escape from "the tyranny of the senses." It may be so for the spectator: he may find that the spectacle of supreme works of art takes from the life of the senses something of its turbid fever. But this is possible for the spectator only because the artist, in producing those works, has gradually sunk his intellectual and spiritual ideas in sensuous form. He may

live, as Keats lived, a pure life; but his soul, like that of Plato's false astronomer, becomes more and more immersed in sense, until nothing which lacks the appeal to sense has interest for him. How could such an one ever again endure the greyness of the ideal or spiritual world? The spiritualist is satisfied as he watches the escape of the sensuous elements from his conceptions; his interest grows, as the dyed garment bleaches in the keener air. But the artist steeps his thought again and again into the fire of colour. To the Greek this immersion in the sensuous was, religiously, at least, indifferent. Greek sensuousness, therefore, does not fever the conscience: it is shameless and childlike. Christian asceticism, on the other hand, discrediting the slightest touch of sense, has from time to time provoked into strong emphasis the contrast or antagonism to itself, of the artistic life, with its inevitable sensuousness.—*I did but taste a little honey with the end of the rod that was in mine hand, and lo! I must die.*—It has sometimes seemed hard to pursue that life without something of conscious disavowal of a spiritual world; and this imparts to genuine artistic interests a kind of intoxication. From this intoxication Winckelmann is free: he fingers those pagan marbles with unsinged hands, with no sense of shame or loss. That is to deal with the sensuous side of art in the pagan manner.

The longer we contemplate that Hellenic ideal, in which man is at unity with himself, with his physical nature, with the outward world, the more we may be inclined to regret that he should ever have passed beyond it, to contend for a perfection that makes the blood turbid, and frets the flesh, and discredits the actual world about us. But if he was to be saved from the *ennui* which ever attaches itself to realisation, even the realisa-

tion of the perfect life, it was necessary that a conflict should come, that some sharper note should grieve the existing harmony, and the spirit chafed by it beat out at last only a larger and profounder music. In Greek trag-
5 edy this conflict has begun: man finds himself face to face with rival claims. Greek tragedy shows how such a conflict may be treated with serenity, how the evolution of it may be a spectacle of the dignity, not of the impotence, of the human spirit. But it is not only in tragedy
10 that the Greek spirit showed itself capable of thus bringing joy out of matter in itself full of discouragements. Theocritus too strikes often a note of romantic sadness. But what a blithe and steady poise, above these discouragements, in a clear and sunny stratum of the air!
15 Into this stage of Greek achievement Winckelmann did not enter. Supreme as he is where his true interest lay, his insight into the typical unity and repose of the highest sort of sculpture seems to have involved limitation in another direction. His conception of art excludes
20 that bolder type of it which deals confidently and serenely with life, conflict, evil. Living in a world of exquisite but abstract and colourless form, he could hardly have conceived of the subtle and penetrative, yet somewhat grotesque art of the modern world. What would he
25 have thought of Gilliatt, in Victor Hugo's *Travailleurs de la Mer*, or of the bleeding mouth of Fantine in the first part of *Les Misérables*, penetrated as those books are with a sense of beauty, as lively and transparent as that of a Greek? Nay, a sort of preparation for the romantic
30 temper is noticeable even within the limits of the Greek ideal itself, which for his part Winckelmann failed to see. For Greek religion has not merely its mournful mysteries of Adonis, of Hyacinthus, of Demeter, but it

is conscious also of the fall of earlier divine dynasties. Hyperion gives way to Apollo, Oceanus to Poseidon. Around the feet of that tranquil Olympian family still crowd the weary shadows of an earlier, more formless, divine world. The placid minds even of Olympian gods are troubled with thoughts of a limit to duration, of inevitable decay, of dispossession. Again, the supreme and colourless abstraction of those divine forms, which is the secret of their repose, is also a premonition of the fleshless, consumptive refinements of the pale, medieval artists. That high indifference to the outward, that impassivity, has already a touch of the corpse in it: we see already Angelico and the *Master of the Passion* in the artistic future. The suppression of the sensuous, the shutting of the door upon it, the ascetic interest, may be even now foreseen. Those abstracted gods, "ready to melt out their essence fine into the winds," who can fold up their flesh as a garment, and still remain themselves, seem already to feel that bleak air, in which, like Helen of Troy, they wander as the spectres of the middle age.

Gradually, as the world came into the church, an artistic interest, native in the human soul, reasserted its claims. But Christian art was still dependent on pagan examples, building the shafts of pagan temples into its churches, perpetuating the form of the *basilica*, in later times working the disused amphitheatres as stone-quarries. The sensuous expression of ideas which unreservedly discredit the world of sense, was the delicate problem which Christian art had before it. If we think of medieval painting, as it ranges from the early German schools, still with something of the air of the

charnel-house about them, to the clear loveliness of
Perugino, we shall see how that problem was solved. In
the very "worship of sorrow" the native blitheness of
art asserted itself. The religious spirit, as Hegel says,
"smiled through its tears." So perfectly did the young
Raphael infuse that *Heiterkeit*, that pagan blitheness, in-
to religious works, that his picture of Saint Agatha at
Bologna became to Goethe a step in the evolution of
Iphigenie [1]. But in proportion as the gift of smiling was
found once more, there came also an aspiration towards
that lost antique art, some relics of which Christian art
had buried in itself, ready to work wonders when their
day came.

The history of art has suffered as much as any history
by trenchant and absolute divisions. Pagan and Chris-
tian art are sometimes harshly opposed, and the Renais-
sance is represented as a fashion which set in at a definite
period. That is the superficial view: the deeper view is
that which preserves the identity of European culture.
The two are really continuous; and there is a sense in
which it may be said that the Renaissance was an un-
interrupted effort of the middle age, that it was ever
taking place. When the actual relics of the antique were
restored to the world, in the view of the Christian ascet-
ic it was as if an ancient plague-pit had been opened.
All the world took the contagion of the life of nature
and of the senses. And now it was seen that the medieval
spirit too had done something for the new fortunes of
the antique. By hastening the decline of art, by with-
drawing interest from it and yet keeping unbroken the
thread of its traditions, it had suffered the human mind

[1] *Italiänische Reise. Bologna*, 19 Oct. 1786.

to repose itself, that when day came it might awake, with eyes refreshed, to those ancient, ideal forms.

The aim of a right criticism is to place Winckelmann in an intellectual perspective, of which Goethe is the foreground. For, after all, he is infinitely less than Goethe; and it is chiefly because at certain points he comes in contact with Goethe, that criticism entertains consideration of him. His relation to modern culture is a peculiar one. He is not of the modern world; nor is he wholly of the eighteenth century, although so much of his outer life is characteristic of it. But that note of revolt against the eighteenth century, which we detect in Goethe, was struck by Winckelmann. Goethe illustrates a union of the Romantic spirit, in its adventure, its variety, its profound subjectivity of soul, with Hellenism, in its transparency, its rationality, its desire of beauty— that marriage of Faust and Helena, of which the art of the nineteenth century is the child, the beautiful lad Euphorion, as Goethe conceives him, on the crags, in the "splendour of battle and in harness as for victory," his brows bound with light[1]. Goethe illustrates, too, the preponderance in this marriage of the Hellenic element; and that element, in its true essence, was made known to him by Winckelmann.

Breadth, centrality, with blitheness and repose, are the marks of Hellenic culture. Is such culture a lost art? The local, accidental colouring of its own age has passed from it; and the greatness that is dead looks greater when every link with what is slight and vulgar has been severed. We can only see it at all in the reflected, refined light which a great education creates for us. Can we

[1] *Faust, Th. ii. Act. 3.*

bring down that ideal into the gaudy, perplexed light of modern life?

Certainly, for us of the modern world, with its con-flicting claims, its entangled interests, distracted by so
5 many sorrows, with many preoccupations, so bewilder-ing an experience, the problem of unity with ourselves, in blitheness and repose, is far harder than it was for the Greek within the simple terms of antique life. Yet, not less than ever, the intellect demands completeness,
10 centrality. It is this which Winckelmann imprints on the imagination of Goethe, at the beginning of life, in its original and simplest form, as in a fragment of Greek art itself, stranded on that littered, indeterminate shore of Germany in the eighteenth century. In Winckelmann,
15 this type comes to him, not as in a book or a theory, but more importunately, because in a passionate life, in a personality. For Goethe, possessing all modern inter-ests, ready to be lost in the perplexed currents of mod-ern thought, he defines, in clearest outline, the eternal
20 problem of culture—balance, unity with one's self, con-summate Greek modelling.

It could no longer be solved, as in Phryne ascending naked out of the water, by perfection of bodily form, or any joyful union with the external world: the shad-
25 ows had grown too long, the light too solemn, for that. It could hardly be solved, as in Pericles or Pheidias, by the direct exercise of any single talent: amid the mani-fold claims of our modern intellectual life, that could only have ended in a thin, one-sided growth. Goethe's
30 Hellenism was of another order, the *Allgemeinheit* and *Heiterkeit*, the completeness and serenity, of a watchful, exigent intellectualism. *Im Ganzen, Guten, Wahren, reso-lut zu leben:*—is Goethe's description of his own higher

life; and what is meant by life in the whole—*im Ganz-en*? It means the life of one for whom, over and over again, what was once precious has become indifferent. Every one who aims at the life of culture is met by many forms of it, arising out of the intense, laborious, one-sided development of some special talent. They are the brightest enthusiams the world has to show: and it is not their part to weigh the claims which this or that alien form of genius makes upon them. But the proper instinct of self-culture cares not so much to reap all that those various forms of genius can give, as to find in them its own strength. The demand of the intellect is to feel itself alive. It must see into the laws, the operation, the intellectual reward of every divided form of culture; but only that it may measure the relation between itself and them. It struggles with those forms till its secret is won from each, and then lets each fall back into its place, in the supreme, artistic view of life. With a kind of passionate coldness, such natures rejoice to be away from and past their former selves, and above all, they are jealous of that abandonment to one special gift which really limits their capabilities. It would have been easy for Goethe, with the gift of a sensuous nature, to let it overgrow him. It comes easily and naturally, perhaps, to certain "other-worldly" natures to be even as the *Schöne Seele*, that ideal of gentle pietism, in *Wilhelm Meister*: but to the large vision of Goethe, this seemed to be a phase of life that a man might feel all round, and leave behind him. Again, it is easy to indulge the commonplace metaphysical instinct. But a taste for metaphysics may be one of those things which we must renounce, if we mean to mould our lives to artistic perfection. Philosophy serves culture, not by the fancied

gift of absolute or transcendental knowledge, but by suggesting questions which help one to detect the passion, and strangeness, and dramatic contrasts of life.

But Goethe's culture did not remain "behind the veil": it ever emerged in the practical functions of art, in actual production. For him the problem came to be: —Can the blitheness and universality of the antique ideal be communicated to artistic productions, which shall contain the fulness of the experience of the modern world? We have seen that the development of the various forms of art has corresponded to the development of the thoughts of man concerning humanity, to the growing revelation of the mind to itself. Sculpture corresponds to the unperplexed, emphatic outlines of Hellenic humanism; painting to the mystic depth and intricacy of the middle age; music and poetry have their fortune in the modern world.

Let us understand by poetry all literary production which attains the power of giving pleasure by its form, as distinct from its matter. Only in this varied literary form can art command that width, variety, delicacy of resources, which will enable it to deal with the conditions of modern life. What modern art has to do in the service of culture is so to rearrange the details of modern life, so to reflect it, that it may satisfy the spirit. And what does the spirit need in the face of modern life? The sense of freedom. That naïve, rough sense of freedom, which supposes man's will to be limited, if at all, only by a will stronger than his, he can never have again. The attempt to represent it in art would have so little verisimilitude that it would be flat and uninteresting. The chief factor in the thoughts of the modern mind concerning itself is the intricacy, the universality of natural

law, even in the moral order. For us, necessity is not, as of old, a sort of mythological personage without us, with whom we can do warfare. It is rather a magic web woven through and through us, like that magnetic system of which modern science speaks, penetrating us with a network, subtler than our subtlest nerves, yet bearing in it the central forces of the world. Can art represent men and women in these bewildering toils so as to give the spirit at least an equivalent for the sense of freedom? Certainly, in Goethe's romances, and even more in the romances of Victor Hugo, we have high examples of modern art dealing thus with modern life, regarding that life as the modern mind must regard it, yet reflecting upon it blitheness and repose. Natural laws we shall never modify, embarrass us as they may; but there is still something in the nobler or less noble attitude with which we watch their fatal combinations. In those romances of Goethe and Victor Hugo, in some excellent work done *after* them, this entanglement, this network of law, becomes the tragic situation, in which certain groups of noble men and women work out for themselves a supreme *dénouement*. Who, if he saw through all, would fret against the chain of circumstance which endows one at the end with those great experiences?

1867.

Conclusion[1]

Λέγει που Ἡράκλειτος ὅτι πάντα χωρεῖ καὶ οὐδὲν μένει

To REGARD ALL THINGS and principles of things as in-
constant modes or fashions has more and more be-
come the tendency of modern thought. Let us begin
with that which is without—our physical life. Fix upon
it in one of its more exquisite intervals, the moment, for
instance, of delicious recoil from the flood of water in
summer heat. What is the whole physical life in that
moment but a combination of natural elements to which
science gives their names? But those elements, phos-
phorus and lime and delicate fibres, are present not in
the human body alone: we detect them in places most
remote from it. Our physical life is a perpetual motion
of them—the passage of the blood, the waste and repair-
ing of the lenses of the eye, the modification of the tis-
sues of the brain under every ray of light and sound—
processes which science reduces to simpler and more
elementary forces. Like the elements of which we are
composed, the action of these forces extends beyond us:
it rusts iron and ripens corn. Far out on every side of
us those elements are broadcast, driven in many cur-
rents; and birth and gesture and death and the springing
of violets from the grave are but a few out of ten thou-
sand resultant combinations. That clear, perpetual out-

[1] This brief "Conclusion" was omitted in the second edition of this book,
as I conceived it might possibly mislead some of those young men into whose
hands it might fall. On the whole, I have thought it best to reprint it here,
with some slight changes which bring it closer to my original meaning. I
have dealt more fully in *Marius the Epicurean* with the thoughts suggested
by it.

186

line of face and limb is but an image of ours, under which we group them—a design in a web, the actual threads of which pass out beyond it. This at least of flame-like our life has, that it is but the concurrence, renewed from moment to moment, of forces parting sooner or later on their ways.

Or if we begin with the inward world of thought and feeling, the whirlpool is still more rapid, the flame more eager and devouring. There it is no longer the gradual darkening of the eye, the gradual fading of colour from the wall—movements of the shore-side, where the water flows down indeed, though in apparent rest—but the race of the midstream, a drift of momentary acts of sight and passion and thought. At first sight experience seems to bury us under a flood of external objects, pressing upon us with a sharp and importunate reality, calling us out of ourselves in a thousand forms of action. But when reflexion begins to play upon those objects they are dissipated under its influence; the cohesive force seems suspended like some trick of magic; each object is loosed into a group of impressions—colour, odour, texture—in the mind of the observer. And if we continue to dwell in thought on this world, not of objects in the solidity with which language invests them, but of impressions, unstable, flickering, inconsistent, which burn and are extinguished with our consciousness of them, it contracts still further: the whole scope of observation is dwarfed into the narrow chamber of the individual mind. Experience, already reduced to a group of impressions, is ringed round for each one of us by that thick wall of personality through which no real voice has ever pierced on its way to us, or from us to that which we can only conjecture to be without. Every one of those impressions is the impression of the individual

in his isolation, each mind keeping as a solitary prisoner its own dream of a world. Analysis goes a step further still, and assures us that those impressions of the individual mind to which, for each one of us, experience 5 dwindles down, are in perpetual flight; that each of them is limited by time, and that as time is infinitely divisible, each of them is infinitely divisible also; all that is actual in it being a single moment, gone while we try to apprehend it, of which it may ever be more truly 10 said that it has ceased to be than that it is. To such a tremulous wisp constantly re-forming itself on the stream, to a single sharp impression, with a sense in it, a relic more or less fleeting, of such moments gone by, what is real in our life fines itself down. It is with this 15 movement, with the passage and dissolution of impressions, images, sensations, that analysis leaves off—that continual vanishing away, that strange, perpetual, weaving and unweaving of ourselves.

Philosophiren, says Novalis, *ist dephlegmatisiren, vivific-* 20 *iren.* The service of philosophy, of speculative culture, towards the human spirit, is to rouse, to startle it to a life of constant and eager observation. Every moment some form grows perfect in hand or face; some tone on the hills or the sea is choicer than the rest; some mood 25 of passion or insight or intellectual excitement is irresistibly real and attractive to us,—for that moment only. Not the fruit of experience, but experience itself, is the end. A counted number of pulses only is given to us of a variegated, dramatic life. How may we see in them all 30 that is to be seen in them by the finest senses? How shall we pass most swiftly from point to point, and be present always at the focus where the greatest number of vital forces unite in their purest energy?

CONCLUSION

To burn always with this hard, gem-like flame, to maintain this ecstasy, is success in life. In a sense it might even be said that our failure is to form habits: for, after all, habit is relative to a stereotyped world, and meantime it is only the roughness of the eye that makes any two persons, things, situations, seem alike. While all melts under our feet, we may well grasp at any exquisite passion, or any contribution to knowledge that seems by a lifted horizon to set the spirit free for a moment, or any stirring of the senses, strange dyes, strange colours, and curious odours, or work of the artist's hands, or the face of one's friend. Not to discriminate every moment some passionate attitude in those about us, and in the very brilliancy of their gifts some tragic dividing of forces on their ways, is, on this short day of frost and sun, to sleep before evening. With this sense of the splendour of our experience and of its awful brevity, gathering all we are into one desperate effort to see and touch, we shall hardly have time to make theories about the things we see and touch. What we have to do is to be for ever curiously testing new opinions and courting new impressions, never acquiescing in a facile orthodoxy, of Comte, or of Hegel, or of our own. Philosophical theories or ideas, as points of view, instruments of criticism, may help us to gather up what might otherwise pass unregarded by us. "Philosophy is the microscope of thought." The theory or idea or system which requires of us the sacrifice of any part of this experience, in consideration of some interest into which we cannot enter, or some abstract theory we have not identified with ourselves, or of what is only conventional, has no real claim upon us.

One of the most beautiful passages of Rousseau is that

in the sixth book of the *Confessions*, where he describes the awakening in him of the literary sense. An undefinable taint of death had clung always about him, and now in early manhood he believed himself smitten by
5 mortal disease. He asked himself how he might make as much as possible of the interval that remained; and he was not biassed by anything in his previous life when he decided that it must be by intellectual excitement, which he found just then in the clear, fresh writings of Vol-
10 taire. Well! we are all *condamnés*, as Victor Hugo says: we are all under sentence of death but with a sort of indefinite reprieve—*les hommes sont tous condamnés à mort avec des sursis indéfinis*: we have an interval, and then our place knows us no more. Some spend this interval in
15 listlessness, some in high passions, the wisest, at least among "the children of this world," in art and song. For our one chance lies in expanding that interval, in getting as many pulsations as possible into the given time. Great passions may give us this quickened sense of life, ecstasy
20 and sorrow of love, the various forms of enthusiastic activity, disinterested or otherwise, which come naturally to many of us. Only be sure it is passion—that it does yield you this fruit of a quickened, multiplied consciousness. Of such wisdom, the poetic passion, the de-
25 sire of beauty, the love of art for its own sake, has most. For art comes to you proposing frankly to give nothing but the highest quality to your moments as they pass, and simply for those moments' sake.
 1868.

THE END

Pater's Review of
Children in Italian and English Design
by Sidney Colvin (London, 1872)

THIS ELOQUENT ESSAY, reprinted from the *Portfolio*, is a good specimen of that best and most legitimate sort of writing on art which has for its aim the adjustment of a special knowledge of artists and their work to the needs and interests of general culture. Its subject is the treatment of children by Blake, Stothard and Flaxman, as prominent examples of the temper and mode of work of a whole school of English artists three generations ago; and this gives the writer an opportunity of analysing the general characteristics of those three great designers in a very happy and interesting way. His object has been to show that "there exists what may be justly called a modern sentiment towards children and appreciation of them, in a sense in which no such novelty of sentiment or appreciation exists between grown-up people towards each other"; and again, "how that observant home-tenderness, that new, subtle and affectionate intimacy with children, of which Reynolds had first given signs in his portraits of them taken individually, had got to be part of the regular endowment of the age, and had sunk down even into the lightest incidental work and ornament in which its more finely gifted artists revealed their prevailing temper." Sir Joshua Reynolds, notwithstanding the wonderful variety and perfection of his delineation of childish character, is excluded, because in portrait-painting the general

temper and sentiment of the artist are controlled by the
exigencies of his special function and the necessity of
dealing directly with the special and individual traits of
the subject in hand; and what Mr. Colvin wishes to seize
5 and analyse is a "type," a "mode of conceiving child-
hood generally"; and he rightly looks for this in "design
of the independent or ideal kind," work which the artist
"does out of his own head," like the designs in Blake's
Songs of Innocence or Stothard's illustrations of books.

10 In the chapter on Blake, which is illustrated by two
plates full of that peculiar mingling of sweetness and
strangeness which characterise the work of this great
artist, he dwells at length on the original of the *Songs of
Innocence*, the text of which has been lately reprinted,
15 bringing clearness into the bewildered beauties of that
singular *mélange* of design and verse. Afterwards, illus-
trating what he says here, as in other parts of his book,
by vignettes introduced with pleasant effect into the
printed page, he defines a certain affinity between Stot-
20 hard and Blake, two artists at first sight so incompatible
or contrasted, lingering pleasantly over the *rapports* of
Stothard with his time, and giving some interesting de-
tails on the early history of English engraving, showing
by many incidental indications and a well selected epi-
25 thet here and there an unusual knowledge of that per-
plexed subject, the general history of English art; seeing
these things always in close relation to the artists who
produced them, and those artists themselves in close
relation to their times. "Stothard's age," he says in a
30 characteristic passage,

and its ways in England had enough charm in them to have
become pleasantly ideal to us, in the sense in which it takes

something more than mere lapse of time to make an age ideal;
and he, like the stronger souls between whom we have set
him, was a votary of the ideal within his age itself; he knows
how to add the necessary touch, to accent or generalise the
costume, to find grace in frilled shirts and large lappets, and 5
knee-breeches and stockings, to sweeten and dignify the type,
to group and harmonise the figures just within the fitting
measure. And in his landscape and accessories he makes just
the abstraction required by the pitch of the subject and the
conditions of the scale and material. Stothard was a real 10
student of outer nature both in general and detail (his tender
passion for flowers is one of the prettiest things which Mrs.
Bray, his daughter-in-law, tells about him in her *Life*); and his
miniature landscapes of hill, lake, park, garden, and wood-
land, or cottage and thicket, have the elements which speak 15
most directly to the quieter side of the landscape faculty in us.

And the same skill with which Mr. Colvin has struck
upon the remote affinity between Stothard and Blake is
shown in the passages in which, on the other hand, he
distinguishes the qualities of Stothard from those of 20
Flaxman—designers who have so much in common,
and whose qualities for the superficial observer so easily
fade into each other—thus discriminating admirably
those three distinct faculties. "Unlike Stothard, Flax-
man works in an atmosphere, above that of historical 25
or romance associations, in which ancient and modern
are reconciled under an almost identical ideal," present-
ing this ideal "in a mode which I have called architec-
tonic," the limbs of his figures "being conceived as
masses for adjustment in something like rigid geometri- 30
cal or architectural figures." The frontispiece of the
book is a design of Flaxman's photographed from an
example in Mr. Colvin's own possession—a design
quite monumental and grand, though worked out with

a few simple lines and tints; and on page 46 he suggests in a few words altogether worthy of it what he thinks may be the meaning of this design.

And by way of further defining, through contrast, that exact phase of sentiment in the treatment of children by English artists which he wishes to discriminate and explain, he has prefixed some notices of the very different treatment of children by the Italians of the middle age and the Renaissance, artists who saw in children not their common human relations, but referred them "to other and more remote relations suggested by religion and imagination," looking for supernatural or symbolical types in them, so that "the burden of the supernatural which," as he well says, "is always in some degree the unnatural rests inevitably on all their delineation of them." Here too Mr. Colvin shows an equal knowledge and appreciation of a kind of art so different from that of England in the Georgian era, unravelling distinct threads of feeling here also, and showing how to a true culture workmen so far apart as these early Italians and those later Englishmen suggest no incompatible interests, but with full congruity lie easily enough together in that *House Beautiful* which the genuine and humanistic workmen of all ages, all those artists who have really felt and understood their work, are always building together for the human spirit.

It will be seen from what has been said that although this book is of no great length yet it ranges over a great variety of subjects. And out of all this Mr. Colvin has untwisted with singular skill this one particular thread of the treatment of children, presenting only what he feels clearly and can present with true effect. Thus the little book has a real unity, touching on many diverse

things, but kept together by its main thread, so that it might easily be expanded into a larger volume. Such work is only possible where there is great general knowledge of art. Instances of this general knowledge are everywhere scattered up and down this essay. Mr. Colvin gives us, for instance, by the way, on page 16, a clear characterisation of that obscure artist, Honoré Fragonard, and does an act of historical justice in passing. But this true knowledge in aesthetics is shown best of all by the impression he gives one that in passing over so many phases of art he seizes a fresh *nuance*, a fresh variety of impression and enjoyment from each; you feel that beyond mere knowledge, mere intellectual discrimination, each one of them is a distinct thing for him, and yields him a distinct savour.

Walter H. Pater

Pater's Review of
Renaissance in Italy:
The Age of the Despots,
by John Addington Symonds
(London, 1875)

T HIS REMARKABLE VOLUME is the first of three parts of
a projected work which in its complete form will
present a more comprehensive treatment of its subject
than has yet been offered to English readers. The aim of
5 the writer is to weave together the various threads of a
very complex period of European life, and to set the art
and literature of Italy on that background of general so-
cial and historical conditions to which they belong, and
apart from which they cannot really be understood, ac-
10 cording to the received and well-known belief of most
modern writers. Mr. Symonds brings to this task the re-
sults of wide, varied, and often curious reading, which
he has by no means allowed to overburden his work,
and also a familiar knowledge, attested by his former
15 eloquent volume of *Studies on the Greek Poets*, of that
classical world to which the Renaissance was confessed-
ly in some degree a return.

 It is that background of general history, a back-
ground upon which the artists and men of letters are
20 moving figures not to be wholly detached from it, that
this volume presents. By the "Age of the Despots" in
Italian history the writer understands the fourteenth and

fifteenth centuries, as the twelfth and the thirteenth are
the "Age of the Free Burghs," and the sixteenth and
seventeenth the "Age of Foreign Enslavement." The
chief phenomenon with which the "Age of the Despots"
is occupied is that "free emergence of personal passions, 5
personal aims," which all its peculiar conditions tended
to encourage, of personalities all alike so energetic and
free, though otherwise so unlike as Francesco Sforza,
Savonarola, Machiavelli, and Alexander VI., all "des-
pots" in their way. Benvenuto Cellini and Cesare 10
Borgia are seen to be products of the same general con-
ditions as the "good Duke of Urbino" and Savonarola.
Such a book necessarily presents strong lights and
shades. The first chapter groups together some wide
generalisations on the subject of the work as a whole, on 15
the Renaissance as an "emancipation," which, though
perhaps not wholly novel, are very strikingly put, and
through the whole of which we feel the breath of an
ardent love of liberty. In the next two chapters the writ-
er discusses the age of the earlier despots, the founders 20
of the great princely families, going over ground well
traversed indeed, but with a freshness of interest which
is the mark of original assimilation, with some parallels
and contrasts between Italy and ancient Greece, and led
always by the light of modern ideas. One by one all 25
those highly-coloured pieces of humanity are displayed
before us, those stories which have made Italian history
the fountain-head of tragic motives, all the hard, bright,
fiery things, the colour of which M. Taine has in some
degree caught in his writings on the philosophy of Ital- 30
ian art, and still more completely Stendhal, in his essay
on Italian art and his *Chroniques Italiennes*. You can hard-

ly open Mr. Symonds's volume without lighting on
some incident or trait of character in which man's ele-
mentary power to be, to think, to do, shows forth em-
phatically, and the writer has not chosen to soften down
these characteristics; there is even noticeable a certain
cynicism in his attitude towards his subject, expressed
well enough in the words which he quotes from Machi-
avelli as the motto of his title-page: *Di questi adunque
oziosi principi, e di queste vilissime armi, sarà piena la mia
istoria.*

That sense of the complex interdependence on each
other of all historical conditions is one of the guiding
lights of the modern historical method, and Mr. Sym-
onds abundantly shows how thoroughly he has mas-
tered this idea. And yet on the same background, out
of the same general conditions, products emerge, the
unlikeness of which is the chief thing to be noticed. The
spirit of the Renaissance proper, of the Renaissance as a
humanistic movement, on which it may be said this vol-
ume does not profess to touch, is as unlike the spirit of
Alexander VI. as it is unlike that of Savonarola. Alexan-
der VI. has more in common with Ezzelino da Romano,
that fanatical hater of human life in the middle age, than
with Tasso or Lionardo. The Renaissance is an assertion
of liberty indeed, but of liberty to see and feel those
things the seeing and feeling of which generate not the
"barbarous ferocity of temper, the savage and coarse
tastes" of the Renaissance Popes, but a sympathy with
life everywhere, even in its weakest and most frail
manifestations. Sympathy, appreciation, a sense of la-
tent claims in things which even ordinary good men
pass rudely by—these on the whole are the characteris-

tic traits of its artists, though it may be still true that "aesthetic propriety, rather than strict conceptions of duty, ruled the conduct even of the best"; and at least they never "destroyed pity in their souls." Such softer touches Mr. Symonds gives us in the "good duke Frederic of Urbino," his real courtesy and height of character, though under many difficulties; in his admirable criticisms on the *Cortegiano* of Castiglione; and again in his account of Agnolo Pandolfini's *Treatise on the Family*, the charm of which has by no means evaporated in Mr. Symonds's analysis; above all, in the beautiful description, in the seventh chapter, of the last days of Pietro Boscoli the tyrannicide, a striking instance of "the combination of deeply rooted and almost infantine piety with antique heroism," coming near as it happened, in his friend Luca della Robbia the younger, to an artist who could understand the aesthetic value of the incidents he has related.

I quote a very different episode as a specimen of Mr. Symonds's style:—

There is a story told by Infessura which illustrates the temper of the times with singular felicity. On April 18, 1485, a report circulated in Rome that some Lombard workmen had discovered a Roman sarcophagus while digging on the Appian Way. It was a marble tomb, engraved with the inscription, "Julia, daughter of Claudius," and inside the coffin lay the body of a most beautiful girl of fifteen years, preserved by precious unguents from corruption and the injury of time. The bloom of youth was still upon her cheeks and lips; her eyes and mouth were half open, her long hair floated round her shoulders. She was instantly removed, so goes the legend, to the Capitol; and then began a procession of pilgrims from all the quarters of Rome to gaze upon this saint of the old

Pagan world. In the eyes of those enthusiastic worshippers her beauty was beyond imagination or description; she was far fairer than any woman of the modern age could hope to be. At last Innocent VIII. feared lest the orthodox faith should
5 suffer by this new cult of a heathen corpse. Julia was buried, secretly and at night by his direction, and naught remained in the Capitol but her empty marble coffin. The tale, as told by Infessura, is repeated in Matarazzo and in Nantiporto with slight variations. One says that the girl's hair was yellow,
10 another that it was of the glossiest black. What foundation for the legend may really have existed need not here be questioned.Let us rather use the mythus as a parable of the ecstatic devotion which prompted the men of that age to discover a form of unimaginable beauty in the tomb of the classic world.

15 The book then presents a brilliant picture of its subject, of the movements of these energetic personalities, the magnificent restlessness and changefulness of their lives, their immense cynicism. As is the writer's subject so is his style—energetic, flexible, eloquent, full of vari-
20 ous illustration, keeping the attention of the reader always on the alert. Yet perhaps the best chapter in the book, the best because the most sympathetic, is one of the quieter ones, that on "The Florentine Historians"; their great studies, their anticipations of the historical
25 spirit of modern times, their noble style, their pious humour of discipleship towards Aristotle, Cicero, Tacitus, not without a certain pedantry becoming enough in the historians of those republics which were after all "products of constructive skill" rather than of a true
30 political evolution—all this is drawn with a clear hand and a high degree of reflectiveness. The chapter on "The Prince" corrects some common mistakes concerning Machiavelli, who is perhaps less of a puzzle than has

sometimes been supposed, a patriot devising a desperate means of establishing permanent rule in Florence, designing, in the spirit of a political idealism not more ruthless than that of Plato's Republic, to cure a real evil, a fault not unlike that of ancient Athens itself, the constant exaggerated appetite for change in public institutions, bringing with it an incorrigible tendency of all the parts of human life to fly from the centre, a fault, as it happened in both cases, at last become incurable. The chapter on Savonarola is a bold and complete portrait, with an interesting pendant on "Religious Revivals in Medieval Italy"; and the last chapter on "Charles the Eighth in Italy" has some real light in it, making things lie more intelligibly apart and together in that tangle of events. The imagination in historical composition works most legitimately when it approaches dramatic effects. In this volume there is a high degree of dramatic imagination; here all is objective, and the writer is hardly seen behind his work.

I have noted in the foregoing paragraphs the things which have chiefly impressed and pleased me in reading this book, things which are sure to impress and please hundreds of readers and make it very popular. But there is one thing more which I cannot help noticing before I close. Notwithstanding Mr. Symonds's many good gifts, there is one quality which I think in this book is singularly absent, the quality of reserve, a quality by no means merely negative, and so indispensable to the full effect of all artistic means, whether in art itself, or poetry, or the finer sorts of literature, that in one who possesses gifts for those things its cultivation or acquisition is neither more nor less than loyalty to his subject and

his work. I note the absence of this reserve in many turns of expression, in the choice sometimes of detail and metaphor, in the very bulk of the present volume, which yet needs only this one quality, in addition to the

5 writer's other admirable qualities of conception and execution, to make this first part of his work wholly worthy of his design.

<div align="right">Walter H. Pater</div>

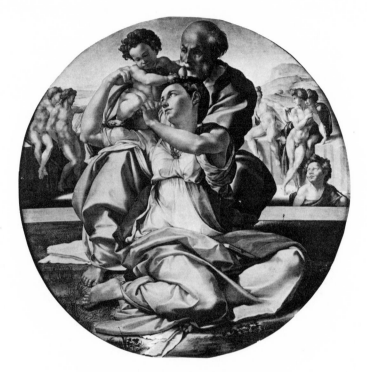

MICHELANGELO
The Holy Family (Doni Tondo), Uffizi.

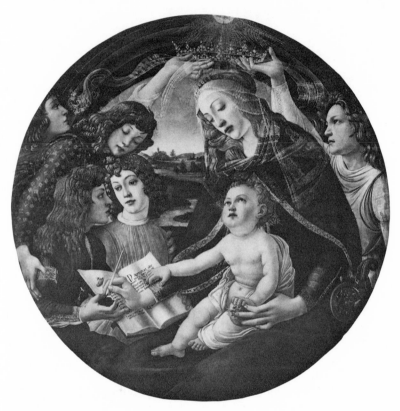

BOTTICELLI
The Madonna of the Magnificat, Uffizi.

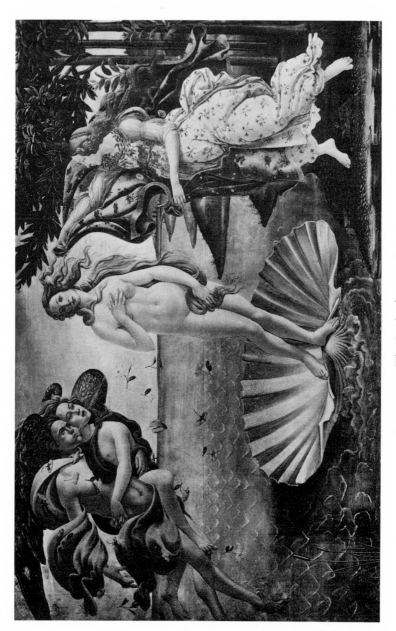

BOTTICELLI *The Birth of Venus*, Louvre.

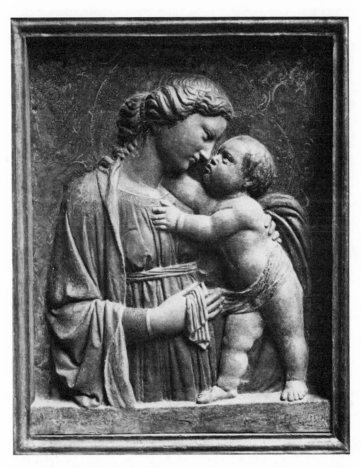

LUCA DELLA ROBBIA
Virgin and Child, Bargello, Florence.

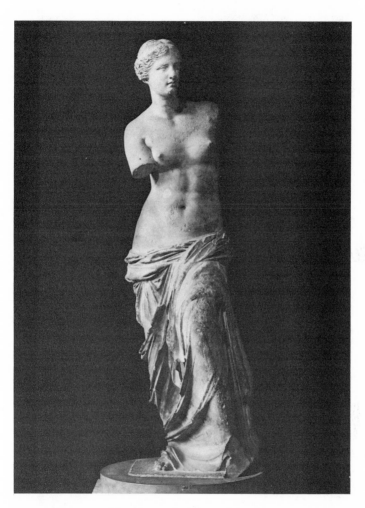

The Venus of Melos, Louvre.

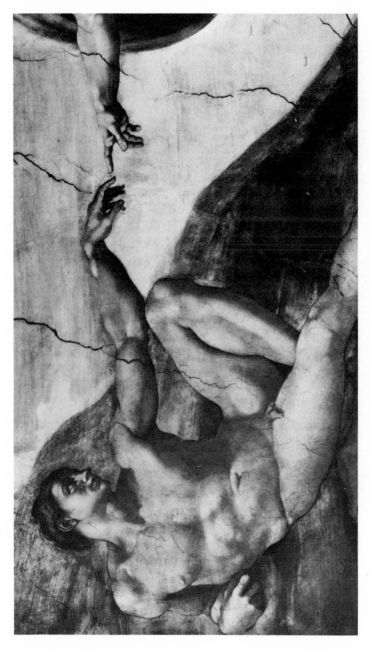

MICHELANGELO Detail from *The Creation of Adam*, Sistine Chapel.

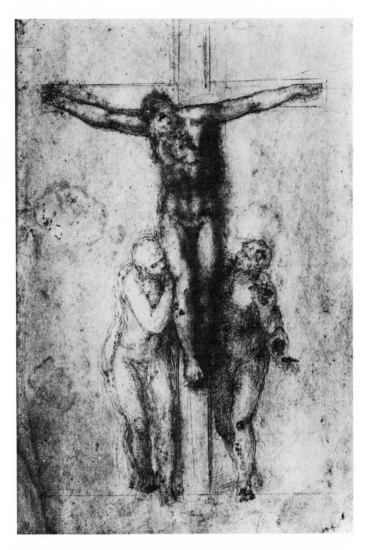

MICHELANGELO
The Crucifixion, British Museum.

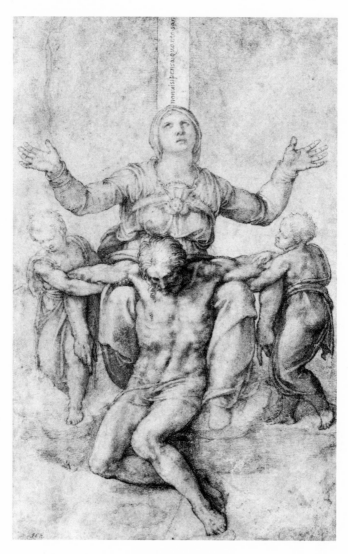

MICHELANGELO
Pietà, Isabella Stewart Gardner Museum, Boston.

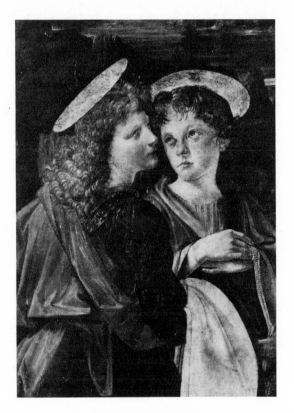

LEONARDO DA VINCI
Detail from Verrocchio's *Baptism of Christ*, Uffizi.

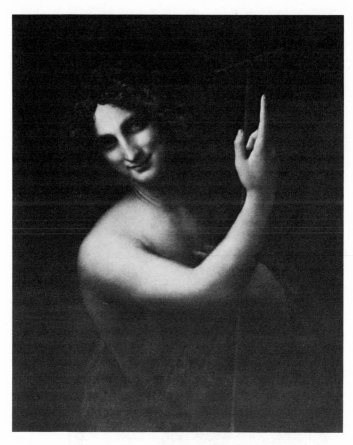

LEONARDO DA VINCI
St. John the Baptist, Louvre.

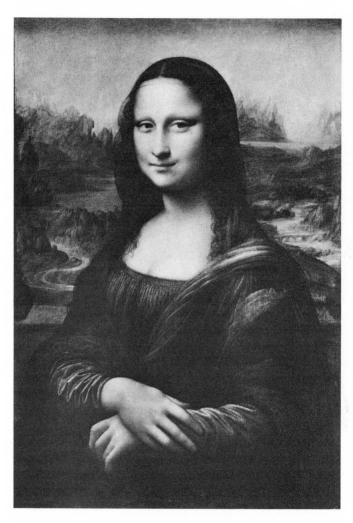

LEONARDO DA VINCI
Mona Lisa, Louvre.

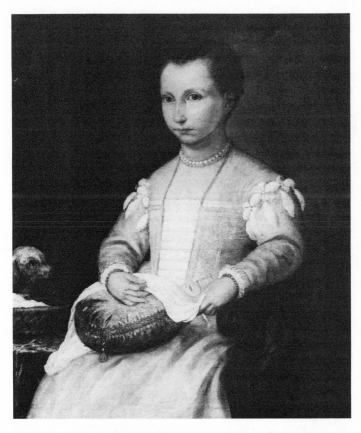

SOFONISBA ANGUISCIOLA
The Lace-Maker, Collection of Pietro Scarpa, Venice.

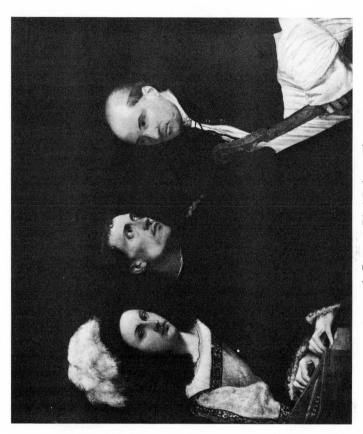

TITIAN *A Concert*, Pitti Palace, Florence.

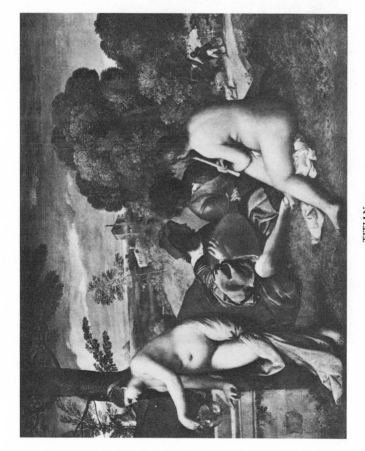

TITIAN
Fête Champêtre, Louvre.

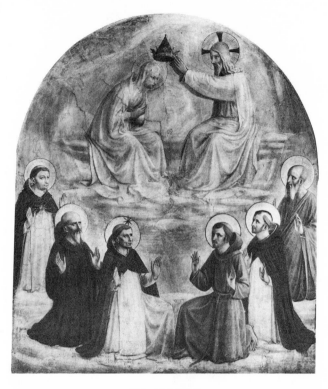

FRA ANGELICO
Coronation of the Virgin, Convent of St. Mark's, Florence.

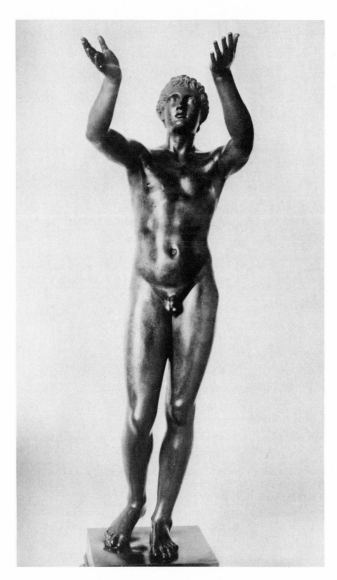

Boy Praying, Berlin State Museum.

A Pater Chronology

1839	Born August 4, the second son of Richard Glode Pater, a physician, and his wife Maria Hill. There were three other children: William Thompson (1835–1887), Hester Maria (1837–1922), and Clara Ann (1841–1910).
1842	Family moved, at father's death, to a house in Chase Side, Enfield, where Pater attended Enfield Grammar School.
1853	Enrolled at King's School, Canterbury.
1854	Mother died February 25.
1858	Entered Queen's College, Oxford, as a commoner with an exhibition (worth sixty pounds a year for three years) from King's School, Canterbury. Spent Christmas in Heidelberg, where his aunt Hester E. M. Pater ("Aunt Bessey") had taken his sisters to complete their education.
1859	Spent the Long Vacation in Germany, returning to Oxford in October.
1861	During the Lent term (January–March) prepared a weekly paper for Benjamin Jowett, professor of Greek, later master of Balliol.
1862	Took a B.A. degree with second-class honors in Literae Humaniores. Then rented rooms in Oxford and read with private pupils, among them Charles Lancelot Shadwell, afterwards fellow and provost of Oriel, his friend and ultimately his literary executor. "Aunt Bessey" died in Dresden, December 28.
1863	Elected member of Old Mortality, an essay society which flourished at Oxford between 1858 and 1865.
1864	Elected probationary fellow of Brasenose College on February 5; went into residence there.

	Spent the Long Vacation in Paris with his sisters. Read before Old Mortality at Oxford the essay "Diaphanéité," first published in *Miscellaneous Studies* (1895).
1865	In the company of his friend Shadwell, made his first journey to Italy, visiting Ravenna, Pisa, and Florence.
1866	"Coleridge's Writings," his first publication, appeared anonymously in the January *Westminster Review*.
1867	Became Lecturer at Brasenose. "Winckelmann" appeared anonymously in the January *Westminster Review*.
1868	Left London about August 1 for five weeks abroad. "Poems by William Morris" appeared anonymously in the October *Westminster Review*.
1869	In the autumn settled with his sisters in a house on Bradmore Road in Oxford. "Notes on Lionardo da Vinci" appeared over his name in the November *Fortnightly Review*.
1870	"A Fragment on Sandro Botticelli" appeared over his name in the August *Fortnightly Review*.
1871	"Pico della Mirandula" appeared over his name in the October *Fortnightly Review* and "The Poetry of Michelangelo," also signed, in the same journal in November.
1872	Review of Sidney Colvin's *Children in Italian and English Design* (1872) appeared over his name in the *Academy* for July 15. Visited Arezzo in August.
1873	*Studies in the History of the Renaissance* published February 15.
1874	"On Wordsworth" appeared over his name in the April *Fortnightly Review* and "A Fragment on *Measure for Measure*," also signed, in the same journal in November.
1875	Review of John Addington Symonds's *Renais-*

sance in Italy: The Age of the Despots (1875) appeared over his name in the *Academy* for July 31.

1877 *The Renaissance: Studies in Art and Poetry* (2d ed.) was published on May 24. "The School of Giorgione" appeared over his name in the October *Fortnightly Review*.

1878 Prepared but cancelled a book of essays entitled "Dionysus and Other Studies." In the autumn delivered lectures on classical archeology, the first (it is said) on the subject given at Oxford.

1882 Left England about December 1 for seven weeks in Italy, chiefly at Rome, where he had not been before.

1883 Resigned the tutorship at Brasenose College.

1885 *Marius the Epicurean* published March 4. In August moved with his sisters to 12 Earl's Terrace, Kensington, London, but continued to live during terms at Brasenose.

1887 *Imaginary Portraits* published May 24.

1888 *The Renaissance* (3d ed.) appeared in January.

1889 *Appreciations* published November 15.

1893 *Plato and Platonism* published February 10. During the summer Pater and his sisters took a house at 64 St. Giles, Oxford. *The Renaissance* (4th ed.) appeared in December.

1894 Died July 30 in Oxford.

1895 *Greek Studies: A Series of Essays* published January 11. *Miscellaneous Studies: A Series of Essays* published October 11.

1896 *Gaston de Latour: An Unfinished Romance* published October 6.

1900–1901 *The Works of Walter Pater*, Edition de Luxe, published in 8 vols.; Vol. I, *The Renaissance*, appeared in September 1900.

1910 *The Works of Walter Pater*, New Library Edition, published in 10 vols.; Vol. I, *The Renaissance*, appeared in June.

Textual Notes

The Renaissance:
Studies in Art and Poetry

The numbers 73, 77, etc., refer to
editions of 1873, 1877, etc.
Virgules differentiate lines on title page.

73. Studies / in the History of the Renaissance / By / Walter
H. Pater / Fellow of Brasenose College, Oxford / Lon-
don / Macmillan and Co. / 1873 / [*All rights reserved*]

77. The Renaissance / Studies in Art and Poetry / By / Walter
Pater / Fellow of Brasenose College, Oxford / Second
Edition, Revised / London / Macmillan and Co. / 1877 /
[*All rights reserved*]

88. The Renaissance / Studies in Art and Poetry / By / Walter
Pater / Fellow of Brasenose College / Third Edition, Re-
vised and Enlarged / Macmillan and Co. / London and
New York / 1888 / *All rights reserved*

93. The Renaissance / Studies in Art and Poetry / By Walter
Pater / Fellow of Brasenose College / Sixth Thousand /
Macmillan and Co. / London and New York / 1893 / *All
rights reserved*

00. The Renaissance / Studies in Art and Poetry / By / Walter
Pater / Fellow of Brasenose College / London / Mac-
millan and Co., Limited / New York: The Macmillan
Company / 1900 / *All rights reserved*

10. The Renaissance / Studies in Art and Poetry / By / Walter
Pater / Macmillan and Co., Limited / St. Martin's Street,
London / 1910

[xviii]. To / C. L. S. 73, 77
FACING [xix]. [EPIGRAPH] NOT IN 73, 77, 88, 00, 10

Preface

Texts: 73, 77, 88, 93, 00, 10

Two Early French Stories

Texts: 73, 77, 88, 93, 00, 10

2:31. Pilon, and thus heals that 73, 77, 88, 00
3:4–5. rather the profane poetry of the middle age, the 73, 77, 88, 00
3:8. this Renaissance within the middle age. In 73, 77, 88, 00
3:9. passion, in its 73, 77, 88
3:11. great clerk and 73, 77, 88, 00
3:13. intelligence round all 73, 77
3:15. NO ¶ 73, 77, 88, 00; Abelard, that legend 73, 77, 88
3:23. be his orphan 73
3:23–24. niece, his love for whom he had testified by 73, 77, 88, 00
3:25. rumour even asserted 73, 77, 88, 00
3:29. as they sat together in that shadowy home, to 73
3:32–33. scholar in that dreamy tranquillity, who, amid 73; who, in that dreamy tranquillity, amid 77
4:2. and how for 73, 77; well to 73, 77
4:3. abstract idea, those 73, 77, 88, 00
4:8. *Trouvères*, of 73, 77, 88, 00
4:10. predecessor; it 73; predecessor. It 77, 88, 00
4:13. NO ¶ 73, 77, 88, 00
4:15. the "mountain" of Saint Genevieve, the 73, 77
4:21. ¶ And 73
4:22. of that shadowy 73, 77
4:28. echo in 73, 77, 88, 00
4:29–12:8. NOT IN 73
5:8. and had abstained 77, 88, 00
5:11. NO ¶ 77, 88, 00
5:12. at what was then the 77, 88, 00
5:13–14. religion. So soon, thought and said the Pope, as 77
5:16. sooner; and 77, 88, 00
5:18. flowers." [IN ERROR] So 88, 00

5:24. Rome; what 77, 88, 00
6:3. the mere professional 77
6:7. quick, as theirs 77
6:7–8. dead, reaching out to and attaining modes 77
6:9–10. though possibly contained in essential germ within 77, 88, 00
6:13. own; after 77, 88, 00
6:28. is a 77
7:15. refer part of 77, 88, 00
7:17. had hitherto made 77, 88, 00
7:18. sweet with 77, 88, 00; offices—though the friendship is saved at last? 77, 88, 00
7:21. heroes, so that they 77, 88, 00
7:27. again, like 77, 88, 00
7:28. similitude, is connected the 77, 88, 00
8:2. whither their parents 77, 88
8:3–4. purpose, out of gratitude for their birth, and cross and recross in 77, 88; in thankfulness for their birth, and cross and recross in 00
8:7. poem, in keeping 77
8:9. enters; with a heightening also of that sense 77, 88, 00
8:12–13. handkerchief; and witnessing to 77, 88, 00
8:14. by primitive people, almost dazzled by it, 77, 88, 00
8:16. human story. 77, 88
8:18. and at last it 77, 88
8:20. death. After that it 77; death. "After that it 88
8:22–23. him; and he departed from 77, 88, 00
8:24. Amile; and 77
8:27. he commanded, carried 77, 88, 00
9:2. was thy cup, for 77
9:5. when he stood before his comrade he demanded 77
9:11. France for his 77
9:12. began to weep greatly, 77, 88, 00

9:35.	spoken to thee?	77
9:37.	spoken to thee.	77
10:4.	Amile to slay	77
10:5.	and thou	77, 88, 00
10:17.	baptism which we	77
10:19.	answered, So	77, 88, 00
10:38.	they were sleeping: and	77, 88, 00
11:9.	heard them, they	77
11:11.	coming, began to ask which	77, 88, 00
11:21.	because of their death, and	77, 88, 00
11:25.	them playing in	77
12:1.	which even a	77, 88, 00
12:3.	element of its	77, 88, 00
12:26.	SUPERSCRIPT NOT IN	73, 77
12:27.	NO ¶ 73, 77, 88, 00, 10; interest by the	73, 77
12:28–34.	NOT IN	73, 77
12:29–30.	Bourdillon. More recently still we	88, 00
13:2.	on from one	73, 77, 88
13:3.	clear and its	73, 77, 88
13:21.	interest is in	73, 77
13:22.	A new music is	73, 77, 88, 00
13:29.	NO ¶	73, 77, 88, 00
14:1.	of part of	73, 77, 88, 00
14:12.	One still sees 73, 77, 88, 00; forest of Gastein, with 73; *forest of Gatine*, with	77
14:19.	burlesque too, so	73, 77
14:21.	piece has certainly this	73, 77
15:4.	itself; unless	73, 77, 88, 00
15:7–8.	proper object of	73
15:8–9.	criticism. These qualities, when they exist, it	73, 77
15:13.	has some of these qualities. Aucassin	73, 77
15:24–25.	forest as 73; she has escaped from	77, 88, 00
16:5.	a faint Eastern delicacy in	73
16:23.	of early prose 73; escape from this place.	73, 77, 88, 00

16:26. of the May 73
16:32. who so mortally 73, 77, 88, 00
17:2. bed-clothes, and other pieces of stuff, and
 knotted 73, 77
17:6–7. was fair, in small curls, her eyes smiling and 5
 of a greenish-blue colour, her face feat and
 clear, the 73, 77
17:13. the street, to avoid the light 73, 77; the way
 to avoid the light 88, 00
17:17. herself close in 73 10
17:20. listened a while she 73, 77
17:31. of that ideal 73, 77
18:5. the slim, tall, debonair figure, *dansellon*,
 73, 77, 88, 00
18:6. with curled 73, 77, 88, 00 15
18:10. at evening because 73, 77, 88, 00
18:11. love, so that he neglects 73, 77, 88, 00
18:22. that strong malady 73, 77
18:22–23. him, so that the 73, 77, 88, 00
18:24–25. of the enemy, and 73 20
18:32. the age. In 73
19:3. the primitive Christian 73
19:4. became a strange idolatry, 73
19:8–11. disguises. The perfection of culture is not re-
 bellion but peace; only when it has realised a 25
 deep moral stillness has it really reached its
 end. But often on the way to that end there is
 room for a noble antinomianism. This ele-
 ment in the middle age, so often ignored by
 those writers on it, who have said so much of 30
 the 'Ages of Faith,' this 73, 77
19:19. age, this rebellious element, this sinister 73,
 77, 88, 00
19:29. a spirit of freedom, in which law has passed
 73, 77 35
19:32. Aucassin makes when 73
19:33–22:19. NOT IN 73, WHICH HAS INSTEAD: mistress. ¶
 'En paradis qu'ai-je à faire[1]? [FOOTNOTE:

[1]I quote Fauriel's modernised version, in which he has retained however, some archaic colour, *quelques légères teintes d'archäisme.*] répondit Aucassin. Je ne me soucie d'y aller, pourvu qui j'aie seulement Nicolette, ma douce mie, qui j'aime tant. Qui va en paradis, sinon telles gens, comme je vous dirai bien? Ces vieux prêtres y vont, ces vieux boiteux, ces vieux manchots, qui jour et nuit se cramponnent aux autels, et aux chapelles. Aussi y vont ces vieux moines en guenilles, qui marchent nu-pieds ou en sandales rapiécetées, qui meurent de faim, de soif et de mésaises. Voilà ceux qui vont en paradis; et avec telles gens n'ai je que faire. Mais en enfer je veux bien aller; car en enfer vont les bons clercs et les beaux chevaliers morts en bataille et en fortes guerres, les braves sergents d'armes et les hommes de parage. Et avec tous ceux-là veux-je bien aller. En enfer aussi vont les belles courtoises dames qui, avec leurs maris, ont deux amis ou trois. L'or et l'argent y vont, les belles fourrures, le vair et le gris. Les joueurs de harpe y vont, les jongleurs et les rois du monde; et avec eux tous veux-je aller, pourvu seulement q'avec moi j'aie Nicolette, ma très-douce mie.'

19:33–20:13. mistress; a passage in which that note of rebellion is too strident for me to translate it here, though it has its more subdued echoes in our English Chaucer. ¶ For in 77

20:2. feeble company 88, 00
20:21. sympathies. That opposition 77
20:22. to the more 77
20:24. I noted 77
20:26. incompatibility of souls 77, 88, 00
20:28–29. guard: here 77, 88, 00

20:30–21:1. which whatsoever things are comely are 77
21:6. time to time become its 77
21:10. kindred, live in 77
21:11. breathing-place, and refuse to 77, 00;
 breathing-place, and refuses to 88 5
21:15. harsh; let me conclude with 77, 88, 00
21:20. *Amile*; it 77
21:21–22. that they were 77
21:22. martyrology, and then out of deference to a
 sort of modern criticism; and their 77 10
21:31. *greatly; and there were built there two* 77, 88,
 00
22:5. *lo! the next* 77, 88
22:14. *gifts; and* 77, 88, 00
22:19. NOT IN 73, 77

Pico Della Mirandola

Fortn. Fortnightly Review, X, n.s. (October 1, 1871),
377–386. Reprinted 73, 77, 88, 93, 00, 10

TITLE: Pico della Mirandola *Fortn.*, 73
23:7. to each other in *Fortn.*, 73, 77, 88, 00
23:8. give the human spirit for the heart *Fortn.*,
 73, 77
24:1. expression about the *Fortn.*, 73, 77
24:2. it much of *Fortn.*, 73, 77, 88, 00
24:14. themselves exposed to the *Fortn.*, 73
24:15. been reduced during *Fortn.*
24:20. disguises. Most of them betook *Fortn.*, 73,
 77
24:27. emigrants, entirely *Fortn.*, 73
24:27–28. ambrosia, had now to take *Fortn.*, 73
24:29. bread. In these *Fortn.*, 73, 77
24:31. and had to *Fortn.*, 73
25:8. sick. And some time afterwards *Fortn.*, 73,
 88, 00; sick. And sometime afterwards 77

25:9. again, so that 88, oo
25:32. and people *Fortn.*, 73
26:7. are laid to rest; just *Fortn.*, 73
26:8–9. are reconciled in the experience of an individual. *Fortn.*, 73
26:10. NO ¶ *Fortn.*, 73, 77, 88, oo
26:14–15. and judges each intellectual product in connection with the age which produced it; they *Fortn.*, 73; proceeded; they 77, 88, oo
26:16–17. ages, of the gradual education of the human race. In *Fortn.*, 73, 77, 88, oo
26:19. back on the *Fortn.*, 73
26:21. a gradual development *Fortn.*, 73, 77, 88, oo
26:23. with each other. And *Fortn.*, 73, 77, 88, oo
27:14. time; and *Fortn.*, 73, 77, 88, oo
27:23. works this life *Fortn.*, 73, 77, 88, oo
28:7. with its periodical *Fortn.*
28:8. villa of Careggi *Fortn.*, 73, 77, 88, oo [THIS VERSION JUDGED CORRECT AND RESTORED FOR THIS EDITION.—D.L.H.]
28:24. NO ¶ *Fortn.*, 73, 77, 88, oo
29:12. During that conversation *Fortn.*, 73, 77
29:21–22. Florence. He was then about twenty years old, having been born in 1463. He *Fortn.*, 73, 77, 88, oo
29:31. had a presentiment *Fortn.*, 73, 77, 88
30:11. with each other, and *Fortn.*, 73, 77, 88, oo
30:20. Alexander VI. Ten *Fortn.*
31:12. of earthly elements 77
31:16. NO ¶ *Fortn.*, 73, 77, 88, oo; schools; but *Fortn.*
31:23–24. right; and it *Fortn.*, 73, 77, 88
32:8. of the grey-headed father of all *Fortn.*, 73, 77, 88, oo
32:13. awe and superstition *Fortn.*, 73, 77
32:24. been such a *Fortn.*, 73, 77, 88, oo
33:4–5. of that abstract, disembodied *Fortn.*, 73, 77,

88; beauty which the Platonists *Fortn.*, 73, 77

33:6. for had already touched him; *Fortn.*, 73, 77; for was already upon him; 88, oo; him; and perhaps it was a sense of this, coupled *Fortn.*, 73, 77, 88, oo

33:7. over-brightness of his, which *Fortn.*, 73, 77

33:8. death, that made *Fortn.*, 73, 77, 88, oo

33:9. those prophetesses whom *Fortn.*, 73, 77

33:10–11. Florence, prophesy, seeing *Fortn.*, 73, 77

33:14. they have sprung *Fortn.*, 73, 77; up. It was now that he wrote *Fortn.*, 73, 77, 88, oo

33:30. the claims on *Fortn.*, 73, 77, 88, oo

34:8. in 1794 [IN ERROR], when *Fortn.*

34:10. Charles VIII. entered *Fortn.*

34:13–14. the cloister at St. Mark's, in *Fortn.*, 73, 77, 88, oo

34:22. perfect an analogue to *Fortn.*, 73

35:14. of analogies. Every *Fortn.*, 73

35:15. the material world *Fortn.*, 73, 77, 88

35:19–20. and there is in the super-celestial world the fire *Fortn.*, 73, 77, 88

35:33. a real desire *Fortn.*, 73, 77, 88, oo

36:3. all, there is a *Fortn.*, 73, 77, 88

36:10. movements upwards of *Fortn.*, 73, 77

36:29. dead religion, the *Fortn.*, 73, 77

37:2. Santo of Pisa, *Fortn.*, 73

37:10. as a mere datum to *Fortn.*, 73, 77

37:12–13. concerning its origin, its primary *Fortn.*, 73, 77, 88, oo

37:14. it. It sank *Fortn.*, 73, 77, 88, oo

37:16. medieval sentiments and *Fortn.*, 73, 77, 88

37:21. introduced other *Fortn.*, 73, 77, 88

37:22. flowers, and he *Fortn.*, 73, 77, 88, oo; given that *Fortn.*, 73

37:25. It is because this *Fortn.*, 73, 77, 88, oo

37:27–28. person, that the *Fortn.*, 73, 77, 88, oo

37:29. of oneself, to *Fortn.*, 73, 77, 88, 00
38:12. and he himself *Fortn.*, 73, 77, 88, 00
38:18. that one belief *Fortn.*, 73
38:22. oracle by which *Fortn.*, 73
38:26. NOT IN *Fortn.*, 73, 77

Sandro Botticelli

Fortn. Fortnightly Review, VIII, n.s. (August, 1870), 155–160. Reprinted 73, 77, 88, 93, 00, 10

TITLE: A Fragment on Sandro Botticelli. *Fortn.*
39:17. religious subjects, painted *Fortn.*, 73
40:3. Castagno; but *Fortn.*, 73, 77, 00; Castegno [IN ERROR]; but 88
41:12. into form, *Fortn.*, 73, 77, 88, 00
41:15. an invention about *Fortn.*, 73, 77, 88, 00
42:4. the exponents of *Fortn.*, 73
42:5. own; with this *Fortn.*, 73
42:10. moreover, through some 77
42:11. subtle structure of his, a mood *Fortn.*; subtle structure of his own, a mood 73, 77
42:13–14. with sensuous circumstances. *Fortn.*, 73, 77; with sensuous circumstance. 88, 00
42:17. the easy formula *Fortn.*, 73, 77
42:24. *Città Divina* [IN ERROR], which *Fortn.*, 73, 77, 88, 93, 00, 10 [CORRECTED FOR THIS EDITION]
42:27. for God nor *Fortn.*, 73
43:5. as he are *Fortn.*
44:19. was even something in them mean or abject, for *Fortn.*, 73, 77
44:23. for God nor *Fortn.*, 73
45:4. and support *Fortn.*, 73; book; but *Fortn.*, 73, 77, 88, 00
45:7. others, in the midst of whom, *Fortn.*, 73, 77
46:16. is the central myth. The *Fortn.*, 73, 77, 88,

Luca Della Robbia

Texts: 73, 77, 88, 93, oo, 10

51:5. form which tries vainly 73, 77

51:6–7. sculpture is constantly struggling; each 73, 77

51:8–9. relieving its hardness, its heaviness 73, 77, 88, oo

51:14. the too fixed 73, 77, 88, oo

51:23–25. individual, to purge from the individual all that belongs only to the individual, all 73, 77

51:25–28. accidents, feelings, actions of a special moment, all that in its [own 77] nature enduring [but 77] for a moment looks like a frozen thing if you arrest it, to abstract and express only what is permanent, structural, abiding [is structural and permanent 77]. 73, 77

51:31. hence that broad humanity 73, 77

52:5–6. involved for the most part the 73

52:8–12. type, which purged away from the individual all that belonged only to him, all the accidents of a particular time and place, left the Greek sculptor only a narrow and passionless range of effects: and when Michelangelo came, with 73

52:11–12. limits strictly defined; 77

52:12. defined; and when Michelangelo came, with 77, 88, oo

52:16. of inward experiences, 73, 77, 88, oo

52:17–18. sacrificed what was inward could 73, 77

52:21–22. expression, character, feeling, 73, 77

52:27. too hard realism 73, 77, 88, oo

52:28–29. tendency which the representation of feeling in sculpture always has to harden into caricature. What 73, 77

52:29. sculpture must always have. What 88, oo

52:31. farm,' has done with a singular 73, 77

53:2. out of it, as if in 73, 77

53:3–5. age, so that of all ancient work its effect is

most like that of Michelangelo's own sculp-
ture;—this [own work—this 77] 73, 77
53:6. leaving all 73
53:11. Pitti, lurks about all his sculpture, as 73
53:16. it, feeling 73
53:17. if that half-hewn form 73
53:18–19. the rough hewn stone: and 73
53:23. form, relieving its hard realism, communi-
cating 73; its hard realism 77, 88, 00
53:26. of life, his 73, 77, 88
53:27. hesitations. It 73
53:29. the expression of 73
54:3. only in pure 73
54:4. all the others, and 73
54:5. that expression of 73, 77, 88, 00
54:6. which would otherwise 73, 77, 88; have
hardened into 73, 77, 88, 00
54:8. expression: their 73, 77, 88, 00
54:9. the studied sepulchral 73, 77, 88, 00
54:10. particular individuals—the tomb of 73
54:11. the Abbey of Florence, the tomb of 73
54:14–18. Bergamo; and they unite the element of tran-
quillity, of repose, to this intense and indi-
vidualised expression 73, 77
54:14. monuments which abound 88, 00
54:17–18. refinement:—and they unite these elements
of tranquillity, of repose, to that intense 88,
00
54:20. Greeks, by subduing all the curves which
indicate 73, 77; Greeks, subduing all 88,
00
54:21. into lower relief 77, 88, 00
54:29. foremost sculptors of that age, 73, 77, 88,
00
54:30. spirit, the manner 73, 77
55:8. was of plain white at 73, 77
55:12. of oriental 73, 77
55:17. are still famous. These 73, 77, 88, 00

55:20. his terra-cotta figures simply 73

55:22–23. them. Cosa singolare, e molto utile per lo state!' 73

55:28. nature. But in his nobler terra-cottas [*terra-cotta* work 88, 00], he never introduces colour into the flesh, keeping mostly to blue and white, the colours of the Virgin Mary. 73, 77, 88, 00

55:29. the work of 73, 77, 88, 00

55:30. an extreme degree that peculiar characteristic 73

55:33–56:1. bring the workman himself very 73, 77

56:1. us, the impress 73, 77, 88, 00

56:3. meant a subtler 73, 77

56:6. call expression carried 73, 77

56:9–10. yet at bottom perhaps it is the characteristic which 73; perhaps, is the quality which 77; makes works in the imaginative and moral order 73, 77, 88, 00

56:13. unmistakable degree that 73

56:14. to oneself the 73, 77, 88, 00

56:16. NOT IN 73, 77

The Poetry of Michelangelo

Fortn. *Fortnightly Review*, X, n.s. (November, 1871), 559–570. Reprinted 73, 77, 88, 93, 00, 10

57:22. forbidding, but felt *Fortn.*, 73, 77, 88, 00

57:26. precisely the quality *Fortn.*, 73, 77, 88, 00

58:13. him. "When *Fortn.*; him, 'When 73

58:21. conceptions; no *Fortn.*, 73, 77, 88, 00

58:30. the creation of *Fortn.*, 73, 77, 88, 00

59:7. which expresses so *Fortn.*, 73

59:9. something rough and *Fortn.*, 73

59:10. the rough hill-side *Fortn.*, 73

59:11. more expectation and *Fortn.*, 73, 77, 88, 00

59:23. Sistine; and *Fortn.*, 73
59:25–26. bird. He secures *Fortn.*, 73, 77
59:30. which I suppose no *Fortn.*, 73, 77, 88, 00
59:32. half-emerged form. *Fortn.*, 73
60:3. life; they *Fortn.*, 73, 77, 88, 00
60:4. scurf to rise *Fortn.*, 73
60:12. of unhewn stone, *Fortn.*, 73
60:17. us no *Fortn.*, 73
60:17–18. Leonardo [Lionardo 73], but only blank ranges of rock, and dim vegetable forms as blank as they; no *Fortn.*, 73
60:24. garments." But *Fortn.*, 73
60:25. a sense of *Fortn.*, 73, 77, 88, 00
60:26. world, and the *Fortn.*, 73, 77, 88, 00
61:1. which it was then thought was favourable *Fortn.*, 73, 77, 88; which, as was then thought, being favourable 00
61:15. among the antiques of *Fortn.*
61:19. blow in the *Fortn.*, 73
61:20. the dignity of *Fortn.*, 73, 77
61:22. NO ¶ *Fortn.*, 73, 77, 88, 00
61:26. omens. A friend of his dreamed *Fortn.*, 73
61:30. which characterised all *Fortn.*
62:3. magistrates interfered. He *Fortn.*, 73
62:9. and dark *Fortn.*, 73
62:11. sculptors, John of Pisa *Fortn.*
62:12. as soft as *Fortn.*, 73, 77
62:15. unique conception of *Fortn.*, 73, 77
62:18. ever gave more *Fortn.*
62:25. which now stands on *Fortn.*, 73
62:26–27. Vecchio. Michelangelo *Fortn.*, 73
63:4. seek; a *Fortn.*, 73, 77, 88, 00
63:10. As one comes in *Fortn.*, 73, 77, 88
64:6–7. always a mere *Fortn.*, 73, 77
64:9. sometimes would *Fortn.*, 73, 77
64:26. done merely to *Fortn.*, 73

64:29. poor squabbles about *Fortn.*

65:15–16. Dante. *Sa reputation s'affirmira toujours*, Voltaire says of Dante, *parce qu'on ne le lit guère.* But *Fortn.*, 73, 77

65:20. the poems. A *Fortn.*

65:24. SUPERSCRIPT NOT IN *Fortn.*, 73, 77

65:32–33. NOT IN *Fortn.*, 73, 77; much poetic taste and skill, by 88, 00

66:13. whose hold on outward things *Fortn.*, 73, 77, 88, 00; letter of his still *Fortn.*

66:22. *muovi*; is *Fortn.*, 73, 77, 88, 00; *stato*— Plato's *Fortn.*, 73, 77, 88, 00

66:23. Plato's anti[*sic*]-natal state 88, 93 [CORRECTED FOR THIS EDITION], 00

67:2. to make sonnets about them, was *Fortn.*, 73, 77, 88, 00

67:12. and thin. Their *Fortn.*, 73, 77, 88, 00

67:16. rises as a *Fortn.*, 73, 77, 88, 00

67:22. is a well-defined *Fortn.*

67:26. Vittoria in it, is *Fortn.*, 73, 77; Vittoria there is 88, 00

67:29. NO ¶ *Fortn.*, 73, 77, 88, 00

68:3. later Petrarchists; and *Fortn.*, 73

68:14. opposite. And it *Fortn.*, 73, 77; opposite; and it 88, 00

68:21–22. Vittoria is *Fortn.*, 73, 77, 88, 00

69:2. eye. Michelangelo *Fortn.*, 73, 77, 88, 00

69:11. *prima.*★ [FOOTNOTE:] ★The 'Contemporary Review' for September, 1872, contains translations of 'Twenty-three Sonnets from Michel Angelo,' executed with great taste and skill, from the original text as published by Guasti. 73, 77 I venture to quote the following:—

To Vittoria Colonna.
Bring back the time when blind desire ran free,

224

With bit and rein too loose to curb his
 flight;
 Give back the buried face, once angel-
 bright,
That hides in earth all comely things from
 me;
Bring back those journeys ta'en so toil-
 somely,
 So toilsome slow to him whose hairs are
 white;
 Those tears and flames that in our breast
 unite;
If thou wilt once more take thy fill of me!
Yet, Love! suppose it true that thou dost
 thrive
Only on bitter honey-dews of tears,
Small profit hast thou of a weak old man.
My soul that toward the other shore doth
 strive,
Wards off thy darts with shafts of holier
 fears;
And fire feeds ill on brands no breath can
 fan.

To Tommaso Cavalieri.

Why should I seek to ease intense desire
 With still more tears and windy words of
 grief,
 When heaven, or late or soon, sends no
 relief
To souls whom love hath robed around with
 fire?
Why needs my aching heart to death aspire,
 When all must die? Nay death beyond
 belief
 Unto those eyes would be both sweet and
 brief,
Since in my sum of woes all joys expire!

Therefore because I cannot shun the blow
I rather seek, say who must rule my breast,
Gliding between her gladness and her woe?
 If only chains and bonds can make me
5 blest,
No marvel if alone and bare I go
 An armèd knight's captive and slave
 confessed.

To Night.

10 O night, O sweet though sombre span of
 time!
 All things find rest upon their journey's
 end—
 Whoso hath praised thee well doth
15 apprehend;
And whoso honours thee hath wisdom's
 prime.
Our cares thou canst to quietude sublime,
 For dews and darkness are of peace the
20 friend:
 Often by thee in dreams up-borne I wend
From earth to heaven where yet I hope to
 climb.

Thou shade of Death, through whom the
25 soul at length
Shuns pain and sadness hostile to the heart,
 Whom mourners find their last and sure
 relief,
Thou dost restore our suffering flesh to
30 strength,
Driest our tears, assuagest every smart,
Purging the spirits of the pure from grief.
73

69:14–15. image over the later and feebler Petrarchists.
35 He *Fortn.*, 73; feebler followers of Pe-
 trarch. He 77, 88, 00
69:17–18. than misery full of *Fortn.*, 73, 77, 88, 00

226

69:27.	created *d'angelica forma*, for *Fortn.*, 73, 77
69:30.	him; for, *Fortn.*, 73, 77, 88, oo
70:10.	him. Neo-catholicism had *Fortn.*, 73, him. The *New-catholicism* had 77, 88, oo
70:17.	of the reform to *Fortn.*, 73
70:18.	enlarged on; far *Fortn.*
70:20.	the catholic church *Fortn.*, 73; the Roman Catholic church 77, 88, oo
70:23.	controversy; he *Fortn.*, 73, 77, 88, oo
70:26.	of Mirandula. But *Fortn.*
70:32–33.	the catholic church *Fortn.*, 73
70:33.	over souls too noble to *Fortn.*; over spirits too noble to 73, 77
71:8.	sensibilities too closely; *Fortn.*, 73, 77, 88, oo
71:9.	in life *Fortn.*
72:2.	is passionate, serious, impulsive *Fortn.*, 73
72:14.	independent, abstract *Fortn.*, 73, 77, 88, oo
73:4–5.	refuge from the [danger of death by 88, oo] plague in a country-house. It *Fortn.*, 73, 77, 88, oo
73:14–15.	Cardinal of Portugal dies *Fortn.*, 73
73:16–17.	say; Rossellino carved his *Fortn.*, 73; say— Antonio Rossellino carves his 77
73:19.	Robbia put his *Fortn.*
73:32.	by their high Italian dignity and culture, *Fortn.*, 73, 77, 88, oo
74:6.	a grand indifference. *Fortn.*, 73
74:7–8.	distinction; and following *Fortn.*, 73, 77, 88, oo; further, and dwelling *Fortn.*, 73, 77; farther, and dwelling 88
74:8–9.	all that transitory dignity broke up, *Fortn.*, 73, 77; all that transitory dignity must break up, 88, oo
74:13–14.	all of pity—*pietà*, pity, the pity of the virgin mother *Fortn.*
74:16.	stones;" that is *Fortn.*, 73, 77, 88, oo
74:23.	between his mother's *Fortn.*, 73, 77

74:24–25. tombs at San *Fortn.*, 73
74:32. them; they come *Fortn.*, 73, 77; them; for those figures come 88
75:2. possibly be. They *Fortn.*, 73
75:6. and define themselves and *Fortn.*, 73, 77, 88, oo
75:9–10. come here for *Fortn.*, 73, 77
75:12. of terrible nor consoling thoughts *Fortn.*, 73, 77, 88, oo
75:16. firm, as much so almost as *Fortn.*, 73, 77, 88, oo
75:28. inquiry, the relapse *Fortn.*, 73
75:29–30. life, change, revolt *Fortn.*, 73
76:11. standards, revealing *Fortn.*, 73, 77
76:15. than their analogues in *Fortn.*, 73, 77, 88, oo
76:16. confused production of *Fortn.*
76:17. once one has succeeded in defining for one's-self [oneself 73] those *Fortn.*, 73
76:18–19. combination, one has acquired *Fortn.*, 73
76:22. products. It *Fortn.*, 73
76:32. NOT IN *Fortn.*, 73, 77

Leonardo da Vinci

Fortn. *Fortnightly Review*, VI, n.s. (November, 1869), 494–508. Reprinted 73, 77, 88, 93, oo, 10

TITLE: Notes on Leonardo da Vinci. *Fortn.*; Lionardo da Vinci. 73
EPIGRAPH: NOT IN *Fortn.*, 73, 77
77:9. is a tendency *Fortn.*
77:12. time-honoured form in *Fortn.*, 73, 77
77:14. high indifferentism, his *Fortn.*, 73, common form of 77
77:21. the works on *Fortn.*, 73, 77, 88, oo
77:22. world, as the *Fortn.*, 73, 77, 88, oo

77:24. the work of meaner hands, as the *Fortn.*,
 73, 77, 88, oo
78:2. and sacred wisdom [IN ERROR]; oo
78:11. one knows, is *Fortn.*, 73, 77, 88, oo
78:12. brilliant in Vasari. *Fortn.*, 73, 77, 88, oo 5
78:15–18. anecdotes intact [untouched 73]. And now
 a French writer, M. Arsène Houssaye, gath-
 ering all that is known about Leonardo in an
 easily accessible form, has done for the third
 of the three great masters what Grimm has 10
 done for Michael Angelo, and Passavant,
 long since, for Raffaelle. Antiquarianism has
 no more to do. For *Fortn.*, 73
78:25. Legend, corrected *Fortn.*, 73, 77, 88, oo
79:4. his youth fascinating *Fortn.*, 73, 77, 88, oo
79:11. smiling. Signor Piero, thinking over *Fortn.*
79:19. a boy into *Fortn.*, 73, 77, 88, oo
80:2. hard and sharp on *Fortn.*, 73, 77, 88, oo
80:9. desire of expanding the *Fortn.*, 73, 77, 88,
 oo
81:4. was the apex of *Fortn.*
81:17. intelligences." So he plunged into *Fortn.*,
 73, 77, 88, oo
81:29. entirely break with art; *Fortn.*
82:2–3. of lines and colours. He *Fortn.*, 73, 77, 88,
 oo
82:5–6. as Giovanni Church, in *Fortn.*
82:7. magic professes to *Fortn.*, 73, 77
82:11. especially fixed in *Fortn.*, 73, 77, 88, oo
82:13. beyond the measure of *Fortn.*, 73, 77, 88,
 oo
82:19. him; and as catching *Fortn.*, 73, 77, 88, oo
82:23. beauty apprehended *Fortn.*, 73, 77, 88, oo
82:31. distorting light of *Fortn.*, 73, 77, 88, oo
83:18. What we may call the *Fortn.*
83:20–21. cheek a rabbit creeps unheeded *Fortn.*
83:26. foreshortening, sloping upwards, almost

sliding down upon us, crown *Fortn.*, 73, 77, 88, oo

83:27. breaks. But it is a subject that may well be left to the beautiful verses of Shelley. *Fortn.*, 73, 77, 88, oo

83:33. years after, compiled *Fortn.*

84:3. But such rigid *Fortn.*

84:4. order was little *Fortn.*, 73, 77, 88, oo

84:7. have of him that *Fortn.*, 73, 77, 88, oo

84:8. those about him received *Fortn.*, 73, 77, 88, oo

84:12. but rather of *Fortn.*, 73, 77, 88, oo

84:30. is thickest here. *Fortn.*

84:32. 1483—year *Fortn.*

85:5–7. susceptible to religious impressions that he turned his worst passions into a kind of religious cultus, and *Fortn.*, 73

85:6. earthly passions with 77, 88, oo

85:13. duke. As *Fortn.*, 73

85:15. harp—strange *Fortn.*

85:18. susceptible to the charm of *Fortn.*, 73; susceptible also of the charm of 77, 88, oo

85:27. to a Florentine *Fortn.*, 73

85:33–86:2. of exquisite amusements—Leonardo became a celebrated designer of pageants—and brilliant sins; and *Fortn.*, 73

86:5. beauty! They are *Fortn.*

86:11. the modern spirit, with *Fortn.*

86:12. experience; it *Fortn.*, 73, 77, 88, oo

86:27. and the gathering *Fortn.*, 73, 77, 88, oo

87:10. all solemn *Fortn.*, 73

87:11. water; you *Fortn.*, 73, 77, 88, oo

87:14. Lake, next, as a goodly river below *Fortn.*, 73, 77, 88, oo

87:19. the hand of *Fortn.*, 73, 77, 88, oo, 10

87:20. shells lie thick *Fortn.*, 73

87:22. grown as fine as 77

87:23. or fancy *Fortn.*

87:25.	Through his strange *Fortn.*, 73
87:33.	on dark *Fortn.*, 73, 77, 88, 00
88:2–3.	invention. So he painted the *Fortn.*, 73, 77, 88, 00
88:9.	Ambrosian. Opposite *Fortn.*, 73
88:16.	art begins *Fortn.*, 73, 77, 88, 00
89:3.	too German and heavy for 88, 00
89:5.	There was *Fortn.*
89:6–7.	had "müde sich gedacht," *thought itself weary.* What *Fortn.*, 73, 77
89:12.	needed; and the *Fortn.*, 73, 77, 88, 00
89:19.	has no *Fortn.*, 73
89:22–23.	is a moment of invention. On this moment he waits; other *Fortn.*, 73, 77, 88, 00
89:25.	as he did. Hence *Fortn.*, 73, 77, 88, 00
90:7.	is something exquisitely tender in *Fortn.*
90:8.	curves of the child *Fortn.*
90:10–12.	mother, indicative of a feeling for maternity always characteristic of Leonardo; a feeling further *Fortn.*
90:14–15.	like tenderness in *Fortn.*
90:17.	uneasy sitting attitude in *Fortn.*, 73; uneasy inclined posture, in 77, 88, 00
90:21–22.	a lion wandering *Fortn.*, 73, 77, 88, 00
90:29–31.	little red chalk drawing, which every one remembers who has seen the drawings at the Louvre. *Fortn.*, 73
90:30.	one remembers who 77, 88, 00
91:3.	but with much *Fortn.*, 73, 77, 88, 00
91:5.	and the *Fortn.*, 73
91:7.	offer, thus *Fortn.*, 73
91:11.	Herodias, their *Fortn.*
91:21–22.	follow; it is as if in certain revealing instances we actually saw them at *Fortn.*, 73, 77, 88, 00
91:24.	faintness, they seem *Fortn.*, 73, 77, 88, 00
91:26.	were, receptacles of *Fortn.*, 73, 77, 88, 00
91:31.	likeness of Salaino *Fortn.*, 73

92:3. recorded; and *Fortn.*, 73, 77, 88, 00
92:10. for which *Fortn.*
92:32. Christ is weighing the 77
93:1. working on some *Fortn.*, 73
93:17. suggests John *Fortn.*
93:18. Ambrosian, and *Fortn.*
93:19. another in *Fortn.*, 73, 77, 88, 00
93:20. the last to *Fortn.*, 73, 77, 88, 00
93:22. it, which *Fortn.*, 73, 77, 88, 00; set Gautier
 Fortn., 73
93:24. themselves, took *Fortn.*
93:29. sentiment, as subtle 73, 77, 88, 00
93:30. over his subject more *Fortn.*, 73, 77, 88, 00
94:4. one quite out of the *Fortn.*, 73, 77, 88, 00
94:8. being far the *Fortn.*, 73, 77, 88, 00
94:13. favourite shrine of *Fortn.*, 73, 77, 88, 00
94:15–16. force. And *Fortn.*
94:17. repose; and a mania for restoring churches
 took possession of the duke. So on *Fortn.*
94:19. Supper. A hundred anecdotes *Fortn.*, 73,
 77, 88, 00; *Supper.* Effective anecdotes 93,
 10 [THE EARLIER READING HAS BEEN JUDGED
 CORRECT AND RESTORED FOR THIS EDITION.—
 D.L.H.]
94:21–22. of whoever thought that art was a *Fortn.*,
 73, 77, 88, 00
94:27. after-thoughts, such a refined working out
 of *Fortn.*
94:30. decay. Protestants, who always found them-
 selves much edified by a certain biblical turn
 in it, have multiplied all sorts of bad copies
 and engravings of it. And *Fortn.*
94:31. studies,—above *Fortn.*
95:1–2. Fiesole,—to *Fortn.*
95:3. It was *Fortn.*, 73, 77, 88, 00; effort to set a
 Fortn., 73, 77; a thing out *Fortn.*
95:4–5. its conventional associations. Strange, after

all the misrepresentations of *Fortn.*, 73, 77, 88, oo

95:6. see it, not *Fortn.*, 73, 77, 88, oo

95:8. years after, the *Fortn.*

95:12. finished. Well; finished or *Fortn.*; finished; 5
but finished or 73, 77, 88, oo

95:13–14. decay, this central head does *Fortn.*, 73, 77, 88, oo

95:17. afternoons; this figure is but the faintest, most *Fortn.*, 73, 77, 88, oo 10

95:18. all. It is the image of what the history it symbolises has been more and more ever since [has more and more become for the world 88, oo], paler and paler as it recedes from us [recedes into the distance 88, oo]. Criticism 15 came with its appeal from mystical unrealities to originals, and restored no life-like reality but these transparent shadows—spirits which have not flesh and bones. *Fortn.*, 73, 77, 88, oo 20

95:21. arrows,* [FOOTNOTE:] * M. Arsène Houssaye comes to save the credit of his countrymen. *Fortn.*, 73, 77

95:22. of the Sforza *Fortn.*

95:22–32. survive. For Ludovico *Fortn.*, 73

95:28. unable himself to 77, 88, oo

95:31. and also, perhaps, by 77, 88, oo

95:33–96:15. and the remaining *Fortn.*, 73

96:1–5. Touraine; allowed, it is said, at last [allowed at last, it is said, 88, oo] to breathe fresher air for awhile in one of the rooms of a high tower there, after many years of captivity in the dungeons below, where all seems sick with barbarous feudal memories, and where his prison is still 77, 88, oo

96:7. little thus through 77; years—vast 77, 88, oo

96:8. and faces and 77, 88, 00
96:10. out, and in which perhaps it is not 77, 88, 00
96:11–12. over all those experiments with Leonardo on 77, 88, 00
96:13. duke, that had 88, 00; so often during 77, 88, 00
96:14. of his fortune 77
96:20. painted the *Fortn.*, 73, 77, 88, 00
96:24. a mere cartoon *Fortn.*, 73, 77, 88, 00
96:27. miraculous; and for *Fortn.*, 73, 77, 88, 00
96:29. gave him a taste *Fortn.*
96:30. of Cimabue's triumph. But *Fortn.*, 73, 77, 88, 00
96:31–32. Florence; for he moved still *Fortn.*; Florence, for he lived still 73, 77, 88, 00
96:33. the salons of *Fortn.*
97:2. gossip is *Fortn.*, 73, 77
97:4. he met Ginevra *Fortn.*
97:6. of the sacred legend, not *Fortn.*, 73, 77
97:8. a symbolical language *Fortn.*, 73, 77, 88, 00
97:9. his thoughts in *Fortn.*, 73, 77, 88, 00
97:10. Pomona, Modesty *Fortn.*, 73, 77, 88, 00
97:19. that cirque of *Fortn.*, 73, 77, 88, 00
98:5–7. had she and the dream *Fortn.*, 73; By means of what strange affinities had the person and the dream 77, 88, 00; grown thus apart, yet *Fortn.*, 73
98:8. first incorporeal in *Fortn.*, 73, 77; Leonardo's thought, dimly *Fortn.*, 73, 77, 88, 00
98:17. that thus so strangely rose beside *Fortn.*, 73; that thus rose so strangely beside 77, 88, 00
98:19. years man had *Fortn.*, 73, 77
98:28. and experiences of *Fortn.*
98:31. Rome, the reverie of *Fortn.*, 73, 77, 88, 00
99:12. modern thought has *Fortn.*, 73, 77, 88, 00
99:18. art; he himself is *Fortn.*, 73, 77, 88, 00

99:24. Sienna, which looks toward Rome, elastic
 Fortn., 73, 77, 88, 00
99:29. had for his rival Michael Angelo. The
 Fortn.
99:31. council chambers, had *Fortn.* 5
100:5. which perhaps would help us [perhaps helps
 us 77, 88, 00] less than what we remember
 of *Fortn.*, 73, 77, 88, 00
100:9. figures may have risen from the *Fortn.*, 73,
 77, 88, 00 10
100:13. and a fragment *Fortn.*, 73
100:15–16. teeth; and *Fortn.*, 73, 77, 88, 00
100:21. years old, visiting *Fortn.*, 73, 77, 88, 00
100:23. of him again *Fortn.*, 73, 77, 88, 00
100:28. was on him *Fortn.* 15
100:29. indifferentism farther; it *Fortn.*, 73, 77, 88,
 00, 10
100:30–31. is out with the Sforzas and in with the
 Sforzas as *Fortn.*; of fortune *Fortn.*
100:32–33. Yet now he was suspected by the anti- 20
 Gallican, Medicean society at Rome, of
 French leanings. It *Fortn.*; Yet now he was
 suspected by the anti-Gallican society at
 Rome, of French tendencies. It 73; of con-
 cealed French 77, 88, 00 25
101:3. was going to be an *Fortn.*
101:6. work. La *Fortn.*, 73
101:8–11. the soft valley of the Masse—[Masse, and
 73] not too far from the great outer sea. M.
 Arsène Houssaye has succeeded in giving a 30
 pensive local colour to this part of his sub-
 ject, with which, as a Frenchman, he could
 best deal. "A *Fortn.*, 73
101:13. most attractive in *Fortn.*, 73, 77
101:14–15. where, under a strange mixture of lights, 35
 Italian *Fortn.*, 73, 77, 88, 00; exotic. M.
 Houssaye does but touch it lightly, and it
 would carry us beyond the present essay if

we allowed ourselves to be seduced [attract-
ed 73] by its interest. *Fortn.*, 73

101:16. after all busy *Fortn.*

101:17–18. question of his *Fortn.*, 73; question of the
form of his 77; question of the precise form
of his 88, oo

101:21. will about the *Fortn.*, 73, 77, 88, oo

101:25. could such hurried candle-burning be
Fortn.

101:28. such definite and precise forms, 77, 88, oo

101:31. NOT IN *Fortn.*, 73, 77

The School of Giorgione

Fortn. **Fortnightly Review**, XXII, n.s. (October,
1877), 526–538. Reprinted 88, 93, oo, 10

102:1–3. To regard all products of art as various forms
of poetry is the mistake of much popular
criticism. For this criticism, poetry, music,
and painting are but *Fortn.*

102:15. not the pure sense *Fortn.*

102:16. the imaginative reason through *Fortn.*

102:19–20. and incommunicable sensuous *Fortn.*, 88, oo

102:27. thought nor sentiment oo

103:6. no definable matter of sentiment *Fortn.*

103:11. was a rememberable contribution. *Fortn.*;
was a very important contribution. 88, oo

103:14. art-casuistries. And it is in the criticism of
painting that this *Fortn.*, 88, oo

103.16. that that false *Fortn.*, 88, oo

103:23. and many *Fortn.*

103:25–26. between, the pledge of the pictorial gift, the
inventive *Fortn.*; unique pledge of 88, oo;
gift, the inventive 88, oo

103:26–27. of line and colour only, which *Fortn.*

104:1–2. poetry, every idea however abstract or ob-
scure, floats up as a visible *Fortn.*, 88, oo

104:2–3.	weaving of imperceptible gold threads of light through *Fortn.*; weaving as of just perceptible gold threads of light through 88, oo
104:5.	*Lace-girl*, the staining *Fortn.*, 88, oo
104:13–14.	and by this delight only be the medium of *Fortn.*; delight only be the medium of 88, oo
104:15.	beyond it in *Fortn.*
104:18.	a moment, on one's wall *Fortn.*; a moment, on the wall 88, oo
104:19.	itself indeed a space of such falling light, *Fortn.*
104:20.	are caught in *Fortn.*, 88, oo
104:27.	sometimes, consummate flower-painting; *Fortn.*
105:2.	charm, and a *Fortn.*
105:9.	limitations, by which *Fortn.*, 88, oo
105:18.	flawless, ringing unity *Fortn.*
105:22.	a wild life *Fortn.*, 88, oo
105:23.	memory and mere *Fortn.*
105:24.	which it often *Fortn.*, 88, oo
105:25.	profits much. Thus *Fortn.*
106:5.	other works of *Fortn.*, 88, oo
106:9.	subject, its *Fortn.*, 88, oo
106:21–22.	one of M. Legros' etchings; but in *Fortn.*; of M. Legros: 88, oo
106:27.	momentary tint of *Fortn.*, 88, oo, 10
106:30.	we say, This *Fortn.*
106:33.	qualities; it *Fortn.*
107:3–4.	scenery the whole material detail is so easily absorbed, or saturated by *Fortn.*
107:5.	throughout its whole extent to a new delightful *Fortn.*
107:10.	being so pure *Fortn.*, 88, oo
107:11–13.	itself, nature has such easy work in tuning and playing music upon it. The *Fortn.*
107:15.	hard and definite; *Fortn.*

107:26.	the mere intelligence; *Fortn.*, 88, oo
107:29.	the expression of *Fortn.*, 88, oo
108:4.	poetry, just because in it you are *Fortn.*
108:8.	often seems to *Fortn.*, 88, oo
108:10.	the definite meaning almost expires, or reaches *Fortn.*
108:15.	kindling power and *Fortn.*
108:24.	a value in *Fortn.*
108:24–25.	themselves; wherein, indeed, lies *Fortn.*, oo; in which, indeed, lies 88
108:27–28.	into an end in themselves, and *Fortn.*
109:5–6.	the imaginative reason, that *Fortn.*
109:10–11.	of form and matter, this strange chemistry, uniting, in the integrity of pure light, contrasted elements. In its ideal, consummate *Fortn.*; of form and matter. In its ideal, consummate 88, oo
109:16–17.	aspire. Music, then, [and 88, oo] not poetry, as is so often supposed, is the true *Fortn.*, 88, oo
109:18.	of consummate art *Fortn.*
109:20–21.	the imaginative reason, yet *Fortn.*
109:25.	the concrete products *Fortn.*
110:4–5.	reputed his, still, more entirely than any other, sums *Fortn.*
110:6.	his work, the spirit of that school. *Fortn.*
110:10–11.	walls of Murano or Saint Mark's of *Fortn.*
110:22.	been even tempted to *Fortn.*; been tempted even to 88, oo
110:31–32.	than a spark of the divine fire to *Fortn.*
111:1.	serve for uses neither of *Fortn.*, 88
111:2.	or historical teaching *Fortn.*, 88
111:5.	play, refined *Fortn.*, 88, oo; upon and idealised *Fortn.*
111:9.	wall; he *Fortn.*, 88, oo
111:11–12.	go, like a poem in *Fortn.*, 88, oo
111:13.	will for all subtle purposes of culture, stimulus *Fortn.*

111:15.	cabinet, as we say, to *Fortn.*; with a personal aroma *Fortn.*
111:17.	art like this, *Fortn.*, 88, oo
111:21.	undisturbed; and while *Fortn.*, 88, oo
111:30.	so close to *Fortn.*
112:1.	in Mr. Browning's *Fortn.*, 88, oo
112:3.	Giorgione; he *Fortn.*, 88, oo
112:6.	of it. But *Fortn.*, 88, oo
112:8.	narrowly examined to *Fortn.*, 88, oo; narrowly explained to 93, 10 [THE EARLIER READING HAS BEEN JUDGED CORRECT AND RESTORED FOR THIS EDITION.—D.L.H.]
112:10–11.	expresses quintessentially, in elementary suggestion and effect, that *Fortn.*, 88
112:15.	the brilliance of *Fortn.*
112:21.	were undoubtingly attributed *Fortn.*, 88; were undoubtedly attributed oo
112:28–29.	us that we possess of it less than *Fortn.*, 88, oo; to have. Much *Fortn.*
112:30.	fame rested, work *Fortn.*
113:6.	person obscure themselves. It *Fortn.*; person become obscured. It 88, oo
113:30.	them on the lips and hands for ever—these *Fortn.*
114:2.	in the world. ¶ It *Fortn.*
114:7.	here enough to *Fortn.*, 88, oo
114:8.	mastery, it assigns to *Fortn.*
114:9–11.	Louvre, for certain points in which it comes short of that standard, but which will *Fortn.*, 88, oo
114:15–16.	wind-searched energy of physical and spiritual being, and of which the blue *Fortn.*
114:17.	the material pledge. *Fortn.*
114:18.	another beloved picture *Fortn.*
114:18–19.	Louvre, the subject of a sonnet by a poet [NO SUPERSCRIPT] whose *Fortn.*, 88, oo
114:20.	work comes often to *Fortn.*
114:21.	to but an *Fortn.*

114:23.　Venice—less of a [—a slighter　88, oo] loss, perhaps, though not without its sweet [its pleasant　88, oo] effect of clearing weather towards the left, its one untouched morsel—to Paris　*Fortn.*, 88, oo

114:26.　knight's noticeably worn gauntlets seem to *Fortn.*; knight's broken gauntlets seem to 88, oo

114:29.　Palma; and, whatever　*Fortn.*, 88, oo

114:33.　NOT IN　*Fortn.*, 88, oo

115:12.　courtesy; and becomes initiated　*Fortn.*, 88, oo

115:13.　manner, dress even, which　*Fortn.*

115:15.　Palace. Hard by his　*Fortn.*

115:18.　*condottiere*—strange picturesque　*Fortn.*

115:19.　manners in a　*Fortn.*, 88

115:25.　Liberale, for which [IN ERROR]　*Fortn.*

115:28.　Gallery, and in which, as in　*Fortn.*, 88, oo

115:30.　of his own　*Fortn.*, 88, oo

116:3.　greatly, the one　*Fortn.*

116:10.　usual, he took　*Fortn.*, 88, oo

116:10–11.　mortally with his kisses, and thus briefly *Fortn.*

116:13–14.　all has not been done　*Fortn.*

116:17–18.　stimulating, and for the æsthetic philosopher, over　*Fortn.*, 88, oo

116:21–23.　whom those supposed works of his are really assignable—a veritable school, indeed, which grew, as a supplementary product, out *Fortn.*; assignable—a veritable school, which grew together out　88, oo

116:27.　for reasons,　*Fortn.*

116:32.　image; Giorgione thus becoming a sort *Fortn.*, 88, oo

117:1.　it thus crystallizing　*Fortn.*, 88, oo

117:4.　may say, which　*Fortn.*

117:7–8.　Florence, Dresden and Paris; and in which

there defines itself for us a certain artistic ideal, the conception *Fortn.*; Florence, Dresden and Paris; and in which a certain artistic ideal is defined for us—the conception 88, oo

117:11. it—in Venetian *Fortn.*

117:12. time, and of which the *Concert Fortn.*, 88, oo

117:14. pledge which authenticates the *Fortn.*

117:15. connexion of the school with the master. *Fortn.*, 88, oo

117:22. with colour and *Fortn.*, 88, oo

117:28. wonderful *finesse* in *Fortn.*

117:29. to entire expression *Fortn.*

117:30. colour, to what I may call again the musical treatment. For *Fortn.*

118:5-6. lips; the momentary *Fortn.*, 88, oo

118:8. are presented together, solving *Fortn.*; are presented at once, solving 88, oo

118:11. expression—this he *Fortn.*, 88, oo

118:12. him, the *fuoco Fortn.*

118:14. of poetry *Fortn.*

118:17. perhaps, a brief and entirely concrete moment, into *Fortn.*

118:18-19. the abstract motives, all the interest and efficacy of *Fortn.*

118:22. with admirable *finesse* from *Fortn.*

118:23. coloured existence of *Fortn.*; coloured life of 88, oo

118:24. Venice; phases of subject in themselves already volatilised almost to the vanishing point, exquisite *Fortn.*

118:26-27. fulness of things for ever, and which are like an extract, or elixir, or consummate fifth part of life. *Fortn.*

118:28. ¶ Who, in some such perfect moment, when the harmony of things inward and outward beat itself out so truly, and with a sense of

receptivity, as if in that deep accord, with
entire inaction on our part, some messenger
from the real soul of things must be on his
way to one, has not felt the desire to per-
5 petuate all that, just so, to suspend it in every
particular circumstance, with the portrait of
just that one spray of leaves lifted just so high
against the sky, above the well, for ever?—a
desire how bewildering with the question
10 whether there be indeed any place wherein
these desirable moments take permanent
refuge. Well! in the school of Giorgione you
drink water, perfume, music, lie in receptive
humour thus for ever, and the satisfying
moment is assured. ¶ It *Fortn.*

118:30–31. Giorgione those perfect moments of music,
the making or hearing of it, song or the ac-
companiment of song, are *Fortn.*

118:33–119:1. Venice, which the visitor there finds so im-
pressive, the world *Fortn.*, 88, 00

119:1. forming itself. In *Fortn.*

119:3. of all that *Fortn.*, 88, 00

119:4–5. influence; and in *Fortn.*, 88, 00

119:7. music, music heard at *Fortn.*, 88, 00

119:11–12. those in Plato, to detect *Fortn.*; passage to
detect 88, 00

119:14. air, as it is said gifted ears may catch the
note of the bat; feeling *Fortn.*

119:19. In such favourite incidents, then, of *Fortn.*,
88, 00

119:20. or music-like intervals *Fortn.*, 88, 00

119:30. without us are *Fortn.*, 88, 00

119:32. to play *Fortn.*

120:3. with purfling and *Fortn.*

120:7. And when *Fortn.*, 88, 00

120:17. into its grassy *Fortn.*

120:18. channels; the air, too, in *Fortn.*, 88, 00

120:19. Giorgione, being as vivid as the souls which

breathe *Fortn.*; Giorgione, seeming as vivid 88, oo

120:20–22. empyrean, its impurities burnt out of it, no taint, no trace or floating particle of aught but its own clear elements *Fortn.*

120:24. some undefined refinement *Fortn.*

120:27. are woven *Fortn.*

120:32. flesh, out away *Fortn.*

121:4. the visible warrant *Fortn.*, 88, oo

121:5. dark soul of rains *Fortn.*

121:6. airy distance, as *Fortn.*

121:8. Rachel, the fiery point of passion, to which all the rest turns up, opening and closing about them, yearningly. Nowhere *Fortn.*

121:10. persons—the earth being here but a "second body," a garment as exactly conformed to and spiritually expressive of the human presence on it, of the "first body," as that "first body" is of the soul—a unison of the human *Fortn.*

121:11. already noted as *Fortn.*

121:15. Giorgione, to adopt *Fortn.*

121:21. ascertained and numerable facts *Fortn.*

121:27. explained out of our *Fortn.*; explained away out of our 88, oo

121:30–31. just there. Set in their true perspective such negations become but *Fortn.*

122:1. knowledge; for, beyond all those strictly deducible facts, *Fortn.*

122:5. culture; and in *Fortn.*

122:7. NOT IN *Fortn.*

Joachim du Bellay

Texts: 73, 77, 88, 93, oo, 10

123:10–11. It produced Château Gaillon—as 73; It produced the Château Gaillon, as 77; It

130:27.	when this brother 73
130:29.	shrinking feeling of 73, 77, 88, 00
131:7.	poor *plante et vergette* of 73, 77
131:11.	only half regret. 73
131:12.	successful man of 73
131:13.	official affairs. It was to him that the 73, 77, 88, 00; the thought of 73
131:19–21.	Rome, which to most men of an imaginative temperament like [such as 88, 00] his would have yielded so many pleasurable sensations, with 73, 77, 88, 00
131:22.	fresh there, his 73, 77, 88, 00
131:24.	wide expanses of 73, 77, 88, 00
132:4.	threw much of 73, 77, 88, 00
132:6.	in seeing these faded decorations, and 73, 77, 88, 00
132:21.	of that poetry 73
132:22–23.	time came when the school of Malherbe too had had 73; time came also when the school of Malherbe had had 77, 88, 00
132:29.	may find it, 73, 77, 88, 00
133:6–7.	that *fleur particulier*, that special flower, which 73, 77
133:12.	them, like that of the Roman Emperor who would eat fish far from the sea. Ronsard 73
133:14.	with blond hair 73, 77
133:19.	the *i voyelle* 73, 77
133:26.	their gayness and nicety, and 73, 77
133:27.	language; and there 73, 77, 88, 00
133:29.	had but an 73
133:31.	was mixed the 73, 77, 88, 00
134:3.	poets, the *poésie* 73, 77
134:4.	To unite together these 73, 77, 88, 00
134:5.	which would scan 73
134:15.	This eagerness for music is almost the only serious thing in the poetry of the *Pleiad*; and it was Goudimel, the severe and 73, 77, 88, 00

134:16–19. music. But except in this these poets are
 never serious. Mythology, which with the
 great Italians had been a motive 73; music.
 But except in this [matter 88, oo] these
 poets seem 77, 88, oo; which for the great
 Italians had been a motive 77, 88, oo
134:21–22. become the *petit enfant Amour*. They 73, 77
134:23. *fondelette* [IN ERROR] 73
134:27. Like the people in Boccaccio's 73; Like the
 party of people who tell the tales of Boccac-
 cio's 77
134:28. a party who in 73
134:29. anxieties, amuse themselves with 73; anx-
 ieties, amuses itself with 77, 88, oo
134:30. intrigue; but 73
134:31. elegance, and 73, 77, 88, oo
134:33. themselves, at 73; death; their 73, 77, 88,
 oo
135:1–2. leaving *le* 73, 77
135:4. trifle; the 73, 77, 88, oo
135:5. for a delicate 73, 77
135:7–8. life; just as the grotesques of 73, 77, 88, oo
135:11. its delicate arabesques 73, 77, 88, oo
135:13–14. this which 73, 77
135:15. diplomatist; and it was significant, one 73,
 77
135:20. grace that comes 73, 77, 88, oo
135:22. faintness, a *fadeur* 73, 77
136:2. country, that *pays* 73, 77
136:3. often occur in 73, 77
136:4. its spaces 73
136:6. country, *Le Bocage*, with 73
136:7–8. road-sides; *la Beauce* 73
136:8. *Beauce*, the granary of France, where 73,
 77, 88, oo
136:9. fields of corn seem 73, 77, 88, oo
136:13. with this 73, 77, 88, oo
136:14. which this Northern 73, 77, 88, oo

246

136:20. of winter, about 73, 77, 88, 00
136:21. and a *bonhomie* 73
136:26. crystallised specimen:— 73, 77, 88, 00
137:13. an historic value 73
137:24. the portrayal of 73
137:25. moods, to 73
137:26. That generation had 73, 77, 88, 00
138:2. up; for 73, 77, 88, 00
138:6. find *intimité*, intimacy, here 73
138:9. who has to plunge 73, 77, 88, 00
138:11. between life 73
138:15. NO ¶ 73, 77, 88, 00
138:23–24. that *le grand tout* itself, into 73, 77
138:24–25. all things pass, ought 73
138:29. North, *la* 73, 77
138:31. and its roofs 77, 88, 00
139:1. and softer 73
139:14. Italian thing transplanted 73, 77, 88, 00
139:16. of Naugerius, into 73; French; but 73, 77, 88, 00; a thing in 73, 77, 88, 00
139:30. An excellent translation 73, 77
139:31. by A. Lang 73; by Andrew Lang 77
140:6. *œlliets* [IN ERROR] 73, 77, 88, 93, 00, 10 [CORRECTED FOR THIS EDITION]
140:21. measured falling of 73, 77, 88, 00
140:25. transfigures a trivial 73, 77, 88, 00
140:26. a winnowing-flail, the 73, 77, 88, 00; door; a 73, 77, 88, 00
140:30. NOT IN 73, 77

Winckelmann

Westm. Westminster Review, XXXI, n.s. (January, 1867), 80–110. Reprinted 73, 77, 88, 93, 00, 10

TITLE: Winckelmann★ [FOOTNOTE:] ★Reprinted from the 'Westminster Review,' for January, 1857 [*sic*]. 73

TEXTUAL NOTES

UNDER TITLE: *The History of Ancient Arts among the Greeks.* By John Winckelmann. Translated from the German by G. H. Lodge. 8vo. London: 1850. *Biographische Aufsätze.* Von Otto Jahn. Leipzig, 1866. *Westm.*

EPIGRAPH: NOT IN *Westm.*, 73, 77

141:11. with undiminished freshness. *Westm.*, 73

141:14. writings. "Winckelmann *Westm.*, 73

141:26. in 1717. *Westm.*

141:27–28. he enacted in early youth an obscure struggle, the *Westm.*

142:12. The rector of *Westm.*

142:15. the rector's library, *Westm.*

142:17–18. warmest cult. Whole *Westm.*, 73

142:20–26. him. "Il se sentit attiré vers le Midi, avec ardeur," [Madame 73, 77] De Staël says of him [says him *Westm.*]; "on retrouve encore souvent dans les imaginations Allemandes quelques traces de cet amour du soleil, de cette fatigue du Nord, qui entraina les peuples septentrionaux dans les contrées meridionales. Un beau ciel fait naître des sentiments semblables à l'amour de la patrie." *Westm.*, 73, 77

142:28. its perfect *Westm.*, 73, 77, 88, 00

142:30. the one side 00

142:31. poverty a *Westm.*, 73

142:32. hands, it *Westm.*, 73

142:33. of travel *Westm.*, 73

143:1. and France, *Westm.*, 73

143:5. eagerness to *Westm.*, 73, 77; he was interested *Westm.*, 73, 77

143:7. Strasburg contained. So *Westm.*, 73, 77, 88, 00

143:16–17. and Halle had no professors who *Westm.*, 73, 77

143:31. became conrector of *Westm.*

248

143:32. most *ennuyant* period *Westm.*
144:4. within a *Westm.*, 73
144:7. reading. On Sundays, too, there were the rector's sermons, during which, however, he could read Homer. Here *Westm.* 5
145:2. born antiquarians like *Westm.*
145:3. Winckelmann, constant *Westm.*, 73, 77, 88, 00
145:7. modern most *Westm.*, 73, 77
145:9. pagan, based on the *Westm.*, 73, 77, 88, 00
145:17. Plato's writings could *Westm.*, 73
145:22–23. myself." Probably the purpose of visiting Rome was *Westm.*, 73, 77, 88; already formed, and *Westm.*, 73; already conceived, and 77, 88; already purposed, and 00
145:24. it. Graf Bünau *Westm.*
145:25. Nöthenitz, near Dresden, a *Westm.*, 73, 77
145:26. 1784 [IN ERROR] *Westm.*, 73, 77, 88, 93, 00 [CORRECTED FOR THIS EDITION]
145:27. French. "He is emboldened," he says, "by *Westm.*, 73
145:29. letters." He *Westm.*, 73
145:32. age, when humane *Westm.*, 73, 77, 88, 00
146:8. after we *Westm.*, 73
146:10. of antiques at *Westm.*, 73
146:12–13. with a practical *Westm.*, 73, 77; practical command of *Westm.*
145:14–15. now there opened for him a new way of communion with the Greek life. Hitherto *Westm.*, 73, 77, 88, 00
146:18. words an unexpressed *Westm.*, 73, 77, 00
146:25–26. earlier Renaissance sentiment. On *Westm.*
146:28–30. we apprehend it! *Westm.*; it! That is *Westm.*, 73, 77; it! Here, surely, is 88, 00; is the more liberal life *Westm.*, 73, 77, 88, 00

146:32.	and religious reverie; *Westm.*, 73
147:1.	little they have emancipated *Westm.*, 73, 77, 88, 00
147:3–4.	themselves. There is an instance of Winckelmann's tendency to *Westm.*, 73; themselves. Here, then, we see in vivid realisation that [the native 88, 00] tendency of Winckelmann to 77, 88, 00
147:6.	has finely theorized on *Westm.*, 73
147:7.	to plastic art; and Hegel can give *Westm.*; to sculpture; and philosophy can give 73, 77, 88, 00
147:20.	us: elasticity, wholeness, intellectual *Westm.*, 73, 77, 88, 00
147:31–32.	interests, religious, moral, political, those *Westm.*, 73
148:6.	Winckelmann's physiognomy, "that *Westm.*
148:11.	in manhood, *Westm.*
148:13.	but as soon *Westm.*, 73, 77, 88, 00
148:17–18.	hair was turning grey, and the South is not reached yet. The *Westm.*
148:18–19.	become Catholic. The *Westm.*
148:20.	through Romish ecclesiastics. *Westm.*, 73, 77, 88, 00
148:21.	the Catholic religion *Westm.*; the Romish religion 73, 77, 88, 00
148:22.	Winckelmann. Once he *Westm.*
148:24.	papal nuncius Archinto *Westm.*
148:26.	as a stage *Westm.*, 73, 77
148:27.	Winckelmann's attainments, and *Westm.*, 73, 77, 88, 00
148:28.	the papal library. *Westm.*, 73, 77, 88, 00
148:30–31.	Maecenas, on condition of the necessary change being made. *Westm.*; Maecenas, on condition that the necessary change should be made. 73, 77, 88, 00
148:32.	the nuncius at *Westm.*
149:1–2.	the Romish church, *Westm.*, 73, 77, 88, 00

149:9.	what Bünau *Westm.*, 73, 77
149:11–14.	of something grand, primeval, pagan, in the Catholic religion. Casting the dust of Protestantism off his feet—Protestantism which at best had been one of the *ennuis* of *Westm.*, 5 73; the weariness of 77, 88, 00
149:21.	sacrifice. He speaks of the doubtful charm of renegadism as something like that which belongs to a divorced woman, or to "Wildbret mit einer kleinen Andeutung von Fäulniss." 10 Certainly at *Westm.*, 73
149:22.	criticism Winckelmann is more than absolved. *Westm.*, 73
149:25.	was lost in *Westm.*, 73
149:27.	from that mediocrity *Westm.*; from the mediocrity 73, 77, 88, 00, 10
150:3.	of a selection *Westm.*, 73, 77
150:11.	another. Criticism *Westm.*
150:16.	appeared, illustrated by Oeser, "Thoughts. *Westm.*
150:20.	was trenchant, an *Westm.*
150:22.	pension was supplied *Westm.*, 73, 77
150:29.	him native *Westm.*, 73
151:4.	that high artist's *Westm.*, 73, 77, 88, 00
151:17.	the intellect against *Westm.*, 73, 77, 88, 00
151:18.	sombre aspects, the *Westm.*
151:19.	are far off; before *Westm.*, 73; are afar off; before 77, 88, 00
151:27.	is pre-eminently intellectual light—modern *Westm.*, 73; light—the modern 77
151:30–31.	most successfully handled by *Westm.*, 73
152:3.	says De *Westm.*
152:6–8.	antiquity." On *Westm.*, 73, 77
152:8–9.	soi-même"*—words spoken on so high an occasion are *Westm.*, 73, 77, 88, 00 [OMITTED, CLEARLY BY MISTAKE, IN 93, 10 AND RESTORED FOR THIS EDITION]
152:14.	temperament, gathering into itself the stress

of the nerves and the heat of the blood, has *Westm.*, 73

152:15. purer motions of *Westm.*, 73

152:18. were interwoven in *Westm.*

152:19. romantic, fervid friendships *Westm.*, 73

152:21. him in contact *Westm.*, 73, 77, 88, 00

152:22. staining his thoughts *Westm.*, 73, 77, 88, 00

152:23. reconciliation with the *Westm.*, 73, 77, 88, 00

152:33. [FOOTNOTE:]* Words of Charlotte Corday. See Quinet: La Revolution. Livre 13ᵉ, chap. iv. *Westm.*

153:6–7. me. Your *Westm.*, 73, 77, 88

153:17. of *man* which *Westm.*, 73

153:18. under our general [IN ERROR] *Westm.*

154:5. physical stir, they *Westm.*, 73; contain just *Westm.*, 73, 77

154:6. the last lurking delicacies *Westm.*, 73

154:9–10. the history of Art—that *Westm.*; the 'History of Art,' that 73

154:10. light for the *Westm.*, 73, 77, 88, 00

154:11–15. family. Excitement, intuition, inspiration, rather than the contemplative evolution of general principles, was the impression which Winckelmann's literary life gave to those about him. The *Westm.*, 73

154:16–17. by the olive complexion, the deep-seated, piercing eyes, the rapid *Westm.*

154:22. the happiest of *Westm.*, 73, 77

154:23. which M. Edgar 73, 77, 88, 00; describes Columbus's famous *Westm.*, 73, 77

154:30. is *en rapport* with *Westm.*, 73, 77

155:4–5. one φιλοσοφήσας *Westm.*, 73, 77

155:7. intellectual culture over *Westm.*, 73, 77, 88, 00

155:8. results. So *Westm.*, 73, 77, 88, 00, 10

155:9. Goethe's judgment on *Westm.*, 73

155:9–10. are *ein* *Westm.*, 73, 77

155:12. In 1785 [IN ERROR] Cardinal oo; who possessed in *Westm.*, 73, 77, 88, oo

155:13. of antiques, became *Westm.*, 73

155:19. for it. It *Westm.*, 73, 77

155:26. of imperial society in *Westm.*, 73

156:1. him; at *Westm.*, 73, 77, 88, oo

156:2. out on a visit with the sculptor Cavaceppi. As *Westm.*, 73

156:3–4. home-sickness came upon him. *Westm.*, 73

156:5. Vienna; there *Westm.*, 73, 77, 88, oo

156:10. All that *fatigue du Nord* had *Westm.*, 73, 77; all that "weariness of the North" had 88, oo

156:12. Rome. At *Westm.*, 73, 77, 88, oo

156:15. medals which he had received *Westm.*, 73, 77

156:16. was aroused. One 88, oo

156:18. leave; Winckelmann *Westm.*, 73, 88, oo; leave of him; Winckelmann 77

156:20. work; Arcangeli *Westm.*, 73

156:23–24. time after a *Westm.*, 73, 77; child, whose friendship Winckelmann had made to beguile the delay *Westm.*, 73, 77, 88, oo

156:26. gave an alarm. *Westm.*, 73, 77, 88, oo

156:28. the sacraments of the Romish church. It *Westm.*, 73, 77, 88, oo

157:2. that that meeting *Westm.*, 73, 77; that the meeting 88, oo

157:3. Goethe did not take place *Westm.*, 73, 77, 88, oo

157:5. the press and storm of *Westm.*, 73, 77, 88, oo

157:6. the noblest kind. *Westm.*, 73, 77

157:16. the *stanze* of *Westm.*

157:18. religion. Along a strip of infinitely quiet sky, *Westm.*; religion. Against a strip of peaceful sky, 73, 77, 88, oo

157:20–21. midst. The companion fresco presents *Westm.*, 73

157:22. Dante only appearing *Westm.*
157:24. of myrtles, sits *Westm.*, 73, 77, 88, 00
157:28. other city of God. In *Westm.*, 73, 77, 88, 00
158:3. might often light *Westm.*, 73
158:6. fashion; but *Westm.*, 73; not farther re-moved 73, 77
158:8. from the vestiges *Westm.*, 73, 77
158:10. of fashion. Yet *Westm.*, 73
158:11. divines the veins of *Westm.*, 73, 77, 88, 00
158:12–13. Scyles in *Westm.*, 73, 77
158:14. Herodotus★ [FOOTNOTE:] ★Herodotus, 4-78. *Westm.*
158:18. of culture. The *Westm.*, 73, 77, 88, 00
158:26. an element *Westm.*, 73, 77
159:4. tradition; it *Westm.*, 73, 77, 88, 00
159:6. but by means of the artistic *Westm.*, 73, 77, 88, 00
159:7. which in youth have excited, and at the same time directed *Westm.*, 73, 77, 88, 00
159:9. of each generation thus *Westm.*, 73, 77, 88, 00
159:13–14. ours. This standard takes its rise in *Westm.*, 73, 77, 88, 00
159:25. Thus Dr. Newman *Westm.*, 73, 77
159:27–28. one; in *Westm.*, 73, 77, 88, 00
159:32. conceptions. These two sides indicate two component elements, widely asunder in their origin, out of which Greek religion arose. Religions, *Westm.*
160:7–8. broad characteristic of *Westm.*, 73
160:14. NO ¶ *Westm.*, 73, 77, 88, 00
160:18. his luck, making *Westm.*, 73
160:20. makes wilful gods in *Westm.*, 73
160:20–21. smiling and drunken, or bleeding by a sad *Westm.*, 73
160:25. could; as *Westm.*, 73, 77, 88, 00
160:28. talismans that may *Westm.*, 73, 77, 88, 00
160:30–31. is the eternal stock of all *Westm.*, 73

161:5. sentiment fixes itself *Westm.*, 73, 77, 88, oo
161:7. body, the breaking of bread, the slaughter
 Westm., 73
161:9. a cult, at *Westm.*
161:12–13. remains, developing, but always in a reli- 5
 gious interest, losing *Westm.*, 73, 77, 88, oo
161:15–16. generation.★ [Footnote: ★Hermann's Got-
 tesdienstliche Alterthümer der Griechen.
 Th I, §1, 2, 4. *Westm.*] This pagan cult, in
 Westm., 73; generation. This pagan worship, 10
 in 77, 88, oo
161:16–17. local colouring, essentially one, is the base of
 all *Westm.*, 73
161:22. this cult in *Westm.*, 73
161:23. meanings. With the Hebrew people they 15
 came from individuals of genius, the authors
 of the prophetic literature. In *Westm.*, 73
161:26–27. of anthropomorphic religious conceptions.
 [★Footnote: ★Ibid. §6. *Westm.*] To *Westm.*,
 73 20
161:29. itself the πτερον δύναμιζ, an element
 Westm., 73
161:31–32. While the cult [ritual 77, 88, oo] remains
 fixed, the *Westm.*, 73, 77, 88, oo
162:4. has on a broad *Westm.*, 73 25
162:6–163:3. religion. That primeval pagan sentiment, as
 it is found in its most pronounced form in
 Christian countries where Christianity has
 been least adulterated by modern ideas, as in
 Catholic Bavaria, is discernible also in the 30
 common world of Greek religion against
 which the higher Hellenic culture is in relief.
 In Greece, as in Catholic Bavaria, the beauti-
 ful artistic shrines, with their chastened taste,
 are far between. The wilder people have 35
 wilder gods; which, however, in Athens or
 Corinth, or Lacedæmon, changing ever with
 the worshippers in whom they live and move

and have their being, borrow something
of the lordliness and distinction of human
nature there. The fiery, stupefying wine
becomes in a happier locality clear and ex-
hilarant [happier region clear and exhilarat-
ing. 73, 77]. In both, the country people
cherish the unlovely idols of an earlier time,
such as those which Pausanius found still
devoutly preserved in Arcadia. Athenæus
tells the story of one who, coming to a tem-
ple of Latona, had expected to see a worthy
image of the mother of Apollo, and who
laughed on finding only a shapeless wooden
figure.★ [FOOTNOTE: ★Athen. xiv. 2, quoted
by Hermann. Th. 1, §6, 4. *Westm.*] In
both, the fixed element is not the myth or
religious conception, but the cult [the reli-
gious observance 77] with its unknown
origin and meaning only half understood.
Even the mysteries, the centres of Greek reli-
gious life at a later period, were not a doc-
trine but a ritual; and one can imagine the
[Roman 77] Catholic church retaining its
hold through the "sad mechanic exercise" of
its ritual, in spite of a diffused criticism or
skepticism. Again, each adjusts but imper-
fectly its moral and theological conceptions;
each has its mendicants, its purifications, its
Antinomian mysticism, its garments offered
to the gods, its statues worn with kissing,★
[FOOTNOTE: ★Hermann. Th. ii. c. ii. §21, 16.
Westm., 73] its exaggerated superstitions for
the vulgar only, [its 73, 77] worship of sor-
row, its addolorata, its mournful mysteries.
There is scarcely one [scarcely a 77] wild-
ness of the [Roman 77] Catholic church
that has not been anticipated by Greek poly-
theism. What should we have thought of the

vertiginous prophetess at the very centre of
Greek religion? The supreme Hellenic cul-
ture is a sharp edge of light across this
gloom. The Dorian cult [worship 77] of
Apollo, rational, chastened, debonair, with 5
his unbroken daylight, always opposed to
the sad Chthonian divinities, is the aspiring
element, by force and spring of which Greek
religion sublimes itself.★ [FOOTNOTE: ★Ibid.
Th. i, § 5. *Westm.*, 73] Religions have some- 10
times, like mighty streams, been diverted to
a higher service of humanity as political in-
stitutions. Out of Greek religion under hap-
py conditions arises Greek art, *das Einzige*,
das Unerwartete, to minister to human culture. 15
The claim of Greek religion is that it was
able to transform itself into an artistic ideal.
Unlike that Delphic Pythia, old but clothed
as a maiden, this new Pythia is a maiden,
though in the old religious vesture. *Westm.*, 20
73, 77; ¶ For the thoughts 73, 77

162:28. happier region clear 88, 00
163:3–10. ¶ Under what conditions does Greek reli-
gion thus transform itself into an artistic
ideal? "Ideal" is one of those terms which 25
through a pretended culture have become
tarnished and edgeless. How great, then, is
the charm when in Hegel's writings we find
it attached to a fresh, clear-cut conception!
With him the ideal is a *Versinnlichen* of the 30
idea—the idea turned into an object of
sense.★ [FOOTNOTE:] [★*Aesthetik*, Th. 1,
Kap. 3 A.] By the idea, stripped of its tech-
nical phraseology, he means man's knowl-
edge about himself and his relation to the
world, in its most rectified and concentrated
form. This, then, is what we have to ask
about a work of art—Did it at the age in

which it was produced express in terms of sense, did it present to the eye or ear, man's knowledge about himself and his relation to the world in its most rectified and concentrated form? Take *Westm.*

5

163:5. world, were 73, 77

163:6. be turned into an object for 73; be turned into objects for 77

163:11–12. Virgin," at San Marco, in Florence. *Westm.*, 73

163:13. moon sit the Virgin and our Lord, clad *Westm.*, 73; moon the Virgin and our Lord are sitting, clad 77; moon Christ and the Virgin Mary are sitting, clad 88, oo

163:15. linen. Our Lord, with *Westm.*, 73, 77, 88, oo

163:16. figure of the 77

163:17–18. Apocalypse, sets, with slender finger tips, a crown of pearl on the head of his mother, who, *Westm.*, 73, 77, 88, oo

163:19. refinement, bends to *Westm.*, 73; refinement, is bending to 77

163:22. highest knowledge about *Westm.*

163:26. of an inexpressible *Westm.*, 73, 77, 88, oo

164:2. unmanageable: forms *Westm.*, 73, 77, 88, oo

164:3. struggle vaguely with *Westm.*

164:4. orientalised Ephesian Diana with its numerous breasts, like *Westm.*, 73; orientalised Diana of Ephesus, with its numerous breasts, like 77, 88, oo

164:6–7. cannot adequately express, *Westm.*, 73, 77, 88, oo

164:13. motive. That motive *Westm.*, 73, 77, 88, oo

164:14. as the meaning to the allegory, *Westm.*, 73, 77, 88, oo

164:15. it. For the highest knowledge of the Greek

	about himself and his relation to the world was in the happiest readiness for being thus turned into an object for the senses. The *Westm.*
164:20–21.	nature; in thought he still mingles himself with *Westm.*, 73, 77
164:23.	thought the *Westm.*, 73, 77, 88, oo
164:25.	feet; nature *Westm.*, 73
164:26.	But there *Westm.*, 73, 77, 88, oo
164:28.	not begun to boast of its *Westm.*, 73, 77, 88, oo
164:32.	in a defiance *Westm.*, 73, 77, 88, oo
165:2.	of Christian mysticism. *Westm.*, 73, 77
165:3.	But this ideal, in which the idea does *Westm.*
165:4.	beyond its *Westm.*, 73, 77, 88, oo
165:11.	which the ideal was *Westm.*, 73, 77, 88, oo
165:13.	forms which appear *Westm.*, 73, 77, 88, oo
165:20.	of the bones of *Westm.*, 73
165:22.	enters into life. *Westm.*, 73
165:30.	Egesta, in Sicily, erected *Westm.*, 73, 77, 88, oo
166:5.	an opportunity of having *Westm.*, 73, 77, 88, oo
166:10.	χαριτοβλέφαροϛ. *Westm.*, 73, 77
166:12.	prizes; this *Westm.*, 73, 77, 88, oo
166:22.	children."* [FOOTNOTE:] *Geschichte der Kunst des Alterthums, Th. i. Kap. iv. *Westm.*, 73
166:23.	antiquarianisms, from a few *Westm.*, 73
166:25.	manner is, divines *Westm.*, 73, 77, 88, oo
166:29–30.	life. Gymnastic originated *Westm.*, 73
166:32.	fleet and serpentining, and white *Westm.*, 73, 77
166:34.	artist's studio reacted on each other. The *Westm.*, 73, 77, 88, oo
167:1–2.	them. "Ομνυμι *Westm.*, 73, 77

167:4.	εἶναι. That *Westm.*, 73
167:5.	chose "the better part"—a *Westm.*, 73; if our gods *Westm.*, 73, 77
167:6–7.	fleet and serpentining, and white and red [—not white and red as in Francia's "Golgotha" *Westm.*, 73]. Let us not say, would that that unperplexed youth of humanity, *Westm.*, 73, 77
167:8–9.	humanity, seeing itself and satisfied, had never past into *Westm.*, 73, 77; humanity, seeing itself and satisfied, passed, 88, oo
167:11.	the idea of 77; in its grave. *Westm.*, 73, 77
167:16.	motion; each of these may *Westm.*, 73, 77, 88, oo
167:22.	of its experience. Different *Westm.*, 73, 77, 88, oo
167:25.	combine easily and entirely. The *Westm.*, 73, 77; combine with completeness and ease. 88, oo
167:26.	to the series *Westm.*
167:27.	itself.★ [FOOTNOTE:] ★Hegel: Aesthetik. 2 Theil. Einleitung. *Westm.*, 73
168:2.	reflection; their expression is not *Westm.*, 73, 77, 88, oo
168:8.	unseen intellectual *Westm.*, 73, 77
168:14.	its powers of *Westm.*
168:16.	NO ¶ *Westm.*, 73, 77, 88, oo; music, poetry, *Westm.*, 73
168:17.	endless powers of *Westm.*
168:23–24.	in humour, passion, sentiment. *Westm.*, 73, 77, 88, oo
168:24.	and the romantic *Westm.*, 73, 77, 88, oo
168:25.	poetry, is sculpture, *Westm.*, 73
168:28.	It deals more *Westm.*, 73
169:2.	seems more *Westm.*, 73, 77
169:3.	abstract manner of *Westm.*, 73, 77
169:6.	than the springing of *Westm.*, 73, 77, 88, oo

169:7. and these poetry commands. Painting
 Westm., 73, 77
169:8. and dilation of *Westm.*
169:9. eye, and music *Westm.*, 73, 77; tones, can
 Westm., 73, 77 5
169:11. its finest threads. *Westm.*, 73, 77, 88, oo
169:16. not help that *Westm.*, 73, 77; not help for-
 ward 88, oo
169:18. this colour has *Westm.*, 73, 77
169:20. never admitting more *Westm.*, 73, 77, 88, oo 10
169:22. as sculpture *Westm.*, 73
169:25. by sinking or heightening tones. *Westm.*,
 73, 77, 88, oo
169:28. are not more precious than *Westm.*, 73, 77
169:29. feet. The very slightness of its material is 15
 Westm., 73, 77; feet. The 88, oo
169:33. these.* [FOOTNOTE:] *The reader may see
 this subject treated with great delicacy in Mr.
 F. T. Palgrave's Essays on Art. Essay on
 Sculpture and Painting. *Westm.* 20
170:3. characteristics. Its white *Westm.*, 73, 77,
 88, oo
170:5-6. but the god, as *Westm.*, 73, 77; but the god
 in him, as 88, oo
170:6-7. to man's restless movement. It records
 Westm., 73, 77; to man's restless movement.
 The art 88, oo
170:12. a vital, mobile individuality.* [FOOTNOTE:
 *Hegel: Aesthetik, Th. 3, Abschnitt 2.
 Westm.]; a vital, mobile individuality. 73,
 77; a vital and mobile individuality. 88, oo
170:23. NO ¶ The base of all artistic genius is the
 Westm., 73, 77, 88, oo
170:24. new, striking, rejoicing way, *Westm.*, 73,
 77, 88, oo
170:26. of common days, of generating *Westm.*,
 73, 77, 88, oo

170:31. a choice of *Westm.*, 73, 77, 88, 00
171:1. magic. This is *Westm.*, 73, 77
171:7. artist has to employ *Westm.*, 73, 77, 88, 00
171:9–10. thousand-fold. The poems of Robert Browning supply brilliant examples of this [power 88, 00]. His *Westm.*, 73, 77, 88, 00
171:16. character and throws *Westm.*, 73, 77, 88, 00
171:17. situation, apprehends *Westm.*, 73
171:18. ideal. Take an instance from *Dramatis Personae.* In *Westm.*, 73, 77, 88, 00
171:19. Jours," we *Westm.*, 73, 77, 88, 00
171:21. relief in this exquisite way. Those *Westm.*, 73, 77, 88, 00
171:22–23. they only begin to interest us when *Westm.*, 73, 77, 88, 00
171:31. motive; we *Westm.*, 73, 77, 88, 00
171:33. requires the *Westm.*, 73
172:3. backgrounds. Mr. Hunt's "Claudio and Isabella" is an instance. To *Westm.*
172:12. the limitations of *Westm.*, 73, 77, 88, 00
172:15. intrinsically interesting—that *Westm.*
172:20–21. accidental, that *Westm.*, 73; effect of *Westm.*, 73, 77
172:26. of limitation; it *Westm.*, 73, 77, 88, 00
172:28. it is necessarily transitory, *Westm.*, 73, 77
172:30. In the allegorical *Westm.*, 73
172:31. middle ages, we *Westm.*, 73
173:1. fixed obdurately into *Westm.*, 73
173:1–2. of religious sentiment; and men and women, in *Westm.*, 73; of placid reverie; and men and women, in 77, 88, 00
173:7. It lets passion play *Westm.*, 73, 77
173:8. form, which loses by it nothing *Westm.*, 73, 77
173:12. NO ¶ *Westm.*, 73, 77, 88, 00
173:13. been thawed, its *Westm.*, 73, 77, 88, 00

173:14.	reserve, which is very *Westm.*, 73, 77, 88, 00
173:24–25.	as Apollo *Westm.*, 73
173:26.	or Venus *Westm.*, 73
173:30.	legitimate only *Westm.*, 73
173:31.	NO ¶ *Westm.*, 73, 77, 88, 00; painting and, as we have lately seen, in poetry, because *Westm.*, 73, 77
173:32.	or to the lips it *Westm.*
174:1–2.	as the colour, 88, 00; arrangement faintly *Westm.*, 73, 77, 88, 00
174:3.	no enmeshed or broken light. *Westm.*, 73, 77, 88, 00
174:6–7.	hair. It deals *Westm.*, 73, 77, 88, 00
174:10.	emphasized; when the *Westm.*
174:15–17.	If one had to choose a single product of Hellenic art, to save in the wreck of all the rest, one would choose from *Westm.*, 73, 77, 88, 00
174:18–19.	on horses, with *Westm.*, 73, 77
174:25.	of that indifference *Westm.*, 73, 77, 88, 00; which is beyond *Westm.*, 73, 77
174:31.	victory. Naïve, unperplexed, *Westm.*, 73
175:1.	experience, characterless *Westm.*, 73, 77, 88, 00
175:2.	life. In dealing with youth, Greek art betrays a tendency even to merge distinctions of sex. The Hermaphrodite was a favorite subject from early times. It was wrought out over and over again, with passionate care, from the mystic terminal Hermaphrodite of the British Museum, to the perfect blending of male and female beauty in the Hermaphrodite of the Louvre [Louvre.* FOOTNOTE: *Hegel: Aesth., Th. 3, Absch. 2, Kap. 1. *Westm.*, 73]. *Westm.*, 73, 77
175:4.	human form was *Westm.*

175:11. view; for *Westm.*, 73, 77, 88, oo
175:18–19. order, without the perfection of one being diminished by *Westm.*, 73, 77
175:33. of his culture *Westm.*, 73, 77, 88, oo
176:1. him, political, moral, religious, never *Westm.*, 73
176:2. clue of an unerring *Westm.*, 73, 77, 88, oo
176:4. he enunciates no *Westm.*, 73, 77, 88, oo
176:5. one-sided; it remained for Hegel to formulate what in Winckelmann is everywhere individualized and concrete. Minute *Westm.*, 73
176:8. and cultivating his *Westm.*, 73, 77, 88, oo
176:14. him ever in *Westm.*, 73, 77, 88, oo
176:17. sexlessness, a kind of impotence, an ineffectual *Westm.*, 73
176:18. a divine beauty and significance *Westm.*, 73; a higher beauty and insignificance [*sic*] 77
176:20. serenity, a *Heiterkeit*, *Westm.*, 73, 77
176:23. perhaps, at bottom a *Westm.*
176:25. sensuous of Greek *Westm.*
176:26. It is sometimes *Westm.*
177:3–4. nothing else has any interest *Westm.*, 73; lacks an appeal 77, 88, oo
177:6–7. satisfied in seeing the sensuous elements escape from *Westm.*, 73, 77, 88, oo
177:11. was indifferent. *Westm.*, 73, 77, 88, oo
177:12. the blood; it *Westm.*, 73, 77, 88, oo
177:13–14. childlike. But Christianity, with its uncompromising idealism, discrediting *Westm.*, 73
177:15–17. has lighted up for the artistic life, with its inevitable sensuousness, a background of fame [of flame 73]. "I *Westm.*, 73
177:19. It is hard *Westm.*, 73
177:21. artistic interest a *Westm.*

178:1. of perfection, it *Westm.*, 73, 77, 88, 00

178:2–4. come, that some sharper note should grieve the perfect harmony, in order that the spirit, chafed by it, might beat out at last a broader and *Westm.*, 73, 77; come, and some sharper note grieve the perfect harmony, to the end that the spirit chafed by it might beat out at last a larger and 88, 00

178:9. spirit.* [FOOTNOTE:] *Hegel: Aesth., Th. 2, Absch. 2, Kap. 3. Die Auflösung der klassischen Kunstform. *Westm.*

178:10–11. thus winning joy *Westm.*, 73, 77, 88, 00

178:12. too, often strikes a note *Westm.*, 73, 77, 88, 00

178:18. repose of the sculpturesque seems *Westm.*, 73

178:23. penetrative, but somewhat *Westm.*, 73, 77, 88, 00

178:25–26. Gilliatt, or *Westm.*, 73; in that first *Westm.*, 73

178:27. as it is with *Westm.*, 73, 77, 88, 00

178:29–30. Greek? He failed even to see, what Hegel has so cunningly detected, a sort of preparation for the romantic within *Westm.*; Greek? There is even a sort of preparation for the romantic temper within 73, 77, 88, 00

178:31–32. itself. Greek art has *Westm.*; which Winckelmann 73, 77, 88, 00

178:33. Hyacinthus, of Ceres, but *Westm.*, 73

179:5. world. Even their still minds are *Westm.*, 73, 77, 88, 00

179:14. The crushing of *Westm.*, 73, 77, 88, 00

179:15–16. the flesh-outstripping interest, is already traceable. Those *Westm.*, 73, 77; the ascetic interest, is already traceable. Those 88, 00

179:18. and remain *Westm.*, 73, 77

179:20. Troy herself, they *Westm.*, 73, 77
179:21. Age.★ [FOOTNOTE:] ★Hegel: Aesth., Th. 2,
 Absch. 3, Kap. 2. *Westm.*
179:22. ¶ In this way there is imported into Hellen-
ism something not plastic, not sculptur-
esque; something "warm, tremulous, de-
vout, psalterian." So some of the most
romantic motives of modern poetry have
been borrowed from the Greek. M. Sainte-
Beuve says of Maurice de Guérin's 'Cen-
taure,' now so well known to English read-
ers through Mr. Arnold's essay, that under
the form of the Centaur Maurice *a fait son
René*. He means that in it Maurice has found
a vehicle for all that romantic longing which
the modern temper has inherited from
mediaeval asceticism, and of which the
René of Chateaubriand is the most distin-
guished French exponent. What is observ-
able is that Maurice has found that vehicle
in the circle of Greek mythology. This ro-
mantic element was to increase. It did not
cause the decay of Hellenic art; but it shows
how delicate, how rare were the conditions
under which the Hellenic ideal existed, to
indicate the direction which art would take
in passing beyond it. In Roman hands, in the
early days of Christianity, it was already
falling to pieces through the loose eclecticism
which characterized the age, not only in reli-
gion and philosophy, but also in literature
and art. It was the age of imitators, mechan-
ically putting together the limbs, but unable
to unite them by the breath of life. Did
Christianity quicken that decline? The wor-
ship of sorrow, the crucifixion of the senses,
the expectation of the end of the world, are

not in themselves principles of artistic re-
juvenescence. Christianity in the first in-
stance did quicken that decay. That in it
which welcomed art was what was pagan
in it, a fetichistic veneration for particular
spots and material objects. Such materialism
is capable of a thin artistic varnish, but has
no natural connection with art of a higher
kind. So from the first we see Christianity
taking up a few fragments of art, but not
the best that the age afforded, careless of
their merits; thus aiding the decline of art
by consecrating it in its poorest forms. ¶
Gradually *Westm.*

179:22-23. church, as Christianity compromised its
earlier severities, the native artistic interest
reasserted *Westm.*, 73

179:27-28. as quarries. The sensuous expression of con-
ceptions which *Westm.*, 73, 77, 88, oo

179:32. with the air of a charnel-house *Westm.*, 73

180:2-3. see that the problem was met. [was solved.
77, 88, oo]; Even in the worship of sorrow
the *Westm.*, 73, 77, 88, oo

180:4. itself; the *Westm.*, 73, 77, 88, oo

180:9. as this power of *Westm.*, 73, 77, 88, oo

180:10. was refound, there *Westm.*, 73; was found
again, there 77, 88, oo

180:15. trenchant, absolute *Westm.*

180:18. the deeper is *Westm.*

180:22. Middle Ages, that *Westm.*

180:24-25. world, it was to Christian eyes as if *Westm.*,
73

180:25-26. opened; all *Westm.*, 73, 77, 88, oo

180:27. senses. Christian art allying itself with that
restored antiquity which it had ever emu-
lated, soon ceased to exist. For a time art
dealt with Christian subjects as its patrons

required; but its true freedom was in the life of the senses and the blood—blood no longer dropping from the hands in sacrifice, as with Angelico, but, as with Titian, burning in the face for desire and love. And *Westm.*, 73

180:28. the destiny of *Westm.*, 73, 77, 88, 00

180:30. keeping the thread *Westm.*, 73

180:32. 1786 *Westm.*, 73; 1876 [IN ERROR] 77; 1776 [IN ERROR] 88, 93, 00, 10 [CORRECTED FOR THIS EDITION]

181:1–2. repose, that it might awake when day came with eyes refreshed to those antique forms. *Westm.*, 73, 77, 88, 00

181:3. ¶ But even after the advance of the sixteenth century the Renaissance still remained in part an unfulfilled intellectual aspiration. An artificial classicism, as far as possible from the naturalism of the antique, was ready to set in if ever the Renaissance was accepted as an accomplished fact; and this was what happened. The long pilgrimage came to an end with many congratulations; only the shrine was not the genuine one. A classicism arose, based on no critical knowledge of the products of the classical spirit, unable to estimate the conditions either of its own or the classical age, regarding the adoption of the classical spirit as something facile. And yet the first condition of an historical revival is an appreciation of the differences between one age and another. The service of Winckelmann to modern culture lay in the appeal he made from the substituted text to the original. He produces the actual relics of the antique against the false tradition of the era of Louis XIV. A style or manner in art or

literature can only be explained or repro-
duced through those special conditions of
society and culture out of which it arose, and
with which it forms one group of phenom-
ena. A false classicism, in the unhistorical 5
spirit of the age, had tried to isolate the clas-
sical manner from the group of phenom-
ena of which it was a part; it supposed that
there was some shorter way of reaching and
commanding this manner than a knowledge 10
of the vital laws of the classical mind and
culture. In opposition to that classicism be-
come a platitude, Winckelmann says, the
Hellenic manner is the blossom of the Hel-
lenic spirit and culture, that spirit and culture 15
depend on certain conditions, and those con-
ditions are peculiar to a certain age. Repro-
duce those conditions, attain the actual root,
and blossoms may again be produced of a
triumphant colour. The clearest note of this 20
new criticism was the rehabilition of
Homer. Werther's pre-occupation with
Homer is part of the originality of his char-
acter. ¶ The *Westm.*

181:6.	Goethe; it *Westm.*, 73, 77, 88, 00	25
181:10.	he of the *Westm.*, 73, 77, 88, 00	
181:14.	illustrates that union *Westm.*, 73, 77, 88, 00	
181:14–16.	Romantic [spirit 73, 77], its adventure, its variety, its deep subjectivity, with Hellen- ism, its *Westm.*, 73, 77	
181:20.	battle," "in *Westm.*, 73, 77	
181:26.	Is that culture *Westm.*, 73, 77, 88, 00	
181:28.	it; the *Westm.*, 73, 77, 88, 00	
181:30.	severed; we *Westm.*, 73, 77, 88, 00	
181:31.	a high education *Westm.*, 73, 77, 88, 00	
182:5.	sorrows, so many *Westm.*, 73, 77, 88, 00	
182:10.	Winckelmann prints on *Westm.*, 73	

182:11. beginning of his culture in *Westm.*, 73, 77, 88, oo

182:16. but importunately in a passionate life and [or 77, 88, 00] personality *Westm.*, 73, 77, 88, oo

182:19. the problem *Westm.*, 73, 77, 88, oo

182:20. with oneself, consummate *Westm.*

182:24. the world without; the *Westm.*, 73, 77, 88, oo

182:28. of modern culture that *Westm.*, 73, 77, 88, oo

183:7–8. show. They do not care to *Westm.*, 73, 77; show. It is not their part to 88, oo

183:9. of culture makes *Westm.*, 73, 77, 88, oo; the pure instinct *Westm.*, 73, 77, 88, oo

183:10–11. that these forms of culture can *Westm.*, 73, 77, 88, oo

183:20. selves. Above *Westm.*, 73, 77, 88, oo

183:21. that *abandon* to *Westm.*

183:24. him. But the utmost a sensuous gift can produce are the poems of Keats, or the paintings of Giorgione; and often in some stray line of Shakspeare, some fleeting tone of Raphael, the whole power of Keats or Giorgione strikes on one from its due place in a complete composite nature. It *Westm.*

183:24–26. It is easy with the other worldly gifts to be a *schöne Seele*; but *Westm.*, 73; It comes naturally, perhaps, with certain other worldly gifts to be even as the *Schöne Seele* in *Wilhelm* 77

183:27. Goethe that seemed *Westm.*, 73, 77, 88, oo

184:5. ever abutted on the *Westm.*, 73

184:6. art, on actual *Westm.*, 73

184:7–8. the *Allgemeinheit*, the *Heiterkeit* of the antique be *Westm.*; the *Allgemeinheit* and *Heiterkeit* of the antique be 73, 77

184:9. which contain *Westm.*, 73

184:12–13. concerning himself, to the growing relation [IN ERROR] of *Westm.*, 73; concerning himself, to the growing revelation of 77, 88, 00

184:18. NO ¶ *Westm.*, 73, 77, 88, 00 5

184:19. giving joy by *Westm.*

184:26. does that spirit *Westm.*

185:2. old an image without *Westm.*, 73

185:3. warfare; it is a *Westm.*, 73, 77, 88, 00

185:10–12. freedom? Goethe's *Wahlverwandtschaften* is a 10 high instance of modern *Westm.*, 73; Hugo, there are high 77, 88, 00

185:12–13. life; it regards that *Westm.*, 73

185:14. it, but reflects upon its [IN ERROR] blitheness *Westm.*; it, but reflects upon 73

185:18–19. In *Wahlverwandtschaften* this entanglement *Westm.*, 73

185:20–21. becomes a tragic situation, in which a group of *Westm.*, 73

185:21–22. out a *Westm.*, 73

185:22–23. he foresaw all, *Westm.*, 73

185:23–24. against circumstances which endow one *Westm.*, 73

185:24–25. with so high an experience? *Westm.*, 73

185:26. NOT IN *Westm.*, 73, 77

Conclusion

Westm. Westminster Review, XXXIV, n.s. (October, 1868), 300–312.
Six of the last seven paragraphs of this review article (pp. 309–312) were reprinted as the "Conclusion" to 73, 88, 93, 00, and 10.

TITLE: Poems by William Morris. *Westm.*; Conclusion 73, 88, 93, 00, 10

UNDER TITLE: *The Defence of Guenevere: and Other Poems.*
By William Morris. 1858. *The Life and Death
of Jason: a Poem.* By William Morris. 1867.
The Earthly Paradise: a Poem. By William
Morris. 1868. *Westm.*

EPIGRAPH: NOT IN *Westm.*

PARAGRAPH JUST PRECEDING THE OPENING PARAGRAPH OF THE
"CONCLUSION," NEVER REPRINTED:

One characteristic of the pagan spirit these
new poems have which is on their surface—
the continual suggestion, pensive or passion-
ate, of the shortness of life; this is contrasted
with the bloom of the world and gives new
seduction to it; the sense of death and the
desire of beauty; the desire of beauty quick-
ened by the sense of death. "*Arriéré!*" you
say, "here in a tangible form we have the
defect of all poetry like this. The modern
world is in possession of truths; what but a
passing smile can it have for a kind of poetry
which, assuming artistic beauty of form to
be an end in itself, passes by those truths
and the living interests which are connected
with them, to spend a thousand cares in tell-
ing once more these pagan fables as if it had
but to choose between a more and a less
beautiful shadow?" It is a strange transition
from the earthly paradise to the sad-coloured
world of abstract philosophy. But let us ac-
cept the challenge; let us see what modern
philosophy, when it is sincere, really does
say about human life and the truth we can
attain in it, and the relation of this to the
desire of beauty. *Westm.*

186:9. But these elements, 73, 88, 00
186:13. the wasting and *Westm.*, 73, 88, 00
186:15. brain by every *Westm.*, 73, 88, 00

186:20.	us these elements *Westm.*, 73
186:20–21.	driven by many forces; and *Westm.*, 73, 88, 00
186:23.	thousand resulting combinations. *Westm.*, 73
186:24–29.	NOT IN *Westm.*, 73
187:10.	eye and fading *Westm.*, 73, 88, 00
187:11.	wall, the movement of *Westm.*, 73, 88, 00
187:16.	sharp, importunate *Westm.*, 73
187:18.	to act upon *Westm.*, 73, 88, 00
187:20.	force is suspended *Westm.*, 73; like a trick *Westm.*, 73, 88, 00
187:23.	dwell on *Westm.*, 73
187:28.	dwarfed to the narrow *Westm.*, 73, 88, 00
187:29.	a swarm of *Westm.*, 73, 88, 00
187:34.	of an individual *Westm.*
188:2.	¶ *Westm.*, 73; step farther still, 88, 00, 10
188:3.	and tells us *Westm.*, 73
188:4.	the individual to *Westm.*, 73
188:14–15.	with the movement, the *Westm.*, 73
188:19.	¶ Such thoughts seem desolate at first; at times all the bitterness of life seems concentrated in them. They bring the image of one washed out beyond the bar in a sea at ebb, losing even his personality, as the elements of which he is composed pass into new combinations. Struggling, as he must, to save himself, it is himself that he loses at every moment. ¶ *Philosophiren*, *Westm.*
188:20–22.	philosophy, and of religion and culture as well, to the human spirit is to startle it into a sharp and *Westm.*, 73; it into sharp and 88, 00
188:24.	or sea *Westm.*, 73
188:26.	attractive for us for *Westm.*, 73, 88, 00
188:30.	How can we *Westm.*, 73
189:2–3.	life. Failure *Westm.*, 73

189:4.	for habit *Westm.*, 73; world; meantime *Westm.*, 73
189:6.	two things, persons, situations— *Westm.*
189:7.	well catch at *Westm.*, 73, 88, oo
189:11.	dyes, strange flowers and curious *Westm.*, 73
189:14.	the brilliance of *Westm.*, 73; the brilliancy 88, oo
189:21–22.	testing opinion and *Westm.*
189:24.	own. Theories, religious or philosophical ideas, *Westm.*, 73
189:26–27.	us. *"La philosophie,"* says Victor Hugo, *"c'est le microscope de la pensée."* The *Westm.*; us. *La philosophie, c'est la* [*sic*] *microscope de la pensée.* The 73
189:30.	abstract morality we *Westm.*, 73
189:31.	or what *Westm.*, 73, 88, oo
189:33.	beautiful places [passages 88, oo] in the writings of *Westm.*, 73, 88, oo
190:3.	had always clung about *Westm.*, 73, 88, oo
190:4.	himself stricken by *Westm.*, 73
190:9.	found in *Westm.*, 73
190:10–13.	Hugo somewhere says: we have *Westm.*; says: *les hommes* 73
190:13–14.	then we cease to be. Some *Westm.*
190:15–16.	the wisest in *Westm.*, 73
190:17.	chance is in *Westm.*, 73; that one interval, *Westm.*
190:18–19.	time. High passions give one this *Westm.*, 73
190:20–22.	love, political or religious enthusiasm, or the "enthusiasm of humanity." Only *Westm.*, 73
190:24.	Of this wisdom, *Westm.*, 73, 88, oo
190:25.	for art's sake, *Westm.*, 73, 88, oo
190:25–26.	most; for art comes to you professing frankly *Westm.*, 73, 88, oo
190:29.	NOT IN *Westm.*, 73

Children in Italian
and English Design

The Academy, III (July 15, 1872), 267–268. Not reprinted by
Pater.

HEADING: Children in Italian and English Design. By Sidney
Colvin. With Illustrations. Seeley, Jackson, and Co.

Renaissance in Italy
The Age of the Despots

The Academy, VIII (July 31, 1875), 105–106. Not reprinted by
Pater.

Reprinted in *Uncollected Essays* (Portland, Maine, 1903), pp.
1–12 (not collated).

HEADING: *Renaissance in Italy; the Age of the Despots.* By John
Addington Symonds. (London: Smith, Elder & Co.,
1875.)

Critical and Explanatory Notes

IN THESE NOTES all references which include colons (e.g., "See 35:10") should be read as references to page and line numbers of Pater's text.

In the notes to each of Pater's essays in *The Renaissance*, the first citation of a book is made in full; later citations are shortened. Books often cited by short form are listed below for easy reference.

Translators are cited in the notes by name and page number only. All translations not credited to others are my own. Translations used are listed below. The original texts of translated passages are given on pages 465–482.

Pater's writings:
Letters of Walter Pater, ed. Lawrence Evans (Oxford, 1970).
The Renaissance, ed. Kenneth Clark (New York, 1961; repr. 1967).
The Works of Walter Pater, 10 vols. (London, 1910). This is the Library Edition, published by Macmillan. The volumes are not numbered, but in printed announcements the publisher assigned the numbers shown below. I have used these numbers for reference in this edition.
 I. The Renaissance: Studies in Art and Poetry.
 II. Marius the Epicurean: His Sensations and Ideas, I.
 III. Marius the Epicurean: His Sensations and Ideas, II.
 IV. Imaginary Portraits.
 V. Appreciations. With an Essay on "Style."
 VI. Plato and Platonism. A Series of Lectures.
 VII. Greek Studies. A Series of Essays.
 VIII. Miscellaneous Studies. A Series of Essays.
 IX. Gaston de Latour. An Unfinished Romance.
 X. Essays from "The Guardian."

Other works:
The Complete Prose Works of Matthew Arnold, ed. Robert H. Super, 11 vols. (Ann Arbor, 1960–1977).
Oeuvres complètes de Charles Baudelaire, ed. Jacques Crépet, 19 vols. (Paris, 1930–1953).
The Works of Thomas Carlyle, ed. H. D. Traill, 30 vols. (New York, 1896–1901).
Charles Clément, *Michel-Angelo, Léonard de Vinci, Raphael* (Paris, 1861).
Ascanio Condivi, *Vita di Michelagnolo Buonarroti*, ed. Emma Spina Barelli (Milan, 1964).
J. A. Crowe and G. B. Cavalcaselle, *A History of Painting in North Italy*, 2 vols. (London, 1871).
J. A. Crowe and G. B. Cavalcaselle, *A New History of Painting in Italy*, 3 vols. (London, 1864–1866).
Oeuvres françoises de Joachim du Bellay, ed. Charles Marty-Laveaux, 2 vols. (Paris, 1866).
Johann Wolfgang von Goethe, *Werke*, 105 vols. (Weimar, 1887–1912).
Herman Friedrich Grimm, *Leben Michelangelo's*, 2d ed. (Hannover, 1864).
Germain d'Hangest, *Walter Pater: L'Homme et l'oeuvre*, 2 vols. (Paris, 1961).
Georg W. F. Hegel, *Vorlesungen über die Aesthetik*, ed. H. G. Hotho, 2d ed., 3 vols. (Berlin, 1842–1843).
Michelangelo, *Rime*, ed. Enzo Noè Girardi (Bari, 1960).
Le rime de Michelangelo Buonarroti, ed. Cesare Guasti (Florence, 1863).
Jules Michelet, *Histoire de France*, 17 vols. (Paris, 1833–1867). Volume VII, "Renaissance," was first published in 1855. The copy of vol. II cited in the notes is from the 2d ed. (Paris, 1835–1845); it is dated 1835.
The English Works of Sir Thomas More, ed. W. E. Campbell, 2 vols. (London and New York, 1931).
Nouvelles françoises en prose du XIII^e siècle, ed. L. Moland and Charles d'Héricault (Paris, 1856).
Giovanni Pico della Mirandola, *Omnia Quae Extant Opera*, 2 vols. (Venice, 1557).

CRITICAL AND EXPLANATORY NOTES

Charles F. M., Comte de Rémusat, *Abélard: Sa Vie, sa philosophie, et sa théologie*, 2 vols. (Paris, 1855).

Oeuvres complètes de Ernest Renan, ed. Henriette Psichari, 10 vols. (Paris, 1947).

Alexis-François Rio, *De L'Art chrétien*, 4 vols. (Paris, 1861–1867).

Oeuvres complètes de P. de Ronsard, ed. Prosper Blanchemain, 12 vols. (Paris, 1857–1867).

The Works of John Ruskin, ed. Sir Edward T. Cook and Alexander D. O. Wedderburn, 39 vols. (London, 1903–1912).

J. C. Friedrich von Schiller, *Sämmtliche Werke*, 12 vols. (Stuttgart, 1862).

Giorgio Vasari, *Le vite de' più eccellenti pittori, scultori ed architetti*, ed. Ferdinando Ranalli, 2 vols. (Florence, 1845–1848).

Johann Joachim Winckelmann, *Briefe*, ed. Walther Rehm, 4 vols. (Berlin, 1952).

Johann Joachim Winckelmann, *Sämtliche Werke*, ed. Joseph Eiselein, 12 vols. (Donauöschingen, 1825–1829).

Translators:

Carmichael, Douglas. Pico della Mirandola, *On the Dignity of Man, On Being and the One, Heptaplus* (New York, 1965). Carmichael's share in this translation consists of the *Heptaplus* only.

Cornford, Francis M. *The Republic of Plato* (Oxford, 1941).

Jowett, Benjamin. *The Dialogues of Plato*, 4 vols. (New York, 1874). *The Politics of Aristotle*, 2 vols. (Oxford, 1885).

Knox, Thomas Malcolm. Georg W. F. Hegel, *Aesthetics: Lectures on Fine Art*, 2 vols. (Oxford, 1975).

Lang, Andrew. *Ballads and Lyrics of Old France, with Other Poems* (London, 1872).

Muckle, Joseph T. *The Story of Abelard's Adversities: A Translation with Notes of the Historia Calamitatum* (Toronto, 1964).

Norton, Charles Eliot. *The Divine Comedy of Dante Alighieri* (New York and Boston, 1920).

Scott-Moncrieff, Charles K. *The Song of Roland* (London, 1919).

Snell, Reginald. J. C. Friedrich von Schiller, *On the Aesthetic Education of Man* (London, 1954).

The Renaissance:
Studies in Art and Poetry

THE FIRST EDITION of Pater's book, entitled *Studies in the History of the Renaissance* (1873), contained a Preface, eight essays, and a Conclusion. The essays were "Aucassin and Nicolette," "Pico della Mirandula," "Sandro Botticelli," "Luca della Robbia," "The Poetry of Michelangelo," "Lionardo da Vinci," "Joachim Du Bellay," and "Winckelmann." In the second edition (1877) the title was changed to *The Renaissance: Studies in Art and Poetry*. The essay on "Aucassin and Nicolette," enlarged by the account of Amis and Amile, was renamed "Two Early French Stories," and the Conclusion was omitted. The third edition (1888) restored the Conclusion and included one additional essay, "The School of Giorgione," reprinted from the *Fortnightly Review* of October, 1877. The contents of the book remained the same for the fourth edition (1893), the last published during Pater's lifetime.

Though Pater's correspondence with his publisher, Alexander Macmillan, is incomplete, we learn from the extant letters that he had called on Macmillan in spring 1872 (probably in June) to propose the publication of a book of his essays. Macmillan was evidently encouraging, for on June 29 Pater sent him copies of six essays, five of which (those on Winckelmann, Leonardo, Botticelli, Pico, and Michelangelo) had been published before; one, called only "the paper in MS," had not. This "paper in MS" was presumably the essay mentioned (but never named) in subsequent letters, put into page proofs during the summer, canceled at Pater's request in late October, and returned so that, in the words of Macmillan's agent, he could "embody parts of it in the Preface"—*Letters of*

Walter Pater, ed. Lawrence Evans (Oxford, 1970), p. 8, n. 1. Probably, as Evans suggests, this essay was "a first version of 'The School of Giorgione,' whose extended theoretical passages enlarge on the doctrines of the Preface."

Along with copies of his essays, Pater sent Macmillan a list or "table" of the whole series proposed for the book, noting that "of the ten essays five only will have appeared before." The table has not been published. Of the five new essays, four must have been the Preface, "Aucassin and Nicolette," "Luca della Robbia," and "Joachim Du Bellay"; the fifth was presumably the canceled "Giorgione." On September 21 Pater wrote that he had "received a printed specimen of the essays" and added, "I expect to get the remaining essays finished very soon—in two or three weeks—and hope to have the pleasure of calling on you with them . . ." And on November 2 he wrote once again to Macmillan that he hoped to send him "in a day or two an additional essay, to form the conclusion of the series." He seems therefore to have finished writing the last of the new essays sometime in October, about as he had hoped, and to have sent the Conclusion to the publisher early in November. The Preface, dated 1873 in later editions, was apparently not ready until after the turn of the year.

In his earliest surviving letter to Macmillan, that of June 29, 1872, Pater had spoken of "the form in which I should like the essays to appear." In the months leading to publication he made several specific proposals, to each of which Macmillan posed objections in such a way as to win Pater over to his views. "I have received a printed specimen of the essays," he wrote Macmillan on September 21, "but regret to say not in the form which I think most suitable for the book. Some of the essays are so short, and all of them in some ways so slight, that I think the only suitable form would be a small volume, costing about five shillings; and I should like to make some suggestions on the binding and some other points." In his reply of September 24 Macmillan stated his preference for the octavo size and promised to give his reasons when Pater came again to see him.

On November 2 Pater agreed to the larger size but now

made further suggestions as to binding and paper. He wanted "the old-fashioned binding in pasteboard with paper back and printed title, usual, I think, about thirty years ago, but not yet gone quite out of use [as] an economical, and very pretty binding for my book. It would, I am sure, be much approved of by many persons of taste, among whom the sale of the book would probably in the first instance be." Though Macmillan replied that "the cloth and gilt is infinitely more useful and surely not less beautiful," Pater held out in a letter of November 11 for "the old-fashioned binding in boards," with a paper wrapper to prevent soiling: "Something not quite in the ordinary way is, I must repeat, very necessary in a volume the contents of which are so unpretending as in mine, and which is intended in the first instance for a comparatively small section of readers." On November 12 Macmillan, to persuade him, sent him a sample volume in a cloth binding with paper specially made to imitate the "old wirewove paper." Pater found it very attractive, and in February 1873 his book came out in the octavo size, printed on the special paper, with a dark blue-green cloth binding. Twelve hundred fifty copies were printed. Macmillan assumed the risk and expense of publication and agreed to share any profits equally with the author.

In the fall of 1876, Pater and Macmillan began to make plans for a new edition. Some discussion of which no record remains evidently preceded the definite proposal made by Macmillan on November 13—*Letters*, p. 18, n. 1. On November 15 Pater replied that he would "be very glad to have a new and revised edition of my essays, adding a small quantity of new matter, and making a good many alterations." He had in mind not only the enlargement of "Aucassin and Nicolette" and the omission of the Conclusion, but a revision of phrasing, punctuation, and other details that would, as it turned out, leave hardly a page untouched. The new title he proposed, *The Renaissance, a Series of Studies of Art and Poetry*, carries a suggestion of order and sequence among the essays which is lost in the handier title actually adopted. (In a brief

autograph vita written late enough to include his publications of 1893, Pater's memory supplied the proposed title, not the adopted one: "In 1873 he published 'The Renaissance, a series of studies in art and poetry; 4th edition, 1893.'"—Bodleian MS Walpole d.19, fol. 95.) In accordance with his diffident suggestion that "perhaps the price might be raised," it was in fact raised—from 7s. 6d. to 10s. 6d.

In the eight letters which follow, Pater again gives evidence of his strong interest in the details of paper, layout, binding, and labeling. On February 24 he reports that he has "nearly finished correcting the proofs" and proposes an edition of 1,000 "instead of 1250, as before." Macmillan preferred the larger edition, writing on February 26 that "the last 250 makes a considerable difference in the money result and they are sure to sell"—*Letters*, p. 20, n. 4. Pater took upon himself the tasks of making up the title page and writing the text of an advertisement for the newspapers. A series of anxious inquiries about the "vignette"—the engraved reproduction of "a favorite drawing" in the Louvre (see 90:28–91:1 and n.)—to be added to the title page was followed, when Pater saw the proof at last, by delighted compliments for C. H. Jeens, the engraver. When he received his inspection copy of the book, though he complained about defects in its condition and appearance, he could say after all: "I find the binding perfectly satisfactory; with print, paper and vignette, it makes a quite typical [ideal] book" (letter of April 26). The publication date was May 24, 1877—*Letters*, p. 21, n. 1.

The only reference in Pater's letters to the third edition of 1888 occurs in his note of December 1 [1887] to R. and R. Clark, printers of Edinburgh, who were producing the book for Macmillan. There he remarks that he is sending "some more copy of the 'Renaissance,'" makes an objection to the compositor's "way of forcing (I think) every chapter to end at the end of a page," and notes that "the added chapter on *The School of Giorgione* is to be printed *between* those on *Leonardo da Vinci* and *Joachim du Bellay*." In these matters the printers complied with his wishes. The fourth edition is mentioned only in a letter of October 30, 1893, to Pater from George

Macmillan, on Pater's request for [presentation?] copies of the book—*Letters*, p. 165.

The first reviews of *The Renaissance* appeared in March, 1873; before the end of the year reviews had been published in the more important journals and papers on both sides of the Atlantic. Those known to me are listed below in the order of their appearance. Authors of unsigned reviews, when they are known, are named in brackets.

Pall Mall Gazette, March 1, 1873, pp. 11–12 [Sidney Colvin]
Academy, IV (March 15, 1873), 103–104, J. A. Symonds
British Quarterly Review, LVII (April, 1873), 548–549
Fortnightly Review, XIII, n.s. (April, 1873), 469–477, Editor [John Morley]
Westminster Review, XLIII, n.s. (April, 1873), 639–640, Mrs. Mark Pattison
Spectator, XLVI (June 14, 1873), 764–765 [Richard Holt Hutton]
Athenaeum, June 28, 1873, 828–829
London Quarterly Review, XL (July, 1873), 505–507
Saturday Review, XXXVI (July 26, 1873), 123–124
Scribner's Monthly, VI (August, 1873), 506
Atlantic Monthly, XXXII (October, 1873), 496–498 [William Dean Howells]
Nation, XVII (October 9, 1873), 243–244
Blackwood's Magazine, CXIV (November, 1873), 604–609 [Mrs. Margaret Oliphant]

Most of the reviews were generally favorable, some strongly so. A few attacks were made on the Conclusion (see my headnote to that essay), but these were not presented as objections to the book as a whole, and about half the reviews make no mention of the Conclusion. Not all the reviewers were prepared to accept Pater's conception of the Renaissance as a benign "outbreak of the human spirit," his insistence on and evident endorsement of its "antinomian" character, or his doctrine of its early origins and its long uninterrupted life in

later European history. Some complained that Pater was taking inadmissible liberties with the term Renaissance; one or two questioned the "continuity" of the Renaissance; one held that Pater had culpably ignored the artificiality and sheer imitativeness of one side of the Renaissance. Some argued with Ruskin and against Pater that the rise of paganism had brought on the decay of art. In a telling statement Pater's friend Mrs. Mark Pattison called his title "misleading. The historical element [she wrote] is precisely that which is wanting, and its absence makes the weak place of the whole book . . . the work is in no wise a contribution to the history of the Renaissance"—*Westminster Review*, XLIII, n.s. (April, 1873), 640.

In one of the earliest and most illuminating of the reviews, however, Pater's view of the historical Renaissance received high praise from Sidney Colvin, who began by commending his grasp of "the notion of the continuity of the Renaissance," an idea introduced in the Preface and elaborated in later chapters. He went on to characterize Pater's book as, in one of its aspects, an attack on an opposing view already well established in the public mind: "Another notion of the Renaissance prevails, representing it as a movement of discontinuity, a movement of aggression and innovation, whereby Pagan thought and Pagan art were enthroned, and Christian thought and Christian art supplanted or brought low. It was from writers of the modern Catholic school in France, and most of all from the eloquent and comprehensive work of [Alexis-François] Rio, that this notion got hold of us." Pater, he declared, "is quite right in calling the notions of Rio and the Catholic school superficial as well as popular. He himself writes out of a culture too considerate and ripe, and out of reflections too finely sifted, to let pass anything of the kind"—*Pall Mall Gazette*, March 1, 1873, p. 11. Colvin was careful not to mention Ruskin, whose endorsement of Rio was well known. Another reviewer, however, pointed out that Pater's teachings were "diametrically opposed" to those of Ruskin's Edinburgh Lectures (of 1853) and held that

Ruskin's denunciation of the Renaissance as "hollow and unholy" was now "outmoded"—*Saturday Review*, XXXVI (July 26, 1873), 123.

As to Pater's achievement as a practical critic, most of the reviewers were ready to grant that in the essays of *The Renaissance* he had earned the right to high praise. John Addington Symonds called the book "a masterpiece of the choicest and most delicate aesthetic criticism," each of whose eight studies was "a wonderfully patient and powerful attempt [of the critic] to do that which is most difficult in criticism, to apprehend for his own mind, and to make manifest to the minds of others, the peculiar *virtue* which gives distinction to the work he has to treat of"—*Academy*, IV (March 15, 1875), 103–104. Colvin was equally complimentary: "By the strength and delicacy of the impressions the present writer feels, by the pains he has taken completely to realize them to himself, above all, by the singular and poetical personality with which they are transfused, he shows himself born for the task; he seems like a congener of those Florentines of the fifteenth century in whom he delights . . ." —*Pall Mall Gazette*, March 1, 1873, p. 12.

Other reviewers were struck by Pater's learning, acumen, modesty, exactness, vividness of expression, suggestiveness, and depth of thought. Most of them nonetheless gave utterance to certain reservations. Though granting Pater's subtlety and ingenuity, some of them found these powers treacherous in practice, and they were not always willing to approve his opinions. Several, among them Symonds and Howells, demurred at Pater's readiness (so they thought) to impute his own feelings and fancies to artists who could never have had anything like them. Mrs. Oliphant made this one of her main points in a generally derisive review of what she called a "very artificial" and "rococo" book. Having quoted from Pater's essay on Botticelli, she commented: "This is surely the very madness of fantastic modernism trying to foist its own refinements into the primitive mind and age used to no such wire-drawing. The same mixture of sense and nonsense, of real discrimination and downright want of under-

CRITICAL AND EXPLANATORY NOTES

standing, runs through the whole book"—*Blackwood's Maga-
zine*, CXIV (November, 1873), 607. John Morley, on the
other hand, took the occasion to hail the rise of "a learned,
vigorous, and original school of criticism" that should make a
much-needed and much-desired "English contribution to the
research and thought of Europe." He saw in Pater's studies
"the most remarkable example of this younger movement
towards a fresh and inner criticism . . ." Unlike Mrs. Pat-
tison, who had berated Pater for treating art as if it had "no
relation to the conditions of the actual world," Morley found
in Pater's criticism a "constant association of art with the
actual moods and purposes of men in life," a way of unfold-
ing the significance of art always "in relation to human
culture and the perplexities of human destiny"—*Fortnightly
Review*, XIII, n.s. (April, 1873), 469–474.

All the reviewers, even the least sympathetic, acknowl-
edged that *The Renaissance* was in its way a distinguished
piece of writing. Even Mrs. Oliphant found in it "much that
is really graceful and attractive"; yet she and some others held
that on the whole it was mannered, esoteric, and fit for few
readers. Comparisons with Ruskin came to mind. According
to the *Saturday Review* "Mr. Pater, by his tone of thought and
style of diction, might almost pass for a disciple of Mr. Rus-
kin"—XXXVI (July 26, 1873), 123. But W. D. Howells, on
firmer ground, saw that Pater was "as far from thinking with
Mr. Ruskin as from writing like him"—*Atlantic Monthly*,
XXXII (October, 1873), 498. Pater's style was praised for its
"care" and "finish," its "penetrative force and subtlety," its
economy and "fine reserve," and by Mrs. Pattison for a
choice of words "so brilliantly accurate that they gleam upon
the paper with the radiance of jewels." His best passages,
remarked R. H. Hutton in the *Spectator*, though "perhaps too
visibly laboured, have subtle touches of lovely colour, and a
sweet, quiet cadence, hardly amounting to rhythm, which are
distinguishable from those of poetry only in form"—XLVI
(June 14, 1873), 765. "The great distinction of this book,"
said Symonds, "is that its author has been completely con-
scious of what he wished to achieve, and has succeeded in the

CRITICAL AND EXPLANATORY NOTES

elaboration of a style perfectly suited to his matter and the temper of his mind. He has studied his prose as carefully as poets study their verses, and has treated criticism as though it were the art of music. Yet he is no mere rhetorician. The penetrative force and subtlety of his intellect are everywhere apparent"—*Academy*, IV (March 15, 1873), 104. But the highest and most memorable commendation came in Colvin's carefully deliberated statement:

Mr. Pater's style is often beautiful, always intimately his own, and always sedulously taken care of. The worst that could possibly be said against it, by a critic having no sympathy with its personal sentiment, would be that it went sometimes to the edge of fancifulness and affectation, or that the poetry of its descriptions and allusions seemed sometimes to cloy by recurrence. The best that could be said of it is something almost stronger than we like to venture. Or we would say that no English prose writer of the time had expressed difficult ideas and inward feelings with so much perfection, address, and purity, or had put more poetical thoughts or more rhythmical movement into his prose without sacrificing that composure and lenity of manner which leave it true prose nevertheless. The masterpiece of the style is the Conclusion . . . (*Pall Mall Gazette*, March 1, 1873, p. 12.)

Colvin goes on to say that much as he admires its eloquence he does not accept what he calls the philosophy of the Conclusion. The care and discrimination of his statement remind us that reading *The Renaissance* was a complex experience. Most of the reviewers show evidence of mixed feelings; some readers, for various reasons, found the book wrong-headed, dangerous, or pernicious. But the climate of feeling and opinion was changing, and two reviewers professed to be aware of a significant number of readers who were already prepared in 1873 to respond sympathetically to Pater's outlook on life and art. John Morley, editor of the *Fortnightly Review*, welcomed *The Renaissance* as one expression of a new secular spirit at work in England—the spirit, he said, of "a recent pagan movement" made up of "a numerous sect of cultivated people" who, though indifferent to religion, politics, and

"philanthropy," had already adopted something like Pater's faith in art and were shaping their lives by it. That a serious writer like Pater, he added, "should thus raise aesthetic interest to the throne lately filled by religion only shows how void the old theologies have become"—*Fortnightly Review*, XIII, n.s. (April, 1873), 476. The writer for the *Saturday Review* was cheered by evidence of what he called "a new life" stirring, animated in part by a reaction against Ruskin, fostered and guided by the work of younger artists and writers: "These remarkable 'Studies' [he wrote] are among the signs of the times. Since the days of the purists, when Mr. Ruskin denounced the Renaissance as hollow and unholy, a singular change has come over the younger generation who are now in turn moulding the literature and art of the country. Poetry, painting, and criticism alike—the poetry and pictures of Mr. Rossetti, the poetry of Mr. Swinburne, not to mention a host of imitators, the paintings of Mr. Burne Jones, together with divers critical writings such as the work now before us—all tell of a modern renaissance of the old Renaissance, of a new life sometimes surrendered to passion and to pleasure, but in its better aspects aspiring through the ministration of the arts to conditions of high mental enjoyment and pure aesthetic culture"—*Saturday Review*, XXXVI (July 26, 1873), 123. Even if these two reviewers were lured by sympathy into some degree of exaggeration, they were speaking of a genuine surge of thought and feeling in the early 1870's. For better or for worse, educated people were becoming familiar with the idea that art might take the place of religion as the most serious interest in life, that one might aspire, if not to salvation, at least to fulfillment, through "the ministration of the arts." Aestheticism was in the air, and *The Renaissance* would be its sacred book.

Title page: Illustration. Charles Henry Jeens (1827–1879) engraved this vignette during the winter of 1876–77 from the Leonardesque drawing no. 2252 in the Louvre. Pater was delighted with his work, as he said in more than one letter to Alexander Macmillan, his publisher. His first view of the

proof stirred him to write, "I have received the proof of the vignette, and think it the most exquisite thing I have seen for a long time—a perfect reproduction of the beauty of the original, and absolutely satisfactory in the exactness and delicacy of its execution. My sincere thanks to Mr. Jeens" —*Letters*, p. 22. The letter is dated March 31 [1877]. For Pater's comments on the original drawing, see 90:28–91:1 and n.

xvii. Dedication. Charles Lancelot Shadwell (1840–1919), "Fellow, and later (1905–14) Provost, of Oriel College, Oxford, and said to have been the closest friend of Pater's adult life. As an undergraduate at Christ Church, Shadwell became Pater's private pupil (1863), and like Pater was elected to the 'Old Mortality,' a notable Oxford literary society. He was Pater's companion in 1865 on his first trip to Italy, where they visited Ravenna, Pisa, and Florence. As a token of their friendship and in memory of this trip, Pater dedicated *Studies in the History of the Renaissance* to 'C.L.S.' Shadwell was an eager student of Dante, and an early (1877) member of the Oxford Dante Society, to which Pater also was elected in 1890. To Shadwell's translation of cantos I–XXVII of the *Purgatorio* Pater contributed a prefatory essay [Introduction to *The Purgatory of Dante Alighieri*, trans. Charles Lancelot Shadwell, 1892; repr. in *Uncollected Essays*, 1903]. After Pater's death Shadwell undertook the role of literary executor . . ." *Letters*, p. xxxvii.

Facing xix. "Though ye have lain among the pots, yet shall ye be as the wings of a dove covered with silver, and her feathers with yellow gold"—Psalms 68:13. A study of this psalm will yield no easy understanding of the reasons why Pater took from it the words which serve as the epigraph for his book. He must have had in mind Pico della Mirandola's happy use of the image in his prayer to the "ultramundane spirits" in the opening lines of the "Proem" to the third book ("Of the Angelic and Invisible World") of his *Heptaplus* (1496): "Thus far we have discussed the celestial world, unveiling the mysteries of Moses to the best of our ability. Who will now give me the wings of a dove, wings covered

CRITICAL AND EXPLANATORY NOTES

with silver and yellow with the paleness of gold? I shall fly above the heavenly region to that of true repose, peace, and tranquility, especially that peace which this visible and corporeal world cannot give. Unveil my eyes, you ultramundane spirits, and I shall contemplate the wonders of your city, where God has laid up for those who fear him what the eye has not seen, nor the ear heard, nor the heart thought"— *Omnia Quae Extant Opera* (Venice, 1557), p. 3 (trans. Carmichael, p. 106).

Preface

In his letter to Macmillan of June 29, 1872, Pater enclosed six completed essays and "a table [now lost] of the proposed series which I hope to complete by the end of the long Vacation, with a short Preface"—*Letters of Walter Pater*, ed. Lawrence Evans (Oxford, 1970), p. 7. Four months later, on October 30, George Lillie Craik, acting for Macmillan, wrote Pater that one of the essays already "printed" was now, in deference to his wish, being "cancelled" and returned to him so that he could "embody parts of it in the Preface"—*ibid.*, p. 8, n. 1. On November 2 Pater advised Macmillan that he had "not yet received the Preface and the rejected essay, which were to be returned to me for the alteration of the former"—*ibid.*, p. 9. The canceled essay was probably, as Evans suggests, "a first version of 'The School of Giorgione,'" an essay not published until 1877. Although he does not repeat himself, Pater is concerned in both the Preface and in "Giorgione" with what he calls "the function of the aesthetic critic" (xx:30–31) and the "functions of aesthetic criticism" (109:24). The date 1873, which he later assigned to the Preface, suggests that it was still unfinished at the end of 1872; if so, it was the last of the pieces to assume its final form. Once published, it appeared in the later editions of the book without any major changes.

Pater's idea of the "aesthetic critic" was respectfully charac-

terized by Sidney Colvin as "a very distinct idea, the result, it seems, partly of temperament and partly of reflection upon the nature of things and the place of aesthetics in life. A temperament acutely sensitive to impressions of art, and to subtle differences and shades in the quality of these impressions, and a philosophy which accepts objects as relative, experience as everything, the Absolute as a dream—life as a flux, and consciousness as an incident in the encounter of forces—these together lead him to value very little the criticism which works by abstract rules and metaphysical definitions, and very much the criticism which works by concrete analysis and the precise description of individuals"—*Pall Mall Gazette*, March 1, 1873, p. 12. Colvin granted a large measure of merit to Pater's position and spoke of his critical practice in terms of the highest praise. John Addington Symonds also took up Pater's distinction between two kinds of criticism, the kind that seeks abstract definitions and standards and the opposing kind, which Pater calls "aesthetic criticism." Symonds warned that "the aesthetic critic too easily becomes a voluptuary" and held that Pater himself was not "wholly free from the intellectual Sybaritism to which the critics of his school . . . are liable." Yet he agreed that Pater's method is the right one, "for criticism is not a science, neither is there any absolute definition of beauty . . . It is enough that the critic should be accomplished, sincere, gifted with delicate perceptions, and rational." Like Colvin, he found Pater a very distinguished master of his own kind of criticism—*Academy*, LV (March 15, 1873), 103–104. John Morley was another who welcomed Pater's insistence in the Preface on the importance for the critic of "a certain kind of temperament," rather than an interest in the abstract definition of beauty—*Fortnightly Review*, XIII, n.s. (April, 1873), 472.

As one might have foreseen, there were those who disagreed. One reviewer remarked with emphasis that "what is wanted . . . is a thorough nomenclature of art and definition of all its qualities in the abstract . . ."—*Nation*, XVII (October 9, 1873), 243. Pater's idea of the critic's task drew a skeptical response from R. H. Hutton, who wrote: ". . . we

take no exception to the doctrine enunciated, but the impressions of which Mr. Pater speaks will obviously vary with every change in the temperament, education, and capacities of the observer, and must, in every case, be extremely difficult to describe. The eye sees, as Goethe said, what it brings with it the power of seeing. There being a million subtle variations in the impressions made by a work of art upon a million different spectators, nature has not provided a linguistic machinery fine enough to distinguish each from each" —*Spectator*, XLVI (June 14, 1873), 764. Mrs. Margaret Oliphant ridiculed as pretentious Pater's notion of the "aesthetic critic" set up before us, as she said, "in full possession of his high office, standing, as it were, as mediator between art and the world . . ."—*Blackwood's Magazine*, CXIV (November, 1873), 605. And yet she praised Pater's idea that the "aesthetic critic" properly seeks to identify and to disengage the "virtue" in an artist's work and quoted with approval the passage on Wordsworth (xxi: 30–xxii: 17) in which Pater sketches out his method. The reviewers' response to Pater's general idea of the Renaissance, set forth explicitly in the final pages of the Preface, in the opening pages of "Aucassin and Nicolette," and more briefly elsewhere, is touched on above, pp. 284–286.

During his lifetime and for twenty years or so after his death, Pater's program for the "aesthetic critic," and also his own critical practice, were held on the whole in high esteem. In the 1920's and 1930's, however, his reputation suffered a decline, and his name was commonly invoked to signify a kind of criticism that is merely "impressionistic" and appreciative, overpersonal or subjective, undisciplined by reference to ideas or standards of judgment, precious or trifling. Efforts to do his work justice by a closer study of his writings began with Ruth Child's *The Aesthetic of Walter Pater* (New York, 1940; repr. 1969), which includes a careful and fair-minded elucidation of some of the key terms in the Preface. In an acute and judicious essay in *The Last Romantics* (London, 1947; repr. 1961), Graham Hough concludes (p. 164) that Pater's critical theory, "sketchy and allusive though it is, is

generally admirable. It provides a continual directive towards sincerity and against irrelevance. But it must be confessed that by no means all of these admirable intentions are fulfilled in practice . . ."

xix:1–4. Pater's readers would recall that one of these writers was John Ruskin, who had made elaborate efforts to define beauty in abstract terms, notably in the earlier volumes of *Modern Painters* (1843–1860). But his reference would include also the more systematic treatises on aesthetics produced chiefly by German philosophers since the mid-eighteenth century.

xix:11–13. The doctrine that beauty is relative follows inescapably from the broader principle set forth and elaborated in Pater's first published essay, seven years before the date of the Preface: "To the modern spirit nothing is or can be rightly known except relatively and under conditions"—"Coleridge's Writings," *Westminster Review*, XXIX, n.s. (January, 1866), 107. On the same page Pater had decried abstraction and found "the true illustration of the speculative temper" in Goethe, "to whom every moment of life brought its share of experimental, individual knowledge, by whom no touch of the world of form, colour, and passion was disregarded."

The relativity of knowledge is a doctrine too familiar in philosophy to be traceable to any particular source in Pater's reading. It was a cardinal principle for empiricists and positivists, and indeed it was held in one form or another, as Herbert Spencer remarked, by "almost every thinker of note."—*First Principles* (1862), *Works* (London and Edinburgh, 1880), I, 69. John Stuart Mill defined it as the affirmation that "our knowledge of objects, and even our fancies about objects, consist of nothing but the sensations which they excite, or which we imagine them exciting, in ourselves."—*An Examination of Sir William Hamilton's Philosophy*, 2nd ed. (London, 1865), p. 8.

To Pater as a student of philosophy the corollary doctrine of the relativity of beauty would have been equally familiar. He could have met with a lively statement of it in Baude-

laire's art criticism for 1846: "Absolute and eternal beauty does not exist, or rather it is only an abstraction skimmed from the general surface of various beauties."—*Curiosités esthétiques*, in *Oeuvres complètes de Charles Baudelaire*, ed. Jacques Crépet (Paris, 1930–1953), II, 197. (See also his witty return to the subject in 1855.—*ibid.*, 223.) Though Pater does not mention Baudelaire's name until 1876 (in his essay "Romanticism," later retitled "Postscript"), no one who knew Swinburne at all in the late 1860's could have remained unaware of his admiration for Baudelaire, an admiration that was strongly expressed in print—in "Charles Baudelaire: *Les Fleurs du mal*," *Spectator*, XXXV (September 6, 1862), 998–1000; in *Notes on Poems and Reviews* (London, 1866), p. 16; and in *William Blake* (London, 1868), pp. 91–92 and n. And Pater did know Swinburne, though just how well remains in doubt. If, as Edmund Gosse testified, Swinburne "was a not infrequent visitor in those years [1868–1870] to Pater's college rooms," where the two read verse aloud until sunrise (see *Letters*, pp. xxxviii–xxxix and n.), then Pater had almost certainly read or heard the poet read his elegy on Baudelaire, "Ave atque Vale," written in 1867 though not published until 1878.

xix:16. "Formula," one of Pater's favored terms in *The Renaissance*, had been used in 1859 by Baudelaire: "I torment my mind to tear from it some formula which expresses well the distinguishing quality of Eugène Delacroix."—*Curiosités esthétiques* (1868), *Oeuvres complètes*, II, 297–298. Pater had probably read this essay of Baudelaire by 1872, the year of the Preface, for he quotes from it in his "Giorgione," probably composed by that time though not published until 1877 (see headnote to Preface and n. to 105:9–11). In any case, he would have encountered not only the term but also a memorable statement of the critic's aim in Sainte-Beuve's essay on Taine (1857): "I willingly accept as true . . . that every genius, every distinguished talent has a form, a general interior procedure which he applies then to everything. Subjects, opinions change, the process remains the same. To arrive thus at the general formula of a talent is the ideal

end of the study of the moralist and the painter of characters."—*Causeries du lundi*, 3d ed. (Paris, 1857–1862), XIII, 222. (This ed. of the *Causeries* was in Pater's personal library.) Probably, as Germain d'Hangest supposes, the term was borrowed from the vocabulary of chemistry—*Walter Pater: L'Homme et l'oeuvre* (Paris, 1961), I, 155.

xix:19–24. "Of the literature of France and Germany, as of the intellect of Europe in general, the main effort, for now many years, has been a critical effort; the endeavour, in all branches of knowledge, theology, philosophy, history, art, science, to see the object as in itself it really is."— Matthew Arnold, "On Translating Homer" (1862), Lecture II, *The Complete Prose Works of Matthew Arnold*, ed. Robert H. Super (Ann Arbor, 1960–1977), I, 140. Arnold repeated these words in the opening paragraph of "The Function of Criticism at the Present Time" (1864), *ibid.*, III, 258.

In spite of the approval apparently conveyed by the word "justly," Pater subverts Arnold's meaning profoundly in what follows. The point is well made by Geoffrey Tillotson: "Arnold's phrase 'the object as in itself it really is' was for rescuing the object from the clutches of the individual. Pater was for clutching it closer. Arnold had sought to disencumber the object of any 'individual fancy,' but here was Pater exalting temperament, the very hive of such fancies . . . For Arnold the object lay in the external world sharply clear for anybody who had not blinded himself with some insular or provincial zeal or other. For Pater the object as it really is lay in the privacy of the individual impression of it . . ." "Arnold and Pater: Critics Historical, Aesthetic and Unlabelled," in *Criticism and the Nineteenth Century* (London, 1951), p. 108. Why then did Pater quote Arnold at all? Because, says Tillotson, "he liked Arnold's criticism and liked it too indiscriminately, and liked also to show his liking" (p. 108). But Pater often differed with Arnold, and to some readers it will seem more likely that he knew exactly what he was doing here with Arnold's famous phrase.

At any rate, when Pater insists on the primacy of "one's own impression" of the object, he seems merely to demon-

strate his conviction that knowledge is relative—that, in short, we cannot "see the object as in itself it really is." As Mill explained, those who hold the doctrine of the relativity of knowledge in its usual form "believe that there is a real universe of 'Things in Themselves,' and that whenever there is an impression on our senses, there is a 'Thing in itself,' which is behind the phaenomenon, and is the cause of it. But as to what this Thing *is* 'in itself,' we . . . can only know what our senses tell us; and as they tell us nothing but the impression which the thing makes upon *us*, we do not know what it is *in itself* at all."—*Hamilton*, p. 9. Mill's use of the word "impression" is much like Pater's, as when he says later that our knowledge of the properties of objects is "merely phaenomenal. The object is known to us only in one special relation, namely, as that which produces, or is capable of producing, certain impressions on our senses; and all that we really know is these impressions."—*ibid.*, pp. 13–14. But this is only to say that Pater found the word in the standard vocabulary of philosophy.

xix:24–28. Compare Mill's similar use of the word "power": "It is obvious that what has been said respecting the unknowableness of Things 'in themselves,' forms no obstacle to our ascribing attributes or properties to them, provided these are always conceived as relative to us. If a thing produces effects of which our sight, hearing, or touch can take cognizance, it follows, and indeed is but the same statement in other words, that the thing has *power* to produce those effects. These various powers are its properties, and of such, an indefinite multitude is open to our knowledge."—*ibid.*

xix:28–xx:5. Compare Arnold's account of Goethe's skeptical habit in his essay on Heine (1863): "Goethe's profound, imperturbable naturalism is absolutely fatal to all routine thinking; he puts the standard, once for all, inside every man instead of outside him; when he is told, such a thing must be so, there is immense authority and custom in favour of its being so, it has been held to be so for a thousand years, he answers with Olympian politeness, 'But *is* it so? is it so to *me*?'"—*Complete Prose Works*, III, 110.

xx: 17–28. Compare Baudelaire: "An artist, a man truly worthy of that great name, must possess something essentially *sui generis*, by virtue of which he is *himself* and not another. From this point of view, artists can be compared to various flavors . . ." "Richard Wagner et Tannhäuser à Paris" (1861), collected in *L'Art romantique* (1868), in *Oeuvres complètes*, III, 237–238.

xx: 17. Although in his Preface Pater does not name any "aesthetic critic" who would meet his requirements, the terms in which (not long before writing the Preface) he speaks of Sidney Colvin's "great general knowledge of art" and his capacity for aesthetic experience suggest that he had Colvin in mind as an example. See especially the concluding words (195:9–15) of his review of Colvin's book *Children in Italian and English Design* (1872). This review appeared on July 15, 1872. A year later a reviewer of *The Renaissance* remarked that "the critic to whom Mr. Pater most nearly approaches is Mr. Sidney Colvin. . . ."—*Saturday Review*, XXXVI (July 26, 1873), 123. Colvin's relationship with Pater is summarized in *Letters*, p. 5n.

xx: 24–25. Leonardo da Vinci's famous painting in the Louvre, better known as the Mona Lisa, the subject of Pater's reverie at 98:17–99:16. The Tuscan district of Carrara is known for its white marble. The philosopher Pico of Mirandola (1463–1494) is studied in a later chapter of *The Renaissance*.

xxi: 9–11. All texts read "a recent critic of Sainte-Beuve: —". But the words that follow are those of Sainte-Beuve himself, and "critique" is my conjectural emendation. The quoted words are taken from a passage in which the noted French critic Charles Augustin Sainte-Beuve (1804–1869) recalls what it had meant to be "humaniste" just at the moment when the first literary labors of Renaissance erudition had been completed and the great authors of ancient times were available in printed books. "Let us allow ourselves to imagine what it was like to be a friend of Racine or Fénelon, a M. de Tréville, a M. de Valincour, one of those well-bred people who did not aim at being authors, but who confined

themselves to reading, to knowing beautiful things at first hand, and to nourishing themselves on these things as discriminating amateurs, as accomplished humanists. For one was humanist then, something almost no longer permitted today" —Review of *Oeuvres françoises de Joachim du Bellay*, ed. Charles Marty-Laveaux (Paris, 1866), in *Journal des savants*, June 1867, pp. 345–346. This excursus appears in the second of three essays on du Bellay; the series was republished in *Nouveaux lundis*, 5th ed. (Paris, 1879–1884), XIII, 266–356.

xxi:12–16. Compare Pater's account of Winckelmann's "temperament" at 153:32ff and 175:27ff.

xxi:23–24. From Blake's annotations to vol. I of *The Works of Sir Joshua Reynolds*, 2d ed. (London, 1798), 71. (The copy with Blake's annotations is in the British Museum.) Reynolds had written: "Albert Durer . . . would, probably, have been one of the first painters of his age . . . had he been initiated into those great principles . . ." Blake protests: "What does this mean *"would have been"* one of the *first Painters of his Age"* Albert Durer *Is*! Not would have been! Besides, let them look at Gothic Figures & Gothic Buildings. & not talk of Dark Ages or of Any Age! Ages are All Equal. But Genius is Always Above the Age." Pater probably took his quotation from Alexander Gilchrist's *Life of William Blake* (London, 1863), I, 263, where it appears as: "Ages are all equal, but genius is always above its Age."

xxi:27–xxii:2. Byron is a strange example here. Goethe, Byron, and Wordsworth are an Arnoldian trio, as in "Memorial Verses" (1850), Arnold's poem on the death of Wordsworth. Perhaps Pater takes the suggestion from Arnold, who seems to have been much on his mind as he wrote the Preface. Arnold's judgment that Wordsworth's best poems were "mingled with a mass of pieces very inferior to them; so inferior to them that it seems wonderful how the same poet should have produced both" was not published until 1879—"Wordsworth," *Complete Prose Works*, IX, 42.

xxii:5–6. Wordsworth's "Ode: Intimations of Immortality from Recollections of Early Childhood" (1807).

xxii:13–17. Pater's essay "On Wordsworth" was just such

an attempt to "disengage" and describe at length this "virtue" or "active principle" in Wordsworth's poetry. The essay appeared first in the *Fortnightly Review*, XV, n.s. (April, 1874), 455–465; it was revised and reprinted under the title "Wordsworth" in Pater's *Appreciations* (1889).

xxii:27–29. The phrase "Christian art" had a vogue or currency derived from two well-known books: (a) *De La Poésie chrétienne* (Paris, 1836), translated as *The Poetry of Christian Art* (London, 1854) and revised and enlarged in four volumes as *De L'Art chrétien* (Paris, 1861–1867), by Alexis-François Rio; and (b) *Sketches of the History of Christian Art*, 3 vols. (London, 1847) by Alexander William Crawford Lindsay, 25th Earl of Crawford. Ruskin speaks in *Modern Painters*, V (1860) of "the art which, since the writings of Rio and Lord Lindsay, is specially known as 'Christian'"— *Works*, ed. Cook and Wedderburn (London, 1903–1912), VII, 264. His long and generally favorable review of Lord Lindsay's book is reprinted in *Works*, XII, 169–248. Rio conceived of the history of Italian art as a struggle between Christian piety, ardor, and exaltation and the opposing forces of paganism and naturalism. In his view, a turning point toward the latter came about 1500, and he saw the degeneracy of Italian painting in the sixteenth century as a consequence of the increasingly secular spirit of Italian life. Lord Lindsay also in his more elaborate and eccentric work insisted on the primacy of Christian faith and the corruption of paganism. Pater knew Rio's writings and seems to have had him in mind, as Sidney Colvin assumed, at 180:14–23 and possibly also at 163:10–29. He probably also knew, or knew of, a collection of lectures published as *Christian Art and Symbolism* (London, 1872) by the Rev. R. St. John Tyrwhitt, vicar of St. Mary Magdalen in Oxford from 1858 to 1872, a well-known writer on art and a fervent admirer of Ruskin. For this book Ruskin himself wrote a laudatory "Preface," repr. in his *Works*, XXII, 109–110.

xxiii:1–2. "The heart and the imagination" is Arnold's phrase, repeated here as a sign of protest against Arnold's idea of the medieval spirit. For Arnold, in his essay on "Pagan

and Medieval Religious Sentiment" (1864), the later pagan spirit was that of "the senses and the understanding," the medieval spirit that of "the heart and the imagination"; the Renaissance was in part "a return towards the life of the senses and the understanding," a return brought to its culmination in the eighteenth century and brilliantly championed in the nineteenth by Heine—*Complete Prose Works*, III, 226–227. Arnold argues that neither spirit is adequate, that both are merely partial, that "the main element in the modern spirit's life is neither the senses and understanding, nor the heart and imagination; it is the imaginative reason." And it is this last element, nobly enshrined in the Greek poetry of about 530 to 430 B.C., "by which the modern spirit, if it would live right, has chiefly to live" (p. 230).

Here in the Preface and elsewhere, partly by adopting some of Arnold's terms and using them differently, Pater indicates his sharp rejection of Arnold's account of the characteristic spirit of pagan, medieval, and Renaissance life. For Pater at xxiii:1–2, medieval life is not "the rule of the heart and imagination"; these powers were held in thrall by "the religious system," to be freed in time only by the dissolving charm of the Renaissance spirit, whose motives and aspects are more fully noted at 1:24ff and elsewhere. For Pater's adoption of Arnold's phrase "the imaginative reason" for his own distinct purposes, see 102:16 and n. For his criticism of Arnold's failure to acknowledge and take into account "the pagan sadness," see 162:3–25 and 178:12–14 and nn. For his rather different treatment of the question what the modern spirit needs above all, see 184:25–185:25. On these and other aspects of Pater's complex relationship with Arnold, see David J. DeLaura's careful study, *Hebrew and Hellene in Victorian England: Newman, Arnold, and Pater* (Austin and London, 1969).

xxiii:17. For this favored word, see also Pater's *Marius the Epicurean* (1885), *Works* (London, 1910), II, 25; "Style" (1888), *Works*, V, 17; *Plato and Platonism* (1893), *Works*, VI, 58, 61, 110.

xiii:22–23. Here, and even more closely at xxiv:32–xxv:1

and 1:26–27, Pater's terms recall Arnold's: "a curiosity,— a desire after the things of the mind simply for their own sakes and for the pleasure of seeing them as they are,—which is, in an intelligent being, natural and laudable"—"Culture and Anarchy" (1869), ch. 1, *Complete Prose Works*, V, 91.

xxiii:24–25. Here and elsewhere (as at xxiv:13–17) Pater speaks with admiration of the great personalities of the "happier eras" as self-molded works of art. He finds the idea in Hegel. See his quotation (175:4–26) from Hegel's *Aesthetik* on "ideal artists of themselves" in the age of Pericles.

Two Early French Stories

Possibly this essay, first entitled "Aucassin and Nicolette," was "the paper in MS . . . not . . . published hitherto" sent to Macmillan on June 29, 1872. If so, it was one of those back in Pater's hands by September 21, when he acknowledged receiving "a printed specimen of the essays" on which, as he noted, he planned to make corrections for the printer— *Letters of Walter Pater*, ed. Lawrence Evans (Oxford, 1970), p. 8. If not, then it was one of "the remaining essays" completed between September 21 and November 2. In any case, it was the only one of the essays significantly expanded after its first appearance in print: the version of 1873 is only about three-fifths as long as the revision made for the 1877 and later editions. The added pages consist chiefly of two extended passages. Within the first of these (4:29–12:8) Pater retells the story of Amis and Amile (6:30–12:8), a medieval tale of perfect faith rewarded by a miracle; but he also includes (5:11–6:17) a strongly outspoken attack on the medieval church and its "merely professional, official, hireling ministers." The second addition (20:13–22:18) introduces the "House Beautiful," the abode of those "souls really 'fair'" who are above "the spirit of controversy," and ends with the coda to "Amis and Amile" in which the story of

a second miracle is told. Less important revisions were made at 19:8–11 and at 19:33–20:12.

For this essay Pater probably got his incentive—surely he took some of his ingredients—from two or three pages of Swinburne's *William Blake* (London, 1868). Insisting there on the eternal opposition between Puritanism and art, Swinburne had referred to "the notably heretical and immoral Albigeois with their exquisite school of heathenish verse" (pp. 88–89); to the poem known at the time as "Chaucer's *Court of Love*, absolutely one in tone and handling as it is with the old Albigensian *Aucassin* and all its paganism" (p. 89); to Aucassin's "famous speech," in which he decides to go to hell with the better sort of companions; to the legend of Venus and Tannhäuser; and to a "pagan revival" within the medieval period. As soon as this "revival" begins to get breathing room, he says, "there breaks at once into flower a most passionate and tender worship of nature, whether as shown in the bodily beauty of man and woman or in the outside loveliness of leaf and grass . . ." (p. 89, n.). So one may speak of Swinburne as "announcing thus in 1868 the essay Pater was to write in 1872"—Germain d'Hangest, *Walter Pater: L'Homme et l'oeuvre* (Paris, 1961), I, 356, n. 57.

Pater's general idea of the Renaissance is most fully outlined in the first pages of "Aucassin and Nicolette" and in the last pages of the Preface. The reviewers' response to this idea is noted above, pp. 284–286. On other aspects of "Aucassin and Nicolette" the reviewers of the first edition made no comments worth preserving, though much later two admirers of his writing criticized him gently in print for omitting an important episode in retelling the title story (see n. on 12:28–34).

1:5–15. One writer well known for his insistence on the importance of French sources for Italian literature was the learned Victor Le Clerc, editor (1842–1863) of vols. XXII–XXIV of the monumental *Histoire littéraire de la France* (Paris,

1733–). Pater could have drawn all his examples, and a great many more, from the *Histoire*, to which not only Le Clerc but other scholars on his staff made contributions. On St. Francis' familiarity with the French romances, see Le Clerc in *Histoire*, XXIV, 557; on Boccaccio's debt to the French fabliaux, see Le Clerc, *Histoire*, XXIII, 81–83 and other passages; on Dante's reference (*Purgatorio* XI, 79–81) to Paris as the acknowledged center of miniature-painting or manuscript illumination, see Le Clerc, *Histoire*, XXIV, 555, and Ernest Renan, *Histoire*, XXIV, 725. In his reference to "French writers" at 1:5, Pater probably had in mind at least two other writers with whose work he was familiar: Edgar Quinet and Claude Charles Fauriel. See, for example, the essay "Des Épopées françaises inédites du douzième siècle," in *Oeuvres complètes de Edgar Quinet* (Paris, 1857–1870), IX, 408–424 (esp. pp. 414–418). See also Fauriel's *Dante et les origines de la langue et de la littérature italiennes* (Paris, 1854), I, 246–307, on Provençal troubadours and their influence in Italy.

1:10. Giovanni Boccaccio (1313–1375), Italian author of the *Decameron*, a collection of a hundred stories published in 1353.

1:13–2:20. For his idea of the Renaissance as "a whole complex movement," Pater is deeply indebted to Jules Michelet's *Histoire de France*, vol. VII (1855). He follows Michelet when he insists on its twelfth-century origins, affirms its intellectual and imaginative vitality, and applauds its "antinomianism."

1:14–18. "That era [the Renaissance] would certainly have been the twelfth century, if things had followed their natural course"—Michelet, Notes de l'introduction, *Histoire de France* (Paris, 1833–1867), VII, cxxxv. Not only Michelet but many other French historians had made the medieval "Renaissance" a familiar idea by Pater's time. Ernest Renan, a writer important to Pater, was one of these: "The eleventh century had witnessed, in philosophy, in poetry, in architecture, a renaissance such as humanity reckons only a few in its long memory. The twelfth and the thirteenth centuries had de-

veloped that fruitful seed, the fourteenth and fifteenth centuries had seen its decline"—Renan, "L'Art du moyen age et les causes de sa décadence," *Revue des deux mondes*, XL (July 1, 1862), 203.

1:26–27. Pater's phrasing approximates Arnold's. See xxiii:22–23 and n.

2:31. Jean Cousin the elder (circa 1490–1560) was an engraver and a painter and designer of stained glass. Although attributions of particular works to him are uncertain, some of the windows of Sens Cathedral are thought to be his. Without being a member of the Italianate Fontainebleau school, "he seems to have been directly familiar with contemporary Italian art." His son Jean (1522–1594) was a book illustrator and glass painter. Germain Pilon (1537–1590) was a French sculptor, chiefly of royal and other court figures; in his later period his "debt to the school of Michelangelo is apparent"— *Oxford Companion to Art*.

3:11. Abelard's dates are 1079–1142, Heloise's about 1101–1164. The inception of their love while he served as her tutor in her uncle's house, the birth of their child, their secret marriage, her removal to a convent, and her uncle's revenge (the castration of Abelard) had all occurred by about 1118, when Abelard became a monk and Heloise a nun. Abelard continued to teach at various monasteries, attracting large numbers of students but arousing enemies within the church. He was condemned for his teachings on the Trinity by a synod at Soissons in 1121 and convicted of heresies by the Council of Sens and the Pope in 1140. On his way to Rome to defend himself, he was persuaded to submit to the verdict of the Council and to make peace with his enemies.

3:12–13. Compare the language of Arnold's proposal that the "disinterested love of a free play of the mind on all subjects, for its own sake" is essential to criticism—"The Function of Criticism at the Present Time" (1864), *Complete Prose Works*, III, 268.

3:26–28. Rémusat (mentioned below, 4:7–8) speaks of "a curious Breton chanson in Cornish dialect, in which Heloise,

Loiza, tells how instructed by her clergyman, *my clerk, my gentle Abelard*, she became, thanks to her knowledge of languages, a sorceress like the celtic druidesses (*Barzas-Breiz, Chants populaires de la Bretagne*, published by M. Th. de la Villemarqué, Paris, 1839, I, p. 93)"—*Abélard: Sa Vie, sa philosophie, et sa théologie* (Paris, 1855), I, xvii.

3:30–31. I have not been able to identify the source of this quotation—unless it is just possibly a confused recollection of the final words of the following passage: "Les entretiens savans ne fesaient pas seuls l'occupation de ces amans trop heureux, l'amour en fesait la plus grande partie"—"Idée des amours d'Héloïse et d'Abeilard," in *Lettres et épitres amoureuses d'Héloïse et d'Abeilard*, ed. A. E. Cailleau (London, 1780), II, 71 ("Learned conversations did not make up the whole occupation of these too happy lovers, love made up the greatest part of it"). The corresponding passage in the *Historia Calamitatum* is "Apertis itaque libris, plura de amore quam de lectione verba se ingerebant . . ." *Historia Calamitatum: Texte critique . . .* ed. J. Monfrin (Paris, 1959), p. 72 ("We opened our books but more words of love than of the lesson asserted themselves"—trans. Muckle, p. 28).

3:31–4:5. The "Island" is the ancient Île de la Cité in the Seine, the site of Notre Dame. After years of strenuous study, teaching, and philosophical contention with other masters, Abelard, now about thirty-eight years old, had established his pre-eminence in dialectic and theology. He had been appointed *magister scholarum* at Notre Dame, a lucrative and respected position he had long desired. Although for the time being he had put down all his rivals and enjoyed unprecedented success as a teacher, there would seem to have been no room in his life nor in his temperament for "dreamy tranquillity . . . in a world of something like shadows." His own later account of the mood or state in which he found himself just before he began to devise the seduction of Heloise leaves a different impression: "But success always puffs up fools and worldly repose weakens the strength of one's mind and readily loosens its fiber through carnal allurement. At a time when I considered that I was the one philosopher in

the world and had nothing to fear from others, I, who up to that time had lived most chastely, began to relax the reins on my passions"—*Historia Calamitatum*, ed. Monfrin, p. 70 (trans. Muckle, p. 25).

4:7–10. Charles François Marie, Comte de Rémusat (1797–1875). Pater translates from his *Abélard*, I, 54. Abelard's "verses in the vulgar tongue" have disappeared. About fifteen years later, in her letter of response to his *Historia Calamitatum*, Heloise reminds Abelard of these songs, which, she says, gave him power over the hearts of women, kept his name on every lip, and spread abroad her own name and fame.

4:10–12. The letters begin with Heloise's response to Abelard's autobiographical *Historia Calamitatum*, which she read soon after he sent it to an unknown "friend" about 1132. The whole exchange consists of the *Historia Calamitatum* itself and seven further letters, three by Heloise and four by Abelard. They were printed first in Paris in 1616 and have been translated and reprinted many times since. The Latin text of the letters was republished by Victor Cousin in the first volume of his edition of Abelard's *Opera* (Paris, 1849). Controversy about the authenticity of the correspondence was well advanced in Pater's time. Pater borrowed the edition of 1616 from the Brasenose College Library in October and November, 1870, and again from March to July, 1871. In addition to Rémusat's thorough study, he knew Michelet's characteristically suggestive account of Abelard's career in *Histoire de France* (Paris, 1835–1845), II, 281–297, and his further comments on Abelard in his Introduction, *Histoire de France* (Paris, 1833–1867), VII, LIX–LX, and in his Notes de l'introduction, *ibid.*, CXXXV–CXXXVIII.

4:13–21. Pater translates from Michelet's "Notes de l'introduction," *Histoire de France*, VII, CXXXVI. The translation is close, but Michelet has "la Révolution," clearly intending by his capital letter a reference to the French Revolution; Pater's use of the small letter blurs the reference. Three or four sentences later (pp. CXXXVI–CXXXVII) Michelet adds a passage worth quoting for what it reveals of Pater's depen-

dence on him for his conception of Abelard's "spirit"—of its "sweetness" (4:24) in particular: "What then was this prodigious teaching, which had such results? Certainly, if it were no more than what has been preserved, there would be good reason to be surprised. But one sees very well that there was something else entirely. It was more than a science, it was a spirit, a spirit above all of great sweetness, the effort of a humane logic to interpret the somber, harsh theology of the Middle Ages. It is by that, very probably, that he wins over the world, far more than by his logic and his theory of universals." And in what immediately follows, Michelet remarks that other authors who had recently written about Abelard had not recognized or emphasized that "spirit of great sweetness above all" which he himself now regards as Abelard's distinctive power.

4:20. Arnold of Brescia (d. 1155) was one of the most vigorous and outspoken critics of the corruption of the clergy, the right of churchmen to hold property, and the temporal power of the popes. He was accused by Bernard of Clairvaux of sharing Abelard's doctrines, and like Abelard was condemned, largely through Bernard's efforts, at the Council of Sens in 1140. He continued to denounce the clergy and to gather fame and adherents. Anathematized by the Pope in 1148, and ultimately seized by order of Emperor Frederick I and condemned to death, he was hanged, his body was burned, and his ashes were thrown into the Tiber.

4:21–22. ". . . cette demeure modeste, au jour sombre que des fenêtres étroites laissaient pénétrer dans la chambre simple . . ." Rémusat, *Abélard*, I, 52 (". . . this modest dwelling, in the dim light which some narrow windows let penetrate into the simple room . . .").

4:29–30. Abelard is not mentioned by Dante, but it is worth noting that his chief adversary, Bernard of Clairvaux (1090–1153), who worked hard for and procured his condemnation at Sens, is one of the most highly honored saints in Dante's Paradise. He is presented in the *Paradiso* as the type of the mystical contemplative, one who "in this world, in contemplation, tasted of that peace" (XXXI, 110–111). It

is St. Bernard who at the climactic end of the poem implores the Virgin to intercede so that the poet may share the vision of God.

5:4–5. The Latin Quarter, a district on the south side of the Seine frequented for centuries by students and artists, was the site of the several places of study that became the University of Paris in the early thirteenth century. Writing about 1360, Boccaccio says that Dante went to Paris and there gave himself entirely to the study of theology and philosophy— *La vita di Dante Alighieri* (Florence, 1833), p. 32. Modern scholars grant that Dante may have visited Paris about 1308 but find the evidence inadequate.

5:10. An allusion, perhaps, to the words of Dante's celestial eagle, symbolic of justice, who demonstrated that his song was unintelligible to the poet and then added: "As my notes are to you who do not understand them, such is the Eternal Judgment to you mortals"—*Paradiso*, XIX, 97–99.

5:11–18. Long familiar to the Germanic peoples, the story of Tannhäuser had become "famous" in Pater's own lifetime, chiefly, but not solely, through Wagner's opera. Ludwig Tieck's story "Der getreue Eckart und der Tannenhäuser" (1799) had given a new renown to the old legend among the Romanticists. Wagner's opera had been performed in Dresden in 1845 and in Paris in 1861, though it would not be presented in London until 1876. George Eliot, who was present at a performance in Weimar in 1854, gave a summary of the opera in her article "Liszt, Wagner, and Weimar," in *Fraser's Magazine* for July, 1855. German collectors of folksongs had begun to study the Tannhäuser ballads in their various dialects and with their various emphases and sympathies. Pater had probably read Heine's essay "Les Dieux en exil" (1853), and he certainly knew the German version of the essay in Heine's *Sämmtliche Werke*, ed. Strodtmann (Hamburg, 1861–1869), VII, 209–300. (See 24:6–25:12 and n.) He would of course have known Swinburne's "Laus Veneris" (1866) and Morris' "The Hill of Venus" (1870), both versions of the Tannhäuser story, and he must have read Swinburne's memorable defense of his own treatment of the subject in

Notes on Poems and Reviews (1866). There Swinburne speaks of the fallen Olympians "grown diabolic among ages that would not accept them as divine" and praises Baudelaire's essay "Richard Wagner et Tannhäuser à Paris" (1861), reprinted in *L'Art romantique* (1868), a book Pater probably knew as early as 1872.

5:18–23. Godstow Nunnery on the Thames in Oxfordshire, the retreat and burial place of "Fair Rosamond" Clifford, the object of Henry II's famous courtship, who died about 1176.

5:18–27. Abelard set out for Rome soon after his condemnation at Sens in 1140, but while stopping at Cluny he was persuaded to give up his pilgrimage, to become reconciled to Bernard of Clairvaux, and to seek absolution from the Pope. "Although the pope's response has not come down to us, there is no doubt that he yielded with good grace to so just a request. Freed of all anxiety, Abelard passed the rest of his days in a calm which equalled the troubles by which they had been harassed until then. All his free moments were divided among prayer, study, and the lectures which the abbot charged him with delivering from time to time to the religious community"—*Histoire littéraire de la France*, XII (1869), 101. Rémusat gives a detailed account, based on the letters of Peter of Cluny to the Pope and to Heloise, of the serenity and piety of Abelard's last year and a half at Cluny. —*Abélard*, I, 251–257. Pater seems to have ignored these details because his argument (that Abelard's "relation to the general beliefs of his age" remained uncertain) depends for its symbolic and dramatic power on the figure of the pilgrim dying on his way to Rome with his fate still in question.

6:13–15. "As for those who do not wish to welcome this kind of writing, which they call obscure because it goes beyond their power of understanding, I leave them with those who, after the invention of wheat, still want to live on acorns"—Joachim du Bellay, Preface to "L'Olive," *Oeuvres françoises*, ed. Marty-Laveaux (Paris, 1866), I, 69.

6:30–31. *Nouvelles françoises en prose du XIIIe siècle publiées*

d'après les manuscrits avec une introduction et des notes, ed. L. Moland and Charles d'Héricault (Paris, 1856).

7:3–5. Pater translates loosely from the editors' Introduction to *Nouvelles françoises*: "L'amitié pure et généreuse, poussée jusqu'à l'exaltation, arrivant jusqu'à la passion . . ." (p. xv).

7:12–14. Lines 1077–1079.

7:24. A Doppelgänger, or "double-goer," is the supposed ghost, wraith, double or counterpart of a living person. The Dioscuri are Castor and Pollux, twin sons of Zeus, who after they died became the constellation Gemini. In *Plato and Platonism* (1893), Pater tells their story as that of "brothers, comrades, who could not live without each other"—*Works* (London, 1910), VI, 230–232.

8:20–24. Pater summarizes the events recounted in *Nouvelles françoises*, pp. 60–62.

8:27–11:30. Pater translates with minor omissions or abridgments from the old French text—*ibid.*, pp. 62–72.

9:15. ". . . qu'il avoit occis Ardré"—*ibid.*, p. 64.

9:25. ". . . compains des celestiaus citieins, tu es ensegu [tu as ensuivi, suivi, imité] Job et Thobie [Tobit] per patience. Je suis Raphael . . ." *ibid.*, p. 65.

9:31–32. Pater mistranslates "Il le covient ainsie [convient ainsi] faire" (This is the way it must be done)—*ibid.*, p. 66.

10:23–24. ". . . por quoi ne li garderai je foi? Abraham fu salvez per foi; et li saint vainquirent les reaumes per foi. Et Dex dit en l'Avangile: 'Ce que vos volez que li home vos facent et vos lor faites cele meismes chose.' Et Amiles . . ." *ibid.*, p. 68.

10:26. ". . . le servise Nostre Seignor. Et li Contesse s'an alai a l'englise ausi cum ale l'avoit acostumé. Et li Cuens prist s'apée [épée] . . ." *ibid.*, pp. 68–69.

11:6. ". . . de meselerie [lèpre], et cil rendarent graces à Nostre Seignor à grant joie, et distrent: 'Benoit soit Dex, li pères Nostre Seignor Jhesucrit, qui salve ces qui ont esperance en lui!' Et Amiles . . ." *ibid.*, p. 70.

12:9–17. Pater's remarks are based on Claude Charles

Fauriel's *Histoire de la poésie provençale* (Paris, 1846), II, ch. 18. Fauriel defines the "tenson" as "dialogues in which two or several interlocutors maintain contrary opinions on a given thesis" (pp. 101–102). In his essay "Poems of William Morris" (p. 95), Pater defines the "aubade" in words that amount to a paraphrase of Fauriel: a "waking song . . . put sometimes into the mouth of a comrade of the lover, who plays sentinel during the night ['qui fait le guet au sommet du beffroi'—Fauriel], to watch for and announce the dawn; sometimes in the mouth of one of the lovers, who are about to separate"—*Westminster Review*, XXXIV, n.s. (October, 1868), 145. In the same chapter Fauriel distinguishes between the studied, often difficult love songs of the courts and chateaux, which the people could not understand or enjoy, and the simpler, more straightforward love poetry meant for a wide audience (p. 83). Bernard de Ventadour (fl. 1150–1195) and Pierre (or Peire) Vidal (fl. 1175–1215) were celebrated troubadours.

12:20. Claude Charles Fauriel (1772–1844), from 1830 professor of foreign literature at the Sorbonne, author of *Histoire de la poésie provençale* (Paris, 1846), wrote also *Dante et les origines de la langue et de la littérature italiennes* (Paris, 1854) and other works.

12:20–23. "We have a single copy of the story of Aucassin and Nicolette: it is the manuscript catalogued as no. 7989[2] (*Baluze*) in the French collection of the imperial library. The dialect is that of the Ile de France, which tends in general to approximate modern usage and pronunciation"—*Nouvelles françoises*, p. lxi.

12:23–26. *Histoire de la poésie provençale*, III, 183, 214n.

12:28–34. F. W. Bourdillon, *Aucassin and Nicolette* (London, 1887); Andrew Lang, *Aucassin and Nicolette* (London, 1887). Vernon Lee is the pseudonym of Violet Paget (1856–1935), a friend of Pater and his sisters. Her *Euphorion* (London, 1833) is dedicated to Pater. In the chapter "The Outdoor Poetry," she writes that she "can recall one, though only one, occasion in which medieval literature shows us the serf," and she retells the story of Aucassin and Nicolette so as to

focus on the episode in which Aucassin converses with the unlucky serf who has lost his master's bullock. She points out that in his essay Pater "has deliberately omitted this episode, which is indeed like a spot of blood-stained mud upon some perfect tissue of silver flowers on silver ground" (p. 133). Later she remarks of the same episode: "It is the one occasion upon which that delicate and fantastic medieval love poetry . . . is confronted with the sordid reality, the tragic impersonation of all the dumb miseries, the lives and loves, crushed and defiled unnoticed, of the peasantry of those days" (p. 137).

If Paget's interest in the episode of the serf is humane and historical, Bourdillon's interest might be called moral and dramatic: he observes that "the introduction of this grotesque and incongruous figure has offended some critics; but the sudden impact of the defiant independence of this sturdy and almost monstrous rustic, upon the 'overwrought delicacy' of the dreamy and exquisite hero, is as bracing as a breath from the frosty night let into a heated opera-house. The hearty and wholesome scorn which the ploughboy displays for the young lord's weakness, and the contrast of his unbroken spirit under more real and material trouble, seem to give Aucassin for the first time an idea of the possibility of manful endurance of sorrow. 'Certes tu es de bon confort,' he says after his scolding; and though he rides on still without finding Nicolette, he weeps no more. Undoubtedly this side-picture of the unromantic wretchedness of the world, and of the sturdy spirit that is undaunted by it, is introduced as being one of the enduring lessons in the hero's life"— Introduction to *Aucassin and Nicolette*, liii–lv. In both writers' comments some measure of indirect reproof for Pater seems to be intended.

When *Euphorion* was published, Pater thanked Miss Paget for her dedication and praised her work at length without mentioning "Aucassin and Nicolette"—*Letters*, pp. 53–54 (letter of June 4, 1884). Later still, in Pater's unsigned review of Paget's second series of "Essays on Sundry Aesthetical Questions," somewhat deceptively entitled *Juvenilia* (Lon-

don, 1887), he took note of "her growing sense of great social and other evils" and added that there had always been traceable in her work "an unaffected sense of great problems, of the real probation of men and women in life, of a great pity, of the 'sad story of humanity,' bringing now and again into her exposition of what is sometimes perhaps decadent art a touch of something like Puritanism"—*Pall Mall Gazette*, August 5, 1887, p. 5.

13:29–14:5. *Nouvelles françoises*, pp. xxxvii–xxxix.

14:5–7. Pater adopts suggestions and even a phrase or two from Fauriel's comments on the "manner" of the piece— *Histoire de la poésie provençale*, III, 185.

14:9–11. *Nouvelles françoises*, p. 233.

14:12–14. *Ibid.*, pp. 271–272.

14:14–16. *Ibid.*, p. 275.

14:16–18. *Ibid.*, p. 270.

14:25. "Dax est li cans, biax est li dis, / Et cortois et bien assis . . ." (The singing is sweet, the story is beautiful, and courtly and well handled . . .)—*ibid.*, p. 232.

14:26–15:8. For other indications of Pater's idea of "charm," "expression," or "intimacy" in art, see 52:4–23, 56:1–15, and 137:11–20. Although their terms are different, and the differences are significant, Pater's distinction between the "antiquarian" and the "aesthetic" interest of old literature is similar to Arnold's later, more fully illustrated distinction (in "The Study of Poetry," 1880) between the "historic estimate" and the "real estimate." Both men warn against over-rating the old merely because it has historic value, and both have in mind examples from contemporary French scholarship and criticism. Indeed, it is Charles d'Héricault, one of the editors of the volume in which Pater found his two early French stories, whom Arnold quotes and chides for recommending in somewhat extravagant terms a skeptical historical outlook and method rather than the "conventional admiration" of the classics—*Complete Prose Works*, IX, 164–165.

16:24–17:20. Pater translates with minor alterations and

omissions from the old French of the *Nouvelles françoises*, pp. 258–260. As a translator, Pater was timid even by comparison with his contemporaries. The description of Nicolette in particular is fuller and the detail more vivid in the old French than in Pater's version. Compare, for example, Gustave Cohen's faithful translation of the passage at 17:6–10 into modern French: "Elle avait les cheveux blonds, en petites boucles serrées et les yeux clairs et rieurs, le visage allongé, le nez haut et bien planté, les lèvres minces et plus rouges que cerise ni rose en saison d'été, et les dents blanches et menues et elle avait ses petits seins si durs qu'ils soulevaient sa tunique, comme si ç'avaient été deux grosses noix. Elle était si fine de taille que vous auriez pu l'enserrer dans vos deux mains et les fleurs des marguerites qu'elle brisait avec les orteils et qui lui tombaient par-dessus le cou-de-pied, semblaient tout à fait noires à côté de ses pieds et de ses jambes, tant était entièrement blanche la fillette"—*Aucassin et Nicolette* (Paris, 1954), p. 31.

Bourdillon renders this passage into English as follows: "Her hair was golden and in little curls, and her eyes blue-grey and laughing, and her face oval, and her nose high and well-set, and her lips vermeil, so as is no cherry nor rose in summer-time, and her teeth white and small; and her bosom was firm, and heaved her dress as if it had been two walnuts; and atween the sides she was so slender that you could have clasped her in your two hands; and the daisy blossoms which she broke off with the toes of her feet, which lay fallen over on the bend of her foot, were right black against her feet and her legs, so very white was the maiden"—*Aucassin and Nicolette* (1887), pp. 110–111. Lang makes "her breasts so firm that they bore up the folds of her bodice as they had been two apples"—*Aucassin and Nicolette* (1887), p. 18—and adds in a note: "*Two apples*; *nois gauges* [walnuts] in the original. But *walnuts* sound inadequate," p. 51.

16:27. ". . . les nuis coies et series [sereines]"—*Nouvelles françoises*, p. 258. The adjective "coi, coite," though it might

be labelled "vieilli," was included in nineteenth-century dictionaries and is still in use. From the Latin *quietus*, it means "calm, tranquil, still."

17:32–34. "uno segnore di pauroso aspetto"—Dante, *Vita Nuova*, sect. III. The lover's loss of his senses in the presence of his lady is described in sects. III, XI, and XIV, and the book includes other references, both in the prose and in the poems, to experiences of the kind.

18:16–20. The Provençal text of the poem which Pater evidently has in mind appears with minor omissions in F. J. M. Raynouard's *Lexique roman* (Paris, 1838), I, 405–417. Raynouard presents the poem as one of several by Pierre Vidal. Later scholars have rejected the attribution of the poem to Vidal, and it does not appear in modern editions of his works. Whether or not Pater knew Raynouard's collection or had seen the poem elsewhere, he had almost certainly read the versification of its first episode in John Addington Symonds' *An Introduction to Dante* (London, 1872), pp. 254–255. Symonds explains that he has put into English verse not the poem itself, but only "the prose abstract given of the poem by [Jean Charles L. S. de] Sismondi," to whose book (in Roscoe's translation) he gives a reference in a footnote. Sismondi's "prose abstract" reads as follows: "The poet relates, that once, when he was in the country, he saw a young cavalier, fair as the morning, advancing towards him, with whose mien he was unacquainted. His eyes were soft and tender; his nose was beautifully formed; his teeth, shining like the purest silver; his mouth, blooming and smiling, and his figure, slight and graceful. His robe was embroidered with flowers, and his head was adorned with a crown of roses. His palfrey, which was white as snow, was marked with spots of black and purple. His saddle-bow was of jasper, his housings were of sapphire, and the stirrups, of chalcedony. Addressing himself to the poet, he said, 'Know, Pierre Vidal, that I am Love; this lady is called Mercy, that damsel is Modesty; and my esquire, there, is Loyalty' "—*Historical View of the Literature of the South of Europe*, trans. Thomas Roscoe, 2d ed. (London, 1846), I, 137. Still following Sis-

mondi, Symonds adds to his verses a comment that would have suggested to Pater the likeness he perceives between Aucassin and "the Provençal love-god" of the poem: "The importance of this vision cannot be exaggerated. Chivalrous Love is presented to us here as in a mythus. He is a very distinct personage . . . A youthful knight, in the bloom of beauty, among the fields of May, riding a snow-white steed, attended by Loyalty for squire, and by Modesty and Mercy for handmaidens—What could be a better portrait than this of the chivalrous passion?" (p. 255).

19:7–8. "And the Lord said unto Satan, Whence comest thou? And Satan answered the Lord, and said, From going to and fro in the earth, and from walking up and down in it"—Job 1:7, 2:2.

19:21–23. The counts of Toulouse in particular gave protection to Albigensian heretics and also handsomely encouraged the troubadours.

19:23–25. After St. Francis' death in 1226, some of his more faithful followers took up the doctrines attributed to Joachim of Flora (see n. to 19:26–30), and some of their writings were condemned as heretical. Later in the century these "zealots" or "spirituals," as they were called, split into various mystical, ecstatic, and prophetic sects, some of them beyond the pale of Christianity.

19:26–30. Joachim of Flora (circa 1145–1202), theologian and abbot of the monastery of San Giovanni in Fiore. Pater had certainly read Michelet's three or four startling pages on Joachim and "l'Évangile éternel." Joachim knew, says Michelet, "that the Holy Spirit is the free spirit, the age of science: 'There are three ages, three orders of persons among the faithful. The first have been called to the work of fulfilling the Law; the second, to the work of the Passion; the last, who come from both, have been elected for the Freedom of contemplation. It is that which Scripture attests to when it says: "Where the Spirit of the Lord resides, there is Freedom." The Father imposed the work of the Law, which is fear and servitude; the Son, the work of Discipline, which is wisdom; the Holy Spirit offers Freedom, which is love.'"

Michelet ends his account of Joachim's doctrine and its historical effects with some words that indicate dramatically enough what lies behind Pater's citation of Joachim among the great "antinomians": "This great teaching was the alpha of the Renaissance. It circulates from that time on as an eternal Gospel. Many were to teach it in flames. And Jean of Parma . . . boldly declared 'That the doctrine of Joachim is better than the doctrine of Christ'"—Introduction, *Histoire de France*, VII, LXII–LXIV.

Pater had probably read Ernest Renan's article "Joachim de Flore et l'évangile éternel," *Revue des deux mondes*, LXIV (July 1, 1866), 94–142; and perhaps also Victor Le Clerc's prior and shorter account of Joachim's doctrines and influence, especially among Franciscan friars, in vol. XXIV (1862) of *Histoire littérature de la France*, pp. 111ff.

20:2–12. Pater translates selectively from Fauriel's modern French version of Aucassin's speech in his *Histoire de la poésie provençale*, III, 190–191. Pater was evidently convinced that a full translation of this passage into English would offend his readers. In the 1873 edition he reproduced (with an explanatory footnote) Fauriel's translation of Aucassin's whole speech into modern French. (For this translation, see 213:38–214:27.) In the 1877 edition, in which foreign words and phrases are regularly translated into English, Pater omitted Aucassin's speech entirely, calling it "a passage in which that note of rebellion is too strident for me to translate it here, though it has its more subdued echoes in our English Chaucer." In 1888 and even in 1893 he was still unwilling, it seems, to give the full text in English, and yet by that time the full translations of Bourdillon and Lang had both been published (1887). Lang offered no apology, but Bourdillon tried to win over his more sensitive readers by this footnote: "Those of my readers to whom this passage comes with pain,—as it must with surprise to all,—will, I hope, simply pass it over. [Jean Baptiste de la Curne de] Sainte-Palaye, the earliest editor [Paris, 1756], omits it, and I have only not followed his example for two reasons: First, from a very great desire to translate the little work in its

completeness; secondly, because—though the words here used are still the words of our own faith, yet the ideas they represent in an age of superstition, and in an age of enlightenment, respectively, have little more in common than if the speaker had been a Greek or a Roman, making light of the mythical torments of Sisyphus or Ixion"—*Aucassin and Nicolette* (1887), pp. 94–95.

20:13. In *The Pilgrim's Progress*, Bunyan speaks of "a very stately Palace . . . the name whereof was *Beautiful*," and later he twice uses the phrase "the House *Beautiful*"—ed. James Blanton Wharey, 2d ed., rev. by Roger Sharrock (Oxford, 1960), 45, 251, 252. If the phrase has another source, I do not know of it. Bunyan's House Beautiful is "a house built for the relief and security of Pilgrims." Pater does not use the phrase in the 1873 edition of *The Renaissance*, but introduces it for the first time in the final three pages (20:13–22:18) added to the essay for the 1877 edition. He does use it earlier, however, in his review of Sidney Colvin's *Children in Italian and English Design* (London, 1872), which appeared in the *Academy*, III (July 15, 1872), 267–268. (See 194:23.) He repeats it in his essay "On Wordsworth," *Fortnightly Review*, XV, n.s. (April, 1874), 464. And the phrase occurs again in the essay first entitled "Romanticism," *Macmillan's Magazine*, XXXV (November, 1876), 64. This essay, revised and retitled "Postscript," became the last essay in the collection called *Appreciations* (1889).

20:25–21:2. Compare Sainte-Beuve: "It is truly not a question of sacrificing anything, of disparaging anything. The Temple of taste, I believe, needs to be rebuilt; but, in rebuilding it, it is only necessary to enlarge it, so that it shall become the Pantheon of all noble humans, of all those who have notably and permanently increased the sum of the pleasures and claims of the spirit"—"Qu'est-ce qu'un classique?" (1850) in *Causeries du lundi*, 3d ed. (Paris, 1857–1862), III, 50.

20:26. The section called "Bekenntnisse einer schönen Seele" in bk. VI of Goethe's novel *Wilhelm Meister's Lehrjahre* (1795–1796) gave the phrase its currency, but the "fair"

or "noble" soul was a verbal commonplace. In his essay on Coleridge Pater mentions "the 'Beautiful Soul,' in 'Wilhelm Meister'"—*Westminster Review*, XXIX, n.s. (January, 1866), 111; and in "Winckelmann" he speaks of "the Schöne Seele, that ideal of gentle pietism, in *Wilhelm Meister*" (243 : 15–16).

20:30–21:1. "Whatsoever things are true, whatsoever things are honest, whatsoever things are just, whatsoever things are pure, whatsoever things are lovely, whatsoever things are of good report; if there be any virtue, and if there be any praise, think on these things"—Philippians 4:8.

20:31–33. The word "parage" is Fauriel's ("les hommes de parage"); it does not appear in the old French text, which has instead "li franc home"—translated by Gustave Cohen as "les nobles hommes"—*Aucassin and Nicolette* (1887), pp. 94–95.

21:9–10. Leonardo da Vinci, whose ruined masterpiece, painted on the wall of the refectory of Sta Maria delle Grazie in 1496–1498, can still be seen in Milan.

21:20–22. Introduction, *Nouvelles françoises*, xx–xxi.

21:25–22:18. Pater translates selectively from *Nouvelles françoises*, pp. 79–82, omitting some details of King Charles's campaign and victory.

21:33. Identified by the editor of *Nouvelles françoises* (p. 80, n. 5) as St. Eusèbe de Verceil.

Notes to Canceled Passages

214:1. Claude Charles Fauriel, *Histoire de la poésie provençale*, III, 190–191.

214:31. Swinburne speaks of "Chaucer's *Court of Love*, absolutely one in tone and handling as it is with the old Albigensian *Aucassin* and all its paganism . . ." *William Blake* (London, 1868), p. 89. A long note draws out the comparison. Nine stanzas toward the end of this poem are given to the fruitless laments of monks, nuns, and friars for having chosen lives of poverty and chastity rather than the worship of Venus. "The Court of Love" was once believed to be

Chaucer's, but by 1880 it was recognized that it had been written about 1500.

215:9–10. "Dom Berthod brought to the study of their deeds the cold, severe criticism which distinguishes the works of the Bollandists, and he concluded, without contesting the reality of their existence, that nothing in their lives allowed one to consider them martyrs. (1794, *Acta sanctorum*, October, vol. VI.)"—Introduction, *Nouvelles françoises*, p. xxi.

Pico della Mirandola

First published in the *Fortnightly Review* for October 1, 1871, this essay was one of those sent to Alexander Macmillan on June 29, 1872, and reset by his printers during the summer. Neither in 1873 nor in later editions did it undergo any major revisions. Reviewers spoke favorably of it without singling it out for extended comment. Sidney Colvin noted accurately that Pater includes Pico "as a representative of what is more commonly called the Renaissance in its encyclopedic guesswork, and its ambition of finding harmony between conflicting theosophies"—*Pall Mall Gazette*, March 1, 1873, p. 11. He quoted the passage about the new anemone that grew from the mixed earth of the Campo Santo in Pisa (36:27–37:9) as an example of one strength of the book, "its delicate poetry and imaginative charm." Symonds remarked that the essay on Pico makes us "feel with an intensity peculiar to Mr. Pater's style, the charm, as of some melody, which clung about him"—*Academy*, IV (March 15, 1873), 105.

24:6–25:12. Heine's essay appeared first as "Les Dieux en exil," *Revue des deux mondes* (April 1, 1853), 5–38, and again with the same title in the successive French editions of *De l'Allemagne* (Paris, 1855, 1860, 1866, 1872, and so on). But, as a comparison of the texts will reveal, Pater translates not

from this French version, but from the revised and truncated German translation of the essay prepared by Heine and published in Germany in 1853 and 1854; in the Philadelphia edition of Heine's *Werke* in 1856; and, with additions, in the *Sämmtliche Werke*, ed. Adolf Strodtmann (Hamburg, 1861–1869), VII, 209–300. No doubt the Hamburg edition was Pater's source. Heine's German version, though it included the passage translated by Pater, did not include pp. 5–19 of the first French version, the pages within which Heine presents his French translation of one of the old folksongs of Tannhäuser with a commentary on the poem and his parody of it. For the Hamburg edition, Strodtmann combined the French and the German versions of the essay, along with minor additions from what he called "das deutsche Originalmanuscript" (VII, 257n.), into a composite German text, the first complete German version of the French essay of 1853.

At 24:24, after "hiding-places," Pater omits one of Heine's sarcasms: "als der wahre Herr der Welt sein Kreuzbanner auf die Himmelsburg pflanzte . . ." (when the true lord of the world planted his crusading banner on the castle of heaven). Heine's fantasy of the gods in exile took a strong hold on Pater's imagination. He refers to it again and again in later works and carries out aspects of the notion in two of his stories, "Denys l'Auxerrois" (1886) and "Apollo in Picardy" (1893).

25:22–26:9. The "modern scholar" outlines here the "historic method" through which Hegel's imagination made its profound impression during the century on every aspect of thought and learning. "The characteristic trait of the nineteenth century," says Ernest Renan in a book Pater had read, "is to have substituted the historic for the dogmatic method in all studies relative to the human spirit"—Preface to *Averroès et l'averroïsme* (1852), in *Oeuvres complètes*, d. Henriette Psichari (Paris, 1947), III, 15. Hegel's "historic method" is Pater's acknowledged guide in his *Plato and Platonism* (1893), where his mature understanding of it is summarized in these terms:

Dogmatic and eclectic criticism alike have in our own century, under the influence of Hegel and his predominant theory of the everchanging 'Time-spirit' or *Zeit-geist*, given way to a third method of criticism, the historic method, which bids us replace the doctrine, or the system, we are busy with . . . as far as possible in the group of conditions, intellectual, social, material, amid which it was actually produced, if we would really understand it. That ages have their genius as well as the individual; that in every age there is a peculiar *ensemble* of conditions which determines a common character in every product of that age, in business and art, in fashion and speculation, in religion and manners, in men's very faces; that nothing man has projected from himself is really intelligible except at its own date, and from its proper point of view in the never-resting 'secular process'; the solidarity of philosophy, of the intellectual life, with common or general history; that what it behoves the student of philosophic systems to cultivate is the 'historic sense': by force of these convictions many a normal, or at first sight abnormal, phase of speculation has found a reasonable meaning for us"—*Works* (London, 1910), VI, 9–10.

26:1–2. "The gradual education of the human mind" was followed at 26:16–17 in all the earlier texts by a similar phrase, "the gradual education of the human race" (see Textual Notes). The words carry a double allusion, surely caught by many of Pater's readers, to Lessing's essay "Die Erziehung der Menschengeschlechts" (1780) and to Frederick Temple's "The Education of the World," the first essay in the controversial collection of liberal statements published in 1860 as *Essays and Reviews*. A translation of Lessing's essay by F. W. Robertson had appeared in London as "The Education of the Human Race" (1858), and his ideas are recognizable here and there throughout the *Essays and Reviews*. Liberal churchmen like Temple and others who sought Christian solutions to the problems raised by the "higher criticism" of the Bible were attracted to Lessing's idea of divine revelation, not as the gift of a single book or compilation, but as the gradual and continuous education of mankind throughout human history: "What education is to the individual

man, Revelation is to the whole human race"—Lessing, *Werke* (Berlin, 1868), XVIII, 199, §1.

Headmaster of Rugby School in 1860, Archbishop of Canterbury later, and writing of course as a committed churchman, Temple likens the human race to "a colossal man, whose life reaches from the creation to the day of judgment," a man who "grows in knowledge, in self-control, in visible size, just as we do. And his education is . . . precisely similar to ours"—*Essays and Reviews*, 9th ed. (London, 1861), p. 3. Benjamin Jowett, Regius Professor of Greek at Oxford from 1855, master of Balliol from 1870, and one of Pater's teachers in the early 1860's, elaborates the same notion in his essay "On the Interpretation of Scripture," *ibid.*, pp. 387–389. In an undated autograph manuscript, Pater praises Lessing's essay as an early example of the historic spirit given its mature philosophical expression by Hegel: "~~In~~ ⟨under⟩ the conception of humanity he philosophy ~~finds a~~ explains as the stages of an education that education which dawned so illuminatingly on the mind of Lessing in this as in some other matters ~~an~~ ⟨one of Hegel's⟩ anticipators. What seemed caprices or errors are in the light of this thought seen to be ⟨stages⟩ of development consequent upon each other with a sort of logical necessity" —MS bMS Eng 1150 (17), Houghton Library, Harvard University, pp. 41–42. (Editor's note: Pater's superlinear insertions are printed here in angle brackets; words are stricken out and spaces left as in the manuscript.)

26:10–33. The "eclectic or syncretic method [wrote Pater in 1893] aims at a selection from contending schools of the various grains of truth dispersed among them. It is the method which has prevailed in periods of large reading but with little inceptive force of their own, like that of the Alexandrian Neo-Platonism in the third century, or the Neo-Platonism of Florence in the fifteenth"—*Plato and Platonism*, *Works*, VI, p. 9.

26:20–27. While of course the "modern scholar" was having things more and more his way in 1871, the dream of

CRITICAL AND EXPLANATORY NOTES

making Plato and Homer "speak agreeably to Moses" had not entirely lost its old attraction. The eminent Liberal statesman William Ewart Gladstone gave the problem an astonishing amount of time and attention throughout his long life (1809–1898). After a "strenuous argument" with Mrs. Humphrey Ward about her novel *Robert Elsmere* in 1888, he said, "There are still two things left for me to do! One is to carry Home Rule; the other is to prove the intimate connection between the Hebrew and Olympian revelations!"—Mary Augusta Ward, *A Writer's Recollections* (New York and London, 1918), II, 78. "But," as she says of the second of these ends, "it was not for that he was born . . ." (p. 79). See also 157:16–30 and n.

26:31–32. Pater takes the Latin phrase from the "Proemium" (n.p.) to Pico's exposition of Genesis, entitled *Heptaplus*, in his *Omnia Quae Extant Opera* (Venice, 1557).

27:1–2. "Madhouse Cells" was the general title under which two of Browning's dramatic monologues, "Porphyria's Lover" and "Johannes Agricola in Meditation," appeared in *Dramatic Lyrics* (1842) and in the collected edition of 1849. The general title was dropped in the collection of 1863.

27:19–25. Pico's nephew Giovanni Francesco Pico della Mirandola had published his life of Pico at Bologna in 1496 as an introduction to the first edition of his works. More knew either this edition or the Venetian edition of 1498. More's translation "was printed about 1510 by More's brother-in-law, John Rastell, and reprinted by Wynken de Worde, probably piratically"—A. W. Reed, "Philological Notes," in *The English Works of Sir Thomas More*, ed. W. E. Campbell (London and New York, 1931), I, 197. Pater used *The Workes of Sir Thomas More Knyght*, ed. William Rastell (London, 1557).

27:26–27. See 29:17–18 and n.

27:30. Cosimo de' Medici (1389–1464), grandfather of Lorenzo the Magnificent.

27:32–28:3. *Averroès et l'averroïsme* (1852), in Ernest Renan, *Oeuvres complètes*, III, 293.

28:8. The Villa Medicea, built in 1417 at Careggi, not far from Florence, was the literary and artistic center of the Medici court.

28:15–17. "Marsilio Ficino who had a lamp burning before Plato's bust as before a saint . . ." Herman Friedrich Grimm, *Leben Michelangelo's*, 2d ed. (Hannover, 1864), p. 84.

28:17–23. Giovanni Francesco Pico's words are: "forma autem in signi fuit et liberali: procera et celsa statura: molli carne. Venusta facie in universum; albenti colore decentique rubore interspersa: caesiis et vigilibus oculis: flavo et inaffectato capillitio. Dentibus quoque candidis et aequalibus"— "Vita" (n.p.) prefixed to Pico's *Omnia . . . Opera*. Pater quotes More's translation exactly, except that More ends with the words "his hair yellow and not too picked"—*English Works*, I, 350. Pater has no authority for calling Pico's hair abundant; and, as A. W. Reed points out, he fails to understand More's Tudor word "picked," a word used by Holofernes in describing Don Armado: "he is too picked, too spruce, too affected . . ." (*Love's Labour's Lost*, V, i, 14)— Introduction to More's *English Works*, I, 20.

29:2–6. The archangel Raphael accompanied Tobias, son of Tobit, on a journey, helped him drive off the evil spirit Asmodeus, cured his father of blindness, and relieved the family of other afflictions. The story is told in the apocryphal book of Tobit. Pater might have seen Botticini's "Tobias and the Angel" in the Uffizi. In Botticelli's painting "Primavera," in the Uffizi, the young man on the left has often been taken to represent Mercury, though other interpretations are many and the meaning of the allegory remains unclear. Piero di Cosimo (1462–1521) seems not to have painted a Mercury, but angelic or godlike youths appear in the works of both painters.

29:17–18. *Opera Omnia* (Basle, 1561–1576), II, 1537.

30:26–27. "Oratio Iannis Pici Mirandulani Concordiae Comitis" (Oration by Giovanni Pico della Mirandola, Count of Concordia)—*Omnia . . . Opera*, pp. 55–59. The usual title in later editions is "De Hominis Dignitate" (On the Dignity of Man).

31:3–6. See, for example, Pico's *Heptaplus*, bk. 5, ch. 7: "Homini mancipantur terrestria: homini favent coelestia, quia et coelestium et terrestrium vinculum et nodus est . . ." —*Omnia . . . Opera*, p. 7. (Earthly things are subject to man and the heavenly bodies befriend him, since he is the bond and link between heaven and earth"—trans. Carmichael, p. 136).

The Latin phrase for "interpreter of nature" occurs in the third sentence of Pico's "Oratio." It is listed there as one of several traditional epithets which Pico regards as inadequate if taken as reasons why man, of all creatures, is worthy of the greatest wonder. For Bacon's reference to man as the "interpreter of nature" see, for example, the first of his "Aphorismi de interpretatione naturae, et regno hominis" in Part II of the "Instauratio Magna," *The Works of Francis Bacon* (London, 1826), VIII, 7: "Homo, naturae minister et interpres, tantum facit et intelligit, quantum, de naturae ordine, re vel mente observaverit; nec amplius scit, aut potest" (Man, as the minister and interpreter of nature, can do and understand only so much as he has observed, in fact or in thought, of nature's order; beyond this he knows nothing and can do nothing). Beginning with the edition of 1888, Pater uses the phrase *Homo Minister et Interpres Naturae* as a subtitle for his essay on Leonardo da Vinci.

31:6–10. Pater quotes from the "Aliud Proemium," or "Second Proem," (n.p.), to Pico's *Heptaplus*.

31:19–31. David J. DeLaura plausibly calls this passage "conflated Arnold." He adds that "Pater's 'reassertion' and 'rehabilitation of human nature' are very close to Arnold's definition in *Culture and Anarchy* [1867] of the Renaissance as 'an uprising and reinstatement of man's intellectual impulses and Hellenism' [*Collected Prose Works*, V, 172]. Moreover, Pater's four-part division of human nature—'the body, the senses, the heart, the intelligence'—is so close to the final formula of Arnold's 'Pagan and Medieval Religious Sentiment,' 'the senses and understanding, . . . the heart and imagination,' as to suggest that Pater is consciously countering Arnold's assignment to the Renaissance of the senses and

understanding alone. Pater is in effect asserting that the Renaissance is as adequate an expression of the 'imaginative reason,' as adequate a servant of the 'modern spirit,' as Arnold's great Greek century"—*Hebraism and Hellenism in Victorian England: Newman, Arnold, and Pater* (Austin and London, 1969), p. 236. For the relevant passage in Arnold's "Pagan and Medieval Religious Sentiment," see n. to 102:16.

32:7–9. In all the earlier texts of this essay Pater had said, more simply, "in the hands of the grey-headed father of all things . . ." It is not entirely clear why he revised this passage, nor, in revising it, why he waited until the 1893 edition. He must have seen the fresco itself when he visited Pisa in 1865. The central figure holding the "target or shield," though gray-headed, has a young unbearded face. In his review of the first edition of *The Renaissance*, John Addington Symonds held that this figure was intended as Christ. Pater, he says, "has forgotten that the point of this old picture lies in the fact that it is *not* the creative Demeurgus, but Christ, in the prime of manhood, who supports the disc of the universe, with its concentric rings of created beings"—*Academy*, IV (March 15, 1873), 104. But Vasari had no doubt that it represented "un Dio Padre" and quotes verses written (so he believed) by the painter himself beneath the painting to explain it. These refer to "this painting of merciful God the most high Creator, who made all things through love . . ." *Le vite*, ed. Ferdinando Ranalli (Florence, 1845–1848), I, pt. 1, 401. Carlo Lasinio calls the figure that of "the Eternal Father who embraces the Universe . . ." *Pitture a fresco del Campo Santo di Pisa* (Florence, 1812), p. 14. Giuseppe Rossi also identifies it as "un Eterno Padre . . ." *Pitture a fresco del Camposanto di Pisa* (Florence, 1832), p. 20. Crowe and Cavalcaselle, whose books Pater knew, assert simply that the figure represents "the Eternal . . ." *A New History of Painting in Italy* (London, 1864–1866), I, 396, n. 4.

For the 1893 edition what Pater has done, it seems, is to rephrase the passage in accordance with the language of John 1:1–3: "In the beginning was the Word, and the Word was

with God, and the Word was God. The same was in the beginning with God. All things were made by him; and without him was not any thing made that was made"; also 1:14: "And the Word was made flesh, and dwelt among us . . ." and perhaps 1:18: "No man hath seen God at any time; the only begotten Son, which is in the bosom of the Father, he hath declared *him*." In effect, then, he adopted Symonds' correction just twenty years after it was made.

Writing for publication in the *Contemporary Review* for February, 1894, Pater concluded his discussion of early Greek sculpture by suggesting that by the faithful representation of "pure humanity" in art the ancient Greek "had been faithful . . . in the culture, the administration, of the visible world; and he merited, so we might go on to say—he merited Revelation, something which should solace his heart in the inevitable fading of that. We are reminded of those strange prophetic words [from Proverbs 8:30–31] of the Wisdom, the *Logos*, by whom God made the world, in one of the *sapiential*, half-Platonic books of the Hebrew Scriptures: 'I was by him, as one brought up with him; rejoicing in the habitable parts of the earth. My delights were with the sons of men'"—"The Age of Athletic Prizemen," *Greek Studies*, *Works*, VII, 298–299.

32:17. *Pensées*, iii, 206—*Oeuvres de Blaise Pascal*, ed. Léon Brunschvicg (Paris, 1921), XIII, 127.

32:20–25. Pater is quoting Sir Thomas More, whose exact words are "followed the crooked hills of delicious pleasure." More speaks also of Pico's burning "five books that in his youth of wanton verses of love with other like fantasies he had made in his vulgar tongue . . ." *English Works*, I, 353. In 1497, three years after Pico died, Savonarola persuaded the Florentines to burn light books, indecent pictures, carnival masks, and other frivolous objects in a famous "bonfire of vanities."

32:26–33:3. Pico's commentary is included in the *Opere di Girolamo Benivieni* . . . (Venice, 1524) in three "books," or sections. On pp. 64–66 appears an account of six stages by

which the soul rises from earthly to heavenly beauty. This "Commento" was printed in various editions of Benivieni's works and in other publications.

32:33–33:1. The Cabala is a Jewish tradition of the mystical interpretation of the Scriptures. Dionysius the Areopagite is named in Acts 17:34 as one of those Athenians who believed when they heard Paul preach on Mars Hill. In the fourth century, Eusebius mentions a report that he was the first "bishop" of Athens. Hundreds of years later his name was attached to a number of anonymous theological writings of unknown origin. These were destined to exert enormous influence on medieval thought.

33:8–9. Camilla Bartolini Davanzi (1455–1520) married Ridolfo di Filippo Rucellai in 1484, was divorced in 1496, and became a nun in 1500—*A George Eliot Dictionary*, ed. Isadore G. Mudge and M. E. Sears (London and New York, 1924), p. 195. Pater tells the story of her prophecy as George Eliot tells it in ch. 29 of *Romola*, a novel that Pater had read by 1864.

33:15–18. These are the *Duodecim Regularum Epitoma ad Bene Vivendum*, prose apothegms which More translated into rhyme royal as "Twelve Rules of John Picus Earl of Mirandula, Partly Exciting, Partly Directing a Man in Spiritual Battle"—*English Works*, I, 381–385. The translator who added them to the "books of the *Imitation* [*of Christ*]" was Richard Whytford (1495–1555?), whose book was entitled *The folowing of Christ . . . the Golden epistle of Sainct Bernarde, and . . . the Rules of a Christian lyfe, made by Iohn Picus the elder Earle of Mirandula* (Rouen, 1585).

33:18–20. "Oserai-je le dire? On connaît Dieu facilement, pourvu qu'on ne se contraigne pas à le définir"—"Pensées," *Oeuvres de J. Joubert*, ed. de Raynal, 7th ed. (Paris, 1880), II, 12. This saying of Joseph Joubert (1754–1824) was one of many quoted and praised by Matthew Arnold in his essay "Joubert" (1864), *Complete Prose Works*, III, 197.

33:20–25. Pater quotes selectively from More's translation of the biography written by Giovanni Francesco Pico, who in turn is quoting from the fifth chapter of Pico's *De Ente et Uno*, a work addressed to Angelo Poliziano—*English Works*, I, 358.

34:2–3. Pater quotes from More, whose exact words are: "He was content with mean fare at his table, howbeit somewhat yet retaining of the old plenty in dainty viands and silver vessels"—*ibid.*, I, 356.

34:20–21. Pater adapts the last two lines of Wordsworth's poem "My Heart Leaps Up When I Behold" ("And I could wish my days to be / Bound each to each by natural piety.") Thus, in accordance with the analogy drawn at 26:3–9, Pater makes Wordsworth's lines refer not to the "days" of the individual life, but to the "ages" in the education of the human race. In an essay Pater must have read, Benjamin Jowett had put these lines to the same use when he likened mankind in its maturity to "the patriarch looking back on the entire past, which he reads anew, perceiving that the events of life had a purpose or result which was not seen at the time; they seem to him bound 'each to each by natural piety'"—"On the Interpretation of Scripture," in *Essays and Reviews*, 9th ed. (London, 1861), p. 388.

34:30–33. Lorenzo had provided Pico with a villa at Fiesole, where he wrote the *Heptaplus* in 1489. The dedication addressed to Lorenzo opens with Pico's assertion that it is emulation of Lorenzo's studies that has moved him to explore the secrets of the books of Moses.

34:33–35:8. Pater translates selectively from the "Proemium" (n.p.) to Pico's *Heptaplus*.

35:18–23. Pater translates from the "Aliud Proemium" (n.p.) to the *Heptaplus*.

36:33–37:6. Versions of this legend of the "sacred earth" have often been repeated—by Montaigne, Evelyn, Smollett, and others—but I do not know where Pater read of the "new flower" that grew up in the mixed soil. The Maremma is the marshy coastal region from the mouth of the Cecina to Orbitello.

37:16–24. "The Holy Family," painted for Angelo Doni, now in the Gallery of the Uffizi Palace in Florence. In the background are several naked youths. The phrase "Mighty Mother," which I have not found elsewhere in Pater, foreshadows his later studies on the borderline of mythology and

anthropology. It is one of the titles of Cybele, the Phrygian goddess of nature, who was sometimes blended by the Greeks, as Pater observes, with Demeter—"The Myth of Demeter and Persephone," *Fortnightly Review*, XIX, n.s. (January and February, 1876), 92, 265. In Pater's phrases, Demeter's story is "the myth of the earth as a mother" (p. 89) and Demeter is "the great mother" (p. 91) or, in the seated figure discovered at Cnidus in 1857, "the glorified mother of all things" (p. 274).

37:32–38:2. Pico himself admits that he paid a high price for his Cabalistic manuscripts: "I procured those books at no small expense to me"—"Oratio," *Omnia . . . Opera*, p. 59.

38:12–14. For the Latin text, see n. to 28:17–23.

Sandro Botticelli

The essay on Botticelli appeared first in the *Fortnightly Review* for August, 1870. It was reproduced in the first and later editions of *The Renaissance* without major revisions. Pater wrote to Henry James Nicoll on November 28, 1881, that he believed his essay on Botticelli to be "the first notice in English of that old painter. It preceded Mr. Ruskin's lectures on the same subject by I believe two years"—*Letters of Walter Pater*, ed. Lawrence Evans (Oxford, 1970), p. 41. Ruskin's editors observe that "Ruskin's first mention of Botticelli was in a lecture delivered at Oxford during the Lent Term, 1871" —*Works of John Ruskin*, ed. Cook and Wedderburn (London, 1903–1912), IV, 355n. In 1883 Ruskin claimed that "it was left to me, and to me alone, first to discern, and then to teach . . . the excellency and supremacy of five great painters, despised until I spoke of them,—Turner, Tintoret, Luini, Botticelli, and Carpaccio"—*ibid*. And yet in respect to Botticelli both he and Pater had been preceded by Crowe and Cavalcaselle, who had long since given a highly respectful chapter to that painter in their pioneering work, known to all students

of Italian art, *A New History of Painting in Italy* (London, 1864), II, 414–430.

Colvin found the Botticelli essay to be one of Pater's most successful efforts "to convey the impression of what is most inward and peculiar in the moods of an ancient artist." In his view, "the accounts of Botticelli and Leonardo commended themselves signally by their felicity and penetration as well as by their subtlety and poetry . . ." *Pall Mall Gazette*, March 1, 1873, p. 12. Symonds, however, held that Pater had misinterpreted Botticelli's intent in his Madonnas and had attributed to the painter "a far greater amount of skeptical self-consciousness than he was at all likely to have possessed." Probably, he argued, "the type itself was the note of a specific school, and not the deliberate invention of an antagonist of the most cherished Catholic tradition"—*The Academy*, IV (March 15, 1873), 104. Mrs. Oliphant, writing anonymously for *Blackwood's Magazine*, agreed, observing that "Mr. Pater finds in the old painter's reverential, pathetic angel-faces, and wistful, thoughtful Madonnas, a sentiment of dislike and repulsion from the divine mystery placed among them, such as, we think we may venture to say, never entered into the most advanced imagination within two or three hundred years of Botticelli's time, and was as alien to the spirit of a medieval Italian, as it is perfectly consistent with that of a delicate Oxford don in the latter half of the nineteenth century"—CXIV (November, 1873), 606.

Four years later Symonds, though he names Ruskin and Burne-Jones as among those who had helped raise Botticelli's reputation in the 1870's, does not mention Pater—*Renaissance in Italy: The Fine Arts* (London, 1877), p. 249n. He does, however, pause to reaffirm his disagreement with "Mr. Pater's reading of the Madonna's expression" in Botticelli's paintings (p. 254n.).

Kenneth Clark gives several reasons why (he believes) Pater's essay on Botticelli has "worn less well" than some of the others: the inadequacy of Vasari's life of Botticelli, Pater's probable aversion to the prose style of Crowe and Caval-

caselle, and his natural timidity in the role of initiator. He adds that "Pater does not seem to feel the spring and flow of line which makes Botticelli one of the greatest draughtsmen in European art, and he speaks of him chiefly as an illustrator" —Introduction to his edition of *The Renaissance* (New York, 1961), pp. 16–17. In an able discussion of Pater's critical method in the Botticelli essay, R. V. Johnson finds that Pater "overstresses the melancholy and languor of Botticelli, and tends to overlook his sheer vigour in conception and execution"—*Walter Pater: A Study of his Critical Outlook and Achievement* (London and New York, 1961), p. 32.

39:1–2. Leonardo names Botticelli just once and no other painter at all—*Trattato della pittura* (Lanciano, 1914), I, 54.

39:10. Leonardo da Vinci (1452–1519), Michelangelo (1475–1564), and Raphael (1483–1520).

39:12. Giotto's dates are circa 1267–1337.

39:15–16. Dante lived 1265–1321, Boccaccio 1313–1375, Botticelli 1445–1510.

39:20–26. See xx:17–28 and n.

40:2–3. Fra Filippo Lippi of Florence (1412–1469), whose "legend" includes the story of his abducting Lucrezia Buti from the convent of Sta Margherita in Prato near Florence— Vasari, *Le vite*, ed. Ferdinando Ranalli (Florence, 1845–1848), I, pt. 2, 861–862. Crowe and Cavalcaselle find no evidence to corroborate Vasari's story and a number of reasons for doubting its authenticity—*A New History of Painting in Italy*, II, 332–347. Vasari reports also that the Florentine painter Andrea del Castagno (circa 1423–1457) murdered his fellow painter Domenico Veneziano. But by the time of Pater's writing it was known that Domenico died almost four years later than Andrea—*ibid.*, II, 307–308.

40:5–7. Vasari, *Le vite*, I, pt. 2, 1031. Alessandro, born in Florence in 1445, was the fourth son of Mariano and Smeralda Filipepi. Vasari's derivation of the name Botticelli from that of the goldsmith who taught him is no longer accepted— Gabriele Mandel, ed., *The Complete Paintings of Botticelli* (London, 1970), p. 83.

40:10–14. Vasari, *Le vite*, I, pt. 2, 1036. Savonarola was burned at the stake in Florence in May, 1498. According to the *Libro dei morti* of the city of Florence and of his guild, Botticelli was buried in the cemetery of the Church of Ognissanti on May 17, 1510—*Complete Paintings of Botticelli*, p. 83.

40:14–15. *Le vite*, I, pt. 2, 1036.

40:21–24. Pater's understanding of his startling phrase "abstract painting" is illustrated and elaborated at 103:17–104:32. See also 110:17–30 and 111:19–29.

40:25–29. Pater is referring to the drawings of Botticelli, probably engraved by Baccio Baldini, that illustrated the Dante edited with commentary by Cristoforo Landino and published in Florence. "Unfortunately Pater did not know the marvellous series of eighty-eight drawings by Botticelli illustrating Dante which was sold from Hamilton Palace in 1882 to the Berlin print room"—Kenneth Clark's n. in his ed. of *The Renaissance*, p. 70. "In 1886 [eleven] other sheets were discovered in a miscellany . . . in the Vatican Library . . . The surviving drawings are: the plan of Inferno (recto) and the illustration for Canto I and those for Cantos IX-XVI, in the Vatican; those for Cantos VIII and XVII-XXXIV (two sheets for this last) of *Inferno*, all 333 of *Purgatorio* (and the plan), and 31 of *Paradiso* (except XXX and XXXIII, blank pages), in Berlin"—*Complete Paintings of Botticelli*, p. 114.

40:29–32. The copy in the Bodleian Library has such impressions at the beginning of the first, second, and third cantos only, and the illustration for the third canto, "upside down, and much awry," is merely another impression of the design used for the second.

41:12–14. The drawings in Berlin, which Pater did not know of, do include a complete set for the *Purgatorio*. See n. to 40:25–29.

41:14–15. The Simoniacs, who are plunged head downward into holes in the rock—*Inferno*, XIX.

41:18–23. The Centaurs guard the banks of the river of boiling blood in which the Violent against Their Neighbors are immersed—*ibid.*, XII.

41:32. "There is a tradition that while he was engaged in

decorating the Scrovegni Chapel [in Padua], Giotto was visited by Dante. However, there is no other evidence of his friendship with the poet"—Edi Baccheschi, ed., *The Complete Paintings of Giotto* (London, 1969), p. 83. Masaccio (1401–1428) executed paintings in Florence and Pisa. Ghirlandaio (circa 1448–1494) had an influential workshop in Florence.

42:3–14. That every good painter "usurps" the data in the service of his own vision is a principle often repeated by Baudelaire, and a single example of his words can be taken to represent many others: "In fact, all good and true draftsmen draw by referring to the image inscribed in their heads, and not according to nature"—"Le Peintre de la vie moderne" (1863), *L'Art romantique*, in *Oeuvres complètes*, III, 71. The idea was familiar in French art criticism as early as the 1830's. Admirers of Delacroix in particular had reason to attack imitative painting and to exalt the personal vision of the artist. "When M. Delacroix composes a picture, he looks into himself instead of putting his nose to the window: he has taken from nature what he requires for his art, and it is this which gives that power of intimate attraction to pictures often repellent in appearance"—Théophile Gautier, "Salon de 1841," *Revue de Paris*, XXVIII, 3d ser. (April, 1841), 160. Many other passages to the same effect could be cited from Gautier. Hegel also makes the point, as in his *Aesthetik*, ed. H. G. Hotho, 2d ed. (Berlin, 1842), I, 207. One might compare 42:3–14 with Pater's earlier, more comprehensive and far-reaching statement at 170:23–30.

42:19–22. Vasari, *Le vite*, I, pt. 2, 1033–1034. "This picture, representing the Assumption of the Virgin, is now in the National Gallery, London, No. 1126. It is not by Botticelli, and is usually, though not altogether convincingly, ascribed to Francisco Botticini"—Kenneth Clark in his ed. of *The Renaissance*, p. 72n.

42:22–43:4. Pater refers to "La Città di Vita" (not "Divina"), a long poem in terza rima written between 1455 and 1464. Matteo Palmieri (1406–1475)—a Florentine not obscure in his time—was a student of the Platonic tradition

under celebrated humanists, an orator, a statesman, and the author of many writings. After his death "La Città di Vita" was condemned by the church for its unorthodox doctrine on the origin of souls. Through God's mercy, says the poet, the offending angels were given a second chance as human beings (bk. I, ch. 5, tercets 40–47). The picture which Pater takes to be Botticelli's was thought to have "copied" the heresy of the poem by showing human souls in the ranks of several of the nine angelic orders. "The inference is obvious that here are represented the angels who remained neutral at the time of the Fall, and who as human beings have won the 'seconda prova' and therefore return in human form to their original place in the celestial hierarchy"—Margaret Rooke, "Preface to the First Edition of the *Città di Vita*," *Smith College Studies in Modern Languages*, VIII (October 1926–January 1927), vii.

The Palmieri mortuary chapel in the Benedictine abbey of S. Pier Maggiore, where the picture hung, was interdicted and the picture was covered until about the mid-seventeenth century. By 1854 it had found its way into the collection of the Duke of Hamilton; in 1873 it was publicly exhibited in London at Burlington House; and in 1882 it was bought by the National Gallery—Rooke, "Editor's Afterword," *ibid.*, IX (October 1927–July 1928), 265–266. In misquoting Palmieri's title, Pater simply reproduces an error in the *Nouvelle biographie générale* (Paris, 1863), vol. XXXIX, on which he must have relied for information. Records show that he borrowed volumes of this reference work from the Brasenose College library in the early 1870's.

43:1–2. The fresco of Paradise on the end wall of the Magdalen Chapel in the Bargello in Florence includes "a number of historical personages including Dante, though much retouched. All the critics discount the possibility of [the frescoes in this chapel] having been executed by Giotto, though they may be the work of one of his pupils"—*The Complete Paintings of Giotto*, p. 122.

43:19–20. In the Vestibule of Hell, Virgil and Dante hear the wailing sent forth in concert by the wretched souls of men who lived without infamy and without praise and also by

"that wicked choir of the angels who were not rebellious nor yet were faithful to God, but were for themselves. Heaven chased them out to keep its beauty unstained, and the deep Hell does not receive them, for the damned might claim some glory over them"—*Inferno*, III, 37–42.

43:22. Among the crowd of the dead in the Vestibule of Hell, says Dante, "I saw and knew the shade of him who made through cowardice the great refusal"—*Inferno*, III, 58–60. This is probably Celestine V, who was made pope in 1294, at the age of eighty, but resigned five months later.

43:26–27. Frate Giovanni da Fiesole (1387–1455) called Fra Angelico. Andrea di Cione (circa 1308–1368), commonly called Orcagna, was the most noted Florentine painter and sculptor of his time. What Pater means by his reference to Orcagna's "Inferno" is uncertain. Vasari reports that Andrea and his brother painted a fresco representing the Inferno according to Dante in one of the Strozzi chapels in the church of Sta Maria Novella—*Le vite*, I, pt. 1, 447. In Pater's time, however, it was known that this fresco had been entirely repainted—Crowe and Cavalcaselle, *A New History of Painting in Italy*, I, 435. Vasari reports also that Andrea's brother Nardo painted the Inferno on the south wall of the Campo Santo in Pisa—*Le vite*, I, pt. 1, 451. This too, however, had been much repainted; and in any case Crowe and Cavalcaselle, on whose authority Pater normally relied, insist that it is the work of a master of the Sienese style—*A New History . . .* I, 449–451. Later scholars agree that it is not the work of either Orcagna.

43:31–44:3. Elsewhere Pater insists that sympathy was one of the characteristic traits of the Renaissance artist (198:17–199:4) and holds more generally that "sympathy alone can discover that which really is in matters of feeling and thought . . ." "'Measure for Measure'" (1874), in *Appreciations, Works* (London, 1910), V, 183. See also Pater's essay "Postscript" (1876), *ibid.*, 254.

44:16. The most famous of Raphael's madonnas, in the Dresden Gallery.

44:22. "And I will shake all nations, and the Desire of all

nations shall come: and I will fill this house with glory, saith the Lord of hosts"—Haggai 2:7.

44:32–45:2. The "Madonna of the Magnificat" in the Uffizi in Florence.

45:22. Jean Auguste Dominique Ingres (1780–1867), French painter.

47:13–14. Pater may be thinking of the "Venus and Mars" acquired in Florence by Sir Alexander Barker about 1865, removed to London in 1874 and now in the National Gallery; or the allegorical "Primavera," with Venus as its central figure, in the Uffizi in Florence; or "Venus offering Gifts to a Young Woman accompanied by Graces," in the Louvre.

47:18–23. "The Return of Judith" in the Uffizi, Florence. Judith carries in her right hand the sword with which she has cut off the head of Holofernes; in her left is an olive branch. Her maid follows her with the severed head in a basket. "La bella Simonetta" Vespucci died in 1476 (see 73:12–14 and n.).

47:24–26. "Fortitude," in the Uffizi.

47:26–29. "The Calumny of Apelles" in the Uffizi, based on a description in Lucian's *De Calumnia* of a lost picture by Apelles.

47:30–31. Pater seems to refer here to the engravings he has mentioned earlier (at 40:25–32), those in the first printed Florentine edition (1481) of the *Divine Comedy*, some copies of which he had been able to inspect. Modern scholars find a good many examples of engravings made from Botticelli's designs by Baccio Baldini and Francesco Rosselli. See John Goldsmith Phillips' list in his *Early Florentine Designers and Engravers* (Cambridge, Mass., 1955), pp. 87–88.

Luca della Robbia

One of the hitherto unpublished pieces sent to the publisher Alexander Macmillan on June 29, 1872, this essay was praised in passing by most reviewers. Of Pater's distinction among

the sculptural methods of Robbia, Michelangelo, and the Greeks, Colvin remarked: ". . . we are inclined to say that it is very ingenious and subtle rather than that it unreservedly recommends itself." But he added that "it is the property of this kind of writing, when it is thoughtfully done, to suggest even where it does not illuminate"—*Pall Mall Gazette*, March 1, 1873, p. 12. Symonds, less guarded, found in the same passage one of Pater's "characteristic mistakes of criticism," a criticism which he considered subtle and original but "somewhat over-refined." He conceded much to Pater's idea that "incompleteness is Michelangelo's equivalent for color in sculpture; it is his way of etherealizing pure form . . ." (53:21–24). "This is extremely ingenious," he wrote, "and subjectively it is perhaps true: *we* gain by the suggestive ruggedness of much of Michelangelo's work—in which it seems as if a soul were escaping from the stone. But did Michelangelo really calculate this effect? That is what is more than doubtful"—*Academy*, IV (March 15, 1873), 104–105. Four years later he argued with more assurance that we are not justified in assuming, "as a recent critic has suggested, that Michael Angelo sought to realise a certain preconceived effect by want of finish," for many of his best statues are highly finished. It is more likely that he left some works incomplete "through discontent and *ennui* and the importunity of patrons . . ." *Renaissance in Italy: The Fine Arts* (London, 1877), pp. 420–421.

49:6. Filippo Brunelleschi (1377–1446), celebrated architect who designed the dome of the cathedral and a number of churches in Florence.

49:19–22. Mino di Giovanni, called da Fiesole (circa 1430–1484). Maso del Rodario worked for forty years, 1487–1526, on the Cathedral of Como. Donatello (1386–1466) left many works in Florence and others in Padua, where he worked for ten years.

51:18–28. For Pater's understanding of this term, see also 170:13–22 and 172:16–173:11. So far as I can discover, Winckelmann does not use the term "Allgemeinheit" in any

pertinent passage. Goethe uses it about fifty times, but never in reference to ancient sculpture nor to the artist's search for "the type in the individual"—*Goethe Wörterbuch* (Stuttgart, 1968), I, 384–385. Even if one widens the field to include "das Allgemeine," he will find no good example in Goethe. Pater's paragraph is based on Hegel, who uses the word "Allgemeinheit" often—but not, it seems, in just those passages (like the one following) from which Pater takes his idea. In defining a man's figure or character, says Hegel, sculpture "must lay hold simply on what is unalterable and permanent, i.e. the substance, and only the substance, of his determinate characteristics; it must not choose for its content what is accidental and transient . . ." *Aesthetik*, ed. H. G. Hotho, 2d ed. (Berlin, 1842), II, 368 (trans. Knox, II, 712).

51:21–22. Pheidias (circa 500–432 B.C.) supervised Pericles' architectural program, including the sculptures of the Parthenon. He and Praxiteles were regarded in antiquity as the two greatest masters.

52:4–23. On "charm," "expression," or "intimacy" in art, compare 14:26–15:8, 55:30–56:15, and 137:11–20.

52:32. The famous statue in the Louvre, discovered on the island of Melos in 1820. "Deriving her head from the later 5th c. B.C., her nudity from the 4th c., and her spiral, omnifacial posture from the Hellenistic, she is a harmonious creation of the Classicism of c. 100 B.C."—*Oxford Companion to Art.*

53:8–11. The story is told by Vasari, *Le vite*, ed. Ferdinando Ranalli (Florence, 1845–1848), II, pt. 3, 1381, and repeated by Herman Friedrich Grimm, *Leben Michelangelo's*, 2d ed. (Hannover, 1864), pp. 89–90. Piero de' Medici (1472–1503), Lorenzo's son, became ruler of Florence on Lorenzo's death in 1492.

54:10–11. The tomb of Conte Ugo (Count Hugo von Andersburg) was executed in 1481 by Mino da Fiesole.

54:11–14. The tomb of Medea Colleoni was executed by Giovanni Antonio Amadeo (1447–1522) about 1475.

54:22–26. Luca lived 1400–1482.

54:27–28. These include the marble cantoria now in the

cathedral museum, work on colossal heads for the cupola, five reliefs of the arts and sciences for the campanile, and marble altars for the cathedral chapel of SS. Peter and Paul—all completed before 1440.

55:18–24. Pater translates a sentence from Vasari and then quotes the words in Italian from the far end of the next sentence, which might be translated without rearrangement as follows: "The magnificent Piero di Cosimo de' Medici, among the first who had Luca work on things of colored clay, had him do the whole vault in half relief of a study in the palace built, as will be told, by Cosimo his father, with various fancies, and the pavement likewise, a curious thing and very useful for summer-time"—*Le vite*, I, pt. 2, 605. Vasari appears to mean that the study itself, so paved and decorated (or perhaps the pavement only), was "curious" or unique, and useful in the summer. Pater applies Vasari's phrase not to the study at all, but to Luca's figures of baked earth in color.

56:1–15. On "charm," "expression," or "intimacy" in art, compare 14:26–15:8, 52:4–23, and 137:11–20.

The Poetry of Michelangelo

First published in the *Fortnightly Review* in November, 1871, "The Poetry of Michelangelo" was sent to Alexander Macmillan on June 29, 1872, and reset during the summer. Three of Michelangelo's sonnets in translations by John Addington Symonds were added after September, 1872, when they appeared in the *Contemporary Review*. (See 224:28–226:33 and n. p. 360.) These were omitted in the 1877 and later editions. Reviewers failed to comment on the subject announced in Pater's title. Colvin, while he called it "an essay of very great interest," entered a carefully phrased objection to what he took to be Pater's main point: "that the true stamp of Michael Angelo, and the true type of the Michael Angelesque, is sweetness together with strength, or sweetness through

strength—*ex forti dulcedo.*" Granting that "there were un-
doubtedly moments and flashes of sweetness in Michael An-
gelo," he argued that the true stamp of the master is to be
discerned in his energy, his imaginative ambition, and his Ti-
tanic unquiet and rebelliousness—*Pall Mall Gazette*, March 1,
1872, p. 12.

Symonds, however, came out strongly for Pater's view, re-
marking that "Mr. Pater shows the truest sympathy for what
has generally been overlooked in this stern master—his
sweetness. The analysis of the nature of that sweetness is
one of the triumphs of Mr. Pater's criticism"—*Academy*, IV
(March 15, 1873), 105. William Dean Howells in the *Atlantic
Monthly* commended Pater's view of Michelangelo "as the
last rather than the first of his kind . . . to be understood
through those sculptors who went before him, and some
modern authors and artists, and not through his immediate
successors or his school . . ." XXXII (October, 1873), 498.
In Pater's elaborate fancy of the meaning of the Pietà for
Florentine masters looking on the newly dead, Mrs. Oliphant
found evidence of Pater's "absolute obtuseness" and of a
"curious dullness of apprehension"—*Blackwood's Magazine*,
CXIV (November, 1873), 607.

57:5–8. Compare Baudelaire's dictum, somewhat less
stringent in its context: "The beautiful is always bizarre"—
"Exposition universelle 1855" (1855), collected in *Curiosités
esthétiques* (1868), *Oeuvres complètes*, ed. Jacques Crépet (Paris,
1930–1953), II, 224.

57:17. "De comedente exivit cibus, et de forti egressa est
dulcedo" (Out of the eater came forth meat, and out of the
strong came forth sweetness)—Judges 14:14.

58:5–6. Part 5, bk. I, ch. 1. Pater seems to be recalling,
not quite accurately, the scene at the barricade of the Fau-
bourg du Temple, defended by its excellent marksman: "Al-
most every shot found its mark. There were some corpses
here and there, and pools of blood on the paving-stones. I
remember a white butterfly which came and went in the
street."

58:7–10. Part 2, bk. II, ch. 4.

58:12–18. Herman Friedrich Grimm, *Leben Michelangelo's,* 2d ed. (Hannover, 1864), pp. 650–651.

59:5. Sculptures chiefly from the Parthenon which Thomas, seventh Earl of Elgin, procured from the Turks, sent to England 1803–1812, and sold to the nation in 1816. They are now in the British Museum. The "young men" of Pater's reference are the horsemen of the Panathenaic procession shown in low relief on the Parthenon frieze.

59:21–22. The tomb of Pope Julius II in the church of S. Pietro in Vincoli, Rome, and the tombs of Giuliano and Lorenzo de' Medici in the church of S. Lorenzo in Florence.

59:22–23. Michelangelo's last work in the Sistine Chapel was his fresco of the "Last Judgment," painted on the east wall 1536–1541.

59:24–25. Michelangelo's "Leda," painted for Duke Alfonso d'Este during the siege of Florence (1530) "was never delivered and is now lost. We know it only from copies and preparatory sketches"—L. D. Ettlinger, Introduction to *The Complete Paintings of Michelangelo,* ed. Ettore Camesasca (London, 1969), p. 6. "The delight of the world" is evidently Helen, daughter of Leda by Zeus, who visited her in the shape of a swan. Leda's children were sometimes shown as babies just hatched from her eggs, the broken shells of which lie nearby.

59:25–32. See 52:29–53:30.

60:1–3. In French medieval architecture, in the cathedrals of Paris, of Saint-Denis, of Reims, "Stone is imbued with life and spirit by the ardent and severe hand of the artist. The artist makes life spring out of it. He was very well named in the middle ages: 'The master of living stone,' *Magister de vivis lapidibus*"—Michelet, *Histoire de France,* 2d ed. (Paris, 1835–1845), II, 666. Michelet adds that the Latin title was the nickname of one of the architects brought from Germany by Ludovico Sforza to work on the Cathedral of Milan.

60:11. See n. to 62:24–27.

60:20–24. Michelangelo called these people poor, not simple. See Vasari, *Le vite,* ed. Ferdinando Ranalli (Florence,

1845–1848), II, pt. 3, 1410. Condivi has ". . . those who are painted here were poor people [*poveri*]"—*Vita di Michelagnolo Buonarroti*, ed. Emma Spina Barelli (Milan, 1964), p. 52.

60:31. Grimm, *Leben Michelangelo's*, p. 59. Michelangelo was born on March 6, 1475. Pater gets his biographical details from Vasari and Grimm. The latter draws not only on Vasari but also on Ascanio Condivi (who published his life of Michelangelo in Rome in 1553), on Michelangelo's letters, and on other sources. That Pater had read Condivi is unlikely. The details of Michelangelo's birth on a midnight journey are not in Vasari.

61:7–12. Grimm, pp. 59–60.

61:12–14. *Ibid.*, pp. 60–63.

61:14–17. *Ibid.*, pp. 71–75.

61:17–21. *Ibid.*, pp. 179–180.

61:26–62:5. Lorenzo died in 1492, when Michelangelo had been attached to his school and household for about three years. His son Piero de' Medici, who succeeded him, lacked the authority of his father, and Florence was uneasy under his rule. Michelangelo left Florence in 1494 for Bologna, where he was received into the household of the Aldovrandi family. He returned to Florence a little more than a year later.

61:26–27. Vasari does not tell this story. Condivi says that Lorenzo's apparition wore a tattered black gown, "una veste nera e tutta stracciata"—*Vita di Michelagnolo*, p. 30. Grimm follows Condivi—*Leben Michelangelo's*, p. 93.

61:31–62:3. Condivi, p. 31; Grimm, p. 93.

62:3–5. Condivi, p. 32.

62:8–14. "In fact," says Kenneth Clark, "Michelangelo added to these works three small figures, an angel, a St. Proculus and a St. Petronius on the shrine of St. Dominic, Bologna"—Pater, *The Renaissance*, ed. Clark (New York, 1961), p. 89n. According to Vasari, Giovanni da Pisa or Pisano (circa 1245–1320) directed construction of the major chapel of the church of S. Domenico in Bologna, furnished a marble altar for it, and later made a marble panel showing the Virgin and eight other figures—*Le vite*, I, pt. 1, 278. The work of Jacopo della Quercia (circa 1374–1438) in Bologna includes the portal

of the basilica of S. Petronio, with reliefs of "a directness and strength which won the admiration of Michelangelo . . . Several of the motifs are to be found, reinterpreted, on the Sistine ceiling"—*Oxford Companion to Art*.

62:15–16. The marble statue of the "Drunken Bacchus," executed in Rome in 1496–97 for Jacopo Galli, has been in Florence only since 1572. It is now in the Bargello. In this work, says Pater in "A Study of Dionysus" (1876), Michelangelo has represented Dionysus "in the fulness, as it seems, of this [Platonic] enthusiasm, an image of delighted, entire surrender to transporting dreams. And this is no subtle afterthought of a later age, but true to certain finer movements of old Greek sentiment, though it may seem to have waited for the hand of Michelangelo before it attained complete realisation"—*Greek Studies*, *Works* (London, 1910), VII, 19.

62:21. Andrea di Cione Orcagna (circa 1308–1368), Florentine painter, sculptor, architect, and administrator. The "Loggia of Orcagna," or Loggia dei Lanzi, is a porch on the south side of the Piazza della Signoria. Though long named for Orcagna, it was begun in 1376, well after his death, and completed in 1382.

62:24–27. On its completion in 1504, Michelangelo's "David" was mounted in front of the Palazzo Vecchio, where it remained until it was replaced by a copy in 1873. The original statue was moved in 1882 to a hall in the Accademia delle Belle Arti.

63:6–7. "Tu hai fatto una prova col Papa, che non l'arebbe fatta un Re di Francia"—Condivi, *Vita di Michelagnolo*, pp. 43–44. Pier Soderini, gonfalonier of Florence 1502–1512, spoke these words in an effort to persuade the offended Michelangelo to ignore his ill treatment at the hands of Pope Julius II and to obey the Pope's repeated requests that he return to Rome.

63:7–9. "They say that one day the two artists, meeting each other in the courtyard of the Vatican, the one surrounded by his cortege of pupils, going to the *Stanze*, the other solitary, going to the Sistine chapel, Michelangelo said to Sanzio: 'You walk with a big following, like a general'; to

which Raphael replied: 'And you, you go alone, like the executioner'"—Charles Clément, *Michel-Angelo, Léonard de Vinci, Raphael* (Paris, 1861), p. 285. The story originates with Giovan Paolo Lomazzo, *Idea del tempio della pittura* (Milan, 1590), p. 56; it is retold by Grimm, *Leben Michelangelo's*, p. 197.

63:9–10. "Many times," says Michelet, "he had wanted to die. One day, having wounded himself in the leg, he barricaded his door and went to bed, having no desire ever to get up again. A friend, seeing that door which no longer opened, became suspicious, investigated, found a way in, and having reached him, forced him to let himself be cared for and healed"—*Histoire de France*, VII, 222. The story is told by Vasari, *Le vite*, II, pt. 3, 1442–1443, and repeated by Grimm, *Leben Michelangelo's*, p. 583, but without any suggestion that Michelangelo wished to die.

63:13–14. Pater seems to have in mind the "sullen" of the fifth circle of the *Inferno*, who lie immersed in Stygian mud and whose sobs make it bubble at the surface: "Fixed in the slime, they say, 'Sullen were we in the sweet air that by the Sun is gladdened, bearing within ourselves the sluggish fume; now we are sullen in the black mire'"—*Inferno*, VII, 121–124 (trans. Norton, p. 45).

63:20. The so-called "Dying Captive (or Slave)" and "Heroic Captive (or Slave)," sculptured in 1513 for the tomb of Julius II. They are in the Louvre.

63:21–22. Michelangelo seems to have been "an admirer though not a close follower" of Savonarola, the Florentine priest and reformer who was burned at the stake in 1498—Ettore Camesasca, ed., *Complete Paintings of Michelangelo*, p. 83.

63:22–23. The Medici family had been expelled from Florence in 1527. Two years later, in anticipation of a siege of the city by the forces of the Prince of Orange, who was bound by Emperor Charles V to attempt to restore the Medici family to power, Michelangelo was put in charge of devising the fortifications. Although his defensive measures were ingenious, the city was forced to capitulate in 1530.

63:24–25. In his sonnet in praise of Dante, "Dal ciel discese, e col mortal suo, poi," line 6—*Le rime di Michelangelo Buonarroti* . . . ed. Cesare Guasti (Florence, 1863), p. 153.

63:28. Matilda (circa 1046–1115), countess of Tuscany and consort of the Holy Roman Emperor Henry V, is remembered for her role in the struggle between the papacy and the German kings or Holy Roman emperors. Throughout the investiture conflict she firmly supported Pope Gregory VII. Her castle of Canossa was the scene of Henry IV's penance before Gregory VII in January, 1077. Condivi presents Michelangelo's claim to kinship with the house of Canossa—*Vita di Michelagnolo*, p. 21.

63:29–64:12. Pater was well aware that Michelangelo had addressed songs and sonnets of passionate love to Tommaso Cavalieri and to other young men. See n. to 66:23–31.

64:11–12. "I seem to feel as bitter every sweet," from the madrigal "Amor, la morte a forza," line 6. Strangely, in view of his awareness of the defects of the 1623 ed. (see 65:7–11), Pater quotes not the autograph text given by Guasti, but the spurious version devised by Michelangelo the younger, which Guasti prints on the same page. Pater seems to take this madrigal as evidence of Michelangelo's passionate nature in his youth, but it probably belongs to the 1540's—Michelangelo's *Rime*, ed. Enzo Noè Girardi (Bari, 1960), pp. 340–341.

64:22–23. Compare, however, 17:31–34.

65:2–5. For example, the sonnet "Non ha l'ottimo artista alcun concetto," discussed by Benedetto Varchi in the first of his *Due lezzioni* (Florence, 1549). The lecture was given on March 6, 1547, just a few days after the death of Vittoria Colonna.

65:5–11. *Rime di Michelagnolo Buonarroti: Raccolte da Michelagnolo suo Nipote* (Florence, 1623). Cesare Guasti describes the disastrous omissions and alterations made for this edition —*Rime di Michelangelo*, pp. XLIV–XLVI. Grimm, having compared the edition of 1623 with the Vatican manuscripts, with versions of some of the poems to be found elsewhere, and with the manuscripts from which the edition of 1623 was printed, had already arrived, even without access to the fam-

ily papers in Florence, at a good understanding of the short-comings of the edition of 1623—*Leben Michelangelo's*, p. 725, n. 111.

65:11–14. Guasti, "Discorso," *Rime di Michelangelo*, pp. VIII–IX.

65:15–16. "Sa reputation s'affermira toujours, parce qu'on ne le lit guère"—"Le Dante," in *Dictionnaire philosophique*, bk. 3, *Oeuvres complètes de Voltaire* (Paris, 1819), XXXV, 66. Pater probably encountered this quotation in Sainte-Beuve, "Dante," *Causeries du lundi*, 3d ed. (Paris, 1857–1862), XI, 168.

65:16–24. These details are recounted in Guasti's "Discorso," *Rime di Michelangelo*, p. XLVII. On pages LI–LXVI, Guasti describes the autograph mentioned by Pater and other manuscripts used and not used in his handsome edition.

65:30–66:1. According to Grimm, Pater's apparent source of information, Michelangelo first became the friend of Vittoria Colonna in 1536, when he was sixty-one. Francesco d'Ollanda's memories belong to the spring of 1537. Vittoria spent the years 1536–1541 mostly in Rome. She left Rome for Viterbo in 1541 under suspicion for her "new opinions" (see n. to 70:15). On her return to Rome in 1543, she withdrew to the Benedictine convent of Sta Anna dei Funari and spent the last years of her life there in ill health—*Leben Michelangelo's*, pp. 554, 566–567, 575.

65:32–33. *The Sonnets of Michael Angelo Buonarroti and Tommaso Campanella; now for the first time translated into rhymed English by John Addington Symonds* (London, 1878).

66:7. As Grimm explains, Francesco d'Ollanda (or Francisco de Hollanda or Holanda, 1517–1584), was a miniature painter sent to Italy in the 1530's by the King of Portugal, in whose service he was; on his return he wrote an account of his experiences. His manuscript, dated 1549, was found in one of the Lisbon libraries, and Count Atanazy Racynsky published part of it in a French translation—*Leben Michelangelo's*, p. 554. Grimm quotes at length from Count Racynsky's translation, which had appeared in his book *Les Arts en Portugal* (Paris, 1846). Since the time of Grimm and Pater, there have been a

number of editions and translations of Francesco d'Ollanda's conversations in Rome.

66:13–15. If this avowal was made, as Pater says, in a letter, it was also spoken to Condivi—*Vita di Michelagnolo*, p. 80; Grimm, *Leben Michelangelo's*, p. 576.

66:15–17. In a letter quoted by Grimm, Vittoria writes to Michelangelo saying that she has received his design for a crucifix and so greatly admires it that she is resolved to keep it rather than return it for execution in his workshop—*Leben Michelangelo's*, pp. 732–733. Assuming correctly that this is the drawing described at length by Condivi (*Vita di Michelagnolo*, p. 80), Grimm identifies it tentatively with "a wonderfully beautiful drawing in the possession of the Oxford collection"—*Leben Michelangelo's*, p. 569. Authorities now agree that the drawing Grimm admired at Oxford (Parker no. 352 —see below) is not in Michelangelo's hand, but is "one of several existing copies of an original drawing, made about 1541 for the Marchesa di Pescara and described by Condivi . . . now in the British Museum . . ." K. T. Parker, *Catalogue of the Collection of Drawings in the Ashmolean Museum* (Oxford, 1956), II, 187. John Charles Robinson, whose book Pater might have consulted, correctly took Parker no. 352 for "a good old copy"—*A Critical Account of the Drawings by Michel Angelo and Raffaello in Oxford* (Oxford, 1870), p. 85. The original drawing is reproduced as pl. 10 in *The Renaissance*, ed. Clark; it is no. 198 in Charles de Tolnay's *Michelangelo V: The Last Period* (Princeton, 1960), p. 195.

But Pater speaks of "two drawings . . . now in Oxford." Robinson (p. 87) incorrectly believed that a second drawing in the Oxford collection (Parker no. 343, de Tolnay no. 254) was also a study for Vittoria's crucifix. Modern scholars agree with Robinson that this drawing is genuine, but they judge it to be of a later period.

66:21–22. "a bitter sweet, a yes and no moves me." Pater quotes from Sonnet XL in Guasti's edition, "Non so se s'e la desiata luce" (line 13, p. 199). Though Pater takes this to be one of the sonnets addressed to Vittoria Colonna, Michel-

angelo's modern editor shows that it was not—Michelangelo's *Rime*, ed. Girardi, p. 243.

66:22–23. "the shining light of its [the soul's] former state." Pater quotes (though not exactly) from another version of the sonnet cited in the preceding note—in Guasti's ed. sonnet XL, line 6.

66:23–31. The difficulties of dating the poems and determining the identity of the persons to whom they were addressed remain formidable, as one learns by examining the notes in Girardi's edition of the *Rime*. One whole class of problems, among others, arises from the efforts of Michelangelo the younger to conceal—and the failure of Guasti and other scholars of the nineteenth century to recognize, or fully acknowledge—the fact that many of his passionate but always high-minded love poems were addressed to young men. John Addington Symonds opened the subject to the general reader in his *Life of Michelangelo Buonarroti* (London, 1893), both in the chapter on the artist's loves and friends (II, 92–179) and in app. 5, "On Michelangelo's Temperament and Its Bearing on His Poetry" (II, 381–385).

But much earlier, Grimm had represented Michelangelo's love for Tommaso Cavalieri as well established on several grounds and had quoted two of the sonnets addressed to him —*Leben Michelangelo's*, pp. 624–627. Thus, although Pater did not choose to treat the matter directly, he was not unaware of the facts in 1871, when his essay was first published. Symonds, in his article of 1872, had accepted the evidence and quoted the two sonnets given by Guasti along with two others as (with different degrees of certainty) addressed to Il Cavalieri—"Twenty-Three Sonnets of Michelangelo," *Contemporary Review*, XX (September, 1872), 511–512. And Pater quoted one of these with the ascription "To Tommaso Cavalieri" in the first two eds. of *The Renaissance* (see Textual Notes, pp. 225–226). The sonnets to Cavalieri, and others addressed to Cecchino Bracci, were presented frankly as love poems by Symonds in *Renaissance in Italy: The Fine Arts* (London, 1877), 521–524.

Pater's acceptance of Guasti's often wildly inaccurate conclusions about the dates and addressees of the sonnets puts his idea of the relationship between Michelangelo and Vittoria Colonna on a false textual basis. Following Guasti nonetheless saves him from exaggerating the depth and turmoil of their feeling in the manner of "the older, conventional criticism, dealing with the text of 1623," a late example of which is M.-A. Lannau-Rolland's *Michel-Ange et Vittoria Colonna*, new ed. (Paris, 1863). Pater's view that "Vittoria raised no great passion" (67:7) is in accord with that of modern scholars, one of whom speaks of Michelangelo's "chaste autumnal love, Vittoria Colonna"—Robert J. Clements, ed., *Michelangelo: A Self-Portrait* (New York and London, 1968), p. 82.

66:32–67:1. Goethe tells how he saved himself "not so much from the danger as from the whim of suicide" by undertaking a search for "an event, a fable" in which his feelings might be embodied. The result was *Werther*—"Aus meinem Leben: Dichtung und Wahrheit," bk. 13, *Werke* (Weimar, 1887–1912), XXVIII, 220–221. Carlyle quotes the passage at length in his essay on Goethe (1828), and Hegel notes that "through *Werther* Goethe has converted into a work of art his own inner distraction and torment of heart, the experiences of his own breast . . . *Aesthetik*, ed. H. G. Hotho, 2d ed. (Berlin, 1842), I, 255–256 (trans. Knox, I, 203).

67:5–6. "What gives my love its life is not my heart, / The love by which I love you has no heart"—sonnet XXVIII, lines 1–2, Guasti, *Rime di Michelangelo*, p. 186. One version of this sonnet was written on the back of an envelope dated April 18, 1526—Michelangelo's *Rime*, ed. Girardi, p. 188. Girardi does not identify the addressee.

68:5–6. Marsilio Ficino (1433–1499) devoted most of his life in Florence to the translation of Plato and his followers, notably Plotinus.

68:24–28. Michelangelo's images of fire, phoenix, salamander, bow, and mirror are located and discussed by Robert J. Clements, *The Poetry of Michelangelo* (New York, 1965), pp. 271–278.

68:30–33. Vasari, *Le vite*, II, pt. 3, 1379; Grimm, *Leben Michelangelo's*, pp. 70–71.

68:33–69:2. The point is elaborated in Pater's essay on Rossetti (1883): "Spirit and matter . . . have been for the most part opposed, with a false contrast or antagonism by schoolmen, whose artificial creation these abstractions really are. In our actual concrete experience, the two trains of phenomena which the words *matter* and *spirit* do but roughly distinguish, play inextricably into each other. Practically, the church of the Middle Age by its aesthetic worship, its sacramentalism, its real faith in the resurrection of the flesh, had set itself against that Manichean opposition of spirit and matter, and its results in men's way of taking life; and in this, Dante is the central representative of its spirit. To him, in the vehement and impassioned heat of his conceptions, the material and the spiritual are fused and blent: if the spiritual attains the definite visibility of a crystal, what is material loses its earthiness and impurity"—*Appreciations*, *Works*, V, 212.

69:4–5. "E se creata a Dio non fusse eguale, / Altro che 'l bel di fuor, ch' agli occhi piace, / Più non vorria; ma perch' è sì fallace, / Trascende nella forma più universale."—sonnet LII, lines 4–7, *Rime di Michelangelo*, ed. Guasti, p. 214 ("And if it [the soul] were not created equal to God, it would want no more than the outward beauty, which pleases the eyes; but, since that is so misleading, it goes beyond to universal form"). Girardi agrees with other scholars that this sonnet ("Non vider gli occhi miei cosa mortale") was not addressed to Vittoria Colonna—*Rime*, p. 286.

69:11. "there where I first loved you," from sonnet XXVIII ("La vita del mie amor non è'l cor mio"), line 13, *Rime di Michelangelo*, ed. Guasti, p. 186. This is not one of the sonnets written for Vittoria Colonna. See n. to 67:5–6.

69:17–18. From the first madrigal in Guasti's ed., "Per molti, donna, anzi per mille amanti" (lines 12–13, p. 25). Girardi offers documentary evidence that by the lady of the song Michelangelo meant Florence—*Rime*, p. 406.

69:24–29. Pater alludes here not to one of the sonnets, but

to the madrigal cited in the preceding note. Piero de' Medici (1472–1503), the son of Lorenzo, succeeded him as head of the family and ruler of Florence on Lorenzo's death in 1492. Alessandro de' Medici (1511–1537), son of Giuliano, was made Duke of Florence in 1532. The "un sol" of Michelangelo's madrigal, however, must be Cosimo de' Medici (1520–1574), son of Giovanni delle Bande Nere, who became Alessandro's lawful successor in 1537, reduced the old republican institutions to empty forms, and ruled as an independent despot. Girardi dates the poem as of 1546–1547—*Rime*, p. 406.

69:29–30. Madrigal XX, Guasti, p. 45.

70:5. "'Whom the gods love die young' was said of yore" —Byron, *Don Juan*, canto IV, st. xii, line 1. "Quem Di diligunt / Adolescens moritur"—Plautus, *Bacchides*, act IV, scene 7.

70:15. The "Oratory of Divine Love," a society of pious aristocratic persons who came under the influence of Lutheran ideas without giving up hope for reform within the Roman Catholic church. Grimm reports that this society took shape in Rome, moved to Venice, and later flourished in Naples under the patronage of Vittoria Colonna and Giulia Gonzaga in the 1530's—*Leben Michelangelo's*, esp. pp. 544, 553. I do not know of any evidence that Michelangelo was associated with members of the Oratory.

70:19–20. By the 1540's, any kind of speculative freedom had begun to arouse suspicion. The Inquisition was established in Rome in 1542.

71:26–27. Luca Signorelli (circa 1441–1523), a prolific painter and chief master of the nude before Michelangelo. His most characteristic and memorable work is in the fresco series of the events of the end of the world, inspired by Dante's *Divine Comedy*, in the chapel of S. Brizio in Orvieto. The *Oxford Companion to Art* calls this series "a work of extreme, even brutal, vigour." Mino da Fiesole or Mino di Giovanni (circa 1430–1484), a sculptor chiefly of monuments, portrait busts, and profile bas-reliefs, left a number of works in Florence and Rome.

72:19. *The Imitation of Christ*, a devotional book written between 1390 and 1440. Its authorship is still a matter of controversy. It presents the life and thought of Christ as a pattern for the individual Christian. Its simple language and direct appeal to the ordinary reader have helped give it wide influence.

72:30. The New Sacristy of S. Lorenzo, a counterpart to Brunelleschi's Old Sacristy, was planned from 1520 as a mortuary chapel to contain the monuments of four members of the Medici family. Michelangelo stopped work on it in 1527, when the Medici were expelled from Florence, resumed work in 1530, and broke off again in 1534, when he finally settled in Rome. His finished work includes the wall tombs of Giuliano and Lorenzo de' Medici, with seated figures of the two men set above the reclining figures usually taken to symbolize "Day" and "Night" (for the *Vita activa*) and "Dawn" and "Evening" (for the *Vita contemplativa*). But see Pater's objection to the traditional titles at 74:29–75:13.

73:1–5. In the *Decameron*, a collection of a hundred stories published in 1353.

73:12–14. "La bella Simonetta" Cattaneo, wife of Marco Vespucci and, many have assumed, mistress of Giuliano de' Medici (1453–1478), died still young of consumption in April, 1476. Her death was the occasion for public mourning in Florence, and she was eulogized in poems by Giuliano's brother Lorenzo, by Pulci, Benivieni, and others, and notably in four Latin epigrams by Agnolo Poliziano. Her portrait by Piero di Cosimo (circa 1462–1521) is in the Musée Condé, Chantilly. In his prose "Comment on some of his sonnets," Lorenzo de' Medici observes that Simonetta, so much loved for her beauty and "gentilezza," left at her death "a most ardent longing for her. And therefore she was taken uncovered from her house to the burial place, and moved all who crowded around to see her to copious tears"—*Opere*, ed. Attilio Simioni (Bari, 1913), I, 26. See also 47:19–20.

73:14–22. This monument to the Cardinal Prince of Portugal was erected by Antonio Rossellino (1427–1479) in 1461–1466 for the church of S. Miniato al Monte, near

Florence. The Cardinal lies entombed in the chapel of S. Jacopo, on the ceiling of which Luca della Robbia painted the four evangelists and the Holy Spirit. The epitaph given in Pater's line 15 reads: "I was distinguished for my comeliness and extraordinary modesty."

73:22–24. The Pazzi conspiracy, organized in 1478 to break the domination of Florence by the Medici, was an outgrowth of the conflict between the Pazzi and the Medici families and of the anti-Medicean policy of the archbishop, Salviati. On April 26, 1478, in the cathedral of Sta Maria del Fiore, the conspirators attacked Giuliano and Lorenzo de' Medici. The former was killed; the latter, slightly wounded, took refuge in the sacristy. The surprise attack having failed, the people supported the Medici and some of the conspirators were executed. These Botticelli painted, hanging by their necks, on the Porta della Dogana in the Palazzo Vecchio. The paintings were removed in 1494 after the republican citizenry had driven Piero de' Medici out of Florence.

74:10. See n. to 75:23–24.

74:12–21. Michelangelo's sculptured "Pietà" in St. Peter's (completed circa 1500) and his much later unfinished group behind the altar in the cathedral in Florence are two of the most famous examples of the pietà. A closely related scene, "The Entombment of Our Lord," is represented in an unfinished painting by Michelangelo in the National Gallery, London; and, as Pater says, he left many other traces of his interest in the subject.

74:21–24. Pater is describing the black chalk "Pietà" made for Vittoria Colonna, de Tolnay no. 197, now in the Isabella Stewart Gardner Museum in Boston. Though Berenson regarded it as a copy, it is now generally accepted as an original drawing—de Tolnay, *Michelangelo*, V, 194–195. In referring to the drawing as "at Oxford," Pater was in error— that is, if he meant (as it seems he must have) that it was among the Michelangelo drawings owned by the University or one of its colleges. In 1871, when Pater was preparing

his essay on Michelangelo for publication, the "Pietà" was in the collection of John Brooks of Windermere, who had owned it since 1860. When Brooks died in 1872, the drawing was sold as Lot 27 at Christie's on July 3, 1872, to an agent of the art dealer Colnaghi. It was acquired in the same year by Francis Turner Palgrave, graduate of Balliol, editor of *The Golden Treasury of Songs and Lyrics* (1861), and professor of poetry at Oxford, 1885–1895. It went from Palgrave to John Charles Robinson in 1886, and from Robinson to the Isabella Stewart Gardner Museum in 1902. It is not mentioned in Robinson's *A Critical Account of the Drawings by Michel Angelo and Raffaello in Oxford* (Oxford, 1870). Though evidence is lacking, it is almost impossible to believe that Pater did not know Robinson's book, and it seems equally unlikely that he had no acquaintance at all with Palgrave and Robinson themselves. Where and how he could have seen the drawing and why he said it was "at Oxford" are thus unanswered questions. But they are no more teasing than the further question why, having made an error of which he must soon have become aware, he let it stand (though he made other revisions) in all four republications of the essay in his lifetime.

74:26–27. Giuliano de' Medici (1479–1516) was a son of Lorenzo the Magnificent. On the return to power of the Medici after the interlude in which the ancient forms of republican government were restored to Florence, Giuliano ruled Florence in 1512–13, moved to Rome as gonfalonier of the Holy Roman Church, was granted the French title of Duc de Nemours in 1515, and died in 1516. Lorenzo (1492–1519), a grandson of Lorenzo the Magnificent and a son of Piero, took Giuliano's place in Florence in 1513 and was invested by the pope as Duke of Urbino in 1516.

75:23–24. From 74:28 to the end of this paragraph, Pater's aim is to characterize Michelangelo as "the disciple not so much of Dante as of the Platonists" (75:14–15) in his ideas of immortality. And he has remarked earlier that, in his verse at least, Michelangelo was drawn to Plato's dream of the

soul's "passionate haste to escape from the burden of bodily form altogether" (68:11–12) rather than to Dante's belief in the definite forms of souls even in heaven. Nonetheless, Pater could hardly have mentioned the "new body" to be assumed by the soul or spirit at the moment of death without recalling the pertinent doctrine outlined by Statius in the *Purgatorio*, XXV, 79–108:

And when Lachesis has no more thread, this soul is loosed from the flesh, and virtually bears away with itself both the human [the bodily faculties] and the divine [the intellectual or spiritual faculties]; the other faculties [those of sense] all of them mute [because their organs no longer exist], but memory, understanding, and will [the spiritual faculties, independent of the senses] far more acute in action than before. Without a stop, it falls of itself, marvellously, to one of the banks [of Acheron or of Tiber, according as the soul is damned or saved]. Here it first knows its own roads. Soon as the place there [whether Purgatory or Hell] circumscribes it, the formative virtue rays out around it in like shape and size as in the living members. And as the air when it is full of rain becomes adorned with divers colors, by reason of the rays of another [that is, the sun] which are reflected in it, so here the neighboring air shapes itself in that form which the soul that has stopped [in the place allotted to it] virtually imprints upon it. And then like the flamelet which follows the fire whithersoever it shifts, so does its new form [*sua forma novella*] follow the spirit. Since thereafter it has its aspect from this, it is called a shade; and thence it organizes every sense even to the sight; thence we speak, and thence we laugh, thence we make the tears and sighs, which thou mayst have heard on the mountain [of Purgatory]. According as our desires and our other affections impress us, the shade is shaped; and this is the cause of that at which thou wonderest [the emaciation of the spirits within Dante's view] (trans. Norton, pp. 195–196, with his nn. in brackets).

Michelangelo, as a lifelong student of Dante, would of course have been familiar with this passage. As a translation of Dante's "forma novella," Pater's phrase "the new body"

would surely be acceptable to scholars who find a modern equivalent in "un nuovo corpo": "ella [the soul] si forma dell'aria circostante un nuovo corpo, simile al primo nell'apparenza . . ." *La Divina Commedia*, ed. Giuseppe Vandelli, 19th ed. (Milan, 1965), p. 525, n. on the *Purgatorio*, lines 79–108.

In a much later essay, Pater remarks that "the sculptors and glass-painters of the Middle Age constantly represented the souls of the dead as tiny bodies." He adds in a footnote: "In some fine reliefs of the thirteenth century, Jesus himself draws near to the deathbed of his Mother. The soul has already quitted her body, and is seated, a tiny crowned figure, on his left arm (as she had carried Him) to be taken to heaven. In the beautiful early fourteenth century monument of Aymer de Valence at Westminster, the soul of the deceased, 'a small figure wrapped in a mantle,' is supported by two angels at the head of the tomb. Among many similar instances may be mentioned the soul of the beggar, Lazarus, on a carved capital at Vézélay; and the same subject in a coloured window at Bourges. The clean, white little creature seems glad to escape from the body, tattooed all over with its sores in a regular pattern—"The Age of Athletic Prizemen" (1894), in *Greek Studies, Works*, VII, 274. Compare the Prior's doctrine in Browning's "Fra Lippo Lippi" (lines 184–186): "Man's soul, and it's a fire, smoke . . . no, it's not . . . / It's vapor done up like a new-born babe— / In that shape when you die it leaves your mouth) . . ."

76:1–7. See n. to 75:23–24. Samuel Chew finds in Pater's lines 75:28–76:7 an attempt "to express the same 'range of sentiment' which Swinburne is groping after" in "Ave atque Vale," his elegy on the death of Baudelaire: "a sense of profound penetration into the mystery of death, of straining with 'foiled earnest ear' and with 'eluded eyes' after the departed spirit"—*Swinburne* (Boston, 1929), p. 145. Not only the notion, but even the language of these lines on Michelangelo is echoed later in Pater's very personal essay "The Child in the House" (1878): ". . . he came more and more

to be unable to care for, or think of soul but as in an
actual body . . . It was the trick even his pity learned . . ."
Miscellaneous Studies, Works, VIII, 187.

Note on Canceled Passage

224:28–226:33. The sonnets were translated by John
Addington Symonds and presented in his (signed) article with
explanatory comments. Since Pater not only quotes three of
the sonnets but praises the translator, his failure to give his
name is surprising, the more so because Symonds had paid
him a high compliment and represented his own work as
a "supplement" to Pater's essay. "It is not my intention,"
says Symonds, "to criticize the poetry of Michael Angelo.
That has recently been done by Mr. W. H. Pater, whose
essay in a late number of the *Fortnightly Review* reveals the
purest and most delicate sympathy with the poet's mind. As
a supplement to his work, I wish to give some specimens of
translation"—*Contemporary Review*, XX (September, 1872),
506. In a letter of March 3, 1873, to Horatio Forbes Brown,
Symonds called attention to "two misprints" in the sonnets
reproduced in *The Renaissance*: "In the first sonnet, line 7
our should be *one*, and in the second sonnet line 7 *those* should
be *these*. It would also be well to print *knight* in the last
line of the second sonnet with a large K, since Michael
Angelo designed a pun upon the young man's name"—*The
Letters of John Addington Symonds*, ed. Schueller and Peters
(Detroit, 1968), II, 274–275.

Leonardo da Vinci

Published first in the *Fortnightly Review* for November,
1869, the essay on Leonardo da Vinci was one of those sent
to Macmillan on June 29, 1872, and reset during the summer.
It is in the essays on Botticelli and Leonardo, said Colvin,
that the reader "will find most of those passages of delicate

poetry and imaginative charm" which are one of the "great strengths" of the book, and he cited "the account, which is too long to quote, of Mona Lisa and her smile"—*Pall Mall Gazette*, March 1, 1873, p. 12. At least two other reviewers did quote the passage at length, one (in the *Spectator*, June 14, 1873, p. 765) to comment that "criticism like this, whether we agree with it or not, affects us like a tune skilfully played on a fine violin," the other (William Dean Howells in the *Atlantic Monthly* for October, 1873) to complain of Pater's presuming to know more than he could of Leonardo's motives and intentions. To Pater's suggestion (at 99:10–16) that "Lady Lisa might stand as the embodiment of the old fancy [of a perpetual life], the symbol of the modern idea [of humanity as wrought upon by, and summing up in itself, all modes of thought and life]," Howells replied: "She might, but does she? There is really nothing to prove that Lionardo, who lived before the modern thought, had the old fancy in his mind."

Though Pater would surely have answered that in this particular passage he was quite properly concerned, not with Leonardo's intention, but with the suggestive power of the picture, with "the effect of its subdued and graceful mystery" (97:17), Howells' objection was probably felt by many of Pater's readers. He goes on to deprecate Pater's error as characteristic of "modern art criticism" and to lay the blame on Ruskin: "The sight of an old painting inspires the critic with certain emotions, and these he straightway seizes upon as the motives of the painter. It *may* happen that both are identical; or it may happen that the effect produced was never in the painter's mind at all. Very likely it was not; but this vice, which Mr. Ruskin invented, goes on perpetuating itself; and Mr. Pater, who is as far from thinking with Mr. Ruskin as from writing like him, falls a hopeless prey to it. Yet, as Mr. Pater deals more with the general character of the painter than with his intentions in particular works, his offense is far less than that of his original in this respect . . ." *Atlantic Monthly*, XXXII (October, 1873), 497–498.

Another reviewer judged that in this essay "subtle and

searching insight is shown into that part of the artist's career which lies on the frontier of the natural and the supernatural, which touched on divination, 'clairvoyance,' the alchemist's secret, with the strange approaches in animal creation to phases in humanity." After some further appraisal of Pater's views on this and other topics, he concluded by quoting as "exceptional" the passage (91:14–16) in which Pater sees the daughters of Herodias as "the clairvoyants, through whom, as through delicate instruments, one becomes aware of the subtler forces of nature . . ." *Saturday Review*, XXXVI (July 26, 1873), 124.

Kenneth Clark suggests that Pater was attracted to Leonardo as the subject of his first Renaissance study partly by a special sense of "intellectual adventure" and partly because "the sources of information on Leonardo were unusually vivid and full"—Introduction to *The Renaissance*, ed. Clark (New York, 1961), p. 15. "The result," he continues, "is the most effective and memorable of all Pater's essays. Even today, with access to Leonardo's notebooks and to a vast corpus of scholarship, we cannot improve on Pater's characterisation, and the too familiar description of the Mona Lisa . . . remains, if read in its context, a defensible interpretation" (p. 16).

77: Epithet. Francis Bacon described man in these words. See n. to 31:3–6.

77:1–2. Vasari's *Le vite de' più eccellenti pittori, scultori ed architetti* was first published in Florence in 1550. A second, enlarged edition appeared in 1568; on this edition all the later ones are based. In the life of Leonardo, Vasari made significant changes in two passages: a) "His cast of mind was so heretical that he did not adhere to any religion, deeming perhaps that it was better to be a philosopher than a Christian." This sentence was omitted entirely from the second edition. b) "Finally having become old, he lay sick for many months, and seeing himself near death, disputing about Catholic matters, returning to the good way, he brought

himself back to the Christian faith with many tears." After the words "near death," this sentence was changed in the second edition to read: "set about diligently to inform himself about Catholic matters and the good and holy way of the Christian religion, and then with many tears, confessed and contrite . . . he devoutly received the Holy Sacrament" —*Le vite*, ed. Ferdinando Ranalli (Florence, 1845–1848), II, pt. 3, 36.

77:3–4. In his famous mural painting of the "Last Supper" in Sta Maria delle Grazie at Milan.

77:23. See 100:9–22.

77:24. The "Last Supper" showed signs of deterioration as early as 1517 and was described by Vasari in 1566 as "merely a mass of blots." Attempts were made later to restore it by scraping and repainting. See Pater's discussion, 94:6–95:18.

78:3. To Michelet, Leonardo was "the great Italian, the complete man, balanced, all-powerful in all things, who summed up the whole past and anticipated the future; who, above and beyond the universality of the Florentine, had that of the North, uniting the chemical and mechanical arts to those of design." Whereas the middle ages had been timid in the presence of nature, knowing only how to curse, to exorcise "the great fairy," Leonardo, "child of love and himself the most handsome of men, feels that he is also nature; he is not afraid of it. All nature is as if his, loved by him . . . This same audacity is in his Ledas, where the wedding of the two natures is boldly indicated, as modern science has discovered it in our day, and all creation rediscovered as akin to man." In contrast with the "fainting figures" of Fra Angelico, with "their sick and dying gaze," there shines in the paintings of Leonardo "the genius of the Renaissance in its bitterest disquiet, its most penetrating sting."

Leonardo's figures in the Louvre "are gods, but sick gods. Galileo is still far away. Bacchus and St. John, those bitter prophets of the modern spirit, in suffering, are consumed by it." In his time, though much admired, Leonardo was not much encouraged and little followed: "This surprising magi-

cian, the Italian brother of Faust, astonished and alarmed the world"—Introduction, *Histoire de France* (Paris, 1833–1867), VII, LXXXVIII–XCII.

78:13–15. In his *Memorie storiche su la vita gli studi e le opere di Leonardo da Vinci* (Milan, 1804). Whether Pater had read Amoretti is uncertain. For the facts in his essay he seems to have relied chiefly on Vasari, on Charles Clément's *Michel-Ange, Léonard de Vinci, Raphael* (Paris, 1861), and on Alexis-François Rio's *De L'Art chrétien* (Paris, 1861–1867), III, 35–166. Rio's essay had been published separately as *Léonard de Vinci et son école* (Paris, 1855), but Pater used the later volume, borrowed in 1869, along with Clément, from the Taylor Institution at Oxford.

78:18–19. Leonardo bequeathed his drawings and papers to his friend and pupil Francesco Melzi, who died in 1570. Most of the scientific notes and drawings went to the Bibliotheca Ambrosiana in Milan in 1637. Another collection of about six hundred drawings passed in time into the collection of the kings of England and is now at Windsor Castle. A series of twelve small notebooks is in the Institut de France in Paris. Other important collections of drawings and manuscripts are in the British Museum, the Uffizi, the Louvre, and the Accademia in Venice.

Kenneth Clark points out that Pater "did not know Leonardo's original drawings. The great collection at Windsor Castle was almost unknown till a part of it was exhibited in the Grosvenor Gallery in 1878; and the drawings then accepted as originals in the Uffizi and the Louvre, which he refers to on pages [90–91 in this edition] are the work of pupils"—Introduction to his ed. of *The Renaissance*, p. 16. But Pater did know of the existence of the Windsor Collection, for Rio mentions it more than once and even describes it—*De L'Art chrétien*, III, 51, 1; 70; 78–79.

78:30–31. Pater identifies the Chateau de Clou at 101:7–11.

78:31–32. Leonardo was born in 1452 and died in 1519. His father, who was twenty-three at the time of his birth, and

his mother, a peasant girl, were never man and wife. Piero
Antonio made the first of his four marriages in the year of
Leonardo's birth.

79:1. The valley of the Arno, which flows through Flor-
ence.

79:4–8. Vasari, *Le vite*, II, pt. 3, 15–19.

79:9–11. *Ibid*., II, pt. 3, 17.

79:14–15. *Ibid*., I, pt. 2, 1052. Verrocchio's dates are
1435–1488.

79:18–21. Pietro Vannucci, called Perugino, was born in
Umbria about 1450 and died in 1523. As a young man he
worked in Florence, "possibly learning the new oil techniques
from Verrocchio"—*Oxford Companion to Art*.

79:30–33. Vasari, *Le vite*, II, pt. 3, 19. See also I, pt. 2,
1057–1058, on Verrochio. Originally in the church of S. Salvi
in Florence, this painting is now in the Uffizi. In her review of
The Renaissance, Pater's friend Mrs. Mark Pattison chided
Pater rather sharply for historical inaccuracy, citing in par-
ticular this old story, which she said, "has long been exploded
as having no foundation, nor even verisimilitude, and the
angel, which may still be seen at Florence, shows not a trace
of special beauty nor even a sign that it has been touched by a
different hand to that which painted the rest of the picture"—
Westminster Review, XLIII, n.s. (April, 1873), 640. But on
the basis of research done early in the twentieth century, not
only the angel but the piece of landscape behind the angel are
now accepted as Leonardo's work—*The Complete Paintings of
Leonardo da Vinci*, ed. Angela Ottino della Chiesa (London,
1969), p. 88.

80:7–8. Vasari, *Le vite*, I, pt. 2, 1052.

80:8–9. *Ibid*., I, pt. 2, 1055.

80:16–19. *Ibid*., II, pt. 3, 20.

80:21–22. Rio calls this legend "*très–douteuse*"—*De L'Art
chrétien*, III, 39, n. 2.

80:27–28. The "Modesty and Vanity" once regarded as a
painting by Leonardo is the work of Bernardino Luini. It is
now at Pregny in the collection of M. Rothschild.

80:29. "The Virgin of the Balances" in the Louvre is no longer attributed to Leonardo. Its authorship is uncertain. See n. to 87:12–14.

80:31. "St. Anne, Madonna and Child with a Lamb," in the Louvre.

81:1–7. Vasari, *Le vite*, II, pt. 3, 20.

81:16–17. "'Nature alone,' he says somewhere, 'is the mistress of superior intellects'"—Rio, *De L'Art chrétien*, III, 37–38. This saying is quoted also by Arsène Houssaye, *Histoire de Léonard de Vinci* (Paris, 1869), p. 31. Almost certainly Rio is recalling (and improving) the last part of the following sentence: "In the study of the sciences which depend on mathematics, those who consult not nature, but authors, are not the children of nature; I would say that they are only her grandchildren; she alone, in effect, is the master of true geniuses"—quoted in French by Henry Hallam, *Introduction to the Literature of Europe in the Fifteenth, Sixteenth, and Seventeenth Centuries*, 4th ed. (London, 1854), I, 219n. This sentence was taken by Hallam from Giovanni Batista Venturi's *Essai sur les ouvrages physico-mathématiques de Léonard de Vinci* (Paris, 1797), and Venturi himself was translating from Leonardo's manuscripts at the Institut de France in Paris. Rio may of course have read Venturi's *Essai*; Pater almost certainly had not, but he did know Hallam's long note on Venturi, for he quotes from it himself (see 86:24–28 and n.).

81:33–82:3. Vasari, *Le vite*, II, pt. 3, 19.

82:3–6. *Ibid.*, 18.

82:13–14. *Ibid.*, 17.

82:19–22. *Ibid.*, 23.

82:29. I am not sure which of Leonardo's grotesque drawings might have struck Pater as a caricature of Dante.

83:1–2. "The *Medusa* [of the Uffizi] is a seventeenth century picture showing the influence of Caravaggio; but it may be based on a lost original by Leonardo"—Kenneth Clark's n. in his ed. of *The Renaissance*, p. 108.

83:2–3. One of the peasants on the estate of Leonardo's father (says Vasari) asked to have a crude wooden shield painted for him in Florence. Ser Piero took it to Leonardo,

who had it straightened, turned, smoothed, and covered. Then he collected in his room a number of lizards, crickets, snakes, butterflies, locusts, bats, and other similar creatures and made from their parts joined together "uno animalaccio molto orribile e spaventoso," which he used as a model for painting the shield. With this painting, skillfully located and lighted in a darkened room, he gave his father a fright and thereupon pronounced his work satisfactory. Ser Piero bought another shield which he turned over to the peasant; the shield painted by Leonardo he sold to certain merchants for one hundred ducats, and they sold it later to the Duke of Milan for three hundred ducats—*Le vite*, II, pt. 3, 20–22.

83:31–84:1. *Trattato della Pittura di Leonardo da Vinci*, published in 1651, with drawings by Nicolas Poussin. A much fuller edition, based on a manuscript than only recently discovered in the Vatican Library, was published in Rome in 1817 by Guglielmo Manzi.

84:18. Paracelsus was the pseudonym of Theophrastus von Hohenheim (1493–1541), Swiss physician and alchemist. Geronimo (or Girolamo) Cardano (1501–1576) was an Italian physician, mathematician, and astrologer.

85:1–3. This letter was first published by Amoretti in *Memorie storiche*, pp. 20–24. It is often cited by later writers, including Clément and Houssaye, and included in the notes to editions of Vasari. Ludovico Sforza (1451–1508) became Duke of Milan in 1494. His young nephew Gian Galleazzo was the son of Giovanni Galleazzo Sforza, Duke of Milan until 1493; thus Gian was heir to the dukedom. "Il Moro," Ludovico's nickname, means "the mulberry tree."

85:12–13. Francesco Sforza (1401–1466), Ludovico's father, was Duke of Milan from 1450 until the time of his death.

85:13–17. Vasari, *Le vite*, II, pt. 3, 24.

85:24–25. *Ibid.*, II, pt. 3, 38.

85:26–29. Then the largest church in existence, the Duomo or cathedral of Milan was built of brick encased in marble. Its style is elaborately Gothic. Begun in 1386, the work was carried on through several centuries after many designs by a

number of masters. Charles Clément tells of a struggle which seems to lie behind Pater's sentence on the Duomo. About 1490, work on the cathedral was halted because of disagreements between the Italian architects, who wanted to adopt the Renaissance style, and the German architects, who favored the Gothic principles followed so far. Heated discussions ensued in which Leonardo probably had a part—*Michel-Ange, Léonard de Vinci, Raphael*, pp. 197–198. Rio also tells the story of this impasse—*De L'Art chrétien*, III, 60–62.

85:28. Giotto (1267–1337) may have designed the campanile of the cathedral of Florence and perhaps also some of the reliefs carved on the building by Andrea Pisano. Arnolfo di Cambio (d. probably 1302, certainly before 1310), Florentine architect and sculptor, is credited with the rebuilding of the Badia and of the Sta Croce in Florence, but his principal work as an architect was the cathedral of Florence.

85:30–86:4. "The pomp of a brilliant court suited his taste in pleasure. Less scrupulous than Michelangelo would have been in similar circumstances, his brush was lent more than once to the licentious fancies of his master. He directed entertainments of which he himself was the ornament, and the marriages of Gian Galleazzo with Isabella of Naples, of the duke himself with Beatrice d'Este, furnished him the occasion to deploy all the resources of his inventive spirit"—Clément, *Michel-Ange, Léonard de Vinci, Raphael*, p. 184. A certain fascination with crime and vice in the Renaissance was part of Pater's romantic inheritance. "The Borgias, Bianca Capello, and Benvenuto Cellini had inspired the early dramas of Pater's idol, Victor Hugo, and these disreputable figures even play a leading part in Stendhal's *Histoire de la Peinture en Italie*, which Pater is known to have read. This aspect of the Renaissance was always present in his mind. It did not displease him . . ." Kenneth Clark, Introduction to his ed. of *The Renaissance*, p. 24.

86:5–8. "It is the addition of strangeness to beauty that constitutes the romantic character in art; and the desire of beauty being a fixed element in every artistic organization, it is the addition of curiosity to this desire of beauty that consti-

tutes the romantic temper"—from p. 65 of Pater's essay "Romanticism," *Macmillan's Magazine*, XXXV (November, 1876), 64–70 (rev. and repr. under the title "Postscript" in *Appreciations*, 1889). The essay is an attempt to define the romantic spirit as a variable element or tendency in the art of every age. Pater borrows his terms from Arnold, but as usual he puts them to different uses. David DeLaura points out that "Arnold's *Culture and Anarchy*, which had appeared in book form in January 1869, makes 'curiosity' . . . and the 'keen desire for beauty'—the 'sweetness and light' of the farewell lecture—the essential components of culture or the Greek spirit" —*Hebrew and Hellene in Victorian England* (Austin and London, 1969), p. 231. See Arnold's *Complete Prose Works*, ed. R. H. Super (Ann Arbor, 1960–1977), V, 91, 98–100, 107.

86:17–18. "Subtilitas naturae subtilitatem sensus et intellectus multis partibus superat . . ." "Novum Organum," bk. I, aphorism X, *The Works of Francis Bacon* (London, 1826), VIII, 8 ("The subtlety of nature is many times greater than the subtlety of the senses and the understanding").

86:19–21. Fra Luca Paccioli or Pacioli (1450?–1520), Italian mathematician and Franciscan friar, author of *Summa de arithmetica, geometria, proporcioni e proporcionalità* (1494) and of *De divina proportione* (1509), with plates engraved by Leonardo. Marc Antonio della Torre (1481–1512) was a celebrated student of anatomy who lectured at Pavia. Vasari reports that della Torre was greatly aided in his anatomical studies by Leonardo, who made for him a book of drawings in red pencil outlined in ink—*Le vite*, II, pt. 3, 29. The drawings are at Windsor.

86:24–28. "Vinci had a better notion of geology than most of his contemporaries, and saw that the sea had covered the mountains which contained shells . . . He explained the obscure light of the unilluminated part of the moon by the reflection of the earth . . . He ascribes the elevation of the equatorial waters above the polar to the heat of the sun: Elles entrent en mouvement de tous les côtés de cette éminence aqueuse pour rétablir leur sphéricité parfaite [They enter into movement from all the sides of this aqueous eminence to re-

establish their perfect sphericity]. This is not the true cause of the elevation, but by what means could he know the fact?"— Henry Hallam, *Introduction to the Literature of Europe*, I, 219–220n.

Hallam's notes, as he remarks, are drawn from Venturi's *Essai* based on Leonardo's manuscripts at the Institut de France in Paris. Pater's sentence, made up of phrases taken from Hallam, remains incomplete and unintelligible in all editions. Presumably, he saw in the act of appropriating Hallam's language that he could not admit an erroneous explanation into his list of Leonardo's scientific accomplishments and simply failed to bring his sentence to a satisfactory close. Since any emendation based on Hallam's words would be open to this objection, and since there is no other basis for emendation, I have let the passage stand.

87:2–3. ". . . the most elegant flowers, those whose form must have pleased his perfect taste most: columbines and cyclamens"—Clément, *Michel-Ange, Léonard de Vinci, Raphael*, p. 196. ". . . jasmine, favorite flower of Leonardo . . ."— Rio, *De L'Art chrétien*, III, 92.

87:3–5. *The Drawings of the Florentine Painters*, ed. Bernhard Berenson, amplified ed. (Chicago, 1938), no. 1105; or *The Drawings of Leonardo da Vinci*, ed. A. E. Popham (New York, 1945), no. 256. This drawing is in the Accademia.

87:7–8. ". . . that bituminous color which has done so much to darken most of this master's paintings . . ."—Clément, *Michel-Ange, Léonard de Vinci, Raphael*, p. 182.

87:12–14. "The Madonnas '*of the Balances*' and '*of the Lake*' are not by Leonardo, as indeed Pater seems to have recognized, see *infra*"—Kenneth Clark's n. in his ed. of *The Renaissance*, p. 112. The "Madonna of the Balances" is no. 1604 in the Louvre; the "Madonna of the Lake," in the Gentile di Giuseppe Collection, Paris, may be by Marco d'Oggiono (circa 1470–1549). Pater is suitably cautious in his comments on the "Madonna of the Balances" at 92:30–93:2. Some years later he called it "a work by one of his [Leonardo's] scholars . . ." "The Myth of Demeter and Persephone," *Fortnightly Review*, XIX, n.s. (February, 1876), 274.

87:15. Of the two paintings known by this name, one was painted for the chapel of the Confraternity of the Immaculate Conception in the church of S. Francesco Grande, Milan; in 1508 it was still unfinished. Much of the panel, now in the National Gallery, London, is not by Leonardo. The similar painting in the Louvre may belong to Leonardo's early Florentine period, or perhaps to a period slightly before 1493. It is not clear which of these paintings Pater had in mind.

87:17–18. "La Gioconda" is the famous portrait in the Louvre, better known as the Mona Lisa. The "Saint Anne, Madonna and Child with a Lamb" is also in the Louvre.

88:5–13. "The portrait of Cecilia Galerani" is probably the so-called "Lady with an Ermine," in the Czartoryski Museum in Cracow. But critics are divided over the sitter, who may have been Beatrice d'Este. Attribution of the painting to Leonardo is also disputed. As for "La Belle Ferronière," neither sitter nor artist is agreed upon. The male portrait in the Ambrosian library is now designated as the "Musician" (possibly the choir-master of the cathedral), and the attribution to Leonardo remains in doubt. Both sitter and painter of the opposite portrait ("Lady with the Pearl Hairnet") are likewise in doubt.

89:5–7. "Antik und Modern," *Werke* (Weimar, 1887–1912), XLIX, pt. 1, 153. Goethe adds that Leonardo had labored too much at technical matters. Michelet calls Leonardo "the Italian brother of Faust"—*Histoire de France*, VII, 71.

89:8–9. Leonardo was said to have written a book in response to this question—Rio, *De L'Art chrétien*, III, 50n.

89:32–33. "The more an art entails physical toil, the more base it is!"

90:1–91:28. The influence of Swinburne's "Notes on Designs of the Old Masters at Florence" (*Fortnightly Review*, July 1, 1868, pp. 16–40) is conspicuous not only in Pater's notes on Leonardo's drawings, but more generally in the Leonardo essay. A stylistic resemblance was noticed by D. G. Rossetti, to whom Swinburne wrote: "I liked Pater's article on Leonardo very much. I confess I did fancy there was a little spice

of my style as you say, but much good stuff of his own, and much of interest"—*The Swinburne Letters*, ed. Cecil Y. Lang (New Haven, 1959), II, 58 (letter of November 28, 1869). Pater himself acknowledged the influence, according to Swinburne, who recalled that "on my telling him once at Oxford how highly Rossetti (D. G.) as well as myself estimated his first papers in the *Fortnightly*, he replied to the effect that he considered them as owing their inspiration entirely to the example of my own work in the same line . . ." *ibid.*, II, 240–241 (letter of April 11, 1873, to John Morley). As Germain d'Hangest well observes, "a similar attitude toward art, which consists in approaching the works through their imaginative content, in looking within them for the source of an ecstasy, in making the dream above all the major instrument of criticism, engenders a community of language, the same search for slow, stifled cadences, for narcotic effects"— *Walter Pater: L'Homme et l'oeuvre* (Paris, 1961), I, 356, n. 57.

90:3–4. "Unfortunately none of the drawings mentioned in the next two paragraphs is by Leonardo himself. They are by Milanese pupils and reflect the idea of the Leonardesque" —Kenneth Clark's n. in his ed. of *The Renaissance*, p. 114.

90:4–18. I have not been able to identify the drawings mentioned in these lines. Presumably they are all in the Uffizi, and Pater must have examined the originals during a visit to Florence.

90:18–22. A reproduction of this drawing in the Uffizi may be seen in Jens Thiis, *Leonardo da Vinci . . .* (Boston, 1913) with the title "Copy after Leonardo da Vinci: fight between dragon and lion. With small studies for Madonnas in the corners" (p. 207). Or see, for a reproduction with the note "formerly considered by Leonardo's hand, but probably a copy . . . ," *Complete Paintings of Leonardo da Vinci*, p. 112. Swinburne admired the drawing, which he saw at the Uffizi in 1864—"Notes on Designs of the Old Masters at Florence," *Fortnightly Review*, IV, n.s. (July 1, 1868), p. 17.

90:28–91:1. Number 2252 in the Louvre. This is apparently the original of the engraved vignette added to the title

page of the second (1877) edition (facing the title page of later editions) of *The Renaissance*. (See my n. to Title page: Illustration.) Pater mentions the vignette in several letters to Alexander Macmillan, his publisher, between November 15, 1876, and April 26, 1877, when he received a prepublication copy of the book for examination. On March 13, 1877, he writes: "The subject of the vignette has no recognized name, being only a small drawing;—the words of the advertisement might run,—'with a vignette after Leonardo da Vinci, engraved by Jeens'; and in any gossip on the subject it might be described as being from a favourite drawing by L. da V. in the Louvre" —*Letters of Walter Pater*, ed. Lawrence Evans (Oxford, 1970), pp. 21–22.

An engraved reproduction of this drawing appeared as pl. 21 (pl. 4 in the 1784 ed.) of *Disegni di Leonardo da Vinci incisi sugli originali da Carlo Giuseppi Gerli* (Milan, 1830). It was described as "a drawing in which it appears that Leonardo was thinking of the head of an angel; or perhaps it is a portrait of . . . Francesco Melzi, a most beautiful boy whose head, as we know, he often copied to make an angel's head" (p. 4). Though it seems to have been accepted as a work of Leonardo's hand through the nineteenth century, it is now considered a work of Leonardo's school and was so labeled by Louis Demonts, *Les Dessins de Léonard de Vinci* (Paris, 1922), pl. 24, p. 18.

91:2–5. I have not been able to identify this drawing. Pater must have seen the original in the Louvre.

91:11. Salome was the daughter of Herodias (circa 14 B.C. –after 40 A.D.) and Herod Antipas. As a favor for her dancing, she asked her father for the head of John the Baptist—Matthew 14:6–12, Mark 6:17–29. In the past a number of paintings of Salome or Herodias have been thought of as Leonardo's, but none of them is now accepted as his work. It should be noted that Pater is speaking here not so much of particular portraits as of "Leonardo's type of womanly beauty" (91:10), a type that can be studied in "a multitude of other men's pictures" (92:28–29).

91:14–28. "The idea of a continuous chain which, by im-

perceptible degrees, links the world of matter to that of spirit is in this passage a clear reflection of the evolutionism of [Herbert] Spencer"—d'Hangest, *Walter Pater*, I, 355, n. 41. No doubt Pater, like other educated readers of his time, had some acquaintance with Spencer's idea of evolution. In these lines on "Leonardo's type of womanly beauty," however, he seems to draw on the terminology and to evoke the claims of Mesmerism or "animal magnetism," a topic of lively interest and controversy in England in the 1830's and 1840's and of continued debate by scientists and medical men through the century. See Fred Kaplan, "'The Mesmeric Mania': The Early Victorians and Animal Magnetism," *Journal of the History of Ideas*, XXXV (1974), 691–702.

91:29–92:1. This would seem to be the red chalk drawing in the Uffizi, no. 141 in Popham, ed., *The Drawings of Leonardo da Vinci*. Vasari, from whom Pater quotes in lines 24–25, gives the young man's name as Salai—*Le vite*, II, pt. 3, 30–31. Kenneth Clark declares that "there was no such painter as Andrea Salaino. The name seems to be due to a confusion between Andrea Solario and Giacomo Salai. The latter was the boy with curly hair who joined Leonardo in 1490 and stayed with him throughout his life"—*The Renaissance*, ed. Clark, p. 116n.

92:9. Melzi died in 1570. See n. to 78:18–19.

92:30–33. See n. to 87:12–14.

93:3–5. Bernardino Luini (circa 1485–1532). See n. to 91:11.

93:10–16. In his comment on the "St. John," Pater is more cautious than Clément, who asks "by what strange fancy has the painter put a cross into the hand of that profane figure?" He adds: "This *St. John* is a woman, no one can mistake it. It is the image of Voluptuousness . . ."—*Michel-Ange, Léonard de Vinci, Raphael*, p. 222. Hippolyte Taine, in a comment Pater might have read, locates the disturbing power of the painting in its suggestion of spiritual sickness or corruption: "This is a woman, a woman's body, or at the very most the body of a handsome ambiguous adolescent, akin to the andro-

gynes of the imperial age, and who, like them, seems to announce an art more advanced, less sane, almost unhealthy, so avid of perfection and insatiable of happiness, that it is not content to put strength into man and delicacy into woman, but, confounding and multiplying, by a strange mixture, the beauty of both sexes, loses itself in the reveries and affectations of the ages of decadence and immorality"—"Léonard de Vinci," *Revue des cours littéraires*, May 27, 1865, p. 431. For Gautier's comment see n. below.

93:21–23. "The *Bacchus* is not by Leonardo, but is perhaps by Cesare da Sesto"—Kenneth Clark's n. in his ed. of *The Renaissance*, p. 118. Originally a "St. John the Baptist in the Desert," this picture, long attributed to Leonardo without foundation, was changed into a Bacchus in the late seventeenth century. Gautier does not mention the "Bacchus." He says that in the "St. John the Baptist," Leonardo "seems to us to have made ill use of that smile; from a background of dark shadows, the figure of the saint half disengages itself; one of his fingers points to heaven; but his expression, effeminized to the point of making his sex doubtful, is so sardonic, so guileful, so full of reticences and mysteries, that he disquiets and inspires one with vague suspicions about his orthodoxy. He looks like one of those fallen gods of Heinrich Heine who, in order to live, have taken employment in the new religion. He points to heaven, but he derides it, and seems to laugh at the credulity of the spectators. As for him, he knows the secret doctrine, and he does not believe at all in the Christ whom he announces; however, he makes the appropriate gesture for the common people and puts the initiates in his confidence by his diabolical smile"—"Léonard de Vinci," in Théophile Gautier, Arsène Houssaye, and Paul de Saint Victor, *Les Dieux et les semidieux de la peinture* (Paris, 1864), pp. 19–20. On Heine's fallen gods, see 24:6–25:12.

94:7–8. "Giuseppe Bossi: über Leonardo da Vincis Abendmahl zu Mailand," Goethe's *Werke*, XLIX, pt. 1, 201–248. Goethe's essay, written in 1817 in the guise of a review of Bossi's book *Del "Cenacolo" di Leonardo da Vinci* (Milan,

1810), "made Leonardo known to the Germans . . ." Ettore Verga, *Bibliografia Vinciana: 1493–1930* (New York, 1931), I, 130–131.

94:8–17. Duchess Beatrice d'Este died in 1497. Pater follows Rio's phrasing closely in his account of these details—*De L'Art chrétien*, III, 105–108.

94:19–24. These anecdotes are told by Matteo Bandello, writing as an eyewitness, in the dedicatory letter preceding novella LVIII in pt. 1 of his collection *Novelle*, first published in 1554. They are retold in many of the books on Leonardo known to Pater—for example, by Rio in *De L'Art chrétien*, III, 72.

94:29–30. To the reason Pater gives here, Clément adds several others: clumsy efforts to restore the picture in 1726, the cutting of a door through part of it, later mistreatment by French and Austrian soldiers, and the use of the room during Napoleon's time for horses and fodder storage—*Michel-Ange, Léonard de Vinci, Raphael*, pp. 205–206.

94:31. Number 280 in the Brera Museum in Milan. Generally regarded in Pater's time as Leonardo's work, this drawing is now judged to be a copy made from Leonardo's fresco by one of his better disciples—*Catalogo della Pinacoteca di Brera in Milano*, ed. Ettore Modigliani (Milan, 1950), p. 63. There is a reproduction of it in Eugène Müntz, *Leonardo da Vinci: Artist, Thinker, and Man of Science* (London and New York, 1898), I, 190.

95:1. Mino da Fiesole (circa 1430–1484), Florentine sculptor whose work includes a share in the monuments of Leonardo Salutati (in the cathedral of Fiesole), Bernardo Giugni (Florence, Badia), the large tomb of Paul II (fragments in the Vatican Grottoes), and other altars, tombs, and reliefs.

95:3–7. Compare the more candidly expressed opinion of Clément: "The Christ of Leonardo is the most handsome of men, but nothing in his person reveals a god. His tender and ineffable countenance reflects the most profound sorrow. He is a merciful master who reveals without anger to his disciples, to his children, that one of them will betray him. He is

great, pathetic, sublime, but he remains human"—*Michel-Ange, Léonard de Vinci, Raphael*, p. 211. Rio, however, insists at some length that the head of Christ is the product of Leonardo's prolonged meditation on the divine and reproaches Goethe for having accorded "much too large a part to naturalism in his appreciation of the diverse elements which have contributed to the production of this masterpiece"—*De L'Art chrétien*, III, 110.

95:7–10. "This work, known as the Cenacolo di Foligno, is now ascribed to Perugino and his assistants"—Kenneth Clark's n. in his ed. of *The Renaissance*, p. 119.

95:11–12. *Le vite*, II, pt. 3, 25.

95:19–22. The dissatisfied Milanese subjects of Ludovico took advantage of his temporary absence to offer the city to Louis XII of France, who had laid claim to it. The French forces entered the city on October 6, 1499. Leonardo's colossal clay model of the horse for the Sforza monument "was used as a target by the French soldiery . . . and eventually, having been moved to Ferrara, crumbled to pieces"—*Oxford Companion to Art.*

95:26–28. Vasari says only that Verrocchio became overheated and then cooled in casting the work and died within a few days in Venice—*Le vite*, I, pt. 2, 1059.

96:4–10. These details are not in Pater's familiar sources for the essay on Leonardo. Since he loved and often visited the north of France, it is likely that he had seen the room "still shown," as he notes, at Loches.

96:16–18. Clément, *Michel-Ange, Léonard de Vinci, Raphael*, pp. 223–224. Vasari says nothing of Leonardo's poverty.

96:20–22. Leonardo left Milan in 1499. According to one recent summary of learned opinion, the authentic Leonardos in the Louvre are a) "The Annunciation" (first attributed to Leonardo in 1893), 1478; b) "La Belle Ferronière," 1490–1495; c) the "Mona Lisa," 1503–1505; d) the black chalk and pastel portrait of Isabella d'Este, 1500; e) "St. John the Baptist," 1513–1516; f) "St. Anne, the Virgin, and the Infant Christ with a Lamb" (with assistants), 1510; and g) "The Vir-

gin with the Young St. John, the Infant Christ, and an Angel" ("The Virgin of the Rocks"), 1483–1486. "The Bacchus," 1511–1515, is said to be a product of Leonardo's workshop— after a lost prototype of the master, perhaps. Many of these pictures are difficult to date, and scholars disagree—*Complete Paintings of Leonardo da Vinci*. Of the three great paintings that Pater seems to have chiefly in mind, the "Mona Lisa," the "St. John," and the "St. Anne," none went directly from Fontainebleau to the Louvre—*ibid.*, pp. 103, 111, 109.

96:23–24. Vasari, *Le vite*, II, pt. 3, 31. "The cartoon 'now in London' (Burlington House) is not the one which drew a crowd in 1500 but another, executed some years earlier"— Kenneth Clark's n. in his ed. of *The Renaissance*, p. 121.

96:30. Giovanni Cimabue (1240–1302) of Florence, whose painting of the Virgin for the Rucellai chapel in the church of Sta Maria Novella was so much admired that in his honor it was carried from his house to the church in a solemn procession, with the sound of trumpets and much festivity—Vasari, *Le vite*, I, pt. 1, 238–239.

96:1. Savonarola's repressive influence on Florentine gaiety was relieved by his death in 1498.

97:1–4. Mona Lisas, draped and undraped, have been painted by the score, but only the one in the Louvre is accepted as a Leonardo. Why Pater speaks of "the latest gossip" is unclear. Rio reported in 1855 the discovery of a portrait of an unknown woman with a striking resemblance to Mona Lisa, "with little modesty in her pose and in her costume . . . unexpectedly discovered among the pictures of the family of Orleans." He added in a note that "the Duke of Orleans, son of the regent, shocked by that indecent nudity, had had it covered over by another painting which it occurred to no one to remove"—*De L'Art chrétien*, III, 94. Clément also mentions this picture which, as he says, "represents a woman half reclining, almost naked, evidently done from nature. It is Mona Lisa . . ."—*Michel-Ange, Léonard de Vinci, Raphael*, p. 219. He notes (p. 373) that it was bought by M. Morreau at the sale of King Louis-Philippe's paintings and was at Lord Ward's residence at the time of his writing in 1861.

97:4. Ginevra di Benci of Florence may have been the sitter for the small "Head of a Woman" in the National Gallery of Art in Washington.

97:10–11. By her husband Tyndareus, the Spartan queen Leda was the mother of Clytemnestra; and by Zeus in the form of a swan, the mother of Helen of Troy and the twins Castor and Pollux. Leonardo painted at least two versions of a "Leda." The paintings have been lost, but his sketches exist of designs for both versions; one of Leda with her right knee on the ground, the other of a standing Leda. A painted copy of the first is in the Munich Gallery. Many copies were made of the second, which seems to have been the final version. Michelet says: "Leda is the appropriate subject of the Renaissance. Vinci, Michelangelo and Correggio have struggled with it, elevating the subject to the sublime idea of the absorption of nature . . ." *Histoire de France* (Paris, 1833–1867), VII, 326.

Pomona was the Roman goddess of fruits and fruit trees. Though Lomazzo in his *Idea del tempio della pittura* (1590) mentions "a laughing Pomona . . . by Leonardo," no trace of the painting has been found. A "Pomona and Vertumnus" once attributed to Leonardo but since 1830 to Francesco Melzi, is in the Berlin Staatliche Museum. A "Modesty and Vanity," formerly attributed to Leonardo but now accepted as the work of Bernardino Luini, is in the Rothschild collection at Pregny. A similar work, perhaps also by Luini, is in the San Diego Art Gallery in California—*Complete Paintings of Leonardo da Vinci*, p. 113.

97:15. Albrecht Dürer (1471–1528), German painter and engraver, whose "Melancolia" is a copper engraving of 1514.

97:23–27. *Le vite*, I, pt. 2, 1056.

97:32–33. *Le vite*, II, pt. 3, 32.

98:4–5. Clément puts the question: "Could the type of the *Saint Anne*, of the *Gioconda*, of the *St. John*, be a spontaneous creation of Leonardo's mind? or could the painter have chanced in nature on that ideal which he had obscurely pursued until then?"—*Michel-Ange, Léonard de Vinci, Raphael*, p. 219.

98:11–13. Vasari transmits the legend—*Le Vite*, II, pt. 3,32.

98:14–16. Vasari reports that Leonardo labored over the painting for four years and then left it unfinished—*ibid*. A rival story that he finished the work in four months had also gained some currency.

98:17–99:16. The mystery and charm of the Mona Lisa had been remarked and celebrated by many writers before Pater. Among the rapturous appreciations which Pater would have read are those of Michelet, *Histoire de France*, VII, XCI; Clément, *Michel-Ange, Léonard de Vinci, Raphael*, p. 221; Théophile Gautier, "Léonard de Vinci," in Gautier, Houssaye, and Saint-Victor, *Les Dieux et les semidieux de la peinture*, pp. 24–25; and Houssaye, *Histoire de Léonard de Vinci*, pp. 332–339. See also the *Journal des Goncourt* (Paris, 1888), I, 317–318 (entry for March 11, 1860). Pater's visionary meditations on Demeter and Persephone (1876), though less ecstatic, are of the same genre—*Greek Studies, Works*, VII, 114–115 and 148–149. Samuel Chew sees the germ of Pater's idea of Lady Lisa in Swinburne's *Rosamond* (1860), scene 1; "Yea, I am found the woman in all tales, / The face caught always in the story's face; / I Helen, holding Paris by the lips, / Smote Hector through the head; I Cressida / So kissed men's mouths that they went sick or mad, / Stung right at brain with me; I Guenevere . . ." *Swinburne* (Boston, 1929), p. 189. Hints of the femme fatale in the complex makeup of Pater's Mona Lisa reveal her kinship with the "Faustine" and "Cleopatra" of Swinburne's *Poems and Ballads* (1866) and probably also with the beautiful, sinful, and vastly experienced women celebrated in certain poems of Gautier (d'Hangest cites "Imperia," "Lacenaire," and "Coeruli Oculi"). But d'Hangest (*Walter Pater*, I, 358, n. 10) finds the most obvious source of his inspiration in Swinburne's prose meditation on Michelangelo's several drawings of a woman "beautiful always beyond desire and cruel beyond words . . . the deadlier Venus incarnate . . . Lamia re-transformed . . . the Persian Amestris . . . Cleopatra . . ." "Notes on Designs of the Old Masters at Florence," *Fortnightly Review*, IV, n.s. (July, 1868), 19–20.

98:20. "Now all these things happened unto them for en-samples: and they are written for our admonition, upon whom the ends of the world are come"—I Corinthians 10:11.

99:10–16. The "old fancy" of the transmigration and re-incarnation of souls and of reminiscence of the experience of former lives; the "modern idea" of evolution. Pater touches on the old fancy many times, from "Diaphanéité" (read at Oxford in 1864) to *Plato and Platonism* (1893). As d'Hangest points out, nineteenth-century literature "had restored the credit of the myth of reminiscence"; he mentions the exam-ples of Wordsworth, Gautier, Baudelaire, and Swinburne, all writers whose work Pater knew; and others could be cited—*Walter Pater*, I, 357, n. 4. But Gautier introduces the idea im-mediately into his discussion of Mona Lisa herself: "The figures of Vinci seem to come from higher spheres to admire themselves in a glass mirror or rather in a mirror of dusky steel where their reflection remains eternally fixed by a secret like that of the daguerreotype. One has seen them before, but not on this earth; in some prior existence perhaps of which they vaguely remind you. How explain in any other way the singular charm, almost magical, which the portrait of Mona Lisa exerts on the least enthusiastic natures!"—"Les Douze dieux de la peinture," *L'Artiste*, IV, n.s. (July 18, 1858), 166. In his essay "On Wordsworth," Pater remarks on the poet's sense of "that mysterious notion of an earlier state of exis-tence, the fancy of the Platonists, the old heresy of Origen" —*Fortnightly Review*, XV, n.s. (April, 1874), 461. For Pater's striking translation in *Plato and Platonism* (1893) of the "old fancy" into the "modern idea," see n. to 155:2–8. Notwith-standing its late date and its wide purview, this passage may be read as an illuminating commentary on Pater's idea of Lady Lisa.

99:28–29. Begun between 1503 and 1505 (but never car-ried beyond the preliminary stages) on the wall of the council chamber of the Florentine republic in the Palazzo Vecchio.

100:1–3. The battle took place at Cascina, on the Arno above Pisa, in July, 1364, when a band of Florentine soldiers

were surprised while bathing by Sir John Hawkwood and his English riders.

100:4. "The remnants of the cartoon [says Vasari's editor] have been lost. Some old engravers cut plates of some groups. [Luigi] Schiavonetti reunited all the pieces known and published a print now somewhat rare . . ." *Le vite*, II, pt. 3, 1396, n. 1. Schiavonetti published his print in 1808. Pater might have seen a reproduction of it in John S. Harford's *Illustrations . . . of the Genius of Michael Angelo Buonarroti* (London, 1857), pl. 10.

100:6. The background of Michelangelo's "Holy Family," in the Uffizi, includes several nude youths in graceful poses.

100:10. Anghiari was a village on the Arno near Florence, where Florentine troops routed those of Filippo Maria Visconti in 1440.

100:11–13. Sketches by Leonardo's hand that may be studies for this work are in the National Museum in Budapest, in the Accademia in Venice, and at Windsor Castle. The few known copies are confined to the central encounter. The composition by Rubens, a copy of a copy, is in the Louvre —*Complete Paintings of Leonardo da Vinci*, p. 107.

100:13–15. Vasari, *Le vite*, II, pt. 3, 33–34.

100:16–19. I have not been able to identify this drawing. Whatever it is, it is no longer regarded as a study for the "Battle of the Standard."

100:20–22. Vasari reports this visit of Raphael to Florence —*Le vite*, II, pt. 3, 153. But his editor notes on the same page that the story is a doubtful one, and Grimm also warns against it—*Leben Michelangelo's*, p. 695, n. 31.

100:28–101:2. Clément proposes that "'Flee from storms,' that motto which one reads at the top of one of his manuscripts, gives the key to his character and his life, and explains what was lacking in him"—*Michel-Ange, Léonard de Vinci, Raphael*, p. 240.

101:4–5. Francis I (1494–1547) was king from 1515. Louis XII (1462–1515) was king from 1498.

101:11–13. Amoretti, *Memorie storiche*, pp. 97–98.

101:16–19. See n. to 77:1–2 for Vasari's somewhat slur-

ring remarks on Leonardo's religion in his first ed. (1550).
Vasari reports that Leonardo died in the arms of the king—*Le
vite*, II, pt. 3, 37. But evidence exists that the king was else-
where, and the story is no longer credited. Leonardo signed
his will on April 23, 1518, and died on May 2, 1519.

101:24–26. "These extreme reversals are not rare among
the indifferent . . ." Clément, *Michel-Ange, Léonard de Vinci,
Raphael*, p. 238. Rio calls Vasari's charge of impiety "that
odious lie" and defends Leonardo's profession of faith as "that
of a Christian who has candidly made his choice about prac-
tices and beliefs . . ." *De L'Art chrétien*, III, 160.

Notes to Canceled Passages

229:7. Arsène Houssaye, *Histoire de Léonard de Vinci* (Paris,
1869). Mrs. Mark Pattison may have been responsible for the
disappearance of this passage in the second and later editions.
In her review of the first edition, she calls Pater "quite mis-
taken" in supposing that Houssaye is a scholar of the order of
Grimm and Passavant: "M. Houssaye's book is a mere ro-
mance of no scientific pretensions whatever"—*Westminster
Review*, XLIII, n.s. (April, 1873), 641. At the same time,
Pater deleted other references to Houssaye (233:21–22, 235:
29–33, and 235:36–37)—but he removed many such refer-
ences in his later editions.

229:10. Herman Friedrich Grimm, *Leben Michelangelo's*
(Hannover, 1860–1863).

229:11. Johann David Passavant, *Rafael von Urbino und sein
Vater Giovanni Santi* (Leipzig, 1839).

230:4. "On the Medusa of Leonardo da Vinci in the Flor-
entine Gallery" (1819).

233:11–19. "In taking the halo off the saints, Leonardo un-
crowns the middle ages. In the *Last Supper*, the guests have
nothing any longer in common with the consecrated types.
These new-style personages announce a Christianity as new
as they are. Only Christ keeps his dying halo on his forehead;
it seems that it is fading at the breath of the coming age. The
mystery vanishes, the light increases. It is the hour when the

spirits evoked by the middle ages grow pale and disappear. In the *Last Supper* the banquet of Plato begins anew"—Edgar Quinet, *Les Révolutions d'Italie*, in *Oeuvres complètes* (Paris, 1857–1870), IV, 351.

233:21–22. Houssaye offered new documentary evidence to show that it was unlikely that the Gascon bowmen had been permitted to destroy Leonardo's model—*Histoire de Léonard de Vinci*, pp. 114–117.

235:30. *Ibid.*, pp. 213–217.

235:36–37. Pater may be alluding to what is in effect a distinct essay, "Les Arts en France sous Léonard de Vinci," *ibid.*, pp. 229–256.

The School of Giorgione

One essay to which no title was given was sent to Macmillan with five others on June 29, 1872. The unnamed essay was printed with the others but then canceled at Pater's request late in October, 1872, and returned to him so that he could "embody parts of it in the Preface"—*Letters of Walter Pater*, ed. Lawrence Evans (Oxford, 1970), p. 8, n. 1. On this evidence, Evans plausibly suggests that the cancelled essay was "a first version of 'The School of Giorgione,' whose extended theoretical passages enlarge on the doctrines of the Preface"—*ibid.* In any case, "The School of Giorgione" appeared five years later in the *Fortnightly Review* for October, 1877, and took its place in *The Renaissance* in 1888.

Pater's chief source of information about Giorgione and his work was "the new Vasari"—his epithet for *A History of Painting in North Italy*, by Crowe and Cavalcaselle, first published in 1871—and no references to later books or articles appear in his essay. That Pater had known something of Giorgione's work earlier is shown by a reference to his "sensuous gift" in the first published version of the "Winckelmann" essay (1867). (This passage was canceled in later editions. See 270:20–26.)

In the Introduction to his edition of *The Renaissance* (New York, 1961), Kenneth Clark calls the Giorgione essay the most original and influential of the whole collection (p. 20), not for its comments on Giorgione and his followers but for its opening pages of criticism: "To suggest that the basic beauty of a picture was like 'a space of fallen light, caught as in the colours of an Eastern carpet,' and that its value increased insofar as it aspired towards the condition of music, was to go beyond even the most adventurous critics of the next generation . . . We ask if Pater, with his keen sense of tradition, could really have invented such a revolutionary doctrine; and the answer is, I think, that he did" (pp. 21–22). Clark glances at the adumbration of similar ideas in Ruskin, Gautier, and Baudelaire but finds them random and undeveloped: "None of the critics come to the point which Pater saw so clearly . . ." (pp. 22–23).

The essay on Giorgione is regarded by Richard L. Stein as "the theoretical center of the argument implicit throughout *The Renaissance* that the fine arts should receive no ideological interpretation"—*The Ritual of Interpretation* (Cambridge, Mass., and London, 1975), p. 222. By insisting throughout his essay on the strictly artistic interests and traditions of the Venetian painters, Pater sets his own aesthetic view against the moral one of Ruskin, who had attacked "the pestilent art of the Renaissance" on moral grounds in *The Stones of Venice* (1851–1853) and other writings.

102:16. Arnold's phrase: "The poetry of later paganism lived by the senses and understanding; the poetry of medieval Christianity lived by the heart and imagination. But the main element of the modern spirit's life is neither the senses and understanding, nor the heart and imagination; it is the imaginative reason. And there is a century in Greek life,—the century preceding the Peloponnesian war, from about the year 530 to the year 430 B.C.,—in which poetry made, it seems to me, the noblest, the most successful effort she has ever made as the priestess of the imaginative reason, of the element by which the modern spirit, if it would live right, has

chiefly to live"—"Pagan and Medieval Religious Sentiment" (1864), *Complete Prose Works*, ed. Super (Ann Arbor, 1960–1977), III, 230–231.

Undoubtedly Pater knew Arnold's use of the phrase; and his own definitions of it, both here and at 108:30–109:8, take the same form as Arnold's: not *a*, not *b*, but *c* is the "complex faculty" to which art is addressed. But as Arnold's *a* and *b* are not the same as Pater's simpler "sense" and "intellect," the extent to which the two writers would have agreed on the meaning of *c* remains uncertain. D'Hangest, while he does not doubt that Pater took the phrase from Arnold, believes that to explain the concept as Pater understood it one is required to go back to Kant. He gives his reasons in a credible note, though without reference to any particular passage in Kant—*Walter Pater: L'Homme et l'oeuvre* (Paris, 1961), I, 350, n. 24.

The same phrase appears three years earlier in Pater's essay on Wordsworth, of whom he remarks: "Of all great poets, perhaps he would gain most by a skillfully made anthology. Such a selection would show perhaps not so much what he was, or to himself or others seemed to be, as what by the more energetic and fertile tendency in his writings he was ever tending to become; is therefore, to the imaginative reason"—*Fortnightly Review*, XV, n.s. (April, 1874), 455. Much later he employs the phrase to translate Plato's word θεωρία—*Plato and Platonism*, *Works* (London, 1910), VI, 140 (see also 146, 190). The similar phrase "imaginative intellect" appears as early as 1867 in "Winckelmann" (see 169:15 and 170:29–30). For "things of the intellect and the imagination," see Pater's Preface, xxiii:22–23 and xxiv:32.

103:11. Gotthold Ephraim Lessing (1729–1781) published his treatise *Laokoon oder über die Grenzen der Malerei und Poesie* in 1766.

103:24–104:32. The position outlined here is in close accord with that of Baudelaire in certain pages of his essay on Delacroix: "To speak exactly, there is in nature neither line nor color. It is man who creates line and color . . . Both line

and color make us think and dream; the pleasures which derive from them are of a different but perfectly equal nature, and they are absolutely independent of the subject of the picture"—"L'Oeuvre et la vie d'Eugène Delacroix" (1863), collected in *L'Art romantique* (1868), *Oeuvres complètes*, ed. Jacques Crépet (Paris, 1930–1953), III, 15. Of course Pater was familiar with Hegel's discussion of the question of "poetry" in art—*Aesthetik*, ed. H. G. Hotho, 2d ed. (Berlin, 1842), I, 204ff. (trans. Knox, I, 162ff.).

104:4. This painting is now attributed to Sofonisba Anguissola or Anguisciola (1528–1625) of Cremona. In Pater's time it was listed by Crowe and Cavalcaselle among "Uncertified Titians" and described thus: "No. 228 in the Manchester Exhibition of 1857, the property of Mr. Richard Baxter: A canvas with the figure of a girl turned to the left, a little dog at her side, on her lap a lace cushion. Work of some painter of a later time than that of Titian"—*Titian: His Life and Times* (London, 1877), II, 465. It was exhibited not only at Manchester, but again at the British Institution of 1862 and at Burlington House in London in 1873. Thus Pater could easily have seen it while writing his essay on Giorgione.

On Baxter's death, his collection was offered for sale in London in January, 1881. The picture in question, listed in the sale catalog as "The Lace-maker" and attributed to Titian, remained unsold and was returned to the executors of Baxter's estate. Since then it has passed through several collections. It is owned at present by Signor Pietro Scarpa of Venice. The French art critic Théophile Thoré (pseud. W. Bürger), who saw it at Manchester, questioned its attribution to Titian and called the painting "very labored, denuded, despoiled"—*Trésors d'art en Angleterre*, 3d ed. (Paris, 1865), p. 83. Though he added "there are virtues nevertheless in the tone and modeling of the flesh," the difference between his impression and Pater's is bemusing.

104:7. Jacopo Robusti Tintoretto (1518–1594), Venetian painter.

104:10. Sir Peter Paul Rubens (1577–1640), whose first

"Descent from the Cross" is in Antwerp Cathedral; but he also painted a number of variants for other churches of the district.

104:15–22. For Kenneth Clark's comment on this passage, see my headnote to "The School of Giorgione."

104:28–29. Titian's "Bacchus and Ariadne" (1518–1523) is in the National Gallery in London.

104:31–32. Titian's "Presentation of the Virgin" (1534–1538) is in the Accademia in Venice.

105:7–8. Neither Goethe nor Hegel uses the term, and I have not been able to find it in the vocabulary of any other German writers. Both Goethe and Hegel are familiar with the idea outlined in 105:5–11. "The arts themselves," says Goethe, "as well as their varieties, are related to one another, they have a certain proneness to join one another, indeed to lose themselves in one another . . . It has been noticed that all plastic art strives [*strebe*] toward painting, all poetry toward drama . . ." But unlike Pater, he considers the tendency pernicious: "One of the best signs of the decline of art is the mingling of the different kinds"—"Einleitung in die *Propyläen*," *Werke* (Weimar, 1887–1912), XLVII, 22. For relevant passages in Hegel, see n. to 106:4.

105:9–11. Pater translates from Baudelaire's essay "L'Oeuvre et la vie d'Eugène Delacroix," which first appeared in *L'Opinion nationale*, Sept. 2 and 14, Nov. 22, 1863: "C'est . . . un des diagnostics de l'état spirituel de notre siècle que les arts aspirent, *sinon à se suppléer l'un l'autre, du moins à se prêter réciproquement des forces nouvelles*"—*L'Art romantique* (1868) in *Oeuvres complètes*, III, 5 (my italics). This verbal transcription, noted by Germain d'Hangest, is the earliest direct evidence in Pater's work of his acquaintance with Baudelaire, whose extraordinarily fecund views on art, d'Hangest goes on to say, "are found in that period at the end of all perspectives; and . . . overwhelmingly dominate the esthetic developments of the second half of the century. We think, for our part, that Pater's thought on art received from Hegel and from him [Baudelaire] its two major impulses"—*Walter Pater*, I, 349, n. 8.

Pater does not mention Baudelaire's name until 1876, in his essay "Romanticism"—later retitled "Postscript" and included in *Appreciations* (1889). D'Hangest points out that "the notion of 'insurmountable limits' proper to each mode of expression was formulated explicitly by Wagner, who erects upon it his whole system of a collaboration among the different arts within a single work" (*ibid.*). Baudelaire quotes the passage from Wagner's *Lettre sur la musique* (1860) in "Richard Wagner et *Tannhäuser* à Paris" (1861), collected in *L'Art romantique*, *Oeuvres complètes*, III, 213–214. See n. to 109:9–18.

105:17. The Scrovegni or Arena Chapel at Padua. The frescoes on the walls, painted by Giotto in 1305–1308, show the lives of the Virgin and Christ in three tiers of scenes.

105:18. The bell tower of the cathedral of Florence.

106:4. This famous pronouncement is not a translation of Hegel, and Hegel never quite makes Pater's point. The point might easily have been suggested nonetheless by some passages in the *Aesthetik*, as where Hegel declares that "the keynote of romantic art is musical . . ." (II, 134, trans. Knox, I, 528) or where he proposes that "precisely as sculpture in the further development of reliefs begins to approach painting, so painting in the pure *sfumato* [gradation, shading] and magic of its tones of colour and their contrast, and the fusion and play of their harmony, begins to swing over to music"—III, 81 (trans. Knox, II, 853).

106:4–17. Compare Schiller: "In a truly beautiful work of art the content should do nothing, the form everything; for the wholeness of Man is affected by the form alone, and only individual powers by the content. However sublime and comprehensive it may be, the content always has a restrictive action upon the spirit, and only from the form is true aesthetic freedom to be expected. Therefore, the real artistic secret of the master consists in his *annihilating the material by means of the form* . . ." *Briefe über die ästhetische Erziehung des Menschen* (1795), *Sämmtliche Werke* (Stuttgart, 1862), XII, 78–79 (trans. Snell, p. 106).

Even before his "Giorgione" was published, Pater had written that in Wordsworth, "when the really poetical motive

worked at all, it united with absolute justice the word and the idea, each in the imaginative flame becoming inseparably one with the other, by that fusion of matter and form which is the characteristic of the highest poetical expression. His words are themselves thought and feeling; not eloquent or musical words merely, but that sort of creative language which carries the reality of what it depicts directly to the consciousness"—"On Wordsworth," *Fortnightly Review*, XV, n.s. (April, 1874), 463. Later, comparing music and literature, Pater restated his doctrine in his essay "Style" (1888): "If music be the ideal of all art whatever, precisely because in music it is impossible to distinguish the form from the substance or matter, the subject from the expression, then, literature, by finding its specific excellence in the absolute correspondence of the term to its import, will be but fulfilling the condition of all artistic quality in things everywhere, of all good art"—*Appreciations*, *Works*, V, 37–38.

106:19–22. Though Pater does not mention the windy look of this landscape, the etching is probably "Le Coup de Vent," listed as no. 110 in A.-P. Malassis and A.-W. Thibaudeau, *Catalogue raisonné de l'oeuvre gravé et lithographié de M. Alphonse Legros, 1855–1877* (Paris, 1877), and described thus: "Road rising through a wasteland; at left, cluster of trees, one broken in the middle, and bushes shaken by a violent wind which strips them of their leaves; rain in the sky . . ." (p. 71). A good reproduction, though reduced in size, is included in Malassis, *Monsieur Alphonse Legros au salon de 1875: Note critique et biographique ornée de trois gravures du maître* (Paris and London, 1875). Alphonse Legros (1837–1911), the French painter, etcher, and medalist, lived in London from 1863 until he died. He was professor of etching at the Slade School, 1876–1892.

107:6–13. Pater appears to have taken this opinion from Ruskin's discussion of Turner's paintings of French and Swiss landscapes, *Modern Painters*, I (1843), in *Works of John Ruskin*, ed. Cook and Wedderburn (London, 1903–1912), III, 237–238.

108.14.

> Take, o take those lips away
> That so sweetly were forsworn,
> And those eyes, the break of day
> Lights that do mislead the morn:
> But my kisses bring again,
> bring again;
> Seals of love, but seal'd in vain,
> seal'd in vain.
> —act IV, scene 1

In his essay on *Measure for Measure* (1874) Pater speaks of "the moated grange, with its dejected mistress, its long, listless, discontented days, where we hear only the voice of a boy broken off suddenly in the midst of one of the loveliest songs of Shakspere, or of Shakspere's school . . ." *Appreciations, Works*, V, 176.

109:5–6. See 102:16 and n.

109:9–18. Wagner had announced similar if not quite identical doctrines in his *Lettre sur la musique*, quoted with admiration by Baudelaire: "The rhythmic arrangement and the ornamentation (almost musical) of the rhyme are for the poet the means of assuring to the verse, to the phrase, a power which captivates as by a charm and governs the feelings at will. Essential to the poet, this tendency leads him to the limit of his art, a limit which touches immediately on music, and consequently the most complete work of the poet should be the one which, in its final achievement, would be a perfect music"—"Richard Wagner et *Tannhäuser* à Paris" (1861), collected in *L'Art romantique* (1868), *Oeuvres complètes*, III, 217. In his essay "Style" (1888), Pater, without any compromise in the severity of his idea of music as "the true type or measure of perfected art" (109:17–18), seeks through a more exact analysis of verbal composition to define the "specific excellence" of literature—*Appreciations, Works*, V, 37–38.

109:20–21. See 102:16 and n.

110:7–30. In this outline of the tradition of Venetian paint-

ing before Giorgione, Pater stresses the dominance of artistic considerations and the exclusion of sentimental, moral, philosophical, religious, or scientific ones. No doubt Pater is deliberately opposing here the notion of "Christian art" so widely promulgated by Rio, Lord Lindsay, and Ruskin. See n. to xxii:28.

110:10–11. The basilica of SS. Maria e Donato is the most important and beautiful building of the island of Murano (a section of the municipality of Venice north of the city). St. Mark's is the cathedral of Venice.

110:20–21. The Bellini include Jacopo (circa 1400–1470), a noted painter and draftsman, and his two sons Gentile (circa 1429–1507) and Giovanni (1430/40–1516), the most famous and influential painters of Venice in their day. Vittore Carpaccio (circa 1460–1525/6) came under the influence of Gentile Bellini in his youth.

111:30. Giorgione's dates are given by the *Oxford Companion to Art* as 1475–1510, Titian's as 1487–1576.

112:1. Browning's long poem *Sordello*, first published in 1840, was reprinted in 1863 and 1868. See the lines addressed to Dante, bk. I, 345–373; see also bk. VI, 828–835.

112:9–10. Sordello's "one fragment of lovely verse" was this:

> Take Elys, there,
> —Her head that's sharp and perfect like a pear,
> So close and smooth are laid the few fine locks
> Coloured like honey oozed from topmost rocks
> Sun-blanched the livelong summer.
> —Browning, *Sordello*, bk. II, lines 151–155

These lines are partly quoted again in bk. V, 905–909, and in bk. VI, 867–869. The historical Sordello (circa 1200–before 1269), the first Italian troubadour, left 1,325 lines of a didactic poem and 42 lyrical pieces.

112:24–25. Pater means "The Concert." But see n. to 113:19–114:2.

112:32–113:2. Giorgione painted his frescoes on the facade of the "fondaco dei Tedeschi," the warehouse of the

German merchants near the bridge of the Rialto, about 1507. "They appear to have represented mythological figures, but even in his own time the subject was uncertain"—*The Oxford Companion to Art*. The ruined state of these frescoes is discussed by Crowe and Cavalcaselle, *A History of Painting in North Italy* (London, 1871), II, 140–143.

113:2–10. *Ibid.*, 120–121.

113:10. An earlier work by the same authors had been so described in print: "Their book is in short a new Vasari . . ." A. Wilson, "Correspondance de Londres," *Gazette des beaux arts*, XXIV (May, 1868), 504. Of the *History of Painting in North Italy*, Kenneth Clark remarks that "the chapter on Giorgione is one of the least satisfactory parts of the book, and the authors' conclusions are now almost all rejected"—*The Renaissance*, ed. Clark, p. 136n.

113:19–114:2. "'The Concert' is now generally accepted as the work of Titian"—Kenneth Clark in his ed. of *The Renaissance*, p. 136n. Pater, of course, follows Crowe and Cavalcaselle, who observe that this painting, "which has not its equal in any period of Giorgione's practise gives a just measure of his skill, and explains his celebrity"—*History of Painting in North Italy*, II, 144.

114:3–7. Pater takes the word "distinction"—which he uses here and later (115:14) of certain qualities in Giorgione's painting—from Crowe and Cavalcaselle: "It is perhaps to his early intercourse with aristocratic company that he owed the peculiar breadth of distinction which we find in all his impersonations . . ." *ibid.*, 123.

114:8–11. *Ibid.*, 147.

114:19. "For a Venetian Pastoral by Giorgione (In the Louvre)," published in *The Germ* (1850) and again as below, much revised, in *Poems* (1870).

> Water, for anguish of the solstice:—nay,
> But dip the vessel slowly,—nay, but lean
> And hark how at its verge the wave sighs in
> Reluctant. Hush! Beyond all depth away
> The heat lies silent at the brink of day:

Now the hand trails upon the viol-string
That sobs, and the brown faces cease to sing,
Sad with the whole of pleasure. Whither stray
Her eyes now, from whose mouth the slim pipes creep
And leave it pouting, while the shadowed grass
Is cool against her naked side? Let be:—
Say nothing now unto her lest she weep,
Nor name this ever. Be it as it was,—
Life touching lips with Immortality.

114:21–32. A modern editor reports that "Fête Cham-pêtre" is now generally attributed to Titian.—*L'opera completa di Tiziano*, ed. Francesco Valcanover (Milan, 1969), p. 93. Kenneth Clark notes that "modern critical opinion assigns the pictures as follows: *Fête Champêtre* probably Giorgione, pos-sibly Titian; *Tempest* possibly Giorgione completed by Palma Vecchio and a piece added by Paris Bordone; *Knight embracing a Lady* by Romanino; *Jacob meeting Rachel* by Palma Vecchio; *The Finding of Moses* by Giorgione; *The Ordeal of Moses* school of Giorgione"—*The Renaissance*, ed. Clark, p. 137n. Crowe and Cavalcaselle make their attributions in *A History of Paint-ing in North Italy*, II, on the following pages: "Fête Cham-pêtre," 147; "The Tempest," 151; "Knight Embracing a Lady," 166; "Jacob Meeting Rachel," 149. For the last two pictures mentioned by Clark, see n. below.

114:30–32. Oddly, Pater seems to have misunderstood Crowe and Cavalcaselle, who in a long paragraph of de-scription with some conjectures as to Giovanni Bellini's in-fluence nonetheless attribute the "Ordeal of Moses" (in the Uffizi at Florence) to Giorgione—*ibid.*, 125–126. "The Find-ing of Moses" (in the Pitti Palace at Florence) they call "a recognized Bonifazio"—*ibid.*, 163.

115:5–116:11. Pater takes the biographical details of this paragraph from Crowe and Cavalcaselle.

115:15–19. Catarina Cornaro (1454–1510) through her marriage to James de Lusignan became Queen of Cyprus in 1472 and ruled until 1489, when the government of Venice annexed the island and forced her abdication. At the same

time Venice conferred upon her the castle and town of Asolo, where she lived out her years in the midst of a brilliant little court of which Cardinal Bembo was the brightest light. Giorgione's portrait of Queen Catarina, seen by Vasari in Venice (*Le vite*, II, pt. 3, 48), has disappeared. Crowe and Cavalcaselle say only that Queen Catarina—but not Tuzio or Matteo—sat for Giorgione. A portrait bearing the name of the sitter, "Mattheus Constantius," and dated 1510 (though he died in 1504) is in a private collection in New York. Some scholars have assigned it to Giorgione, but others disagree.

115:20–28. Matteo Costanzo died in 1504. "The altarpiece hangs in the choir of the new church," say Crowe and Cavalcaselle, "the original chapel in which it was painted having been razed." It shows the Virgin and Child on a high throne between St. Liberale and St. Francis. "The Warrior-Saint" in the National Gallery in London is perhaps a copy by a student of the figure in the Castelfranco altarpiece, rather than (as Crowe and Cavalcaselle assert—and Pater assumes, following them) an original study by Giorgione for the altarpiece. Some have thought the warrior-saint to be a portrait of Matteo—Crowe and Cavalcaselle, *History of Painting in North Italy*, II, 129–133.

115:32–116:4. *Le vite*, II, pt. 3, 43, 48.

116:4–11. Vasari says Giorgione died of the plague—*Le vite*, II, pt. 3, 48–49. In 1648 Carlo Ridolfi reported both versions (that of Vasari and the story that he died of grief), without deciding between them—*Le Maraviglie dell' arte*, 2d ed. (Padua, 1835), I, 137. The 1848 edition of *Le vite* has an editorial note erroneously assigning one account to Vasari and the other to Ridolfi—II, pt. 3, 49. Crowe and Cavalcaselle also transmit this error—*History of Painting in North Italy*, II, 156.

117:26. "It is among the works of Giorgione and Titian that we first find in Venice what the Renaissance called painted 'poesies' and idylls; that is, pictures of an allusive and poetic bent, in which we detect a love of beauty for its own sake and an a priori wish to charm and fascinate"—Charles Ricketts, *Titian* (London, 1910), p. 6.

118:6–10. Vasari tells of Giorgione's painting a nude figure, all sides of which were displayed simultaneously through the device of reflections in a mirror, in still water, and in polished armor. He desired to prove in this way, says Vasari, that painting was superior to sculpture—*Le vite*, II, pt. 3, 48. The picture is not known.

118:12–13. I do not find the quoted phrase exactly.

118:13–21. Pater seems to have Browning's poetry in mind. See 171:10–32.

119:5–18. Crowe and Cavalcaselle mention a large number of pictures by Giorgione's disciples and imitators; many of these, as they point out, portray figures singing, playing, or listening to music—*History of Painting in North Italy*, II, 157–169.

119:11–12. The students of harmony, says Glaucon, "are absurd enough, with their talk of 'groups of quarter-tones' and all the rest of it. They lay their ears to the instrument as if they were trying to overhear the conversation from next door"—*Republic* 531A, bk. VII (trans. Cornford, p. 250).

119:22. Matteo Bandello (1480?–1562), whose stories (*Novelle*) were published in four vols. 1554–1573.

120:7–18. Pater's reflections on this picture must be colored by his memory of Rossetti's sonnet "For a Venetian Pastoral by Giorgione (In the Louvre)." See 114:19 and n. He expressed a similar thought in print even before the "Giorgione": "And who that has ever felt the heat of a southern country does not know this poetry [of water], the motive of the loveliest of all the works attributed to Giorgione, the *Fête Champêtre* in the Louvre; the intense sensations, the subtle and far-reaching symbolisms, which, in these places, cling about the touch and sound and sight of it?"—"A Study of Dionysus," *Fortnightly Review*, XX, n.s. (December, 1876), 761.

121:7–8. "This picture in the Dresden Gallery is by Palma Vecchio."—Kenneth Clark in his ed. of *The Renaissance*, p. 143n.

Note on Canceled Passage

242:5–7. Pater refers here to a detail of the "Fête Champêtre" in the Louvre.

Joachim Du Bellay

This essay may have been the paper "not . . . published hitherto," sent to the publisher Alexander Macmillan on June 29, 1872, along with five other essays which had appeared in print before. Whether it was or not, at least one touch appears to have been added as late as November: the borrowing from Andrew Lang's article on Léon Gautier's edition of *La Chanson de Roland* (see 125:1–3 and n.). In his review of *The Renaissance*, J. A. Symonds found a similarity between Pater and two contemporary French writers whose work—whether or not Symonds knew it—had been important to Pater: "Of Mr. Pater's two French studies, that on Du Bellay, in whom he sees 'the subtle and delicate sweetness which belong to a refined and comely decadence,' is perhaps the more interesting. Like Théophile Gautier and like Baudelaire, Mr. Pater has a sympathetic feeling for the beauty of autumn and decay"—*Academy*, IV (March 15, 1873), p. 104. Other reviewers made no significant comments on the essay.

123:10–11. Gaillon was the ancient château of the archbishops of Rouen. One of the first monuments of the French Renaissance, it was rebuilt in the first decade of the sixteenth century for Cardinal Georges d'Amboise. In the early nineteenth century it was largely demolished. Chenonceaux, Blois, Chambord, and other great châteaux of the Loire region were also built in the early sixteenth century on medieval foundations or ground plans.

123:12. Israel Silvestre (1621–1691), designer and engraver to the king in the time of Louis XIV. His work consists chiefly of landscapes and architectural views.

123:15–16. Giovanni Battista Rosso Fiorentino (1494–1540), called Maître Roux, "was brought to France in 1530 by Francis I, and with [Francesco] Primaticcio at Fontainebleau became one of the founders of French mannerism . . . Rosso's main work at Fontainebleau was the decoration of the Galerie François I in the Italian style . . ." *The Oxford Companion to Art.* The school of Fontainebleau, which carried out its work between 1528 and 1558, included also Niccolo dell' Abate (circa 1512–1571) and Jean Cousin the elder (circa 1490–1560).

123:26–27. The cathedral of St.-Julien at Le Mans in the province of Maine has stained glass windows of the twelfth and thirteenth centuries. The cathedral of Chartres still has many of its thirteenth-century windows.

124:8. Pierre de Ronsard (1524–1585), of whose poems Pater speaks later in this essay.

124:11–12. The house of Jacques Coeur at Bourges has a central courtyard with galleries and projecting stair turrets, rectangular windows asymmetrically disposed on the various floors, and high dormer windows rising against steeply pitched roofs. The Maison de Justice at Rouen (1508–1509), badly damaged in World War II, is in the flamboyant style.

124:17–19. François Clouet (before 1510–1572), a portrait painter to whom are also attributed several genre scenes incorporating nude female figures of the type of the Fontainebleau school. His father, Jean Clouet (circa 1485–1541), often called Janet, was also a portrait painter of some repute.

124:22–23. Hans, usually known as Memling or Memlinc (1430/35–1494), painter of Bruges. The brothers Hubert (d. 1426) and Jan (active 1422–1441) Van Eyck were founders of the Flemish school of painting.

124:27. François Villon (1431–after 1463), perhaps the greatest French lyric poet. Anne of Brittany (1476–1514) was married successively to Charles VIII (1491–1498) and to Louis XII (1499–1514) of France. Her illustrated and illuminated "Book of Hours," of about 1508, is a masterpiece of French miniature painting. The artist was Jehan Bourdichon (circa 1457–1521). A chromolithographed reproduction of the

manuscript was available in Pater's time: *Le Livre d'heures de la reine Anne de Bretagne, traduit du Latin et accompagné de notices inédites par M. L'Abbé Delaunay* (Paris, 1841), 2 vols.

124:30. Old French epic tales in verse, dealing with history and legend.

125:1. Folgoat or Le Folgoët, a tiny village near Brest. Its fifteenth-century church has a remarkable granite rood loft.

125:1–3. Pater refers to a passage toward the end of *The Song of Roland* (the most famous and probably the oldest of the Old French epics now extant), in which the archbishop Turpin has died of his wounds and the dying Roland settles his body:

Desur sun piz, entre les dous foucheles,
Cruisiées ad ses blanches mains, les beles
Forment le pleint à la lei de sa tere . . .
 —*La Chanson de Roland*, ed. Léon Gautier
 (Tours, 1872), lines 2249–2251.

(Between his two arm-pits, upon his breast, / Crossways he folds those hands so white and fair, / Then mourns aloud, as was the custom there . . . trans. Scott-Moncrieff, p. 73.)

The passage had been singled out earlier by Pater's friend Andrew Lang in his article on Léon Gautier's edition of the poem. Lang had written: "The bishop crosses his hands, 'ses beles mains les blanches,' his fair white hands, that shine out in the rough poem like a delicate *fleur de Paradis* from hewn Gothic work"—*Westminster Review*, C (July, 1873), 20. Although Lang's article was published later than Pater's essay (which appeared in *The Renaissance* in February, 1873), Pater had read it in manuscript the preceding November—*Letters of Walter Pater*, ed. Lawrence Evans (Oxford, 1970), p. 11.

125:11. François Rabelais (1494?–circa 1553), French humorist and satirist whose best-known work was the collection of chiefly narrative writings known as *Gargantua and Pantagruel*, composed and published at intervals between 1532 and 1552. The "rougher element" in Rabelais, the element that, as Pater says, was softened or offset by Ronsard's coun-

tervailing influence, is conspicuous in "the passages of gross indecency, the physiological and medical obscenities that (especially in the first two Books) offend the modern reader . . ." so quaintly says *The Oxford Companion to French Literature* (1959).

125:31–33. This book by Pater's friend Mrs. Mark Pattison, later Lady Dilke, was published in London in two volumes in 1879.

126:3. The Greek lyric poet Pindar lived about 522–443 B.C. Strictly speaking, a Pindaric ode is an ode consisting of a strophe and an antistrophe of similar structure and an epode of contrasting structure. Pater immediately explains his use of the term.

126:9–20. The two stanzas given by Pater are the sixth and seventh of the thirteen that make up the poem entitled "Avril" from "La Première Jour de la bergerie," *Oeuvres poétiques de Remy Belleau*, ed. Charles Marty-Laveaux (Paris, 1878), I, 201–203. Andrew Lang translates the stanzas as follows:

> April, with thy gracious wiles,
> Like the smiles,
> Smiles of Venus; and thy breath
> Like her breath, the Gods' delight,
> (From their height
> They take the happy air beneath;)
>
> It is thou that, of thy grace
> From their place
> In the far-off isles dost bring
> Swallows over earth and sea,
> Glad to be
> Messengers of thee, and Spring.
> —Lang, p. 21.

Sainte-Beuve quotes the whole poem as an "attractive piece" of the school of Ronsard and remarks: "It is enough to glance at this sparkling little picture to feel what a new and modern polish the reform of Ronsard had spread over the language of

poetry"—*Tableau de la poésie française au XVI^e siècle* (Paris, 1876), I, 160. Sainte-Beuve's *Tableau* was first published in 1828 and was several times reprinted.

126:31. In astronomy, the Pleiades or Pleiad is a loose cluster of many hundreds of stars, six of which are visible to ordinary sight, in the constellation Taurus.

127:9–10. First published in Paris in 1549 and often reprinted. My references in the notes below are to the *Oeuvres françoises de Ioachim Du Bellay, gentil-homme angevin, avec une notice biographique et des notes par Charles Marty-Laveaux* (Paris, 1866), 2 vols.

127:28–31. "Anciens Poètes français: Joachim Du Bellay," *Revue des deux mondes*, XXIV (October 15, 1840), 170.

128:13–14. "La Deffence et illustration de la langue françoise," bk. I, ch. 9, in *Oeuvres françoises*, I, 18.

128:16–24. *Ibid.*, ch. 10, I, 25.

128:23–24. "Volito vivos per ora virum"—Quintus Ennius (239–169 B.C.), the Roman epic poet, as quoted by Cicero, *Tusculan Disputations*, bk. I, ch. 15, sect. 34.

128:24–29. "La Deffence . . ." bk. I, ch. 1, *Oeuvres françoises*, I, 5–6. Pater seems to quote the passage approvingly, whereas Sainte-Beuve in the second installment of his review of Marty-Laveaux's edition of du Bellay (a review that Pater had read) makes an objection to it: "One sees the error; it is already the doctrine of rationalism applied to languages. Deeming them all of the same value at the origin, he attributes all the difference to industry and culture . . . It is precisely the contrary which is true historically: languages were born *like plants and grasses*, with all sorts of differences, and the human fancy which plays upon them can draw from them, in the final analysis, only what they permit and what they contain" —*Journal des savants*, June, 1867, p. 348.

128:29–129:3. "La Deffence . . ." bk. I, ch. 1, *Oeuvres françoises*, I, 6. Pater gives these words as if they followed immediately on those translated in lines 24–29, but in the French original three sentences intervene.

129:4–6. Du Bellay's translation of the fourth book of the *Aeneid* was published in 1552 with other translations and

some occasional poems. His translation of the sixth book was added to this collection, which, thus augmented, appeared in 1560 and several times thereafter.

129:8–9. "La Deffence . . ." bk. I, ch. 9, *Oeuvres françoises*, I, 19. Du Bellay is quoting Quintilian, *Institutio oratoria*, I, v, 70.

129:10–25. "La Deffence . . ." bk. I, ch. 5, *Oeuvres françoises*, I, 13.

129:28–29. *Ibid.*, 14.

130:6–7. *Ibid.*, ch. 11, I, 29.

130:7–9. Unlike the ancient languages, says du Bellay, the French language "is still beginning to flower without yet becoming fruitful; or rather, like a plant and small shoot, has not yet flowered, still less borne all the fruit that it might well produce"—*ibid.*, ch. 3, I, 9.

130:12–13. Speaking of the kinds of poems French poets ought to choose to read and write, du Bellay says (along with much more): "Sing me those odes, unknown as yet of the French muse, on a lute well accorded to the sound of the Greek and Roman lyre, and let there be no line wherein appeareth not some vestige of rare and ancient erudition. And for this, matter will be furnished thee by the praises of the gods and virtuous men, the immutable order of earthly things, the solicitudes of young men such as love, flowing wine, and good cheer"—*ibid.*, bk. II, ch. 4, I, 39 (trans. Turquet, p. 72). Pater mistranslates the Latinism "discours," by which du Bellay meant simply "cours," to which the prefix *dis* adds "an idea of space, of dispersion"—Henri Chamard in his ed. of "La Deffence . . ." (Paris, 1904), p. 210.

130:15–16. "La Deffence . . ." bk. I, ch. 9, *Oeuvres françoises*, I, 19. But du Bellay applies the phrase to Greek and to its Roman imitators, not to the French of his time: "I do not wish to allege in this place (though I could do so without shame) the simplicity of our ancestors who were content to express their ideas with bare words without art or ornament, not imitating the curious diligence of the Greeks to whom the muse had given a rounded mouth (as someone said), that is to say, perfect in all elegance and beauty of words, as afterwards

CRITICAL AND EXPLANATORY NOTES

she gave to the Romans, imitators of the Greeks. But I will indeed say that our language is not so irregular as some would declare . . ." (The expression "a rounded mouth" is taken from Horace, *Ars poetica*, 323–324.)

130:17–131:27. The biographical details in this paragraph are taken from Marty-Laveaux's "Notice biographique," *Oeuvres françoises*, I, ix–xxxi. Du Bellay's dates are 1522 (not 1525) to 1560.

130:17–19. The French forces were defeated at Pavia by those of Emperor Charles V. Francis was taken prisoner, sent to Madrid, and forced to sign a treaty in which he gave up his suzerainty over Flanders, Artois, and Tournai, renounced his claims to Milan, Naples, Genoa, and Asti; ceded the duchy of Burgundy to Charles V, and agreed to restore the Duc de Bourbon to his lands and titles.

130:20. See n. to 138:28–30, where the sonnet from which Pater takes this phrase is quoted in full.

130:25–131:2. Pater translates from Charles Marty-Laveaux's French, which is in turn a translation from du Bellay's long Latin elegy addressed in the last years of his life to Jean Morel d'Embrun. The autobiographical part of the Latin text is in Marty-Laveaux's *Oeuvres françoises de Ioachim Du Bellay*, I, xxxiii–xxxv. Marty-Laveaux's translation appears in his "Notice biographique," I, x–xi. Down to line 16, translating or summarizing, Pater follows du Bellay rather closely.

131:3–11. A loose translation-cum-summary of the remarks of Marty-Laveaux, *ibid.*, I, xi.

131:15–16. Jean du Bellay (circa 1492–1560), French cardinal and diplomat, one of the chief counselors to King Francis I and a generous protector of humanists and reformers. Not only Joachim du Bellay (his cousin), but other men of letters, including Rabelais, Etienne Dolet, and the Latin poet Salmon Macrin, were indebted to him for assistance. He himself wrote three books of Latin poems, printed in 1546, and a defense of Francis I (1542).

132:12–16. Mary Stuart (1542–1587), Queen of Scots, was brought up (1548–1558) at the French court. She was queen consort of France during the short reign of her husband

403

Francis II (1559–1560) and Queen of Scotland from 1560. From the time of her flight to England in 1568 until her execution in 1587 she lived in various houses and castles in England as a prisoner of Queen Elizabeth's government. According to Ronsard's editor, Prosper Blanchemain, "the beautiful Marie Stuart adored poetry and in particular that of Ronsard. It was probably at her request that he published the first edition of his Oeuvres" (Paris, 1560). Elsewhere Blanchemain remarks that Ronsard's verses "charmed her captivity"—"Étude sur la vie de Pierre de Ronsard," *Oeuvres complètes de Ronsard* (Paris, 1857–1867), VIII, 28, 40.

132:16. Catherine de' Medici (1519–1589), married in 1533 to the Duke of Orléans, who reigned as King Henry II 1547–1559. She was the mother of three French kings: Francis II, Charles IX, and Henry III.

132:18. François de Malherbe (1555–1628), who stood for verbal harmony, propriety, and intelligibility and opposed loose syntax, dialectal expressions, obscure mythological allusions, and mixed or extravagant metaphors.

132:24–26. Pater is thinking of the generation of 1820 to about 1845 in France, the chief figures of which were Lamartine, Hugo, Musset, and Vigny, who attacked the classicism of Malherbe and Boileau and developed a new poetics consciously opposed to it. Ronsard and the other members of the Pleiad were rehabilitated by Sainte-Beuve in his influential *Tableau historique et critique de la poésie française et du théâtre français au seizième siècle* (Paris, 1828).

133:6–7. "I recommend that you make use of all dialects indifferently, as I have already said; among these the courtly is always the finest, because of the majesty of the prince; but it cannot be perfect without the aid of the others, for every garden has its particular flower..." "Préface sur La Franciade," *Oeuvres complètes*, III, 34.

133:14.
> Petite pucelle angevine,
>> Qui m'as d'un amoureux souris
> Tiré le coeur de la poitrine,
> Puis, dés le jour que tu le pris,

CRITICAL AND EXPLANATORY NOTES

Tu l'enfermas contre raison
Dans les liens de ta prison . . .
 —"Chanson" in "Le Second Livre
 des amours," *ibid.*, I, 148.

(Little maid of Anjou, who with a loving smile stole the heart
from my bosom, and then, from the day you took it, locked
it up against reason in the shackles of your prison . . .)

Very likely the phrase occurs more than once in this second
book of the "Amours," in which the poet celebrates his un-
requited love for Marie of Bourgueil, "fleur angevine de
quinze ans."

133:16–20. Ronsard addresses himself to these topics in
"Advertissement au lecteur," prefixed to the first ed. of his
"Odes" (1550) and repr. in *Oeuvres complètes*, II, 14–18. Pater
quotes from p. 16.

133:22–24. Pater seems to have misread Ronsard, who
says: "I am of the opinion that no poetry ought to be praised
as perfect if it does not resemble nature, which was consid-
ered beautiful by the ancients only for being inconstant and
variable in its perfections"—Preface to first ed. of the "Odes"
(1550), *ibid.*, 12.

133:28–30. ". . . les mots bizarres, forgés par la Pléiade,
et qui n'ont eu qu'une existence éphémère . . ." Charles
Marty-Laveaux, "Advertissement," *Oeuvres françoises de Ioa-
chim Du Bellay*, I, iv.

134:15–16. Though Claude Goudimel (circa 1514–1572)
was known chiefly for his vernacular psalm settings, he was
also a noted composer of chansons: "Nearly all the principal
collections of chansons published in Paris from 1549 onwards
contain compositions by Goudimel"—*Grove's Dictionary of
Music*, s.v. "Goudimel." Paul Laumonier lists fifteen collec-
tions and adds that the principal musicians to set Ronsard's
poems are Certon, Janequin, Goudimel, Arcadelt and others,
including Costeley and Lassus—*Ronsard: Poète lyrique* (Paris,
1909), p. 716n. Goudimel became a Huguenot in the 1550's
and died in the massacre at Lyons. When, in Pater's unfin-
ished novel *Gaston de Latour* (1896), Gaston and his friends

visit Ronsard at his priory of Croix-val, the great poet has the subprior sing his "Elegy of the Rose" in Goudimel's setting— *Works* (London, 1910), IX, 68.

134:21–22. Dante Gabriel Rossetti's translation of "uno segnore pauroso aspetto" in Dante's *Vita Nuova*, ch. 3. "Le petit enfant Amour / Cueilloit des fleurs à l'entour / D'une ruche . . ." (Little boy Love / Picked the flowers around / A bee-hive . . .) ode XIV, "Quatriesme Livre des odes," Ronsard, *Oeuvres complètes*, II, 270.

134:23–24. "ondelette"—du Bellay, *Oeuvres françoises*, II, 77; Ronsard, *Oeuvres complètes*, II, 344. "fontelette"—Ronsard, *ibid*. "Cassandre" is Ronsard's name for his mistress in the "Amours" and "la Cassandrette" the name he confers in her honor on "la gantelée," one of the campanula or bell-flowers: "From the name Cassandre it became Cassandrette" —*ibid*., I, 55: ". . . the red-flower that is called Cassandrette" —*ibid*., 166.

134:26–27. Reported of Ronsard by Claude Binet, *Vie de Ronsard* (1586, 1587, 1596), ed. Helene M. Evers (Philadelphia, 1905), pp. 72–73.

135:1–2. Quand le Ciel et mon heure
 Jugeront que je meure,
 Ravy du beau sejour
 Du commun jour . . .

 —"De L'Élection de son sepulchre,"
 Ronsard, *Oeuvres complètes*,
 II, 249 (*Les Odes*, bk. IV,
 ode IV, lines 9–12).

(When heaven and my hour / Judge that I should expire, / Ravished from my fair stay / In shared day . . .)

135:13–15. Prosper Blanchemain, "Étude sur la vie de Pierre de Ronsard," *Oeuvres complètes*, VIII, 9–10.

135:25–26. All were kings of France. Francis I reigned 1515–1547, Henry III 1574–1589, and Henry IV 1589–1610.

136:1–15. In the earlier chapters of *Gaston de Latour* (1896), Pater offers a description of this country, with a glimpse in

CRITICAL AND EXPLANATORY NOTES

ch. 3 of Ronsard as gardener and host at his priory of Croix-val.

136:15–22. Pater takes some of his details from sonnet XXXI of *Les Regrets*, quoted in n. to 138:28–30.

136:23–25. First pub. Paris, 1549.

136:27–137:8. With grace, with love, and with lofty valor, were the divine fires girt; and the heavens had clothed themselves in a precious mantle of burning rays with colors assorted:

All was filled with beauty, with happiness, tranquil the sea and full of grace the winds, when she in these lowly places was born, who has plundered the world of all honor.

She took her coloring from the blanching lily, her coif from gold, her two lips from the rose, and from the sun her eyes ablaze with light:

The sky, showering her with his munificence, left in her soul his seeds enclosed, and from the gods, her name took immortality.

(trans. Georges A. Perla)
This is the second of the 115 sonnets in *L'Olive—Oeuvres françoises*, I, 82.

137:11–20. On "charm," "expression," or "intimacy" in art, compare 14:26–15:8, 52:4–23, and 55:30–56:15.

137:20–32. Sainte-Beuve does not use the expressions "poésie intime" and "intimité" in his discussion of du Bellay's poetry, and perhaps Pater does not imply that he does. To the quality itself he responds as warmly as Pater does: ". . . all our sympathies remain devoted to the heart of the poet who has shown us his sentiments so nakedly and delivered his confessions in the form of verses"—Review of the first vol. of Charles Marty-Laveaux's ed. of du Bellay's *Oeuvres françoises*, in *Journal des savants* (August, 1867), p. 500. But Pater seems to have in mind a remark of Marty-Laveaux that du Bellay "devoted himself instinctively to that which has been called in our day intimate poetry, and he would still be in this respect an excellent model, if that genre, purely individual, would admit of imitation"—"Notice biographique sur Joachim du Bellay," *Oeuvres françoises*, I, x.

The *Antiquités de Rome* (1558) consists of 47 sonnets (later rendered into English by Edmund Spenser in *The Ruins of Rome*, 1591). The *Regrets* (1558) is made up of 191 sonnets, most of them written in Rome.

137:27. The *Essays* of Michel de Montaigne (1533–1592) first appeared in several books published 1580–1588.

137:27–28. The church of Brou, a late Gothic monument built 1506–1532, is in Bourg, capital of the *département* of Ain in eastern France.

138:2–5. "A voyage to Italy, which he deplored as the greatest unhappiness of his life, put him in full possession of his talent and made his poetic originality stand out positively" —Marty-Laveaux, "Notice biographique sur Joachim du Bellay," *Oeuvres françoises*, I, xvi.

138:9–10. "Someone has said that the reverie of poets is properly *enchanted boredom*; but du Bellay had in Rome chiefly *troubled* boredom, which is entirely different"—Sainte-Beuve, "Joachim du Bellay" (1840), *Tableau de la poésie française*, II, 144.

138:22. From sonnet XIII of "Le Premier Livre des antiquitez de Rome," *Oeuvres françoises*, II, 270.

138:23–24. From sonnet IX, *ibid.*, 268.

138:28–30. Pater takes several details from sonnet XXXI of *Les Regrets*:

> Heureuz qui, comme Vlysse, a fait un beau voyage,
> Ou comme cestuy là qui conquit la toison,
> Et puis est retourné, plein d'usage et raison,
> Viure entre ses parents le reste de son aage!
>
> Quand reuoiray-ie, helas, de mon petit village
> Fumer la cheminee: & en quelle saison
> Reuoiray-ie le clos de ma pauure maison,
> Qui m'est une prouince, & beaucoup d'auantage?
>
> Plus me plaist le seiour qu'ont basty mes ayeux,
> Que des palais Romains le front audacieux:
> Plus que le marbre dur me plaist l'ardoise fine,

Plus mon Loyre Gaulois, que le Tybre Latin,
 Plus mon petit Lyré, que le mont Palatin,
 Et plus que l'air marin la douceur Angevine.
 —*Oeuvres françoises*, II, 182

(Happy is he who, like Ulysses, has had a good journey, or
like that man who won the fleece, and then returned home,
full of experience and wisdom, to live the rest of his days
among his kin.

When shall I see, alas, the chimneys of my little village
smoking, and in what season shall I see again the garden of
my humble house, which is a province, and much more, to
me?

The home my ancestors built pleases me more than the
lofty front of Roman palaces; thin slate pleases me more than
solid marble; my own Gallic Loire more than the Latin Tiber;
my little Liré more than the Palatine Hill, and more than
ocean air the mildness of Anjou.)

In his review of the first volume of Marty-Laveaux's edi-
tion of du Bellay's *Oeuvres françoises*, Sainte-Beuve refers to
this poem as "that little masterpiece which can be called the
king of sonnets." He picks out as especially fine and char-
acteristic touches "la *cheminée de mon petit village*, le *clos de ma
pauvre maison*, l'*ardoise fine*, which is the local color of the
roofs in Anjou, and that indefinable *douceur angevine* opposed
to the salt sea air of the western coast"—*Journal des savants*
(August, 1867), p. 496.

139:6. The Graubünden, most easterly of the Swiss can-
tons, full of mountains and glacier groups.

139:12. "Mignonne, allons voir si la rose," ode XVII, ad-
dressed "À Cassandre" in the first book of "Les Odes,"
Oeuvres complètes, II, 117.

139:16. Andrea Navagero (1483–1529), editor of Cicero,
Latin poet, and keeper of the library of Saint Mark's cathedral
in Venice from 1516 until 1526, when he was sent to Madrid
on a mission to the court of the emperor Charles V.

139:23–140:12. This song is one of the "Jeux rustiques,"

Oeuvres françoises, II, 299. Andrew Lang's translation is as follows:

> To you, troop so fleet,
> That with winged wandering feet,
> Through the wide world pass,
> And with soft murmuring
> Toss the green shades of spring
> In woods and grass,
> Lily and violet
> I give, and blossoms wet,
> Roses and dew;
> This branch of blushing roses,
> Whose fresh bud uncloses,
> Wind-flowers too.
> Ah, winnow with sweet breath,
> Winnow the holt and heath,
> Round this retreat;
> Where all the golden morn
> We fan the gold o' the corn,
> In the sun's heat.
> —Lang, pp. 14–15

Winckelmann

Pater's first publication, his essay on Coleridge, appeared in the *Westminster Review* for January, 1866; "Winckelmann," his second, came out in the same journal just a year later. We first hear of "Winckelmann" soon after John Chapman, the editor, had agreed to accept it for publication. Pater wrote to Chapman on November 12, 1866: "I shall be very glad to have my article inserted in the January number. There are however a good many minute corrections which I should like to make in it . . ." and he asks to have the manuscript returned for that purpose—*Letters of Walter Pater*, ed. Lawrence Evans (Oxford, 1970), p. 4. Just below the title of the pub-

lished article, as if it were to be a review, appeared the names of two books: Otto Jahn's *Biographische Aufsätze* (1866) and G. H. Lodge's translation (1850) of Winckelmann's *Geschichte der Kunst des Altertums*. But Pater makes no reference to, and little or no use of, either book in his essay, drawing his biographical details independently from sources also used by Jahn and making his own translations from Winckelmann's German.

When he revised this essay for republication in *The Renaissance* six years later, he made more than his usual number of changes in wording and some in the order of sentences. Most of these changes were efforts to improve the writing; some were milder restatements, some excisions, of remarks that might be considered disparaging to the Roman Catholic church or to Christianity itself.

Although "Winckelmann" was more than twice as long as any of the other essays and surely among the most interesting, reviewers let it pass without much comment. In Colvin's opinion it was "completely excellent from beginning to end," the one essay in which the reader would find "most of those well meditated and perfectly expressed views of comparative criticism, and descriptions of various phases of culture in their relations to each other, which are one of the great strengths of the book"—*Pall Mall Gazette*, March 1, 1873, p. 12. Symonds, having praised Pater's sketch of Winckelmann's life and character, added that the essay "is full of good criticism of the Greek in contrast with the modern spirit. What is said on p. 195 [properly pp. 194–196 of the 1873 text, 176:20–177:25 of the 1893 text in this edition] about the way in which Winckelmann was privileged to approach Greek art is perfect"—*Academy*, IV (March 15, 1873), 104. The *London Quarterly Review* chided Pater, though gently and without presenting arguments, for his approval of Winckelmann's conversion, for his view of ritual observance as fixed and continuous while religious conceptions come and go, and—oddly enough—for his opinion (255:26–32) that "in Catholic Bavaria Christianity is to be found least adulterated with modern ideas"—XL (July, 1873), 506.

In a particularly thoroughgoing and penetrating study, David J. DeLaura argues that Pater's "Winckelmann" essay "is so centrally a response to Arnold's 'Pagan and Medieval Religious Sentiment' that, after the opening pages in review of Winckelmann's career, the very structure of his argument parallels Arnold's. By rejecting the uniqueness and value of the medieval religion of sorrow, by qualifying Arnold's views on the alleged superficiality of Greek popular religion, and finally by proposing a version of Arnold's Hellenic solution in a larger historical perspective, Pater consciously sets out to re-adjust the relations among the major factors in Arnold's own complex equation"—*Hebrew and Hellene in Victorian England* (Austin and London, 1969), p. 206.

Many readers have been drawn to "Winckelmann" as one of Pater's most deeply felt essays. Kenneth Clark points out that, just at this moment in his life, Pater could easily identify himself with Winckelmann: "The hunger for a golden age, the austere devotion to physical beauty, the feeling of a dedi-cation to art and to the unravelling of its laws, 'the desire' as Pater says 'to escape from abstract theory to intuitions, to the exercise of sight and touch'—all the characteristics which Winckelmann had united with a burning clarity, Pater recog-nized as half-smothered fires in his own being. Even those elements in Winckelmann's character which seem more ques-tionable, his formal acceptance of the Catholic faith as the price of a ticket to Rome, and his passionate love affairs with young men, corresponded to impulses which Pater felt in his own character and increased his feelings of sympathy"—In-troduction to *The Renaissance*, ed. Clark (New York, 1961), p. 13.

141:Epigraph. Literally, "I too have been in Arcadia"—a region of the central Peloponnesus; the primitive domain of Pan, the shepherds' God; in Virgil's *Eclogues* a land of ideal natural beauty, song, and elegiac feeling. With all its old Greek connotations, the motto has a special appropriateness for Winckelmann as Pater conceives of him: as one who had a

"native affinity to the Hellenic spirit" (152:2), to whom the ancient world "early came to seem more real than the present" (142:32–33), who "made himself a pagan for the purpose of penetrating antiquity" (152:5–6), who "seems to realise that fancy of the reminiscence of a forgotten knowledge hidden for a time in the mind itself" (155:2–4). More broadly, Arcadia may signify a state of perfect happiness, an earthly paradise of the spirit, as in Goethe's motto for his *Italienische Reise* (1786): "Auch ich in Arkadien."

141:1–11. Pater has in mind an essay first published in a volume by several authors entitled *Winckelmann und sein Jahrhundert* (Tübingen, 1805). Goethe's contribution appears under the title "Winckelmann" in his *Werke* (Weimar, 1887–1912), XLVI, 1–69. It is divided into short sections with subheadings. Although passing comments on Winckelmann's "character" occur throughout Goethe's essay, Pater's reference appears to be to the section headed "Charakter" (pp. 60–62); and yet nothing in that section (or elsewhere in the "Skizze") can be translated accurately into the language of lines 5–11.

141:14–20. Pater translates selectively from the Introduction to Hegel's *Aesthetik*, ed. H. G. Hotho, 2d ed. (Berlin, 1842), I, 81.

142:3–4. I have not been able to find this remark in the letters of 1763. Perhaps Pater is recalling inaccurately a comment evoked by Winckelmann's enjoyment of Florence in 1758. Winckelmann had gone there in September to prepare a catalog of the engraved stones and other objects in the collection of the learned archeologist Baron von Stosch, who had died in the previous year. He worked in Florence for nine months and then returned to Rome. During his stay in Florence he wrote to his old friend Johann Michael Franke at Nöthenitz: "Florence is the most beautiful place I have ever seen, far superior to Naples. I am making up now for what I have missed; and I had it coming from God. My childhood was entirely too wretched, and my schoolteaching stint I shall never forget"—*Sämtliche Werke*, ed. Joseph Eiselein (Donauö-

schingen, 1825–1829), X, 299 (letter of September 30, 1758). Unless otherwise noted, further references to Winckelmann's writings, including his letters, will be to this ed.

142:10–19. Eiselein, "Winckelmanns Biographie," *Werke*, I, VII–IX.

142:17. "While fluent Greek a vowel'd undersong / Kept up"—Keats, "Lamia," pt. 2, 200.

142:20–26. *De l'Allemagne* (1810), in Mme. de Staël, *Oeuvres complètes* (Paris, 1861), II, 53.

142:31–32. "For we know that, if our earthly house of this tabernacle were dissolved, we have a building of God, a house not made with hands, eternal in the heavens"—2 Corinthians 5:1.

142:33–143:4. Winckelmann's youthful longing to travel is noted by his biographers in the 1808, the 1825, and the 1847 *Werke*. But Pater's interpretation of its motive and spirit seems to be an echo of Goethe's designation of Winckelmann as one who discovered "a land once known and then forgotten." See n. to 154:20–21.

143:4–7. "Aus meinem Leben: Dichtung und Wahrheit," pt. 3, bk. II, *Werke*, XXVIII, 48.

143:7–9. Eiselein, "Winckelmanns Biographie," *Werke*, I, VIII–IX. Almost all of Pater's references to Winckelmann's life can be traced to Eiselein's biography; a very few details come from C. L. Fernow's "Kurzer Abriss von Winckelmanns Leben" in the Dresden ed. of the *Werke* (1808–1825), or from Otto Jahn, "Winckelmann," *Biographische Aufsätze* (Leipzig, 1866).

143:18–20. "Through privation and poverty, through toil and trouble I have had to make my way. In almost everything I have been my own guide"—*Werke*, X, 43 (letter of January 6, 1753).

143:21–22. "A wandering (or aimless) and inconstant man"—A. Krech, *Erinnerungen an Winckelmann* (Berlin, 1835), p. 1. This note appeared in the "Album der Schüler" in the rector's hand, not at Halle but at the Köln Gymnasium in Berlin, attended by Winckelmann in 1735. Reported too late for inclusion in Eiselein's biography in the *Werke* of 1825,

it is mentioned by the anonymous author of the biography in the Stuttgart *Werke* (1847), I, vi, and by Otto Jahn, "Winckelmann," *Biographische Aufsätze*, p. 9.

143:24–26. Schiller's irritation finds expression in the *Briefe über die ästhetische Erziehung des Menschen* (1795); see for example the sixth letter. But Pater is very likely recalling Carlyle's account of Schiller's unhappy days at the Duke of Württemberg's school in Stuttgart—"Schiller" (1831), *The Works of Thomas Carlyle*, ed. H. D. Traill (London, 1896), XXVII, 177–180.

143:32–144:2. "I have tried many things, but nothing has gone beyond the slavery in Seehausen"—*Werke*, X, 61 (letter of March 29, 1753).

144:3–6. These words were written long after Winckelmann's years in Seehausen. The whole sentence is as follows: "I have played the schoolmaster with great fidelity, and made children with scabby heads read their abc's when I wished passionately during this pastime to attain to knowledge of the beautiful, and prayed in similes out of Homer"—*Werke*, XI, 98 (letter of September 22, 1764).

144:6–7. "Winckelmanns Biographie," *Werke*, I, XXI.

144:13–22. Though he owned a set of Voltaire's works in 1755 (see 149:7–8), there is little or no evidence in Winckelmann's writings of a special interest in Voltaire. Much less doubtful is the powerful formative influence of Pierre Bayle's skeptical *Dictionnaire historique et critique* (Rotterdam, 1697—much rev. and repr. till the mid-eighteenth century). Eiselein reports that in 1742–43 Winckelmann twice read through this great work and made a large volume of extracts from it—*Werke*, I, XVI. By such reading and study, says Walther Rehm, the modern editor of his letters, Winckelmann deeply absorbed the spirit of the French Enlightenment—Rehm's Introduction to Winckelmann's *Briefe* (Berlin, 1952), I, 12. He adds that Winckelmann took the French essay as a model for his shorter writings and sought consciously "d'instruire et polire la nation" in the spirit of Diderot, d'Alembert, Voltaire, and other contributors to the famous *Encyclopédie* edited by Diderot (Paris, 1751–1780), 35 vols.

144:26. Goethe's *Iphigenie auf Tauris*, completed in 1786, was a five-act play in the manner of the French classicists.

144:28–29. Christian Wolff (1679–1754) was professor of mathematics and natural philosophy at the University of Halle, 1706–1731. He was expelled for his insistence that the unaided reason could attain to moral and theological truth and for professing (so his enemies said) a determinism that denied all personal responsibility for conduct. After teaching for a time at Marburg, he was recalled to Halle by Frederick the Great in 1740 and became chancellor of the university in 1743. In his letters Winckelmann makes more than one contemptuous reference to Wolff and his great empty books— "Kid stuff" (*Kindereien*), he calls them once, "which finally the mice will eat"—*Werke*, X, 189 (letter of March 9, 1757).

144:30–145:4. Pater seems to have in mind a passage in Goethe's "Winckelmann": "Winckelmann often complains bitterly of the philosophers of his day and their widespread influence, but I think one can escape from every influence by limiting oneself to his own line of work . . ." He adds that "no scholar can afford to reject, oppose, or scorn the great philosophical movement begun by Kant, except the true investigators of antiquity, who by the peculiarity of their study seem to be especially favored above all other men"—*Werke*, XLVI, 55 (trans. George Kriehn). But I do not find that Pater's summing up of Kant's influence on Goethe is based on any such avowal in Goethe's own writings or in his recorded conversations.

145:10–16. "Their way of acting and of thinking was easy and natural; 'their actions were carried out (as Pericles said) with a certain negligence,' and from some dialogues [for example, *Lysis*] of Plato one can get a conception of how the youths carried on their exercises with joking and enjoyment in their gymnasiums"—Winckelmann, "Erläuterung der Gedanken von der Nachahmung der griechischen Werke in der Malerei und Bildhauerkunst . . ." (1756), *Werke*, I, 135–136. The subject of the *Lysis* is friendship.

145:19–22. *Werke*, X, 43 (letter of January 6, 1753).

145:22–24. The first clear indications that his Roman jour-

ney may become a reality emerge in Winckelmann's letter to his friend H. D. Berends of March 27, 1752: "I am determined to put myself on a sure footing in Rome"—*Werke*, X, 36. By January 6, 1753, he is telling Berends, who has advised against his conversion, that "Alea jacta est!" (The die is cast!—Caesar's cry as he led his army across the Rubicon on the way to Rome)—*Werke*, X, 47.

145:24–26. Heinrich Graf von Bünau (1697–1762), statesman and historian. His library of 42,000 volumes was moved to Dresden in 1764. His chief work was *Genaue und umständliche Teutsche Kayser-und Reichs-Historie* . . . (Leipzig, 1728–1743).

145:26–146:7. *Werke*, X, 18–20 (letter of June 16, 1748).

146:11. "Winckelmanns Biographie," *Werke*, X, 96 (letter to Berends, December 29, 1754). Adam Friedrich Oeser (1717–1799), painter and etcher, lived in Dresden from 1739 to 1759, when he settled in Leipzig. There he became director of the Kunstakademie in 1764. Goethe was one of his students in 1768, when Winckelmann died. Later Oeser often visited Goethe in Weimar.

146:27–28. Arnold's phrase: "The Renascence is, in part, a return towards the pagan spirit . . . a return towards the life of the senses and the understanding"—"Pagan and Medieval Religious Sentiment" (1864), *Complete Prose Works*, ed. R. H. Super (Ann Arbor, 1960–1977), III, 226.

147:1–3. Shakespeare, *The Winter's Tale*, V, iii.

147:6–7. Lessing (1729–1781) published his treatise *Laokoon oder über die Grenzen der Malerei und Poesie* in 1766. Winckelmann greatly admired the sculptured group in the Vatican Museum called after its central figure the "Laocoön" and gave his reasons in his early essay *Gedanken über die Nachahmung der griechischen Werke in der Malerei und Bildhauerkunst* (1755). It was Winckelmann's praise of Laocoön's noble calm and grandeur in his mortal agony that provided Lessing with the starting point for his essay. Winckelmann imputes this calm and grandeur to the Greek superiority of soul; Virgil's Laocoön (*Aeneid*, bk. II, line 222), he proposes, is less worthy and utters "fearful shouts." But Lessing argues that

the sculptor, in giving form a moment of static beauty, is bound to avoid extreme emotion; whereas the poet, who tells a story, is obliged to depict the agony of his characters. The two Laocoöns thus illustrate not a moral and cultural difference, but a difference based on aesthetic principles.

147:7–10. In the first published text of this essay, Pater had in line 11 not "philosophy may" but "Hegel can." In Hegel's view, the art of the Greeks had achieved a perfect balance of form and idea, and sculpture was the classical art par excellence. In painting and music, the specially romantic arts—and even more in poetry, a union of painting and music—the sensuous element is subordinate to the spirit.

147:14. "It [the ideal character described in the essay] is a thread of pure white light that one might disentwine from the tumultuary richness of Goethe's nature"—"Diaphanéité" (1864), *Miscellaneous Studies*, *Works* (London, 1910), VIII, 254.

147:17–18. "Man lernt nichts, wenn man ihn liest, aber man wird etwas"—Johann Peter Eckermann, *Gespräche mit Goethe*, 4th ed. (Leipzig, 1876), I, 235.

147:18–29. Winckelmann's influence on Goethe is more fully explored at 182:3–184:3.

148:5–9. Johann Caspar Lavater, *Essai sur la physiognomie* (The Hague, 1783), II, 224. A French version of the words quoted by Pater appears as part of a longer passage in Winckelmann's *Briefe*, ed. Rehm, IV, 556. Lavater (1741–1801) was a poet, mystic, theologian, physiognomist, and friend of Goethe. He shared Winckelmann's belief in the moral and physical superiority of the ancient Greeks and took him (erroneously) to be a pioneer of physiognomy.

148:9–16. Pater translates selectively from "Winckelmann," Goethe's *Werke*, XLVI, 20–21, 24.

148:22–24. "Winckelmanns Biographie," *Werke*, I, XIV.

148:24–32. *Ibid.*, XXXIII–XLVII. Alberico Archinto (1698–1758) was papal envoy to Poland, 1746–1754. Domenico Passionei (1682–1761), cardinal and director of the Vatican library, was a noted connoisseur and collector of books and art objects.

148:32–149:2. *Ibid.*, XLVII–LVIII.

149:3–5. Goethe speaks of Winckelmann as "a born heathen" and holds that "he saw in [the Catholic religion] merely the disguise that he put on, and expressed himself on that subject harshly enough. Even later he appears not have held sufficiently to its practices, indeed to have made himself suspect, perhaps, among ardent confessors through loose talk; at any rate there is evident here and there a little fear of the Inquisition"—"Winckelmann," *Werke*, XLVI, 32, 34.

149:7–8. The works of Voltaire were taken from him at the customs house and not returned for three weeks—Winckelmann's *Werke*, X, 125 (letter of December 7, 1755).

149:8–10. Winckelmann's anxiety about Count Bünau's opinion is expressed in many letters to his friends and finally in the eloquent letter of September 17, 1754, to the Count himself—*Werke*, X, 86–92.

149:21–150:12. The terms "criticism" and "culture" as Pater uses them here and elsewhere (as at 181:3–8) derive, of course, from Arnold, who made them widely known in the 1860's.

150:10. Girolamo Savonarola (1452–1498), the Italian monk and martyr, is mentioned several times in *The Renaissance* for his powerful influence on life in Florence during the 1490's.

150:13–14. *Werke*, X, 280 (letter of July 27, 1758).

150:17–21. It was not long before Winckelmann's death in 1768 that Goethe encountered his early works under Oeser's guidance at the Academy of Design in Leipzig (see 156:6–10). He and his fellow students read those "sometimes so enigmatic writings" with devotion, partly because Winckelmann's "competence was recognized with enthusiasm in the Fatherland," partly because Oeser had been his friend and teacher—"Aus meinem Leben: Dichtung und Wahrheit," pt. 2, bk. VIII, *Werke*, XXVII, 183.

150:25. Antony Raphael Mengs (1728–1779), born in Bohemia of a Danish father, had lived in Dresden before going to Rome in 1741. He was kind to Winckelmann, and they became close friends, planning various writings on art together. A learned man who wrote in Spanish, Italian, and Ger-

man, he was first painter to the elector of Saxony and director of the Vatican school of painting; he made two visits to Madrid to do paintings for Charles III of Spain. He left paintings in the Madrid gallery, in Dresden, in St. Petersburg, and on the ceiling of the Villa Albani in Rome. "This acquaintance with Herr Mengs is my greatest good fortune in Rome," wrote Winckelmann to his friend Johann Michael Franke at Nöthenitz—*Werke*, X, 146 (May 5, 1756).

150:26–27. "Winckelmanns Biographie," *Werke*, I, LXX.

150:29–33. Nowhere in all his writings does Winckelmann cry out in French. These words are taken from a letter written in German—not at the time of Winckelmann's arrival in Rome, but eleven-and-a-half years later, just a year before his death. He had been invited by his young friend Baron Johann Hermann Riedesel to join him in travels through Sicily and Greece. Though Winckelmann had dreamed of such a journey all his life, he was forced to forgo this opportunity because he had already made plans for his fatal visit to Germany. "I must put off this undertaking until after my return journey. My misfortune is that I am one of those whom the Greeks call οψιμαθεις, *sero sapientes* [the too-late wise or learned] . . . for I came too late into the world and to Italy; if I had had a suitable education, it would have had to be at your age"—*Werke*, XI, 353 (June 2, 1767).

A similar utterance of an earlier date is a little more explicit: "I am unhappily one of those whom the Greeks call the late-wise [*Spätkluge*]; education, circumstances, and poverty have held me back from beginning to become wise earlier"—*Werke*, X, 511 (letter to Salomo Gessner, June 20, 1761). In his letter to Riedesel, Winckelmann offered to contribute a preface ("which hopefully would not displease you") for anything Riedesel might choose to write about his projected journey. Though he died too soon to confer this favor, Riedesel went on to write his *Reise durch Sicilien und Grossgriechenland* (Zürich, 1771), a book addressed to his friend Winckelmann and used and valued in his turn by Goethe.

151:2–5. "Aus meinem Leben: Dichtung und Wahrheit," pt. 2, bk. VIII, *Werke*, XXVII, 161, 182–185).

151:5–7. In his "Italienische Reise" Goethe makes a number of references to Winckelmann, whose books he used as a guide in his own viewing of art objects. Goethe took with him his completed prose version of *Iphigenie* and while in Italy rewrote the play in iambics.

151:10–14. Pater translates these two sentences exactly, not from Eiselein, but from the *Werke* of 1847 or an earlier source: "Er hatte weder kein Verlangen nach Ehrenstellen, wohl aber den Wunsch, seine Verdienste anerkannt und seine Existenz gesichert zu sehen . . . Winckelmann war sparsam ohne geizig zu sein, er wollte weder arm noch reich sein" —"Biographie Johann Winckelmanns," *Werke* (Stuttgart, 1847), I, XXXIV–XXXV.

151:22–26. *Purgatorio*, I, 13–28 and passim.

152:3–6. *De l'Allemagne* (ch. 6), Mme. de Staël, *Oeuvres complètes*, II, 53.

152:6–8. A footnote in the first published version of this essay reads thus: "Words of Charlotte Corday. See Quinet: La Revolution. Livre 13ᵉ, chap. iv." Marie Anne Charlotte Corday d'Armont (1768–1793), acting in sympathy with the Girondins, murdered Jean Paul Marat, the revolutionary leader, on July 13, 1793, was condemned by the revolutionary tribunal, and died by the guillotine—Edgar Quinet, *La Révolution*, 6th ed. (Paris, 1869), II, 32. The quotation comes from the official interrogation; it is her answer to the question, "Qui vous a conseillée?"

152:10–12. Pater defines "enthusiasm" in Plato's sense of the word and quotes the relevant passage from *Phaedrus* 249 in *Plato and Platonism*, *Works*, VI, 170–173. See also Pater's "A Study of Dionysus," *Fortnightly Review*, XX, n.s. (December 1, 1876), 756.

152:19–21. "When he had to paint his archangel Michael, Guido [Reni] wrote to a Roman prelate: 'I had wished for my figure a beauty out of Paradise, and to see it in heaven, but I have not been able to raise myself so high, and I have sought it on the earth in vain.' Nevertheless his archangel is less beautiful than some young men I have known and still know"— *Geschichte der Kunst des Alterthums*, *Werke*, IV, 72. Winckel-

mann's point is not that he himself has known many beautiful young men, but that Guido (like Raphael, of whom he tells a somewhat similar anecdote) was not sufficiently attentive to the beauty that occurs in nature. The "Archangel Michael," one of the best-known paintings of Guido Reni (1575–1642), was displayed at the right of the first altar in the Cappuccini church in Rome.

152:24–153:15. This is an essay of 1763 entitled "Abhandlung von der Fähigkeit der Empfindung des Schönen in der Kunst, und dem Unterrichte in derselben," *Werke*, I, 235–273. It consists of forty-seven numbered paragraphs. Pater translates (with one minor omission) the first two paragraphs. The young Baron Friedrich Reinhold von Berg of Livonia (1736–1809) visited Rome briefly in early 1762. Their attraction for each other was quickly felt and acknowledged, and Winckelmann's Platonic "enthusiasm," as Pater calls it, was fervently, solemnly, even heavily expressed in the seven letters to Berg included in the *Werke*: two of 1762, two of 1763, one of 1764, and two of 1767. (Berg's answers to Winckelmann's first two letters are included in footnotes.) That Winckelmann considered his love for Berg to be of the same kind as the heroic friendships of Greek legend and history is made clear in his first letter to Berg, in which his claims about the nature and value of such friendship go far beyond what appears in the passage quoted by Pater. "The Christian morality does not teach it," he writes; "but the heathen worship it, and the greatest deeds of antiquity are achieved through it" —*Werke*, X, 558 (letter of June 9, 1762).

152:30. Winckelmann uses these words from Pindar's Tenth Olympian Ode (epode V, lines 113–114) as an epigraph to his whole essay. In his first paragraph he translates the passage thus: "welcher schön von Gestalt, und mit der Gratie übergossen war" (who was beautiful of form and showered with grace)—*Werke*, I, 237, §1. The poet's excuse, translated by Pater as "a debt paid with usury is the end of reproach," is from the first antistrophe of the same ode, lines 10–11. Winckelmann's German for this is: "Die mit Wucher bezahlete Schuld hebet den Vorwurf"—*ibid*.

153:11. Their "common friend" was probably the Graf von Münnich, mentioned in Winckelmann's letters to Berg. He seems to have stayed in Rome for some months after Berg's departure for Paris.

153:17–31. Pater translates para. 9 of this essay—*Werke*, I, 244.

153:34–154:1. Of about 480 letters published in the *Werke* of 1825 and again (with minor additions) in that of 1847, only eleven are in French. One of these is indeed a letter of passionate friendship (as are some others in German); but no series of letters corresponds to Pater's description.

154:8–10. Walther Rehm lists the published collections in his edition of Winckelmann's *Briefe*, I, 503–504. The two comprehensive collections available to Pater were those included by (a) Joseph Eiselein in his edition of Winckelmann's *Werke* (Donauöschingen, 1825) and (b) Friedrich Förster in his vols. IX–XI (Berlin, 1824–1825) added to the edition of the *Werke* begun by C. L. Fernow and completed by others (Dresden, 1808–1820). The Stuttgart *Werke* of 1847 adds nothing of value to Eiselein's collection. No further collections of letters had been published in books, and nothing of importance to Pater in periodicals, between 1825 and 1866.

154:9–10. Winckelmann's major work, *Geschichte der Kunst des Alterthums* (Dresden, 1764).

154:16–18. "Er hatte . . . kleine schwarze tiefliegende Augen . . ." *Werke*, ed. Fernow, I, XLII; ". . . er hatte eine bräunliche Gesichtsfarbe, lebhafte schwarze Augen . . . und eine rasche Bewegung"—*Werke*, ed. Eiselein, I, CLVIII.

154:20–21. Pater must be thinking of a passage in Otto Jahn's essay "Winckelmann" in *Biographische Aufsätze*, p. 6. But Jahn merely quotes (without giving his source) from one of Goethe's conversations with Eckermann. Winckelmann, Goethe says, is "like Columbus when he had not yet discovered the New World, but bore it in mind as a presentiment" —Johann Peter Eckermann, *Gespräche mit Goethe*, I, 235. (At 147:17–18, Pater quotes an English version of the next sentence, not given by Jahn: "One learns nothing from him, but one becomes something.") In any case, Goethe had made the

comparison earlier in writing: "Soon he rose above the par-
ticulars to the idea of a history of art, and discovered, as a
new Columbus, a land long suspected, augured, and dis-
cussed, indeed, one can say, a land already known earlier and
then forgotten"—"Winckelmann," Goethe's *Werke*, XLVI,
40. Pater was of course familiar with Goethe's essay.

154:22–27. "Les Révolutions d'Italie," *Oeuvres complètes*
(Paris, 1857–1870), IV, 343–344.

155:2–8. These lines are a reworked passage from "Dia-
phanéité," Pater's study of a certain type of ideal character,
read at Oxford in 1864: "It [the character before us] is like the
reminiscence of a forgotten culture that once adorned the
mind; as if the mind of one φιλοσοφήσας ποτὲ μέτ᾽ ἔρωτος,
fallen into a new cycle, were beginning its spiritual progress
over again, but with a certain power of anticipating its stages"
—*Miscellaneous Studies*, *Works*, VIII, 250.

In his earlier years, Pater felt the spell of the "mystic and
dreamy" Plato (28:1) of certain occult doctrines, particularly
those of the reminiscence of innate knowledge and of metem-
psychosis, the transmigration of souls through various forms
of the bodily life. These ideas are explored in the *Meno*, the
Phaedo, the *Phaedrus*, the *Timaeus*, and bk. X of the *Republic*.
Two decades later, reflecting once again on these doctrines
and tracing them back to Pythagoras, Pater asks whether they
are not after all in essential harmony with certain hard-won
ideas of modern evolutionary science: "For in truth we come
into the world, each one of us, 'not in nakedness,' but by the
natural course of organic development clothed far more com-
pletely than even Pythagoras supposed in a vesture of the
past, nay, fatally shrouded, it might seem, in those laws or
tricks of heredity which we mistake for our volitions; in the
language which is more than one half of our thoughts; in the
moral and mental habits, the customs, the literature, the very
houses, which we did not make for ourselves; in the vesture
of a past, which is (so science would assure us) not ours,
but of the race, the species: that *Zeit-geist*, or abstract secular
process, in which, as we could have had no direct conscious-

ness of it, so we can pretend to no future personal interest. It is humanity itself now—abstract humanity—that figures as the transmigrating soul, accumulating into its 'colossal manhood' the experience of ages; making use of, and casting aside in its march, the souls of countless individuals, as Pythagoras supposed the individual soul to cast aside again and again its outworn body"—*Plato and Platonism*, *Works*, VI, 72–73.

155:8–11. "Winckelmann," Goethe's *Werke*, XLVI, 52–53.

155:12–14. Alessandro Albani (1692–1779), nephew of Pope Clement XI, connoisseur and collector of art objects and founder of a distinguished library that was dispersed when the family died out in 1852. The Villa Albani, which he built on the Via Salaria, was a splendid example of the new villa-museum.

155:14–15. Buried under twelve feet or so of lapilli and ash, to which in the course of centuries was added about six feet of earth, the ruins of Pompeii lay almost undisturbed until the late sixteenth century. Systematic excavation was begun in 1748 by the King of Naples, Charles of Bourbon (later Charles III of Spain). In 1763 the ruins were identified as those of Pompeii. Winckelmann made several visits to Pompeii, Herculaneum (also destroyed, along with Stabiae, by the eruption of Vesuvius), and other sites of ancient ruins and carefully described the buildings and art objects in private letters and published reports to his patrons between 1758 and 1763.

155:21–32. "Since that time Greece has been explored and true masterpieces discovered. The marbles of Aegina, the incomparable sculptures of the Parthenon, a few bas-reliefs, a few statues, among which the Venus of Milo must be mentioned, have revealed to us a beauty much greater, more alive and personal, than the elegance of the Apollo Belvedere or even the exquisite charm of the Venus of the Medici"—Léo Joubert, "Winckelmann," *Nouvelle Biographie générale* (Paris, 1857–1866), XLVI, 770.

155:24. Pheidias (or Phidias), the great Greek sculptor and architect, lived in the fifth century B.C.

156:6–10. Goethe, "Aus meinem Leben: Dichtung und Wahrheit," pt. 2, bk. VIII, *Werke*, XXVII, 182–185.

156:10–11. On May 14, 1768, Winckelmann wrote a troubled letter from Vienna to his friend Heinrich Muzel-Stosch, whom he had planned to meet in Berlin. The five-week journey from Rome to Vienna, he said, "instead of entertaining me, has made me extraordinarily melancholy, and since it is not possible to make and to continue it with the necessary comfort, it is not a pleasure; so there is no way for me to appease my spirit and to banish the melancholy but to go back to Rome"—*Werke*, XI, 491.

156:19. ". . . als Winckelmann eben an seinem Tische sass um einige Weisungen für den künftigen Herausgeber seiner Geschichte der Kunst aufzuzeichnen . . ."— C. L. Fernow, "Kurzer Abriss von Winckelmanns Leben," *Werke* (Dresden, 1808–1820), I, xxxix. Pater translates these words exactly from the Dresden edition.

156:23–26. "He would have murdered him then and there if a child with whom Winckelmann was in the habit of playing had not knocked on the door. At this noise the murderer fled, without taking the medallions with him"—Fernow, *ibid.*, I, xl. Later editors do not include this detail of the child; it has no place in the events reconstructed by Domenico de' Rossetti in his carefully prepared essay *Johann Winckelmann's Letzte Lebenswoche* (Dresden, 1818); and it does not appear in the letters and official reports collected by Walther Rehm for his edition of Winckelmann's *Briefe*, IV, 263–415.

156:31–157:1. "Winckelmann," Goethe's *Werke*, XLVI, 69.

157:3–7. "Aus meinem Leben: Dichtung und Wahrheit," pt. 2, bk. VIII, Goethe's *Werke*, XXVII, 182–185. The Sturm-und-Drang period in German literature lasted from about 1770 to 1781. Winckelmann's death occurred on June 8, 1768.

157:16–30. Speaking in 1853 of the same two pictures, one of Theology and the other of Poetry, Ruskin had made his thunderous pronouncement that "from that spot, and from that hour, the intellect and the art of Italy date their degrada-

tion. Observe, however, the significance of this fact is not in the mere use of the figure of the heathen god to indicate the domain of poetry. Such a symbolical use had been made of the figures of heathen deities in the best times of Christian art. But it is in the fact, that . . . *he elevated the creations of fancy on the one wall, to the same rank as the objects of faith upon the other*; that in deliberate, balanced opposition to the Rock of the Mount Zion, he reared the rock of Parnassus . . . The doom of the arts of Europe went forth from that chamber . . ." "Pre-Raphaelitism," Lecture VI of "Lectures on Architecture and Painting," *The Works of John Ruskin*, ed. Cook and Wedderburn (London, 1903–1912), XII, 148–150.

By 1876 Ruskin had lost his indignation; he wrote then that "Raphael, painting the Parnassus and the Theology on equal walls of the same chamber of the Vatican, so wrote, under the Throne of the Apostolic power, the harmony of the angelic teaching from the rocks of Sinai and Delphi"—"Editor's Preface to The Economist of Xenophon," *ibid.*, XXXI, 17. Here Ruskin recognizes the fruitful reconciliation of Christian and Pagan that Pater sees in the two paintings. He adds in a self-correcting note of 1881 that Italy was destroyed "not by reverence for the Gods of the Heathen but by infidelity alike to them, and to her own."

157:16. Raphael's vision of the Church militant and triumphant, often called the "Disputa," in the Camera della Segnatura. Raphael's work in this apartment was completed in 1511.

157:20–21. The fresco known as the "Parnassus."

157:24–25. Castalia, a spring on Mt. Parnassus, was sacred to the Muses and thus a source of poetic inspiration.

157:28. Pater quotes Psalm 46:4: "There is a river, the streams whereof shall make glad the city of God."

158:12–14. Scyles, a Scythian king, had a Greek mother who brought him up to know the Greek language and customs; thus he came to prefer the Greek way of life to the Scythian. He would go with his army to visit a certain Greek town, leave his army outside the gates, and enter the town alone. There he would exchange his Scythian dress for Greek

clothes, walk about the town unguarded, observe the Greek rites, and live as a Greek. Meanwhile, a watch was kept to make sure that no Scythian saw the king in Greek attire. Sometimes he would stay a month or more, after which he would put on Scythian clothes again and depart. This he did repeatedly, says Herodotus, and even built himself a house there and married a woman who was a native of the town— Herodotus' *History*, bk. IV, ch. 78.

159:28–29. Pheidias' colossal statues, the Zeus at Olympia and the Athene Polias of the Parthenon in Athens, "are known from the raptures of ancient critics and little more" —*Oxford Companion to Art*. "Polias" means "guardian of the city."

159:25–27. *An Essay on the Development of Christian Doctrine* (London, 1845), p. 209. Opposing Newman's "partial" view, Pater insists in this and the next two paragraphs (to 163:3) on the "sad" or "sombre" elements in pagan worship. Later in the essay he finds Arnold guilty of a similar distortion (178:12–14 and n.). John Henry Newman (1801–1890) joined the Church of Rome in 1845. Ordained priest and made D.D. in 1846, he was created Cardinal in 1879.

160:19–20. Genesis 1:26.

161:1–2. "But they that wait upon the Lord shall renew their strength: they shall mount up with wings as eagles; they shall run, and not be weary; and they shall walk, and not faint"—Isaiah 40:31.

161:15. In the first published version of this essay, a footnote at the word "generation" refers the reader to "Hermann's Gottesdienstliche Alterthümer der Griechen. Th. 1, §1, 2, 4." The general reference is to pt. 2 of Karl Friedrich Hermann's *Lehrbuch der griechischen Antiquitäten*, entitled *Lehrbuch der gottesdienstlichen Alterthümer der Griechen*, 2d ed. (Heidelberg, 1858).

161:23–27. In the first published version of the essay, this sentence read: "In Greece they were derived from mythology, itself not due to a religious source at all, but developing in the course of time into a body of anthropomorphic religious con-

ceptions." A footnote at the word "conceptions" referred the reader to "Ibid. [Hermann's *Gottesdienstliche Alterthümer der Griechen*. Th. 1] §6."

161:29. Plato, *Phaedrus*, 246D ("The wing is intended to soar aloft and carry that which gravitates downwards into the upper region, which is the dwelling of the gods; and this is that element of the body which is most akin to the divine" —trans. Jowett, I, 552). The "wing" is that of the soul.

162:1–3. Pater's view of the normal development of myth out of ritual, derived from Hermann and—perhaps later but before he wrote "Demeter and Persephone," which appeared in 1876—from other German scholars such as Karl Otfried Müller and Ludwig Preller, was controversial in his time. See Francis Leonard Nye, "Walter Pater's Early Hellenism" (Ph.D. diss., University of North Carolina, 1971), pp. 59–61.

162:8–12. Pausanias was a Greek writer of the second century A.D., author of *Hellados Periegesis* (Description of Greece), a guide in ten books to the various cities, monuments, and works of art in Greece. Pater alludes to Pausanias' report that he had seen a rude wooden image of Hercules, said to be a work of Daedalus—bk. II, pt. 4, sec. 5.

162:9–12. In the first published version of this essay, a footnote at the word "figure" referred the reader to "Athen. xiv. 2, quoted by Hermann, Th. 1, §6, 4." Athenaeus (fl. circa 200 A.D.) was author of the symposium *Deipnosophistai*, a collection of fragments from nearly eight hundred writers.

162:10. Latona is the Roman counterpart of the Greek Leto, mother of Artemis and Apollo.

162:15–16. From Paul's address on Mars Hill in Athens: God, he says, "hath made of one blood all nations of men . . . that they should seek the Lord . . . though he be not far from every one of us: for in him we live, and move, and have our being . . ." Acts 17:26–28.

162:19–20. In the first two published versions of this essay, a footnote at the word "kissing" referred the reader to "Hermann, Th. ii. c. ii. §21, [n.] 16." Hermann observes that the "lips and chin of the bronze statue of Heraklos at

Akragas are worn by kisses"—*Gottesdienstliche Alterthümer der Griechen*, p. 118.

162:21. In the second version of "The Myth of Demeter and Persephone" (first pub. 1876; rev. 1878, repub. 1895), Pater insists at length that, contrary to common belief, "'the worship of sorrow,' as Goethe called it . . . was not without its function in Greek religion . . ." *Greek Studies, Works*, VII, 110–111. See 178:12–14 and n.

Carlyle spoke of "the worship of sorrow" in *Sartor Resartus*, bk. II, ch. 9. He evidently had in mind Goethe's phrases "das Heiligtum des Schmerzes" and "die göttliche Tiefe des Leidens," from *Wilhelm Meisters Wanderjahre*, bk. II, ch. 2. "L'Addolorata" is Our Lady of Sorrows. Demeter is "the weary woman, indeed, our Lady of Sorrows, the *mater dolorosa* of the ancient world . . ." Pater, *Greek Studies, Works*, VII, 114. For an account of Pater's revision of "The Myth of Demeter and Persephone," see C. L. S.[hadwell], Preface, *ibid.*, pp. 2–3.

162:24–25. The priestess of Apollo at Delphi.

162:30–31. Gods of the underworld.

162:32. In the first published version of this essay, a footnote at the word "itself" refers the reader to "Ibid. [Hermann] Th. 1, §5."

163:4. Although Pater does not acknowledge a debt to Hegel until somewhat later in the essay, his ideas in the next two paragraphs are those summarized in the Introduction to pt. 2 of the *Aesthetik* and elaborated in sections that follow on symbolic, classical, and romantic art.

163:11–12. Frate Giovanni da Fiesole, commonly called Fra Angelico (1387–1455). To illustrate the "exaggerated inwardness" (163:33) of medieval art, Pater names Alexis-François Rio's prime example of the "Christian artist." Of the picture in question, Rio said that human words would always be powerless to render "the beauty of that truly divine composition. Beyond the perfection of the principal figure, the artist has succeeded in giving to his colors a lucidity, a transparency, I would almost say an immateriality which har-

monizes *marvellously* with the wholly mystical nature of the subject . . ." *De L'Art chrétien* (Paris, 1861–1867), II, 360. An engraving of "The Coronation of the Virgin" appears as the frontispiece in the English translation of Rio's much earlier book *De la poésie chrétienne* (Paris, 1836), published in London in 1854 as *The Poetry of Christian Art*.

Pater makes another disparaging reference to Fra Angelico at 179:11–14. For the suggestion that Pater may criticize Rio without naming him, see xxii:28 and n. Rio's admiration for Fra Angelico was shared by Ruskin.

163:15–17. "His head and his hairs were white like wool, as white as snow; and his eyes were as a flame of fire"—Revelation 1:14.

164:4. Diana, or Artemis, of Ephesus in ancient Ionia, a primitive goddess of nature and the productive power of the earth. Her cult statue was a figure with many breasts, swathed below the waist in graveclothes.

164:9. The best known of all ancient statues, found in Melos in 1820, now in the Louvre. It is regarded as a work of circa 100 B.C. "You may take the Venus of Melos," said Ruskin, "as a standard of beauty of the central Greek type. She has tranquil, regular, and lofty features; but could not hold her own for a moment against the beauty of a simple English girl, of pure race and kind heart"—"The Queen of the Air" (1869), *Complete Works*, XIX, 413.

164:23–24. "For silence after grievous things is good, / And reverence, and the fear that makes men whole, / And shame, and righteous governance of blood, / And lordship of the soul"—Words spoken by the Chorus in Swinburne's classical Greek tragedy *Atalanta in Calydon* (1865), lines 1197–1200.

165:11. See Textual Notes, 257:23–258:5.

165:11–13. *Faust*, pt. 2, act I.

165:17–18. This castle hath a pleasant seat; the air
Nimbly and sweetly recommends itself
Unto our gentle senses.
—*Macbeth*, I, vi, i

165:24–166:22. Pater translates selectively from *Geschichte der Kunst des Altertums, Werke*, IV, 10–13.

165:32–34. This song is mentioned by Plato, though without reference to its author, in *Gorgias* 304 and in *Laws* I 631 and II 661. Simonides of Ceos (circa 556–467 B.C.), one of the most revered of Greek poets, wrote monodic and choral lyrics, iambics, and elegiacs, including a large group of elegiac epigrams. Epicharmus (b. circa 560 B.C.) was a Greek writer of comedy who spent much of his life in Sicily.

166:9. Greek orator and statesman who governed Athens 317–307 B.C. But Winckelmann has "Demetrius Polyorcetes" (not "Phalereus"), an Athenian general (337–283 B.C.).

166:33. The palaestra was a place for teaching and practicing wrestling and other sports.

167:1–4. Spoken by Kritobulos in Xenophon's *Symposium*, ch. 4, para. 11.

167:27. In the first published version of this essay, a footnote at the word "itself" referred the reader to "Hegel: Aesthetik, 2 Theil. Einleitung." The footnote might reasonably be taken to refer back as far as 167:12. But the "Einleitung" (Introduction) to pt. 2 of the *Aesthetik* is short and highly condensed. Hegel's system of the particular arts of architecture, sculpture, painting, music, and poetry is elaborated at length in pt. 3, to which Pater's exposition in the following pages, at least as far as 176:19, is heavily indebted. And Pater's pages might equally well be seen as a free but sufficiently faithful meditation on Hegel's outline of the types of beauty and the specific arts in the "Eintheilung" (Division of the Subject) that immediately follows the Introduction to the whole *Aesthetik*.

168:11–15. It was reported by Tacitus (*Annals*, bk. II, ch. 61) that one of the colossal statues of Thebes called Memnons gave out a vocal sound at sunrise. Whatever the facts may be, says Hegel, we can give such figures a symbolic meaning. Unable to draw animation from within, they require light from without, for only this liberates the note of the soul from them. The human voice, on the other hand, resounds out of one's own feeling and spirit without any external stimulus,

"just as the height of art in general consists in making the inner give shape to itself out of its own being. But the inner life of the human form is still dumb in Egypt . . ." *Aesthetik*, I, 449–450 (trans. Knox, I, 358).

169:1–11. In this comparison of the powers of sculpture, painting, and poetry to represent the human spirit, Pater follows Hegel closely—*ibid.*, II, 355–356.

169:15. For the similar phrase "imaginative reason," see 102:16, 109:5–6, and 109:20–21.

170:12. In the first published version of this essay, a footnote at the word "individuality" refers the reader to "Hegel: Aesthetik, Th 3, Abschnitt 2." This whole section of about a hundred pages is devoted to sculpture, chiefly "as the art of the classical ideal," and the footnote only very loosely indicates Pater's source for the two preceding paragraphs. In his remarks on the tendency of Greek sculpture to free itself from color and other merely decorative or traditional features, Pater follows Hegel's Introduction to Part III, sect. 2, *Aesthetik*, II, 353–364.

170:13. The terms, of course, are Hegel's: ". . . amongst the fundamental characteristics of the Ideal we may put at the top this serene peace [*heitere Ruhe*] and bliss, this self-enjoyment in its own achievedness and satisfaction. The ideal work of art confronts us like a blessed god. For the blessed gods [of Greek art], that is to say, there is no final seriousness in distress, in anger, in the interests involved in finite spheres and aims, and this positive withdrawal into themselves, along with the negation of everything particular, gives them the characteristic of serenity [*Heiterkeit*] and tranquillity. In this sense Schiller's phrase holds good: 'Life is serious, art cheerful' "—*Aesthetik*, I, 198 (trans. Knox, I, 157). For Pater's understanding of the term "Allgemeinheit," see esp. 51:18–28 and 172:16–173:11.

170:29–30. For the similar phrase "imaginative reason," see 102:16, 109:5–6, and 109:20–21.

171:19–20. "Dîs Aliter Visum; or, Le Byron de Nos Jours," appeared in the collection entitled *Dramatis Personae* in

1864. The "situation" is one in which a still young but now unhappily married woman chides a famous old poet for not declaring his love for her ten years earlier, when an opportunity presented itself. The title means "The gods see otherwise, or the modern Byron."

173:18–19. Hegel, *Aesthetik*, II, 427.

173:25. In Pytho, Apollo killed a dragon, took the name Pythius, and built a temple. The story is told in the second part of the third Homeric Hymn. Apollo Belvedere in the Vatican Museum, a statue of circa 350–320 B.C., is a Roman copy of a Greek original. Winckelmann, who admired it more than any other surviving ancient statue, argued that it is a Pythian Apollo—*Geschichte der Kunst des Alterthums, Werke*, VI, 221–224.

173:26. In a competition among the goddesses Hera, Athena, and Aphrodite, a golden apple inscribed "To the Fairest" was awarded by Paris, son of Priam, king of Troy, to Aphrodite, who had offered him the most beautiful woman in the world as his wife.

173:27–30. A sculpture of about 160–130 B.C., in the Vatican Museum, representing Laocoön (a Trojan priest of Apollo who had warned against the wooden horse of the Greeks) and his two sons, in a struggle with sea serpents by which all three were killed. The story is told in the *Aeneid*, bk. II. In his view of the sculptured group as late, laborious, and mannered, Pater follows Hegel—*Aesthetik*, II, 439.

174:10:15. *Geschichte der Kunst des Alterthums*, in *Werke*, IV, 64–65.

174:17–21. The Parthenon frieze representing the panathenaic procession.

174:21. Here Pater repeats a phrase he had used in "Diaphanéité" (1895), his study of an ideal character read at Oxford in 1864: "For this nature there is no place ready in its [the world's] affections. This colourless, unclassified purity of life it can neither use for its service, nor contemplate as an ideal"—*Miscellaneous Studies, Works*, VIII, 248. The language of "Diaphanéité" is echoed repeatedly, though less exactly, in the lines that follow, up to 175:2. Pater's conception of

the ideal character is clarified by the example of the *adorante*, line 29.

174:28–175:2. A Hellenistic statue in bronze, commonly called "Boy Praying," still in the Berlin Museum: ". . . the *Adorante* of Berlin, Winckelmann's antique favourite, who with uplifted face and hands seems to be indeed in prayer, looks immaculate enough to be interceding for others"— Pater, "The Age of Athletic Prizemen" (1894), *Greek Studies, Works,* VII, 295.

175:3–26. Pater translates from the *Aesthetik,* II, 377. Phryne, a celebrated courtesan of the fourth century B.C., is said to have bathed in the sea at a festival in Eleusis and so to have become the model for Apelles' painting "Aphrodite Anadyomene." Pater considered fifteenth-century Italy to be among the "happier eras," like that of Pericles, "productive in personalities, many-sided, centralized, complete" (xxiv: 13–17).

175:28–30. Here again Pater repeats the words of a passage in "Diaphanéité": "Such a character is like a relic from the classical age, laid open by accident to our alien modern atmosphere"—*Miscellaneous Studies, Works,* VIII, 251.

175:30–32. See xxi:12–16.

176:15–19. Once again Pater quotes from "Diaphanéité": "The beauty of the Greek statues was a sexless beauty; the statues of the gods had the least traces of sex. Here [in the ideal character] there is a moral sexlessness, a kind of impotence, an ineffectual wholeness of nature, yet with a divine beauty and significance of its own"—*Miscellaneous Studies, Works,* VIII, 253.

176:27–28. Though I do not find the phrase in Schiller, the idea is essential to his argument in the *Briefe über die ästhetische Erziehung des Menschen* (1795); see, for example, letter 24. Elsewhere Schiller praises the serenity of the Greek artist in dealing with the sensuous: "The Greek was never ashamed of nature; he granted to sensuousness its full rights and is nevertheless sure that he will never be subjugated by it"—"Ueber das Pathetische," *Werke,* XI, 320; see also XI, 260. Hegel holds that "Art by means of its representations, while remain-

ing within the sensuous sphere, liberates man at the same time from the power of sensuousness"—*Aesthetik*, I, 64 (trans. Knox, I, 49).

177:2. *The Republic*, bk. VII.

177:17–19. 1 Samuel 14:43.

178:9. In the first published version of this essay, a footnote at the word "spirit" refers the reader to "Hegel: Aesth., Th. 2, Absch. 2, Kap. 3. Die Auflösung der klassischen Kunstform." While Pater's whole paragraph from 177:26 to 178:9 might be thought of as drawing its general conception —that of the inability of the spirit to rest indefinitely in the art which has for a time expressed its life perfectly—from the cited chapter in the *Aesthetik*, Pater's debt to the chapter is not detailed or specific.

178:12–14. Theocritus, the Greek poet who invented pastoral poetry, lived in the first half of the third century B.C. Pater's reference to Theocritus suggests that he had in mind not only the section in Hegel to which he refers the reader (see n. above), but also Arnold's essay "Pagan and Medieval Religious Sentiment" (1864), in which Theocritus' fifteenth idyll is made to serve as evidence that "the ideal, cheerful, sensuous pagan life is not sick or sorry"—*Complete Prose Works*, III, 222. Pater implies that by failing to acknowledge the "romantic" side of Theocritus, Arnold has misrepresented Greek religion. In "Demeter and Persephone" (1895) Pater repeats Arnold's words as he makes a gentle protest against the "familiar view of Greek religion" as that of a people who "were never 'sick or sorry.'" To refute this "familiar view," he adds that "the legend of Demeter and Persephone, perhaps the most popular of all Greek legends, is sufficient to show that the 'worship of sorrow' was not without its function in Greek religion; their legend is a legend made by and for sorrowful, wistful, anxious people; while the most important artistic monuments of that legend sufficiently prove that the Romantic spirit was really at work in the minds of Greek artists . . ." *Greek Studies, Works*, VII, 110–111. See 162:3–25 and n. to 162:21. The same general point is made, though without reference to Arnold, in "A Study of Dionysus" (1876), with

its recital of evidence for the worship in Greece of a dark, suffering Dionysus who sometimes required the sacrifice of human beings—*ibid.*, esp. pp. 44–52.

178:24–26. Gilliatt is the heroic solitary who salvages a boat wrecked on the rocks near Guernsey and thereby wins the right to the owner's niece, whom he has long loved in secret. Since she loves another man who must leave the island, Gilliatt persuades them to marry, facilitates their departure, and then lets himself be drowned by the rising tide as their ship disappears from view.

178:26–27. Part 1, *Les Miserables*, bk. V, ch. 10. Fantine sells her front teeth to buy medicine for her child, whose illness has been falsely reported to her.

178:29–31. In the first published version of this essay, Pater gave credit to Hegel for having "cunningly detected" this early "preparation for the romantic temper" (265:22–24). It is sketched out and explained in Hegel's chapter on "The Dissolution of the Classical Form of Art," *Aesthetik*, II, 100–120.

178:33–179:2. Aphrodite fell in love with the handsome young man Adonis. When he was killed by a boar while hunting, she created the anemone from his blood. To assuage Aphrodite's grief, the gods of the underworld allowed Adonis to spend six months of the year with her on earth. His death and rebirth were celebrated at festivals in many cities of the ancient world. Hyacinthus, a young man loved by Apollo, was killed by a discus thrown by the god. From his blood a flower bloomed. Demeter, a Greek earth goddess, was the mother of Persephone, who was abducted by Hades and taken to the underworld. After a long search and a series of adventures, Demeter succeeded in regaining her daughter for two-thirds of every year. She established the Eleusinian mysteries to commemorate her suffering. Hyperion was a Titan, the father of Helios, the sun; sometimes he himself was regarded as the sun. Oceanus was also a Titan, the father of river gods and water nymphs; Homer considers him the father of all the gods. The Titans were overcome and succeeded by the Olympian gods.

179:5–7. "The blessed gods mourn as it were over their blessedness or their bodily form. We read in their faces the fate that awaits them . . ."—Hegel, *Aesthetik*, II, 78 (trans. Knox, I, 485).

179:7–21. "The germ of their decline the classical gods have in themselves . . ." *ibid.*, p. 100. This germ is the very abstractness of form to which they owe their elevation above contingency: "the blissful peace mirrored in their body is essentially an abstraction from the particular, an indifference to the transient, a sacrifice of the external . . . a renunciation of the earthly and evanescent . . ." (p. 78). And Hegel adds that "the actual emergence of that contradiction between loftiness and particularity, between spirituality and sensuous existence, drags classical art itself to its ruin." In the end, as he says of the gods in a later passage, "the mind cannot any longer find rest in them and therefore turns back from them into itself . . ." (p. 102) (trans. Knox, I, 502, 485, 504).

179:13. Probably the so-called "Master of the Berlin Passion," an engraver of the Lower Rhine, who derives his name from seven engravings of "The Passion" pasted into a book of devotions of 1482, now in Berlin.

179:16–17. For 'twas the morn: Apollo's upward fire
 Made every eastern cloud a silvery pyre
 Of brightness so unsullied, that therein
 A melancholy spirit well might win
 Oblivion, and melt out his essence fine
 Into the winds . . .
 —Keats, "Endymion," bk. I,
 lines 95–100

179:21. In the first published version of this essay, a footnote at the word "age" referred the reader to "Hegel: Aesth., Th. 2, Absch. 3, Kap. 2." Although the whole passage from 178:29 to 179:21 is sufficiently Hegelian, Pater's reference is mistaken. A reference to "Th. 2, Absch. 2, Kap. 3" ("Die Auflösung der klassischen Kunstform") would be correct.

179:28–30. Compare Hegel, *Aesthetik*, II, 148, 155–161.

180:2. Pietro Vannucci, called Perugino (1445/50–1523),

prolific Italian painter whose best work—a fresco in the Vatican, an "Assumption" in the Uffizi, Florence, a "Pietà" in the Accaddemia, Florence—is that of a great master, but whose manner has been criticized for excessive "sweetness" —*Oxford Companion to Art*.

180:3. See 162:21 and n.

180:4–5. Even in romantic art, says Hegel, "although suffering and grief affect the heart and subjective inner feeling more deeply there than is the case with the ancients, there do come into view a spiritual inwardness, a joy in submission, a bliss in grief and rapture in suffering, even a delight in agony. Even in the solemnly religious music of Italy this pleasure and transfiguration of grief resounds through the expression of lament. This expression in romantic art generally is 'smiling through tears'" *Aesthetik*, I, 199–200 (trans. Knox, I, 158).

180:5–9. Goethe's *Werke*, XXX, 166–167.

180:14–23. This passage was quoted by Sidney Colvin in his review of *The Renaissance* as evidence that Pater held "the notion of the continuity of the Renaissance" in opposition to the view of Alexis-François Rio and other writers "of the modern Catholic school in France . . ." *Pall Mall Gazette*, March 1, 1873, p. 11. On the phrase "Christian art" and its promulgation by Rio, see Pater's Preface, xxii:28 and n.

181:3–13. The first half of this paragraph is very much in Arnold's manner. See, e.g., the first four or five pages of his "Heinrich Heine," *Complete Prose Works*, II, 107–111.

181:13–21. Carlyle, in an essay that Pater had undoubtedly read, calls Euphorion "the offspring of Northern Character wedded to Grecian Culture"—who "frisks it" in this scene, he adds, "not without reference to modern Poesy, which had a birth so precisely similar"—"Goethe's *Helena*" (1828), *Works*, XXVI, 191.

182:3–8. Pater's terms for the plight of the spirit in the modern world are reminiscent of Arnold's, notably in "The Scholar-Gipsy." For Hegel's observations on "blitheness," "repose," and unity with the self in Greek tragedy, see the *Aesthetik*, I, 198–199.

182:32–33. Goethe's words are "Im Ganzen, Guten,

Schönen / Resolut zu leben . . ." (In wholeness, good, beauty / Resolute to live . . .") "Generalbeichte," *Werke*, I, 126–127. Pater follows Carlyle, who misquotes Goethe in his essay "Schiller" (1831), *Works*, XXVII, 173n.; at the end of his "Death of Goethe" (1832), *ibid.*, 384; and even in his letter of June 10, 1831, to Goethe himself.

183:22–24. For a significant contrast, omitted after 1867, between the amplitude of Goethe's "composite nature" and the narrower "sensuous gift" of Keats and Giorgione, see Textual Notes, 270:20–26.

183:26–27. "Bekenntnisse einer schönen Seele"—Goethe, *Wilhelm Meister's Lehrjahre*, bk. VI.

183:33–184:3. Compare Pater's Conclusion, 188:19–22.

184:4–5. Pater uses the quoted phrase to mean unused, held in reserve. But in the most famous example of his time it means beyond this life on earth:

> O life as futile, then, as frail!
> O for thy voice to soothe and bless!
> What hope of answer, or redress?
> Behind the veil, behind the veil.
> > —Tennyson, *In Memoriam* (1850), LV

184:18–27. In affirming the supreme importance of the spirit's need for "the sense of freedom," Pater follows Hegel: "Freedom is the highest destiny of the spirit"—*Aesthetik*, I, 124 (trans., Knox, I, 97). But Pater's trust in the efficacy of art to satisfy this need in modern times represents a sharp repudiation of Hegel's well-pondered judgment: "For us art counts no longer as the highest mode in which truth fashions an existence for itself . . . We may well hope that art will always rise higher and come to perfection, but the form of art has ceased to be the supreme need of the spirit . . ."—*ibid.*, 132 (trans. Knox, I, 103).

184:31–185:7. Compare the second paragraph of "Coleridge's Writings," where Pater says in part: "The moral world is ever in contact with the physical; the relative spirit has invaded moral philosophy from the ground of the induc-

tive sciences. There it has started a new analysis of the relations of body and mind, good and evil, freedom and necessity"—*Westminster Review*, XXIX, n.s. (January, 1866), 107. In what follows he takes the point of view of the scientist, to whom man is "the most complex of the products of nature," subject and receptive to a wide range of "subtly linked conditions" or forces and thus not so free as had been supposed.

185:4–5. Compare 91:14–28 and n.

185:10–25. This early affirmation, cautious though it is, of the spiritual power and value of literature may serve as a reminder that Pater's interest in art was not limited to considerations of its formal character and perfection. Compare the famous concluding lines of his essay "Style" (1888), in which he insists that "it is on the quality of the matter it informs or controls, its compass, its variety, its alliance to great ends, or the depth of the note of revolt, or the largeness of hope in it, that the greatness of literary art depends . . ." *Appreciations*, *Works*, V, 38.

185:10–12. In the 1867 and 1873 versions of this essay, Pater names Goethe's *Die Wahlverwandtschaften* as "a high instance of modern art dealing thus with modern life . . ."

Notes on Canceled Passages

249:3–5. "Winckelmanns Biographie," *Werke*, I, XXIV.

251:7–11. "Certain conditions of society which we in no way sanction, certain moral blemishes in others, have a special fascination for our imagination . . . it is in this matter as with game which, to the cultivated palate, tastes better with a slight hint of rottenness than when fresh. A divorced woman, a renegade make an especially interesting impression upon us."—"Winckelmann," Goethe's *Werke*, XLVI, 33 (trans. George Kriehn).

255:7–9. Karl Friedrich Hermann, *Lehrbuch der griechischen Antiquitäten*, pt. 2, entitled *Lehrbuch der gottesdienstlichen Altertümer der Griechen*, 2d ed. (Heidelberg, 1858), p. 3.

256:24. But, for the unquiet heart and brain,
　　　　A use in measured language lies:
　　　　The sad mechanic exercise,
　　　Like dull narcotics, numbing pain.
　　　　　　　—Tennyson, "In Memoriam" (1850), V

257:18. The priestess of Apollo at Delphi.

257:25–27. In *Modern Painters*, vol. III (1856), Ruskin had defined the term as it was commonly used and indicated his sense of the need for a better understanding of its meaning: "The pursuit, by the imagination, of beautiful or strange thoughts or subjects, to the exclusion of painful or common ones, is called among us, in these modern days, the pursuit of '*the ideal*'; nor does any subject deserve more attentive examination than the manner in which this pursuit is entered upon by the modern mind."—*Complete Works*, V, 70. He then devotes five chapters (IV-VIII) to a clarification in which Pater could have found little to suit him.

260:5–6. Francesco Raibolini, nicknamed Il Francia (circa 1450–1517), Bolognese painter whose "Golgotha" or "Crucifixion" was acquired by the Louvre in 1864.

261:19–20. Francis Turner Palgrave, "Sculpture and Painting," in *Essays on Art* (London and Cambridge, 1866), pp. 264–272.

262:19–20. William Holman Hunt's painting of about 1850 in the Tate Gallery, London. Based on Shakespeare's *Measure for Measure*, III, i, it shows the prison scene in which Claudio pleads with his sister Isabella to exchange her virginity for his life. Hunt (1827–1910) was a member of the Pre-Raphaelite Brotherhood.

263:34–35. Pater's footnote refers not to the preceding passage on the blurring of sexual distinctions in Greek sculpture (which Hegel treats in the *Aesthetik*, pt. 3, sec. 2, ch. 2, §3), but forward to the quotation at 175:4–26. Of course Pater knew also Winckelmann's paragraphs on the portrayal of eunuchs and hermaphrodites in Greek sculpture—*Geschichte der Kunst des Altertums* in *Werke*, IV, 72–78.

265:22–26. See n. to 178:29–31.

266:6–7. Keats, "Lamia," pt. 1, line 114.

266:9–14. Maurice de Guérin's dreamlike monologue, "Le Centaure," first appeared in the *Revue des deux mondes* in 1840, the year after his death at the age of twenty-nine. In it the last of the centaurs speaks to an inquiring mortal of his long life in the wooded mountains and foresees his approaching death. I do not find the quoted words in Sainte-Beuve's writings about Guérin. Arnold's essay "Maurice de Guérin" had appeared in *Fraser's Magazine* in January, 1863, and in *Essays in Criticism* (1865).

266:18. *René*, François René de Chateaubriand's tale of a sister's passionate love for her brother, was published first as a section of *Le Génie du christianisme* (Paris, 1802) and republished separately in 1805. Full of a spirit of lonely brooding melancholy, of a frustrated yearning for the infinite, it was one of the most famous and influential of early Romantic writings in France.

268:2–5. In his reference to Fra Angelico, Pater seems to have in mind a Crucifixion, probably the fresco painting of S. Dominic worshipping Christ on the Cross in the cloister of S. Antonino, S. Mark's, Florence. He had seen this painting in 1865. He must also have known the Crucifixion with the Virgin, S. Dominic, and S. John the Baptist in the Louvre, regarded in his time—though not in our own—as an authentic Angelico. A number of Titian's paintings would fit Pater's description.

269:22–24. Goethe, *Die Leiden des jungen Werthers*, 1774.

271:10. Goethe's novel of "elective affinities," published in 1809.

Conclusion

The Conclusion made its first appearance as the last quarter of Pater's review "Poems by William Morris," in the *Westminster Review* for October, 1868. In the surviving letters Pater mentions it only once—on November 2, 1872, when, revising copy for the first edition of *The Renaissance*, he writes

Macmillan that he hopes to send him "in a day or two an additional essay, to form the conclusion of the series"—*Letters of Walter Pater*, ed. Lawrence Evans (Oxford, 1970), p. 9. As it appears in the book, the Conclusion lacks a significant opening paragraph (272:9–34) in which Pater makes what he calls "a strange transition from the earthly paradise [the title of Morris' long poem, discussed in Pater's review; but also, in Pater's phrase, "the bloom of the world"] to the sad-coloured world of abstract philosophy." Three sentences well worth attention (273:21–29) were omitted at 188:19, just before the quotation from Novalis. Other revisions made for the first edition are negligible.

It was the Conclusion which, of all the essays in *The Renaissance*, called forth the strongest expressions of disapproval from reviewers. Yet it is worth noting that about half of the dozen or so reviews in the major journals allowed it to pass unmentioned. John Morley's article in the *Fortnightly Review* (of which Morley was editor at the time) gave the Conclusion a full and on the whole a strongly sympathetic hearing. Pater's ideas in *The Renaissance*, he said, "are grouped in an unsystematic way round a distinct theory of life and its purport"; and he added, "this theory is worth attention." After quoting the last lines of the essay, with their highly provocative claim that "the wisest" spend their interval "in art and song," he remarked protectively: "Of course this neither is, nor is meant to be, a complete scheme for wise living and wise dying"—XIII, n.s. (April, 1873), 474. Though Morley's primary interest was in social reform, writing under Arnold's influence he welcomed the "intellectual play and expansion" (p. 476), the "spacious and manifold energizing in diverse directions," of which Pater's criticism was a distinguished example. For, as he said, "only on condition of this . . . can we hope in our time for that directly effective social action which some of us think calculated to give a higher quality to the moments as they pass than art and song, just because it is not 'simply for those moments' sake'" (p. 477). Soon after the review appeared, Pater sent Morley a grateful note: "*Pater thanks Morley* for your explanation of my ethical point of

view, to which I fancy some readers have given a prominence I did not mean it to have"—*Letters*, p. 14. Attacked in the *Examiner* (April 12, 1873, pp. 381–382) for espousing Pater's doctrine, Morley denied the change (April 19, p. 410).

Some of the other reviewers censured the doctrine of the Conclusion but praised its artistry. Colvin, after paying a high compliment to Pater as a prose writer (see p. 288), pointed to the Conclusion as the best example of his art: "The masterpiece of style is the Conclusion, in which the writer expounds something like a philosophy of life. That philosophy is not ours." And he went on to state his reservations, which were shared by a good many of Pater's readers:

It is a Hedonism—a philosophy of refined pleasure—which is derived from many sources; from modern science and the doctrine of relativity; from Goethe, from Heine, Gautier, and the modern French theorists of art for art; from the sense of life's flux and instability and the precious things which life may yield notwithstanding—from all these well transfused into a personal medium of temperament and reflection, well purged from technicalities, and cast into a literary language of faultless lucidity and fitness. But to go with the writer when he analyzes and discriminates exquisite impressions is not to go with him when he makes the research of exquisite impressions the true business of a wise man's life. By all means, let the people whose bent is art follow art, by all means refine the pleasures of as many people as possible; but do not tell everybody that refined pleasure is the one end of life. By refined, they will understand the most refined they know, and the most refined they know are gross; and the result will not be general refinement but general indulgence.—*Pall Mall Gazette*, March 1, 1873, p. 12.

But what (one might ask) about those few whose understanding of refined pleasure is entirely adequate? Can they reasonably hold "that refined pleasure is the one end of life"? Colvin brings the question to the reader's mind, but he does not answer it.

Other reviewers submitted other objections. "Pure selfishness," said the *London Quarterly Review*, "impossible to 'the

vast majority of mankind,' hopeless and refusing to entertain hope, for the present moment is all that is worth living for. The book is as sad as it is beautiful, and well worth the careful study of all who would know the ideal of those to whom God, truth, duty, and the future are unmeaning terms"—XL (July, 1873), 505. Writing anonymously in *Blackwood's Magazine*, Mrs. Oliphant ridiculed the whole book as "rococo" and the Conclusion in particular for its "grandiloquent description of life," its "conscious grandeur." "We are not afraid," she remarked, more trustful than Colvin, "that this elegant materialism will strike many minds as a desireable view of life . . ." CXIV (November, 1873), 607–608. Arch and superior in tone, her review is less substantial than several others; yet it drew a favorable comment from George Eliot, who wrote to John Blackwood on November 5: "I agree very warmly with the remarks made by your contributor this month on Mr. Pater's book, which seems to me quite poisonous in its false principles of criticism and false conceptions of life"—*The George Eliot Letters*, ed. Gordon S. Haight (New Haven and London, 1955), V, 455. Three years later W. J. Courthope, writing anonymously in the *Quarterly Review*, named Pater as "the most thoroughly representative critic that the romantic school has yet produced" and condemned the Conclusion as the work of a writer suffering under "the enervating influence" (stemming from Wordsworth) of a taste for analysis and introspection—CXLI (January, 1876), 69.

However seriously Pater may have felt obliged to take the reviews—some of which, of course, were inconsequential—the antagonism of his colleagues at Oxford must have been more disturbing. There was certainly a great deal of talk. Mrs. Humphry Ward, who was twenty-two at the time, lived near Pater and knew him well. Forty-five years later she recalled "very clearly the effect of that book, and of the strange and poignant sense of beauty expressed in it; of its entire aloofness also from the Christian tradition of Oxford, its glorification of the higher and intenser forms of esthetic pleasure, of 'passion' in the intellectual sense—as against the

Christian doctrine of self-denial and renunciation. It was a doctrine that both stirred and scandalized Oxford. The bishop of the diocese [John Fielding Mackarness] thought it worth while to protest [in a sermon delivered in Christ Church Cathedral and addressed to the clergy of his diocese]. There was a cry of Neo-paganism, and various attempts at persecution"—*A Writer's Recollections* (New York and London, 1918), I, 161.

"The author of the book," adds Mrs. Ward, "was quite unmoved." So it must have appeared to her and also to others; and yet one remains unconvinced. After the publication of *The Renaissance*, says Lawrence Evans, "Pater's name was suspect for more than a decade, and the hostility of powerful elements in the University made itself strongly felt"—*Letters*, p. xxi. Very likely this hostility explains Pater's failure to win appointment in February, 1874, to a University proctorship to which he would normally have succeeded by virtue of seniority—*ibid.*, p. 12, n. 4. The man selected was John Wordsworth, grandnephew of the poet, later bishop of Salisbury—one of Pater's close friends and tutor next in standing to him at Brasenose. Just after publication of *The Renaissance* in February, 1873, Wordsworth had felt obliged to write Pater a letter (not published until 1915) in which he deplored the Conclusion as "an assertion that no fixed principles either of religion or morality can be regarded as certain, that the only thing worth living for is momentary enjoyment and that probably or certainly the soul dissolves at death into elements which are destined never to reunite"—*ibid.*, p. 13 (letter of March 17, 1873).

The heaviest blow delivered in public against the Conclusion must have been the sermon preached from the University pulpit by W. W. Capes in November, 1873, months after the book had made its initial impact. Once Pater's tutor at Queen's College, from 1869 Capes was rector of Bramshott, Hampshire, but he was still active at Oxford as select preacher to the University, University reader in ancient history, and Queen's College examiner. On this occasion Capes directed his fire against "any philosophy of life that shrinks

into a system of mere personal culture, and narrows all our enthusiasm for progress to an effort at individual perfection." Though he mentioned no names, his language makes it clear that he had in mind not only Arnold, but Pater as well. Both the ideal of personal culture and "the new Philosophy of Art," while superficially attractive, were in his view too self-ish in their aims and interests. "That is a poor philosophy of life," he declared, "which would concentrate all efforts upon self, and bid us to console ourselves amid our pleasures, so they be only intense and multitudinous enough. It needs a loftier spirit to give its true dignity to manhood, and happiness itself so hotly wooed, will surely slip like an insubstantial phantom from the grasp." He devoted the latter part of his sermon to a plea for efforts to "bridge over the yawning gulf between what is, and what should be . . . to deal in earnest with poverty, disease, and crime," to spread throughout the nation "the Spirit of a true Humanity, and the Christlike energy of mutual service"—*Oxford Undergraduates' Journal*, November 27, 1873, pp. 98–99.

Another embarrassment came with the publication, in a series of anonymous articles in the magazine *Belgravia* in 1876, of a clever satire on Pater, Arnold, Jowett, Huxley, and others. The articles were collected and published as *The New Republic* in 1877; with the edition of 1878 it was revealed that the author was W. H. Mallock, who had begun to write his unrespectful sketches as a student at Balliol in the early 1870's. The style, tastes, and opinions of "Mr. Rose" are parodied from the essays of *The Renaissance*, especially the Conclusion. His "aesthetic" prescription for the ills of the time is represented as visionary and narcissistic to the point of lunacy; the wearily affected Mr. Rose reveals in his speeches a dreamily erotic fancy, a disposition to value all experience as artistic or sensuous experience, and late in the proceedings an unbecoming desire to possess a certain book on the "cultes secrets" of Roman ladies.

The effect of all this on Pater has always been a matter for conjecture. The often unreliable Edmund Gosse, who knew Pater in those years, much later recalled that Pater "thought

the portrait a little unscrupulous, and he was discomposed by the freedom of some of its details." At the same time Gosse denied that it caused Pater much distress or induced him "to alter his mode of life and thought to the smallest degree . . . What he liked less, what did really ruffle him, was the persistence with which the newspapers at this time began to attribute to him all sorts of 'aesthetic' follies and extravagances. He said to me, in 1876: 'I wish they wouldn't call me "a hedonist"; it produces such a bad effect on the minds of people who don't know Greek.' And the direct result of all these journalistic mosquito-bites was the suppression of the famous 'Conclusion' in the second (1877) edition of his *Renaissance*"—"Walter Pater," in *Critical Kit-Kats* (London, 1896), p. 258.

Though nothing in the surviving correspondence throws any light on his reasons for withdrawing the Conclusion, Pater outlined them as briefly as possible in the note (186:24–29) attached to the essay when it reappeared in the third edition of 1888. Those "slight changes" made, as he said, to "bring it closer to my original meaning" included the removal of potent words like "religion" and "morality" from possibly offensive statements and also here and there a softening of tone where it might have seemed harsh or abrupt. One can easily remain unconvinced that these alterations brought the text any closer to his original meaning; it is doubtful, too, whether "young men" were any less likely to be misled by the revised text than by the original.

In any case, Pater made no attempt through such tinkering to respond to the substantial objections of critics like Colvin and Capes. That was reserved for certain chapters of *Marius the Epicurean* (1885), where, as he says in his note added to the third edition of *The Renaissance*, he "had dealt more fully . . . with the thoughts suggested" by the Conclusion. His leisurely reconsideration of the "New Cyrenaicism" (in *Marius*, pt. 2, ch. 9), of its powerful attraction for the young Marius, and (in pt. 3, ch. 16) of its shortcomings as Marius a little later comes to see them—all this is no mere exercise in apology and compliance, but a serious effort to see things in a wider

perspective. "And we may note," he says, "as Marius could hardly have done, that Cyrenaicism is ever the characteristic philosophy of youth, ardent, but narrow in its survey—sincere, but apt to become one-sided, or even fanatical. It is one of those subjective and partial ideals, based on vivid, because limited, apprehension of the truth of one aspect of experience (in this case, of the beauty of the world and the brevity of man's life there) which it may be said to be the special vocation of the young to express"—vol. II, pt. 3, ch. 16, *Marius the Epicurean: His Sensations and Ideas, Works* (London, 1910), III, 15.

The twenty additional revisions, all minute, made for the fourth edition of 1893, though not at all negligible in importance, seem designed in every case to improve the grace and accuracy of the language. Only one has a further interest: the abandonment (at 190:25) of the slogan "art for art's sake," replaced by "art for its own sake." Even in 1873 one or two reviewers had complained of having heard enough of "art for art's sake"; perhaps by 1893 it struck the ear as worn-out or quaint.

The Conclusion has attracted more attention than any of Pater's other writings over the past hundred years, and an extended guide to the best of the published commentaries would be out of place here. A student could begin with Geoffrey Tillotson's "Pater, Mr. Rose, and the 'Conclusion' of *The Renaissance*," in *Essays and Studies by Members of the English Association*, XXXII, 1946 (Oxford, 1947), 44–60. This fine essay touches profitably on a wider range of topics than the title suggests: not only on Mallock's parody and the question of Pater's response to it, but also on certain inconsistencies of doctrine in the Conclusion itself, and finally on the character of the Conclusion as viewed from several different angles: as a personal revelation, as a document in the wider Victorian context, and as a manifesto in need of supplementation by the very different program of self-cultivation described in the final pages of the essay on Winckelmann.

More recently, in a judicious weighing of all the reasons Pater may have had for suppressing the Conclusion, Law-

rence F. Schuetz warns against unfair and unduly damaging interpretations—"The Suppressed 'Conclusion' to *The Renaissance* and Pater's Modern Image," *English Literature in Transition*, XVII (Winter, 1974), 251–258. And Germain d'Hangest's sympathetic reflections on the Conclusion are worth pondering, not only in his *Walter Pater: L'Homme et l'oeuvre* (Paris, 1961), where Pater's essay, though seen as dreamy and in some respects evasive, is considered as "the supreme, unconditioned formulation of aestheticism" (I, 100–109), but also in a more recent article which assigns to Pater "the essential and decisive role" in the Aesthetic Movement on the grounds that he was "the first to give a body and a definite outline to a philosophy which was seeking, without yet succeeding, to grasp its own nature," and that "furthermore he based it directly on the contemporary disenchantment; he derived it from that very disenchantment and presented it as a remedy, the only one possible, for the confusion in which scientific progress had plunged Victorian spirits in overthrowing their time-honored ideas about the world, about man, and about man's place in the world"— "La Place de Walter Pater dans le Mouvement Esthétique," *Études anglaises*, XXVII (April–June, 1974), 160.

186: Epigraph. "Heraclitus says 'All things are in motion and nothing at rest'" (trans. Jowett)—a saying of Heraclitus repeated by Socrates in Plato's *Cratylus*, 402A. In 1893 Pater translated these words as: "All things give way: nothing remaineth"—*Plato and Platonism*, *Works*, (London, 1910), VI, 14. Pater's maturer reflections on Heraclitus' idea of "perpetual flux" are set forth in *Marius the Epicurean* (1885) and in *Plato and Platonism* (1893). In the first volume of *Marius*, with the heady despair of the Conclusion undoubtedly in mind, he emphasizes the "seduction" of the doctrine, which seemed, he says, to those who had felt it "to make all fixed knowledge impossible." But this "negative doctrine . . . had been, as originally conceived, but the preliminary step towards a large positive system of almost religious philosophy . . . In this 'perpetual flux' of things and of souls, there was, as Heraclitus

conceived, a continuance, if not of their material or spiritual elements, yet of orderly intelligible relationships, like the harmony of musical notes, wrought out in and through the series of their mutations—ordinances of the divine reason, maintained throughout the changes of the phenomenal world; and this harmony in their mutation and opposition, was after all, a principle of sanity, of reality, there"—*Works*, II, 130–131. In *Plato and Platonism*, he finds in Heraclitus the seeds of the most influential and characteristic thought of his own century, that of Hegel and of Darwin:

The most modern metaphysical, and the most modern empirical philosophies alike have illustrated emphatically, justified, expanded, the divination . . . of the ancient theorist of Ephesus. The entire modern theory of 'development,' in all its various phases, proved or unprovable,—what is it but old Heracliteanism awake once more in a new world, and grown to full proportions? [Paragraph.] Πάντα χωρεῖ, πάντα ρεῖ. —It is the burden of Hegel on the one hand, to whom nature, and art, and polity, and philosophy, aye, and religion too, each in its long historic series, are but so many conscious movements in the secular process of the eternal mind; and on the other hand of Darwin and Darwinism, for which 'type' itself properly *is* not but is only always *becoming* . . . Nay, the idea of development (that, too, a thing of growth, developed in the process of reflection) is at last invading one by one, as the secret of their explanation, all the products of mind, the very mind itself, the abstract reason; our certainty, for instance, that two and two make four—*Works*, VI, 19–21.

186:3. What Pater means by "modern thought" is defined by the reflections and considerations of the first two paragraphs of the Conclusion. His imagination of "our physical life" is consistent with the aggressive natural science of his time; his account of "the inward world of thought and feeling" (187:7–8) draws on the skeptical empiricism of Descartes, Locke, Berkeley, Hume, and Kant. (See n. to 187:7–188:2.)

Pater's familiarity with a wide range of philosophical views and positions, even in his earlier years, should not be under-

estimated. One sees evidence of it in his essay on Coleridge (1866) and even as early as 1864 in "Diaphanéité." From 1867 on, his duties as fellow of Brasenose College included lecturing on the history of philosophy, and there was nothing narrow or partisan in his presentation. One of his students recalls that "he treated all systems with grave respect, simply put their leading tenets before you, whether it was the doctrine of Thales that all was water, or of Anaxagoras that all was air, or Heraclitus's theory of the 'perpetual flux,' or—to pass from the ancient to the modern world—Helvetius's that the philosopher should test every experience in his own person; whatever it was, it was stated and elucidated with all gravity, not a tone or a look betraying any personal sympathy or preference. This cultured toleration had the effect of an exquisite irony, reminiscent of Socrates"—Edward Manson, "Recollections of Walter Pater," *Oxford Magazine*, November 7, 1906, p. 61. Manson became a student at Brasenose in 1869.

186:7–187:6. Compare Thomas Huxley: ". . . the naturalists find man to be no center of the living world, but one amidst endless modifications of life"—"On Improving Natural Knowledge" (1866), in *Collected Essays* (New York, 1896–1897), I, 37. There is, moreover, as Ruth Child has noticed, "a decided similarity" between Pater's conception of the physical life and that of Herbert Spencer presented in *First Principles* (London, 1862), pt. 2, on "The Knowable." Compare, for example, this sentence from ch. 14, "The Law of Evolution": ". . . the evolution of an organism is primarily the formation of an aggregate, by the continued incorporation of matter previously spread through a wider space. Every plant grows by taking into itself elements that were before diffused, and every animal grows by reconcentrating these elements previously dispersed in surrounding plants or other animals"—(London and New York, 1910), pp. 283–284.

186:12–17. For its general idea and possibly for its examples, this sentence may be indebted to Spencer's chapter on "Waste and Repair" (1864): "Repair is everywhere and al-

ways making up for waste. Though the two processes vary in their relative rates both are constantly going on"—*The Principles of Biology* (London and New York, 1910), I, 216. Spencer's examples include among others the repair of eye tissue by circulation of the blood (p. 218); the brain also is mentioned, though only as an organ liable to fatigue so severe as to prove permanently disabling (p. 218). Compare Huxley: "All work implies waste, and the work of life results, directly or indirectly, in the waste of protoplasm." Happily, he adds, protoplasm has the "capacity of being repaired," and he goes on to explain that "the vegetable world builds up all the protoplasm which keeps the animal world agoing"—"On the Physical Basis of Life," *Fortnightly Review*, XXVI, n.s. (February 1, 1869), 137, 138.

186:21–22. Laertes at Ophelia's grave: "Lay her i' th' earth, / And from her fair and unpolluted flesh / May violets spring"—*Hamlet*, V, i.

186:24–29. The Conclusion, omitted in the second (1877) edition of *The Renaissance*, was restored "with some slight changes" in the third edition of 1888. In the first volume of *Marius the Epicurean* (1885), Pater reconsiders the doctrines of Heraclitus and their effect on the young men of his narrative —*Works*, II, 128–133.

187:2–3. The image of nature weaving "a design in a web" recalls the "magic web" of 185:3–7 and the "weaving and unweaving of ourselves" of 188:18. In *Marius the Epicurean*, Pater mentions "that eternal process of nature, of which . . . Goethe spoke as the 'Living Garment,' whereby God is seen of us, ever in weaving at the 'Loom of Time'" —*Works*, II, 129. He had in mind the weaving song of the Earth Spirit, *Faust*, pt. 1, scene 1, lines 155–156.

187:7–188:18. The "analysis" (188:2) of this paragraph is based ultimately and consciously on Berkeley and Kant. In an undated, unpaged, autograph manuscript essay, Pater notes that Berkeley's arguments against "the reality of objects, the existence of matter" were taken up by Kant and turned against "the substantial reality of mind"—with the

result that "what remained of our actual experience was but a stream of impressions over the ⟨supposed but⟩ wholly unknown mental substratum which no act of intuition or reflexion could ever really detect. ¶ And if we know so little it might be urged of the supposed substance of one's own mind how much less can we really penetrate into the minds of others of whose whole inward existence in a strictly logical estimate of the facts nothing really comes to us but a stream of material phenomena as of ourselves to ourselves but the stream of the phenomena of our own elusive inscrutable mistakable self"—MS bMS Eng 1150 (3), Houghton Library, Harvard University, pp. [43–44].

What "might be urged"—this skeptical argument traced back in the manuscript to its origins in the empiricist tradition—was urged in fact as an inescapable consequence of "modern thought" in the solipsistic credo of the Conclusion. And the practical effect of this particular vein of skepticism, as Pater describes it (though more cautiously) in the manuscript, is just what the exhortations of the last two paragraphs of the Conclusion would lead us to expect: "That we cannot really know the mental substance in ourselves and still less in others might make us so much the closer observers of the *accidents* of mind the phases and phenomena of its actual and concrete trains of thought in ourselves or in others as still further varied and expanded by the action ⟨influence⟩ of the imagination in art in poetry or fiction; above all it might bring us back with a great sense of relief after the long strain of a too curious self-inquiry to the phenomena of the superficial natural world its conditions and sequences of which indeed those mental phenomena would from this point of view be but a part" (p. [45]). (Editor's note: Pater's superlinear insertions are printed here in angle brackets.)

187:29–188:2. Marius considered the "doctrine of the subjectivity of knowledge" under the influence of Aristippus of Cyrene—vol. I, *Marius the Epicurean*, *Works*, II, 134–143. In "this happily constituted Greek" the idea that "things are but shadows, and that we, even as they, never continue in

one stay" did not lead to an enervating nihilism but "prompt-ed a perpetual, inextinguishable thirst after experience" (pp. 135–136).

188:19–20. "Fragmente II," *Werke* (Heidelberg, 1957), III, 64. Novalis was the pseudonym of Baron Friedrich von Har-denberg (1772–1801), the German poet and novelist. For a similar thought, compare 183:33–184:3.

188:27–28. "Not pleasure, but a general completeness of life, was the practical ideal to which this anti-metaphysical metaphysic [of Aristippus] really pointed . . . From that maxim of *Life as the end of life*, followed, as a practical con-sequence, the desireableness of refining all the instruments of inward and outward intuition, of developing all their capaci-ties, of testing and exercising one's self in them, till one's whole nature became one complex medium of reception, to-wards the vision—the 'beatific vision,' if we really cared to make it such—of our actual experience in the world"—vol. I, *Marius the Epicurean*, *Works*, II, 142–143. In the following chapter on the "New Cyrenaicism," Marius explores some of the implications of this ideal as "a new form of the contem-plative life" (p. 148); in a later chapter, "Second Thoughts," he defines its limitations.

188:28–33. Compare the cooler language of Pater's later restatement of these questions—*ibid.*, 146–147.

189:1–2. Though of course it is the usual sense of "flame" as fire that is invoked by various touches in the paragraphs leading up to this most famous of Pater's sentences, it may be just worth noting that one might speak of the "flame" of a gem, as William Cowper does in his poem "Friendship" (1800).

189:26–27. Victor Hugo, *Les Misérables*, pt. 5, vol. I, bk. 2, ch. 2.

189:33–190:10. *Les Confessions de J.-J. Rousseau*, pt. 1, bk. VI, in *Oeuvres complètes* (Paris, 1836), I, 122. Rousseau does not mention reading Voltaire.

190:10–13. *Le Dernier Jour d'un condamné* (1832), in *Oeuvres complètes* (Paris, 1910), I, 629.

190:16. "And the Lord commended the unjust steward,

because he had done wisely: for the children of this world are in their generation wiser than the children of light"—Luke 16:8.

190:25. All earlier editions of the Conclusion had "art for art's sake." But Pater had already varied that famous phrase: "In the making of prose he [Lamb] realises the principle of art for its own sake, as completely as Keats in the making of verse"—"The Character of the Humourist: Charles Lamb," *Fortnightly Review*, XXIV, n.s. (October, 1878), 468. This essay was reprinted under the title "Charles Lamb" in *Appreciations* (1889).

Notes on Canceled Passages

272:30–34. See nn. to 186:Epigraph and 186:3.

274:31–32. Pater's readers would have recognized his oblique allusion to the "Religion of Humanity" founded by the French philosopher Auguste Comte (1798–1857), who outlined its tenets in his *Catéchisme positiviste* (1852). For the worship of God, Comte proposed the worship of humanity, past, present, and future. His principal English interpreters were John Stuart Mill and Frederic Harrison, through whose writings many others felt his influence. Pater found the idea valuable as "the centre of a new formation of the religious sentiment" and welcomed its ethical implications—unpaged autograph manuscript essay (bMS Eng 1150 [17], Houghton Library, Harvard University, pp. [38–39]; though this MS is not dated, Pater's notes reveal that he thought of using parts of it in *Marius the Epicurean*, composed between 1881 and 1884). For Pater, a Platonic "enthusiasm" may confer a "divinatory power" (152:10–16), and the "enthusiasm of humanity" cannot be very different from the passionate humanism he finds in Pico (38:18) and in Winckelmann.

274:35. Where Pater first encountered a phrase that was so widely current in his lifetime it is of course impossible to say, and one must observe that here in the Conclusion he uses it neither as the slogan for a movement nor as the label for an aesthetic creed. The phrase was used by Benjamin Constant

as early as 1804 and by Victor Cousin in 1818; in England it
achieved currency and familiarity in the 1860's. Pater en-
countered the doctrine, if not the words, in Goethe and in
Baudelaire, both of whom set themselves against "the heresy
of instruction." Hegel also, from whom Pater learned so
much, held that art has no proper end outside itself—*Aes-
thetik*, ed. H. G. Hotho, 2d ed. (Berlin, 1842), I, 71–72. No
one was more firmly attached to this idea than Gautier, who
began in the early 1830's to propagate it tirelessly. In 1847 he
refers to "the famous formula of art for art's sake [*l'art pour
l'art*]" and offers a definition: "Art for art's sake signifies, for
the initiated, a work free from all preoccupation except that of
the beautiful in itself"—*Revue des deux mondes*, XIX, n.s.
(September 1, 1847), 900. Gautier's prestige as a critic and
poet was high in Swinburne's circle, which Pater seems to
have frequented from 1868 to 1870, at just the moment when
Swinburne himself was the chief spokesman and interpreter in
England of French views on art—those above all of Hugo,
Gautier, and Baudelaire. Particularly in his *William Blake*
(London, 1868), a book which Pater must have read, Swin-
burne insists that art must not concern itself with moral,
didactic, or religious ends: "Her business is not to do good on
other grounds, but to be good on her own . . . Art for art's
sake first of all . . ." pp. 90–91.

Review of *Children in Italian and English Design*, by Sidney Colvin

191:1. The parts of Colvin's book had appeared in *The
Portfolio*, an illustrated art magazine, in August, September,
October, and December, 1871, and in April, 1872.

191:6. The artist, philosopher, and poet William Blake
(1757–1827) developed a method of printing his own poetic

works with handwritten text and illustration engraved to-
gether to form a decorative unit. The first of his books to be
produced in this way was *Songs of Innocence* (1789), to which
Colvin gives most of his space and praise. Thomas Stothard
(1775–1834) was the most popular book illustrator of his
time, a designer of prodigious industry and facility. Besides
the vignettes mentioned in Pater's review, Colvin reproduced
one of Stothard's drawings from the 1830 edition of Samuel
Rogers' poem *Italy*, and another showing a boy with his teeth
sunk in an apple while a girl reaches impatiently for her share.
John Flaxman (1755–1826) made his considerable reputation
first as a draughtsman and then as a sculptor, chiefly of monu-
ments and standing figures. Along with several vignettes and
"The Mothers" of his frontispiece, Colvin gives four of Flax-
man's drawings in full-page reproductions without any indi-
cation of their use, history, or location in his own time.

191:12–16. Colvin, p. 17.

191:16–23. Colvin, p. 54. Sir Joshua Reynolds (1723–
1792), "the most important artist of his day . . . established a
new school of English portraiture which combined the dig-
nity of the Grand Manner with a genuine sensitiveness to the
personality of his subjects . . ." *Oxford Companion to Art*.

192:5–6. Portrait painting, says Colvin, "should perhaps
count beside the question when it is a type which we are seek-
ing, an accepted or instinctive mode of designing childhood
generally . . ." p. 2.

192:6–8. *Ibid.*

192:10. One of the plates is from the "Praeludium" to *The
Book of Urizen* (1794); the other is no. 7 of *America: A Prophecy*
(1793).

192:13–14. *Songs of Innocence and Experience, with other
poems*, ed. Richard H. Shepherd (London, 1866).

192:29–193:16. Colvin, pp. 35–36.

193:12–13. Anna Eliza Stothard (afterward Bray), *Life of
T. Stothard* (London, 1851).

193:24–27. *Ibid.*, p. 42.

193:28–31. In Flaxman's earlier "Italian phase," says Col-

vin, "a Roman mother and her child, or children, are usually treated in a mode which is the extreme, the exaggeration of that which I have called architectonic—their limbs being conceived as masses for adjustment in something like rigid geometrical or architectural figures"—p. 45.

193:31–194:3. Colvin's frontispiece, which he called "The Mothers," shows three standing female figures, one on each side holding infants and one in the center facing forward with hands outspread. Though in doubt as to its "meaning or motive," he suggests as a possibility "motherhood in honour and motherhood in dishonour, with Charity coming between the two to proclaim them equally worthy"—p. 46. In his opinion, the drawing was "typical of Flaxman's mastery with pen-and-ink . . ." a claim he supports by comments on its details.

194:11–12. Colvin, p. 3.

194:13–16. "The burden of the supernatural, which is always in some degree the unnatural, rests inevitably upon this fair population of worshipping angel-children . . ." *ibid.*, p. 7.

194:23. See 20:13 and n.

195:7–8. The French painter Fragonard (1732–1806) was in disrepute as much for the frivolity as for the eroticism of his characteristic works, of which "The Swing," now in the Wallace Collection in London, was probably the best-known example. But Colvin reports having seen some of his drawings of children "simply composed and as full of sweetness and delicate expression as need be. That sounds out of keeping with the reputation and improper predilections of Fragonard; but so it is; and his was one of those alert and adroit spirits which lose no impression that is brought across them, and one which, distinctly preferring vice on its own account, could nevertheless see and interpret, not without delightfulness and a touch of poetry, the grace and gestures of the innocent. So much by way of historical justice . . ." p. 46.

195:9–15. See xix:21–24 and n.

Review of *Renaissance in Italy: The Age of the Despots,* by John Addington Symonds

196:1–4. Volumes II, *The Revival of Learning*, and III, *The Fine Arts*, appeared in 1877; IV and V, *Italian Literature*, in 1881; VI and VII, *The Catholic Reaction*, in 1886.

196:15. *Studies of the Greek Poets*, 2 vols. (London, 1873, 1876).

196:21–197:3. Symonds, p. 34.

197:5–6. Symonds, p. 39.

197:8–9. Francesco Sforza (1401–1466), soldier of fortune who forced the republic of Milan to accept him as duke in 1450; Girolamo Savonarola (1452–1498), Dominican monk, preacher, and reformer, burned as a heretic in Florence; Niccolò Machiavelli (1469–1527), Florentine statesman and writer; Rodrigo Borgia (1431?–1503), pope as Alexander VI from 1492.

197:10–11. Benvenuto Cellini (1500–1571), sculptor, goldsmith, and author of the famous autobiography; Cesare Borgia (1475?–1507), son of Rodrigo, soldier and statesman.

197:12. Federigo (1422–1482), Count of Montefeltro, Duke of Urbino from 1474. By profession a military leader, he was known as a model of character, cultivation, and conduct, a generous patron of art and learning, and the center of a brilliant court.

197:16. The Renaissance, says Symonds, was "the emancipation of the reason for the modern world" (p. 6); "the emancipation of the spirit in the modern age" (p. 31).

197:29–31. Hippolyte Taine (1828–1893), *Philosophie de l'art en Italie* (Paris, 1866).

197:31–32. Stendhal was the pseudonym of Henri Beyle (1783–1842), whose *Histoire de la peinture en Italie* was published in Paris in 1817. *Chroniques Italiennes* is a title used first in 1855 for a collection of tales published in Paris as part of an edition of Stendhal's works.

198:8–10. "Of these lazy princes, therefore, and of these despicable arms my history will be full"—*Historie Fiorentine* (Florence, 1532), from the last sentence of bk. I. Symonds explains in his text (p. 181) that in this sentence Machiavelli expressed his contempt for those men in positions of power who failed for various reasons to cultivate the arts of warfare and entrusted their armies to paid captains.

198:21–22. Pope Alexander VI (1431?–1503) was one of the most ruthless and treacherous men of his age. Ezzelino da Romano (1194–1259) was Ghibelline lord of Verona, Vicenza, and Padua. His coldly deliberate cruelty on a vast scale made him legendary. Symonds suggests that he was the victim of "an insane appetite" for bloodshed (p. 45).

198:24. Torquato Tasso (1544–1595), Italian epic poet. For Leonardo da Vinci's name, Symonds uses the spelling "Lionardo," as Pater himself had done in the first edition of *The Renaissance*, though not thereafter.

198:24–199:4. Pater's belief that sympathy in some sense of the word was a characteristic and empowering virtue of the Renaissance artist is easy to trace in his own essays on the Renaissance. Compare Michelet: "*A world of humanity, of universal sympathy begins*. Man is finally the brother of the world . . . There is the true meaning of the Renaissance: tenderness, kindness toward nature"—*Histoire de France* (Paris, 1833–1867), VII, 313–314. See also 43:31–44:3 and n.

198:27–28. Symonds, p. 305.

199:2–3. Symonds, p. 383.

199:4. The Italian despot, says Symonds, not infrequently "destroyed pity in his soul, and fed his dogs with living men, or spent his brains upon the invention of new tortures" (p. 56).

199:5–7. Symonds, pp. 105–114.

199:8. Symonds, pp. 115–122. Baldassare Castiglione (1478–1529), *Il Libro del Cortegiano* (Florence and Venice, 1528), a famous discussion in dialogue of the qualifications of the ideal courtier.

199:9–10. Symonds, pp. 174–179. The *Trattato del Go-*

CRITICAL AND EXPLANATORY NOTES

verno della famiglia, often reprinted as the work of the Florentine Agnolo Pandolfini (1360–1446), is an abridgment of the third book of the treatise *Della famiglia* by the architect, painter, organist, and writer Leon Battista Alberti (1404–1474).
199:11–13. Symonds, pp. 400–402. Pietro Paolo Boscoli failed in his attempt to assassinate the Medici in 1513.
199:13–18. Symonds, p. 401. The artist Luca della Robbia the younger consoled Pietro Boscoli on the night of his execution and wrote a detailed account of their conversation.
199:21–200:14. Symonds, pp. 23–24.
199:21. Stefano Infessura (before 1436–before 1500), *Diario della città di Roma*, in *Rerum Italicarum Scriptores*, ed. L. A. Muratori (Mediolani, 1723–1751), III, pt. 2, cols. 1192–1193.
200:8. Francesco Matarazzo (1443–1518), a humanistic scholar and historian of Perugia known as "Maturànzio." I have not found his version of the story. "Il Notaio del Nantiporto [or Antiporto]" was the anonymous author of a Roman diary of the years 1481–1492—*Rerum Italicarum Scriptores*, III, pt. 2, cols. 1069–1108. He tells the tale in col. 1094.
200:23. Symonds, pp. 182–263.
200:29. Symonds, p. 138.
200:31–33. Niccolò Machiavelli's celebrated treatise *Il Principe* (The Prince), an analysis of the principles by which a prince can gain and keep power, was first published in 1532.
201:9–10. Symonds, pp. 428–471.
201:11–12. Symonds, app. IV, pp. 544–560.
201:12–13. Symonds, pp. 472–525.

Original Texts of Passages
Translated in the Notes

Preface

xix:11–18. La beauté absolue et éternelle n'existe pas, ou plutôt elle n'est qu'une abstraction écrémée à la surface générale des beautés diverses.

xix:16. Je tourmente mon esprit pour en arracher quelque formule qui exprime bien la *specialité* d'Eugène Delacroix. J'admets volontiers . . . que chaque génie, chaque talent distingué a une forme, un procédé général intérieur qu'il applique ensuite à tout. Les matières, les opinions changent, le procédé reste le même. Arriver ainsi à la formule générale d'un esprit est le but idéal de l'étude du moraliste et du peintre de caractères.

xx:17–28. Un artiste, un homme vraiment digne de ce grand nom, doit posséder quelque chose d'essentiellement *sui generis*, par la grâce de quoi il est *lui* et non un autre. A ce point de vue, les artistes peuvent être comparés à des saveurs variées . . .

xxi:9–11. Qu'on veuille bien se figurer ce que pouvait être un ami de Racine ou de Fénelon, un M. de Tréville, un M. de Valincour, un de ces honnêtes gens qui ne visaient point à être auteurs, mais qui se bornaient à lire, à connaître de près les belles choses, et à s'en nourrir en exquis amateurs, en humanistes accomplis. Car on était humaniste alors, ce qui n'est presque plus permis aujourd'hui.

Two Early French Stories

1:14–18. Cette ère [the Renaissance] eût été certainement le douzième siècle, si les choses eussent suivi leur cours naturel.

Le XI^e siècle avait été témoin, en philosophie, en poésie, en architecture, d'une renaissance comme l'humanité en comte peu dans ses longs souvenirs. Le XII^e et le XIII^e siècle avaient développé ce germe fécond, le XIV^e et le XV^e siècle en avaient vu la décadence.

3:26–28. . . . une curieuse chanson bretonne en dialecte de Cornouaille, où Héloïse, *Loiza*, raconte qu'instruite par son clerc, *ma c'hloarek, ma dousik Abalard*, elle est devenue, grâce à la connaissance des langues, une sorcière semblable aux druidesses celtiques.

3:31–4:5. Sed quoniam prosperitas stultos semper inflat et mundana tranquillitas vigorem enervat animi et per carnales illecebras facile resolvit, cum jam me solum in mundo superesse philosophum estimarem nec ullam ulterius inquietationem formidarem, frena libidini cepi laxare, qui antea vixeram continentissime.

4:13–21. Quel était donc ce prodigieux enseignement, qui eut de tels effets? Certes, s'il n'eût rien que ce qu'on a conservé, il y aurait lieu de s'étonner. Mais on entrevoit fort bien qu'il y eut tout autre chose. C'était plus qu'une science, c'était un esprit, esprit surtout de grande douceur, effort d'une logique humaine pour interpréter la sombre et dure théologie du Moyen-age. C'est par là très probablement qu'il enleva le monde, bien plus que par sa logique et sa théorie des universaux.

. . . esprit surtout de grande douceur . . .

4:29–30. . . . in questo mondo, / contemplando, gusto di quella pace.

5:10. Quali / son le mie note a te, che non le 'ntendi, / tal è il giudicio etterno a voi mortali.

5:18–27. Quoique la réponse du pape ne soit pas venue jusqu'à nous, il n'est pas douteux qu'il se prêta de bonne grâce à une demande aussi juste. Délivré de toute inquiétude, Abélard passa le reste de ses jours dans un calme égal aux troubles dont ils avoient été jusqu'alors agités. Tous ses momens libres furent partagés entre la prière, l'étude et des conférences que l'abbé le chargeoit de faire de temps en temps à la communauté.

6:13–15. Quand a ceulx qui ne vouldroient receuoir ce genre d'escripre qu'ilz appellent obscur, pource qu'il excede leur iugement, ie les laisse auecg' ceulx, qui, apres l'invention du Bléd, vouloient encores viure de Glan.

12:9–17. . . . des pièces dialoguées dans lesquelles deux ou plusieurs interlocuteurs soutenaient des opinions contraires sur une thèse donnée.

12:20–23. On possède une copie unique du conte d'Aucassin et de Nicolette: c'est le manuscrit coté no. 7989² (Baluze) du fonds françois de la Bibliothèque impériale. Le dialecte est celui de l'Ile-de-France, qui tend généralement à se rapprocher des formes et de la prononciation modernes.

19:26–30. . . . que le Saint-Esprit, c'est le libre esprit, l'age de science: 'Il y a trois âges, trois ordres de personnes parmi les croyants. Les premiers ont été appelés au travail de l'accomplissement de la Loi; les seconds, au travail de la Passion; les derniers, qui procèdent des uns et des autres, ont été élus pour la Liberté de la contemplation. C'est ce qu'atteste l'Écriture, lorsqu'elle dit: "Où est l'Esprit du Seigneur, là est la Liberté." Le Père a imposé le travail de la Loi, qui est la crainte et la servitude; le Fils, le travail de la Discipline, qui est la sagesse; le Saint-Esprit offre la Liberté, qui est l'amour.

Ce grand enseignement était l'alpha de la Renaissance. Il circula dès lors comme un Évangile éternel. Plusieurs l'enseignèrent dans les flammes. Et Jean de Parme . . . professa hardiment: 'Quod doctrina Joachimi excellit doctrinam Christi.'

20:25–21:2. . . . il ne s'agit véritablement de rien sacrifier, de rien déprécier. Le Temple du goût, je le crois, est à refaire; mais, en le rebâtissant, il s'agit simplement de l'agrandir, et qu'il devienne le Panthéon de tous les nobles humains, de tous ceux qui ont accru pour une part notable et durable la somme des jouissances et des titres de l'esprit.

215:9–10. Dom Berthod apporta dans l'étude de leurs actes la critique froide et sévère qui distingue les travaux des Bollandistes, et il conclut, sans attaquer la réalité de leur existence, que rien dans leur vie ne permettoit de les considérer comme des martyrs.

Pico della Mirandola

25:22–26:9. Le trait caractéristique du XIX^e siècle est d'avoir substitué la méthode historique à la méthode dogmatique, dans toutes les études relatives à l'esprit humain.

26:1–2. Was die Erziehung bei dem einzeln Menschen ist, ist die Offenbarung bei dem ganzen Menschengeschlechte.

32:7–9. . . . questa dipintura / Di Dio pietoso sommo Creatore, / Lo qual fe tutte cose con amore . . .
La figura dell'Eterno Padre che abbraccia l'Universo . . .

37:32–38:2. Hos ego libros non mediocri impensa mihi comparassem . . .

42:3–14. En fait, tous les bons et vrais dessinateurs dessinent d'après l'image écrite dans leur cerveau, et non d'après la nature.

Quand M. Delacroix compose un tableau, il regarde en lui-même au lieu de mettre le nez à la fenêtre: il a pris de la création ce qu'il lui en fallait pour son art, et c'est ce qui donne cette force d'attraction intime à des tableaux souvent rebutants d'aspect.

Sandro Botticelli

43:19–20. . . . quel cattivo coro / degli angeli che non furon ribelli, / nè fur fedeli a Dio, ma per sè foro. / Caccianli i ciel per non esser men belli, / nè lo profondo inferno gli riceve, / chè alcuna gloria i rei avrebber d'elli.

43:22. . . . vidi e conobbi l'ombra di colui / che fece per viltà il gran rifiuto.

Luca della Robbia

51:18–28. Und geht sie nun auch zur näheren Bestimmtheit des Menschlichen in Gestalt und Charakter fort, so muss

sie auch hierin nur das Unveränderliche und Bleibende, die Substanz dieser Bestimmtheit auffassen, und nur diese, nicht aber das Zufällige und Vorübereilende sich zum Inhalt wählen . . .

55 : 18–24. Onde il magnifico Piero di Cosimo de' Medici, fra i primi che facessero lavorar a Luca cose di terra colorita, gli fece fare tutta la volta in mezzo tondo d'uno scrittoio nel palazzo edificato, come si dirà, da Cosimo suo padre, con varie fantasie, ed il pavimento similmente, che fu cosa singolare, e molto utile per la state.

The Poetry of Michelangelo

57 : 5–8. Le beau est toujours bizarre.

58 : 5–6. Presque tout coup portait. Il y avait quelques cadavres çà et là, et des flaques de sang sur les pavés. Je me souviens d'un papillon blanc qui allait et venait dans la rue.

60 : 1–3. La pierre s'anime et se spiritualise sous l'ardente et sévère main de l'artiste. L'artiste en fait jaillir la vie. Il est fort bien nommé au moyen âge: "Le maître des pierres vives."

60 : 20–24. . . . quei che sono quivi dipinti furon poveri ancor essi.

63 : 7–9. On raconte qu'un jour les deux artistes s'étant rencontrés dans la cour du Vatican, l'un, entouré de son cortège d'élèves, allant aux Stanze, l'autre se rendant solitairement à la chapelle Sixtine, Michel-Ange dit au Sanzio: "Vous marchez avec une grande suite, comme un général"; à quoi Raphael aurait répondu: "Et vous, vous allez seul, comme le bourreau."

63 : 9–10. Plusieurs fois il voulut mourir. Un jour qu'il s'était blessé à la jambe, il barricada sa porte, se coucha, n'ayant plus envie de se relever jamais. Un ami, voyant cette porte qui ne s'ouvrait plus, eut des craintes, chercha, trouva un passage, et, étant arrivé à lui, le força de se laisser soigner et guérir.

63 : 13–14. Fitti nel limon dicon: "Tristi fummo / nell' aer

dolce che dal sol s'allegra, / portando dentro accidioso fummo; / or ci attristriam nella belletta negra."

66:32–67:1. nicht sowohl von dem Vorsatz als von der Grille des Selbstmords . . .

eine Begebenheit, eine Fabel . . .

Goethe hat sich, wie er selber sagt, durch die Abfassung des Werther von der Noth und Bedrängniss des Innern, welche er schildert, befreit.

73:12–14. di lei uno ardentissimo desiderio. E, perchè da casa al luogo della sepoltura fu portata scoperta, a tutti che concorseno per vederla mosse grande copia di lacrime.

Leonardo da Vinci

77:1–2. a) Perilche fece ne l'animo, un concetto si eretico che e' non si accostava a qualsiuoglia religione stimando per avventura assai piu lo esser filosofo, che Christiano.

b) Finalmente venuto vecchio, stette molti mesi ammalato, & vedendosi vicino alla morte, disputando de le cose catholiche, ritornando nella via buona; si ridusse a la fede Christiana con molti pianti. [Changed in the second edition to read, following "alla morte"]: si volse diligentemente informare della cose catoliche e della via buona e santa religione cristiana, e poi con molti pianti confesso e contrito . . . volle divotamente pigliare il Santissimo Sacramento . . .

78:3. . . . le grand Italien, l'homme complet, équilibré, tout-puissant en toute chose, qui résumait tout le passé, anticipait l'avenir, qui, par delà l'universalité florentine, eut celle du Nord, unissant les arts chimiques, mécaniques, à ceux du dessin.

. . . la grande fée . . .

. . . fils de l'amour et lui-même le plus beau des hommes, sent qu'il est aussi la nature; il n'en a pas peur. Toute nature est comme sienne, aimée de lui . . .

Même audace dans ses Lédas, ou l'hymen des deux natures est marqué intrépidement, tel que la science moderne l'a

découvert de nos jours, et toute la création retrouvée parente de l'homme.

. . . les défaillantes figures . . .

. . . leurs regards malades et mourants . . .

. . . le génie de la Renaissance, en sa plus âpre inquiétude, en son plus perçant aiguillon.

. . . ceux ci sont des dieux, mais malades. Nous n'en sommes pas à la victoire. Galilée est loin encore. Le Bacchus et le saint Jean, ces âpres prophètes de l'esprit nouveau, en souffrant, en sont consumés.

Ce surprenant magicien, le frère italien de Faust, étonna et effraya.

81:16–17. La nature seule est la maîtresse des intelligences supérieures.

Dans l'étude des sciences qui tiennent aux mathématiques, ceux qui ne consultent pas la nature, mais les auteurs, ne sont pas les enfans de la nature; je dirais qu'ils n'en sont que les petits fils: elle seule, en effet, est le maître des vrais génies.

85:30–86:4. Le faste d'une cour brillante convenait à ses goûts de plaisir. Moins scrupuleux que ne l'eût été Michel-Ange en pareil cas, son pinceau se prêta plus d'une fois aux fantaisies licencieuses de son maître. Il ordonnait des fêtes dont il était lui-même l'ornement, et les mariages de Jean Galeas avec Isabelle de Naples, du duc lui-même avec Béatrice d'Este, lui fournirent l'occasion de déployer toutes les ressources de son inventif esprit.

87:2–3. . . . les fleurs les plus élégantes, celles dont la forme devait le plus flatter son goût parfait: des ancolies et des cyclamens.

. . . jasmin, fleur favorite de Léonard . . .

87:7–8. . . . cette couleur bitumineuse qui a tant fait noircir la plupart des tableaux de ce maître . . .

90:1–91:28. . . . une attitude analogue devant l'art, qui consiste à aborder les oeuvres par leur contenu imaginatif, à chercher en elles la source d'une extase, à faire surtout du rêve l'instrument majeur de la critique, engendre une communauté de langage, une même recherche de cadences étouffées et lentes, d'effets narcotiques.

91:14–28. L'idée d'une chaîne continue qui, par degrés insensibles, relie le monde de la matière à celui de l'esprit est dans ce passage un reflet manifeste de l'évolutionnisme de Spencer.

93:10–16. . . . par quelle étrange fantaisie le peintre a-t-il mis une croix dans la main de cette figure profane? Ce *Saint Jean* est une femme, personne ne s'y trompe. C'est l'image de la Volupté . . .

C'est une femme, un corps de femme, ou tout au plus un corps de bel adolescent ambigu, semblable aux androgynes de l'époque impériale, et qui, comme eux, semble annoncer un art plus avancé, moins sain, presque maladif, tellement avide de la perfection et insatiable de bonheur, qu'il ne se contente pas de mettre la force dans l'homme et la délicatesse dans la femme, mais que, confondant et multipliant, par un étrange mélange, la beauté des deux sexes, il se perd dans les rêveries et les recherches des âges de décadence et d'immoralité.

93:21–23. . . . nous semble avoir abusé de ce sourire; d'un fond d'ombres ténébreuses, la figure du saint se dégage à demi; un de ses doigts montre le ciel; mais son masque, efféminé jusqu'à faire douter de son sexe, est si sardonique, si rusé, si plein de réticences et de mystères, qu'il vous inquiète et vous inspire de vagues soupçons sur son orthodoxie. On dirait un de ces dieux déchus de Henri Heine qui, pour vivre, ont pris de l'emploi dans la religion nouvelle. Il montre le ciel, mais il s'en moque, et semble rire de la crédulité des spectateurs. Lui, il sait la doctrine secrète, et ne croit nullement au Christ qu'il annonce; toutefois il fait pour le vulgaire le geste convenu et met les gens d'esprit dans la confidence par son sourire diabolique.

95:3–7. Le Christ de Léonard est le plus beau des hommes; mais rien dans sa personne ne décèle un dieu. Son tendre et ineffable visage respire la plus profonde douleur. C'est un maître miséricordieux qui avoue sans colère à ses disciples, à ses enfants, que l'un d'eux le trahira. Il est grand, pathétique, sublime, mais il reste homme.

. . . une part beaucoup trop large au naturalisme dans l'ap-

préciation des divers éléments qui ont concouru à la production de ce chef-d'oeuvre.

97:1–4. . . . avec peu de modestie dans le pose et dans le costume . . . inopinément découvert parmi les tableaux de la famille d'Orléans.

Le duc d'Orléans, fils du régent, choqué de cette nudité indécente, l'avait fait recouvrir d'une autre peinture qu'on ne songea plus à enlever.

. . . représente une femme à demi couchée, presque nue, évidemment faite d'après nature. C'est la *Joconde* . . .

97:10–11. La Léda est le sujet propre de la Renaissance. Vinci, Michel-Ange et Corrège y ont lutté, élevant ce sujet à la sublime idée de l'absorption de la nature . . .

98:4–5. Le type de la *Sainte Anne*, de la *Joconde*, du *Saint Jean*, serait-il une création spontanée du cerveau de Léonard? ou bien le peintre aurait-il rencontré dans la nature cet idéal qu'il avait obscurément poursuivi jusqu'alors?

99:10–16. . . . avait remis en honneur le mythe de la réminiscence.

Les figures de Vinci semblent venir des sphères supérieures se mirer dans une glace ou plutôt dans une miroir d'acier bruni où leur reflet reste éternellement fixé par un secret pareil à celui du daguerréotype. On les a déjà vues, mais ce n'est pas sur cette terre, dans quelque existence antérieure peut-être dont elles vous font souvenir vaguement. Comment expliquer d'une autre manière le charme singulier, presque magique, qu'exerce le portrait de Monna Lisa sur les natures les moins enthousiastes?

100:28–101:2. Fuis les orages, ce mot qu'on lit en tête de l'un de ses manuscrits donne la clef de son caractère et de sa vie, et il explique ce qui lui manque.

101:24–26. Ces retours extrêmes ne sont pas rares chez les indifférens . . .

. . . cet odieux mensonge . . .

. . . celle d'un chrétien qui a pris franchement son parti sur les pratiques et sur les croyances . . .

233:11–19. En ôtant l'aureole aux saints, Léonard de Vinci

découronne le moyen âge. Dans la *Sainte Cène*, les convives
n'ont plus rien des types consacrés. Ces personnages nou-
veaux annoncent un christianisme nouveau comme eux. Le
Christ seul garde au front son auréole mourante; on dirait
qu'elle s'efface au souffle du siècle qui se lève. Le mystère
s'enfuit, la lumière s'accroit. C'est l'heure où les esprits
évoqués par le moyen âge pâlissent et disparaissent. Dans la
Sainte Cène recommence le banquet de Platon.

The School of Giorgione

103:24–104:32. Pour parler exactement, il n'y a dans la
nature ni ligne ni couleur. C'est l'homme qui crée la ligne et la
couleur . . . La ligne et la couleur font penser et rêver toutes
les deux; les plaisirs qui en dérivent sont d'une nature dif-
férente, mais parfaitement égale et absolument indépendante
du sujet du tableau.

104:4. . . . très-fatiguée, dépouillée et déflorée. Il y a
pourtant des qualités dans le ton et le modelé des chairs.

105:7–8. Die Künste selbst so wie ihre Arten, sind unter
einander verwandt, sie haben eine gewisse Neigung, sich zu
vereinigen, ja sich in einander zu verliehren. . . . Man hat
bemerkt, dass alle bildende Kunst zur Mahlerey, alle Poesie
zum Drama strebe. . . . Eines der vorzüglichsten Kennzeich-
en des Verfalles der Kunst ist die Vermischung der ver-
schiedenen Arten derselben.

105:9–11. . . . se retrouvent en cette période au terme de
toutes les perspectives; et . . . dominent de très haut les
développements esthétiques de la seconde moitié du siècle.
Nous pensons, pour notre part, que la pensée de Pater sur
l'art reçut de Hegel et de lui ses deux impulsions majeures.

. . . la notion de "limites infranchissables" propre à chaque
mode d'expression a été formulée explicitement par Wagner,
qui érige sur elle tout son système d'une collaboration entre
les différent arts à l'intérieur d'une oeuvre unique.

106:4. können wir sagen, der Grundton des Roman-
tischen . . . sei musikalisch . . .
Doch kann sich diese Magie des Scheins endlich auch so
überwiegend geltend machen, dass darüber der Inhalt der
Darstellung gleichgültig wird, und die Malerei dadurch in
dem blossen Duft und Zauber ihrer Farbentöne und der Ent-
gegensetzung und ineinanderscheinenden und spielenden
Harmonie sich ganz ebenso zur Musik herüberzuwenden
anfängt, als die Skulptur in der weiteren Ausbildung des
Reliefs sich der Malerei zu nähern beginnt.

106:4–17. "In einem wahrhaft schönen Kunstwerk soll der
Inhalt nichts, die Form aber alles thun; denn durch die Form
allein wird auf das Ganze des Menschen, durch den Inhalt
hingegen nur auf einzelne Kräfte gewirkt. Der Inhalt, wie
erhaben und weitumfassend er auch sei, wirkt also jederzeit
einschränkend auf den Geist, und nur von der Form ist wahre
ästhetische Freiheit zu erwarten. Darin also besteht das eigent-
liche Kunstgeheimniss des Meisters, dass er den Stoff durch
die Form vertilgt. . . .

106:19–22. Chemin montant à travers une lande; à gauche,
bouquet d'arbres dont l'un brisé par le milieu, et buissons
secoués par un vent violent qui les effeuille; pluie dans le
ciel . . .

109:9–18. L'arrangement rhythmique et l'ornement (pres-
que musical) de la rime sont pour le poëte des moyens d'as-
surer au vers, à la phrase, une puissance qui captive comme
par un charme et gouverne à son gré le sentiment. Essentielle
au poëte, cette tendance le conduit jusqu'à la limite de son art,
limite que touche immédiatement la musique, et, par con-
séquent, l'oeuvre la plus complète du poëte devrait être celle
qui, dans son dernier achèvement, serait une parfaite musique.

113:10. Leur livre est en somme un nouveau Vasari . . .

Joachim du Bellay

126:9–20. Il suffit de jeter les yeux sur le petit tableau étincelant, pour sentir quel vernis neuf et moderne la réforme de Ronsard avait répandu sur la langue poétique.

128:24–29. On voit l'erreur; c'est déja la doctrine du rationalisme appliquée au langues. Les estimant toutes de même valeur à l'origine, il attribue toute la différence à l'industrie et à la culture . . . C'est précisément le contraire qui est vrai historiquement: les langues sont nées *comme plantes et herbes*, avec toutes sortes de diversités, et la fantaisie des hommes qui s'y joue ne peut tirer d'elles, en définitive, que ce qu'elles permettent et ce qu'elles contiennent.

130:7–9. . . . commence encores à fleurir sans fructifier, ou plus tost, comme une Plante et Vergette, n'a point encores fleury, tant se fault qu'elle ait apporté tout le fruict qu'elle pouroit bien produyre.

130:12–13. Chante moy ces Odes, incognues encor' de la Muse Francoyse d'un Luc bien accordé au son de la Lyre Greque & Romaine, & qu'il n'y ait vers, ou n'aparoïsse quelque vestige de rare & antique erudition. Et quand [quant] à ce te fourniront de matiere les louanges des Dieux & des Hommes virtueux, le discours fatal des choses mondaines, la solicitude des jeunes hommes, come l'amour, les vins libres, & toute bonne chere.

. . . une idée d'écartement, de dispersion.

130:15–16. Ie ne veux alleguer en cet endroict (bien que ie le peusse faire sans honte) la Simplicité de notz Maieurs, qui se sont contentez d'exprimer leurs Conceptions auecques paroles nues, sans Art et Ornement: non Immitans la Curieuse diligence des Grecz, aux quelz la Muse auoit donné la Bouche ronde (comme dict quelqu'un) c'est à dire, parfaite en toute elegance & Venusté de paroles: comme depuis aux Romains Immitateurs des Grecz. Mais ie diray bien que nostre Langue n'est tant irreguliere qu'on voudroit bien dire . . .

132:12–16. . . . la belle Marie Stuart adorait la poésie et en

particulier celle de Ronsard. Ce fut probablement à sa demande qu'il donna la première édition de ses Oeuvres.

133:6–7. Je te conseille d'user indifferemment de tous dialectes, comme j'ay desja dit; entre lesquels le courtisan est tousjours le plus beau, à cause de la majesté du prince; mais il ne peut estre parfait sans l'aide des autres, car chacun jardin a sa particuliere fleur . . .

133:22–24. Je suis de ceste opinion que nulle poësie ne se doit louer pour accomplie si elle ne ressemble la nature, laquelle ne fut estimée belle des anciens que pour estre inconstante et variable en ses perfections.

137:20–32. . . . toutes nos sympathies restent acquises au coeur du poëte qui nous a révélé si à nu ses sentiments et livré sous forme de rimes ses confessions.

. . . s'est adonné instinctivement à ce qu'on a nommé de nos jours la poésie *intime*, et il serait encore à cet égard un excellent modèle, si ce genre, purement individuel, comportait l'imitation.

138:2–5. Un voyage en Italie, qu'il a déploré comme le plus grand malheur de sa vie, le mit en pleine possession de son talent et fit définitivement ressortir son originalité poétique.

138:9–10. Quelqu'un a dit que la rêverie des poëtes, c'est proprement *l'ennui enchanté*; mais Du Bellay à Rome eut surtout l'ennui tracassé, ce qui est tout différent.

138:28–30. . . . ce petit chef-d'oeuvre qu'on peut appeler le roi des sonnets.

. . . l'*ardoise fine*, qui est la couleur locale des toits en Anjou, et ce je ne sais quoi de *douceur angevine* opposé à l'air marin et salé des rivages de l'Ouest.

Winckelmann

142:3–4. Florenz ist der schönste Ort, den ich in meinem Leben gesehen, und sehr vorzüglich vor Neapel . . . Ich hole jetzt nach, was ich versäumet habe; ich hatte es auch von dem

lieben Gott zu fordern. Meine Jugend ist gar zu kümmerlich gewesen, und meinen Schulstand vergesse ich nimmermehr.

142:33–143:4. ein früher schon gekanntes und wieder verlornes Land.

143:18–20. Durch Mangel und Armuth, durch Mühe und Noth habe ich mir müssen Bahn machen. Fast in allem bin ich mein eigener Führer gewesen.

143:32–144:2. Ich habe Vieles gekostet, aber über die Knechtschaft in Seehausen ist nichts gegangen.

144:3–6. Ich habe den Schulmeister mit grosser Treue gemachet, und liess Kinder mit grindichten Köpfen das Abece lesen, wenn ich während dieses Zeitvertreibs sehnlich wünschete, zur Kenntniss des Schönen zu gelangen, und Gleichnisse aus dem Homerus betete.

144:30–145:4. Winckelmann beklagt sich bitter über die Philosophen seiner Zeit und über ihren ausgebreiteten Einfluss; aber mich dünkt, man kann einem jeden Einfluss aus dem Wege gehen, indem man sich in sein eigenes Fach zurückzieht. . . . kein Gelehrter ungestratt jene grosse philosophische Bewegung, die durch Kant begonnen, von sich abgewiesen, sich ihr widersetzt, sie verachtet habe, ausser etwa die echten Alterthumsforscher, welche durch die Eigenheit ihres Studiums vor allen ander Menschen vorzüglich begünstigt zu sein scheinen.

145:10–16. Ihre Art zu handeln und zu denken war leicht und natürlich; "ihre Verrichtungen geschahen, (wie Perikles sagt) mit einer gewissen Nachlässigkeit," und aus einigen Gesprächen [e.g., *Lysis*] des Plato kann man sich einen Begrif machen, wie die Jugend unter Scherz und Freude ihre Übungen in ihren Gymnasien getrieben. . . .

145:22–24. Ich bin entschlossen mich auf einen gewissen Fuss in Rom zu sezen.

149:3–5. als einen gründlich gebornen Heiden
er sah in ihr bloss das Maskenkleid, das er umnahm, und drückt sich darüber hart genug aus. Auch später scheint er an ihren Gebräuchen nicht genugsam festgehalten, ja vielleicht gar durch lose Reden sich bei eifrigen Bekennern verdächtig

gemacht zu haben, wenigstens ist hie und da eine kleine Furcht vor der Inquisition sichtbar.

150:17–21. mitunter so räthselhaften Schriften Winckelmann's "Tüchtigkeit im Vaterlande mit Enthusiasmus anerkannt wurde"

150:25. Diese Bekanntschaft mit dem Herrn Mengs ist mein grösstes Glück in Rom

150:29–33. Ich muss dieses Unternehmen bis nach meiner Rükkunft anstehen lassen. Mein Unglük ist, dass ich einer von denen bin, die die Griechen Οψιμαθεις, *sero sapientes*, nennen, (*sapientes* ist hier nur in dem geringsten Grade des Wissens zu nehmen,) denn ich bin zu spät in die Welt und nach Italien gekommen; es hätte, wenn ich [eine] gemässe Erziehung gehabt hätte, in [Ihren] Jahren geschehen sollen.

Ich bin leider einer von denen, welche die Griechen Spätkluge nennen; Erziehung, Umstände und Mangel haben mich zurückgehalten, früher klug zu werden anzufangen.

die hoffentlich Ihnen nicht missfallen sollte

152:19–21. Guido [Reni] schrieb an einen römischen Prälaten, da er seinen Erzengel Michael zu malen hatte: "Ich hatte eine Schönheit aus dem Paradiese gewünscht fur meine Figur, und dieselbe im Himmel zu sehen, aber ich habe mich nicht so hoch erheben können, und vergebens habe ich dieselbe auf der Erde gesuchet." Gleichwohl ist sein Erzengel weniger schön, als einige Jünglinge, die ich gekannt habe und noch kenne.

152:24–153:15. Die christliche Moral lehret dieselbe nicht; aber die Heiden beteten [sie] an, und die grössten Thaten des Alterthums sind durch dieselbe vollbracht.

154:20–21. dem Columbus ähnlich, als er die Neue Welt zwar noch nicht entdeckt hatte, aber sie doch schon ahnungsvoll im Sinne trug.

Man lernt nichts, wenn man ihn liest, aber man wird etwas.

Doch bald erhob er sich über die Einzelheiten zu der Idee einer Geschichte der Kunst, und entdeckte, als ein neuer Columbus, ein lange geahnetes, gedeutetes und besprochenes,

ja man kann sagen, ein früher schon gekanntes und wieder verlornes Land.

155:21–32. Depuis cette époque on a exploré la Grèce et découvert les véritables chefs-d'oeuvre. Les marbres d'Égine, les incomparables sculptures du Parthénon, quelques bas-reliefs, quelques statues, parmi lesquelles il faut citer *la Vénus de Milo*, nous ont révélé une beauté bien autrement grande, vivante, personelle que l'élégance de *l'Apollon du Belvédère* ou même le charme exquis de *la Vénus de Medicis*.

156:10–11. anstatt dass sie mich hätte belustigen sollen, hat mich ausserordentlich schwermüthig gemachet, und da es nicht möglich ist, mit der benöthigten Bequemlichkeit dieselbe zu machen und fortzusezen, folglich kein Genuss ist, so ist für mich kein Mittel, mein Gemüth zu befriedigen und die Schwermuth zu verbannen, als nach Rom zurückzugehen.

156:23–26. Er würde ihn völlig ermordet, wenn nicht das Kind, mit dem Winckelmann öfter zu spielen pflegte, an die Thür geklopft hätte. Auf dies Geräusch entfliehet der Mörder, ohne die Medaillen mitzunehmen.

162:19–20. Lippen und Kinn der Erzstatue des Heraklos zu Akragas sind durch Küssen stumpf.

163:11–12. . . . la beauté de cette composition vraimente divine. Outre la perfection de la figure principale, l'artiste est parvenu à donner à ses teintes une lucidité, une transparence, je dirais presque une immatérialité qui s'harmonise *merveilleusement* avec la nature toute mystique du sujet . . .

168:11–15. Die menschliche Stimme dagegen tönt aus der eigenen Empfindung und dem eigenen Geiste ohne äusseren Anstoss, wie die Höhe der Kunst überhaupt darin gesteht, das Innere sich aus sich selber gestalten zu lassen. Das Innere aber der menschlichen Gestalt ist in Aegypten noch stumm. . . .

170:13. Wir können . . . die heitere Ruhe und Seligkeit, dies Sichselbstgenügen in der eigenen Beschlossenheit und Befriedigung als den Grundzug des Ideals an die Spitze stellen. Die ideale Kunstgestalt steht wie ein seliger Gott vor uns da. Den seligen Göttern nämlich ist es mit der Not, dem

Zorn und Interesse in endlichen Kreisen und Zwecken kein letzter Ernst, und dieses positive Zurückgenommensein in sich bei der Negativität alles Besonderen gibt ihnen den Zug der Heiterkeit und Stille. In diesem Sinne gilt das Wort Schillers: "Ernst ist das Leben, *heiter* ist die Kunst."

170:23–30. . . . la première affaire d'un artiste est de substituer l'homme à la nature et de protester contre elle.

176:27–28. Nie schämt sich der Grieche der Natur, er lässt der Sinnlichkeit ihre vollen Rechte, und ist dennoch sicher, dass er nie von ihr unterjocht werden wird.

Die Kunst durch ihre Darstellungen befreit innerhalb der sinnlichen Sphäre zugleich von der Macht der Sinnlichkeit.

179:5–7. Die seligen Götter trauren gleichsam über ihre Seligkeit oder Leiblichkeit; man liest in ihrer Gestaltung das Schicksal, sas ihnen bevorsteht. . . .

179:7–21. Den Keim ihres Untergangs haben die klassischen Götter in sich selbst.

. . . der selige Frieden, der sich in ihrer Leiblichkeit abspiegelt, ist wesentlich ein Abstrahiren von Besonderm, ein Gleichgültigsein gegen Vergängliches, ein Aufgeben des Aeusserlichen, . . . ein Entsagen dem Irdischen und Flüchtigen . . .

. . . und dessen Entwickelung, als wirkliches Hervortreten jenes Widerspruchs der Hoheit und Besonderheit, der Geistigkeit und des sinnlichen Daseyns, die klassische Kunst selber ihrem Untergange entgegenführt.

. . . das Bewusstseyn sich zuletzt nicht mehr bei ihnen zu beruhigen vermag, und sich deshalb aus ihnen in sich zurückwendet.

180:4–5. [Es] kann . . . in der romantischen Kunst obgleich das Leiden und der Schmerz in ihr das Gemüth und subjective Innre tiefer als bei den Alten trifft, eine geistige Innigkeit, eine Freudigkeit in der Ergebung, eine Seligkeit im Schmerz und Wonne im Leiden, ja eine Wollust selbst in der Marter zuf Darstellung kommen. Selbst in der italienischen ernst religiösen Musik durchdringt diese Lust und Verklärung des Schmerzes den Ausdruck der Klage. Dieser Ausdruck ist

im Romantischen überhaupt das Lächeln durch Thränen.
184:18–27. Die Freiheit ist die höchste Bestimmung des
Geistes.

Uns gilt die Kunst nicht mehr als die höchste Weise, in
welcher die Wahrheit sich Existenz verschafft. . . . Man kann
wohl hoffen, dass die Kunst immer mehr steigen und sich
vollenden werde, aber ihre Form hat aufgehört, das höchste
Bedürfniss des Geistes zu seyn.

251:7–11. Gewisse Zustände des Menschen, die wir
keinesweges billigen, gewisse sittliche Flecken an dritten Per-
sonen haben für unsre Phantasie einen besondern Reiz. . . . es
ist damit, wie mit dem Wildbret, das dem feinen Gaumen mit
einer kleinen Andeutung von Fäulniss weit besser als frisch
gebraten schmeckt. Eine geschiedene Frau, ein Renegat
machen auf uns einen besonders reizenden Eindruck.

274:35. . . . l'hérésie de l'enseignement . . .

. . . la fameuse formule de l'art pour l'art . . .

L'art pour l'art signifie, pour les adeptes, un travail dégagé
de toute préoccupation autre que celle du beau en lui-même.

Review of Symonds's *Renaissance in Italy: The Age of the Despots*

198:24–199:4. *Un monde d'humanité commence, de sympathie
universelle*. L'homme est enfin le frère du monde . . . C'est là
le vrai sens de la Renaissance: tendresse, bonté pour la nature.

Index

A reference in the index to a page of Pater's text should be taken to include the notes to that page. The index includes the Textual Notes. It also includes references made in the Critical and Explanatory Notes to certain writers of special importance to Pater; otherwise the notes are not indexed.

INDEX

Venetian school of painting, 109–
111
Ventadour, Bernard de, 12
Venus, medieval worship of, 19
Venus of Melos, 52, 164
Veronese, Paolo, 103
Verrocchio, Andrea del: "Baptism
of Christ," 79–80; statue of
Bartolomeo Colleoni, 95; draw-
ings copied by Leonardo, 97, 98
Vidal, Pierre, 12, 18

Villon, François, 124, 125, 134
Voltaire, 65, 149, 190; impression on
Winckelmann, 144

Winckelmann, Johann Joachim,
xxiv–xxv, 51, 141–185, 268–269;
Imitation of Greek Works of Art, 150;
History of Ancient Art, 154, 155
Wolff, Christian, 144
Wordsworth, William, xxi–xxii

489

Designer: Wolfgang Lederer
Compositor: G & S Typesetters
Printer: Halliday Lithograph
Binder: Halliday Lithograph
Text: VIP Bembo
Display: VIP Palatino
Cloth: Holliston Roxite C56668 vellum
and B53663 linen

DATE DUE